THE
FIGURATIVE
ARTIST'S
HANDBOOK

A CONTEMPORARY GUIDE TO FIGURE DRAWING, PAINTING, AND COMPOSITION

ROBERT ZELLER

FOREWORD BY PETER TRIPPI
AFTERWORD BY KURT KAUPER

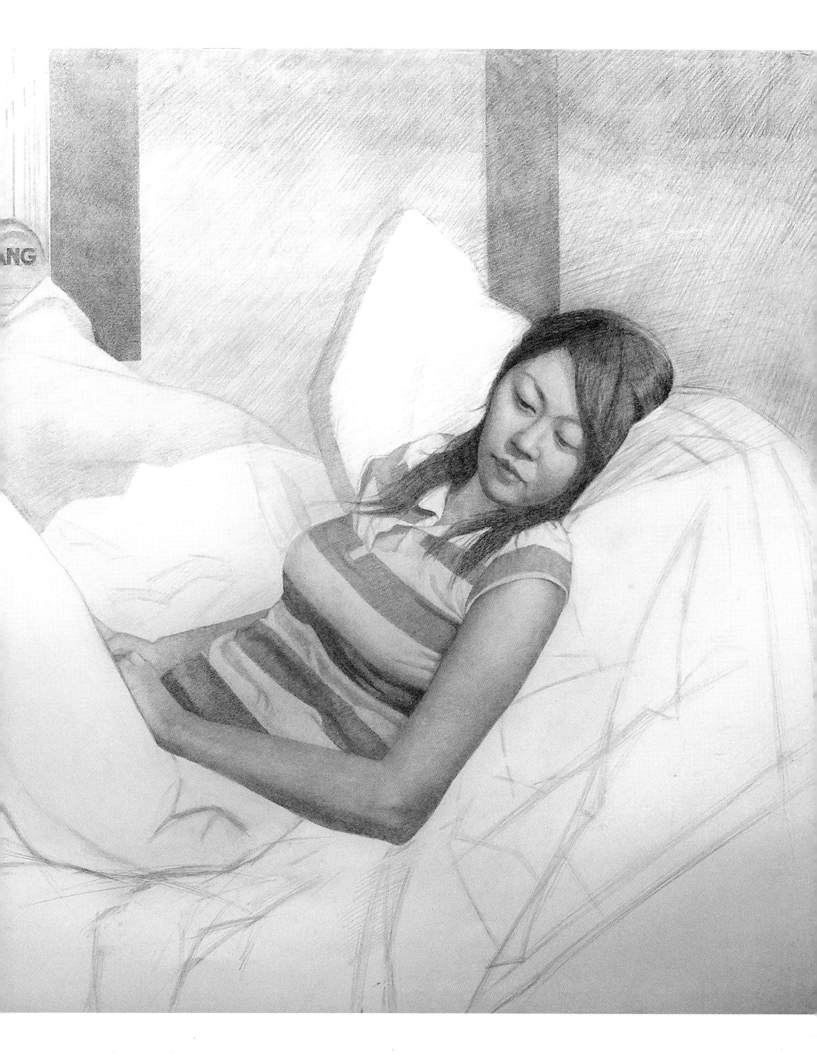

Published in the United States by MONACELLI STUDIO,
an imprint of THE MONACELLI PRESS

Library of Congress Cataloging-in-Publication Data

Names: Zeller, Robert, 1966– author.
Title: The figurative artist's handbook : a contemporary guide to figure
drawing, painting, and composition / Robert Zeller.
Description: First edition. | New York, New York : Monacelli Studio, 2016.
Identifiers: LCCN 2016007845 | ISBN 9781580934527 (hardback)
Subjects: LCSH: Figurative drawing. | Figurative painting. | Human figure in
art. | Composition (Art) | BISAC: ART / Techniques / Life Drawing. | ART /
Techniques / Drawing. | ART / Subjects & Themes / Human Figure.
Classification: LCC NC765 .Z43 2016 | DDC 743.4--dc23
LC record available at https://lccn.loc.gov/2016007845

ISBN 978-1-58093-452-7

Printed in China

Design by JENNIFER K. BEAL DAVIS
Cover design by JENNIFER K. BEAL DAVIS
Cover illustrations by ROBERT ZELLER
Illustration credits appear on page 300.

10 9 8 7 6 5 4 3

First Edition

MONACELLI STUDIO
THE MONACELLI PRESS
6 West 18th Street
New York, New York 10011
www.monacellipress.com

PAGE 1: David Kassan, *Shay*, 2015, charcoal and
Charcoal White on Mylar, 24 x 14 inches (61 x 35.6 cm)

PAGES 2–3: Rob Zeller, *Convalescence*, 2007, pencil
and charcoal on paper, 36 x 52 inches (91.4 x 132.1 cm)

OPPOSITE: Rob Zeller, *Stretched*, 2015, graphite, acrylic,
and oil on paper, 21 x 15 inches (53.3 x 38.1 cm)

This book is dedicated to my daughter, Emalyn.

This book was inspired by Kenneth Clark's *The Nude* and Andrew Loomis's *Figure Drawing for All It's Worth*.

This book would not have been possible without the help of some important people. I'd like to thank:

Elisabeth Conner Skjærvold; without her professionalism, this book would not have been half as good. Christian Johnson for believing in it from the start and extending himself for its betterment. Katie Ferrari for reminding me to include more women. Martin Wittfooth for highlighting two key concepts that have made it a much better work. Gagosian, Driscoll Babcock, Forum Gallery, and Adelson Galleries for being so easy to work with. The families of Andrew Wyeth, Edwin Dickinson, Norman Rockwell, Nelson Shanks, Kent Bellows, Andrew Loomis, and Frank Frazetta for being willing to share their relatives' work in this book. Last, the late Conger Metcalf for always reminding me that I was only as good an artist as my figure drawings. Conger, the art lessons you gave to me as a young man inspire me to this day.

CONTENTS

FOREWORD

BY PETER TRIPPI

At the risk of seeming over the top, it is safe to say that this book is a milestone. Obviously a labor of love, it also marks the opening of the next chapter in the rebirth of figuration in America today. As Rob Zeller notes in his thorough though not overwhelming text, there is growing energy in this sector of contemporary art, yet instructors like him must juggle half a dozen existing books to convey what their students need to know. In the development—in this case, the recovery—of a field, building a solid literature is essential, and this book will definitely be used for at least a generation or two.

Though his primary audience is working artists, Zeller's opening section on the history of figuration makes for lively reading by anyone interested in art. Moving forward, the lessons offered should intrigue even those who don't make art, primarily because the artists—both historical and living—selected by Zeller for emulation are uniformly outstanding. As editor of a magazine called *Fine Art Connoisseur,* I am naturally keen on calling out who's good/better/best, so it gives me joy to see that Zeller has highlighted only the best. It's a reminder of how golden an age we are experiencing now that many of the artists examined here are still in their thirties and forties. There is so much talent at work right now, with decades still to run.

Speaking of those generations, an urgent question about them has been that, though their technical skills are evident, what exactly do they have to say as individuals, and how can their compositions be enhanced to put their messages across in a manner that is unique, authentic, and comprehensible to modern viewers? Zeller's substantial focus on composition and vision is, therefore, gratifying; he wants his readers to take that next step, and he paves the way by showing them who's done it already and how.

Necessity is the mother of invention, so Rob Zeller took matters into his own hands—addressing a need he perceived in his classroom by creating a useful tool. Yet it would surely have been easier and cheaper to make his book short and plain. Monacelli Studio knows a good thing when it sees it, though, and now deserves credit for going the extra mile to produce a volume that will inspire readers through its beauty as much as through its information.

On behalf of the art collectors served by *Fine Art Connoisseur,* I am grateful to everyone involved in this project for making it happen. We all look forward to watching its artist-readers grow to the next level, enhancing our collective vision with important works of art that are both well made and well conceived.

PETER TRIPPI
Editor-in-Chief, *Fine Art Connoisseur* • New York City

OPPOSITE: Rob Zeller, *Jamaal,* 2014, pencil on paper, 24 x 18 inches (60.9 x 45.7 cm)

PREFACE

When I was first asked to consider writing this book, I was reluctant. I could think of at least five artists in my circle of friends who were better figurative draftsmen. To anyone with atelier training, no matter what we tell ourselves about content, there is always a voice that says technical excellence is the most important criterion. We are continually ranking ourselves.

But upon further reflection I saw the need. There are quite literally thousands of books on the subject of figure drawing and painting on the market. But none, as of this writing, are by someone trained in both the atelier method and in an anatomical/structural approach. Nor have any been written by someone with my experience in founding and running an art school that has employed more than thirty different teachers (with as many different artistic viewpoints) as the Teaching Studios of Art. I realized I had a very broad view from which to write a book on the figure.

I bring this up because it gets to the very heart of the book. Working with the figure is a lifelong task and requires a good deal of equilibrium. What it takes to be a figurative artist is actually something of a conundrum. You cannot express your unique creative voice without at least fundamental technique, and you cannot express that voice if you are always focusing on technique. You cannot remain a student forever, and yet you must be perpetually learning and observing. It is very important to be able to shut off the internal critic when necessary, and take a broader view.

I have been teaching figure drawing and painting for seven years. One of the main problems I've faced in teaching the figure is that I have to use six or seven books, because no single book is comprehensive enough. As good as these references are, they are all missing one necessary component or another. What if I could change that? What if I could write something comprehensive regarding the figure that had not been done before, along the lines of a handbook, a "bible"?

The Figurative Artist's Handbook does something very ambitious, something no other book on figure drawing and painting has tried to do. In addition to including how-to, step-by-step lessons, it puts the figure, and the great themes associated with it, in a historical context. It offers glimpses into how I and other artists create compositions using the figure. It features the work of not only internationally famous figurative artists, but also of up-and-coming artists. It also shows their sketchbooks, their creative process.

My hope is that this book is a helpful resource to artists of all ages and levels of experience who want to work with the human figure. It is the book that I wish I had had as a young art student.

ROBERT ZELLER

OPPOSITE: Rob Zeller, *Sheila,* 2003, pencil on paper, 24 × 18 inches (60.9 × 45.7 cm)

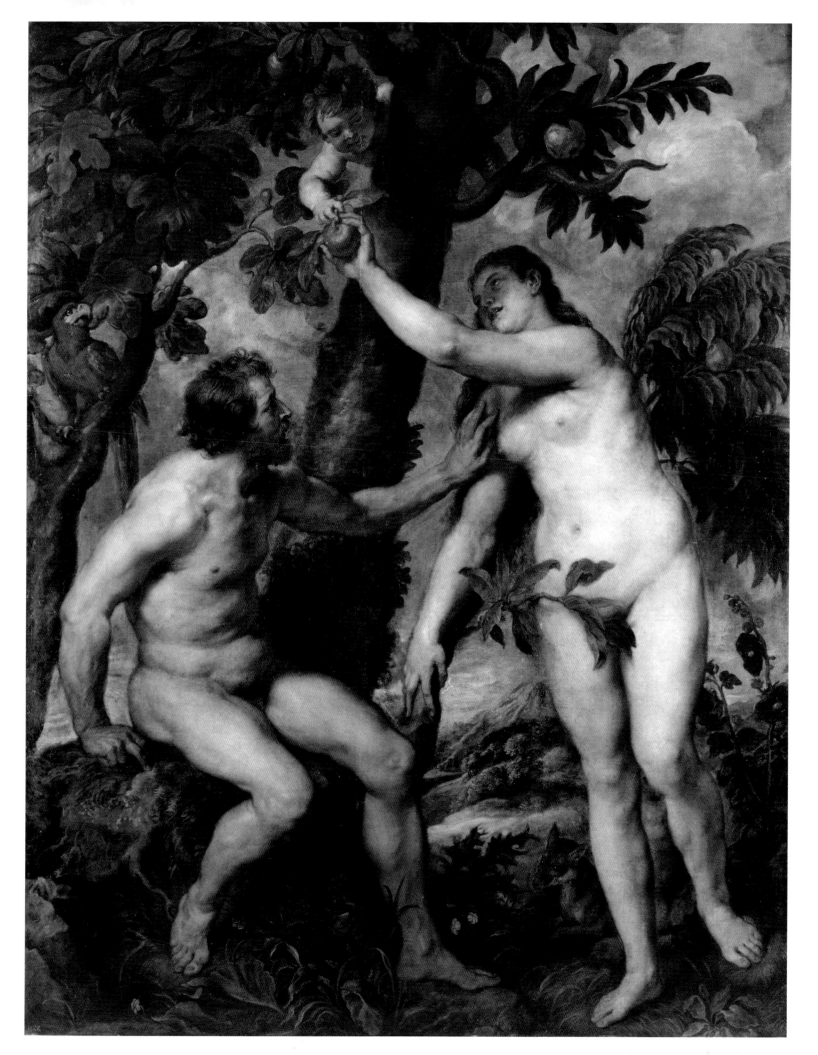

THE GREAT MOVEMENTS IN FIGURATIVE ART

I t is said that history repeats itself, and the great movements in the history of art are no exception. The resurgence of figurative art that we see in the art world at present was preceded by decades of scorn for the genre in the West. The elements that have caused the boom-and-bust cycle of figurative art are the same ones that have governed any changes in the taste of a given society at any time in history—namely, the fashion and philosophy of the wealthy and powerful. Every market has its forces, and the tastes of prominent individuals often coalesce around certain acceptable conventions, which in turn are catered to by the market.

OPPOSITE: Peter Paul Rubens, *The Fall of Man: Adam and Eve* (after a painting of the same subject by Titian), 1628–1629, oil on linen, 93¾ x 72½ inches (237.9 x 184.5 cm), Museo del Prado, Madrid

Artists today do not like to think that what they create and how they create it are in any way tethered to someone else's taste. But, historically speaking, that has almost always been the case. If you want to learn anything about the history of the figure, you are going to become familiar with the tastes of patrons who supported those artists' careers. For instance, serious study of Michelangelo is going to lead you to learn of the popes and members of the de' Medici family who stood behind him and commissioned his work.

Defining terms is necessary in a historical context. I will not use the popular term *Classical Realism*, as it's an oxymoron by definition. The Greek Classical and French Realist movements were antithetical to each other. Instead, I'm going to use the following: *figurative art* and *Figurative Realism*. *Figurative art* is pretty straightforward—it's any art that uses the figure in a narrative context. *Figurative Realism* is a bit more specific. By my definition, it's the use of a figure that displays an understanding of anatomy and form. For example, we can say that Egyptian art was figurative. We would not say that the Egyptians understood anatomy and form the way the Greeks did. This is not meant to disparage the incredible beauty of Egyptian art, but to clarify different levels of figuration in art.

When studying art from the past, I believe we need to look deeper than mere technical facility. In the case of an artist like Hans Holbein the Younger (see pages 28–29), that's tough to do, but we owe it to both ourselves and the artists of the past to make the attempt. We need to discern what they were saying with their work, because figurative art *always* conveys a narrative, a point of view. At the present, it is considered vital for a figurative artist to have his or her own artistic voice, and to exhibit some originality. How can you hope to be original, to contribute to the conversation, if you do not listen to the past, to those who have come before you?

What follows are the very basics of what a figurative artist should know about art history in the Western tradition. It is a cursory, yet precise, overview. It in no way attempts to supplant the role of an art history textbook. If you find yourself intrigued by anything you read here, more serious study is encouraged.

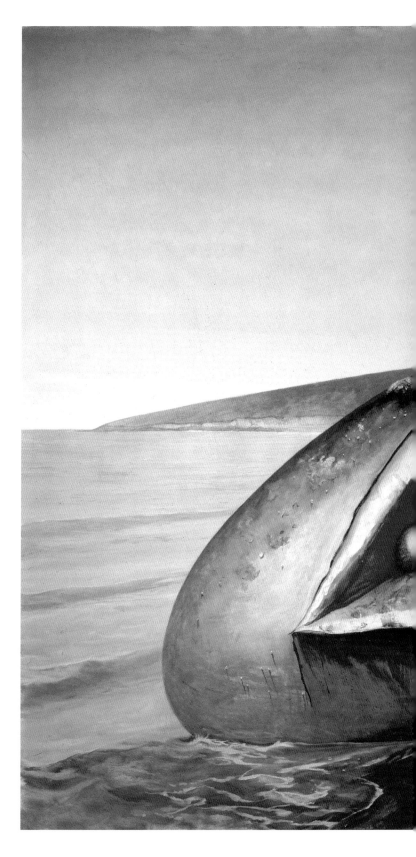

ABOVE: Bo Bartlett, *Leviathan*, 2000, oil on linen, 89 x 138 inches (226 x 350.5 cm)

THE ART OF ANCIENT EGYPT

Our process of understanding the key developments in the history of the figure, and how art is affected by culture and vice versa, begins with ancient Egypt, a sophisticated, polytheistic culture that thrived for more than three thousand years (spanning roughly 3000 to 30 B.C.) along the Nile basin. The entirety of Egyptian culture existed to serve and pay tribute to the gods. It was dominated by a pharaoh, considered to be a god himself as well as an intermediary to the other gods, and a member of the priestly class that served the remaining pantheon of gods on a local level. The power structure was clear. Those who administered to the gods had massive authority over all members of Egyptian society, including the military, merchants, artisans, farmers, and slaves. That authority extended to every aspect of life and culture, including the arts.

For more than three thousand years, the aesthetic conventions that governed Egyptian painting, sculpture, and architecture remained remarkably consistent. If you were an artisan during that time period, you had no choice but to work in this "house style." Many subtle variations blossomed over the millennia, but the essential formal constancy is, in itself, astonishing—particularly considering that today "movements" in art barely last a few years.

The major conventions in Egyptian art as they relate to the figure can be summarized in three main points, each of which can be seen in the image here: First, Egyptian art uses hierarchical proportion, where the size of a figure indicates his or her relative importance. (Thus, the pharaoh and any other gods are usually depicted much larger than high officials or the tomb owners; servants, artists, entertainers, and the like are typically the smallest.) Second, Egyptian paintings incorporate multiple perspectives simultaneously. For instance, the head and feet of a figure are shown in a profile, while the torso is shown from a

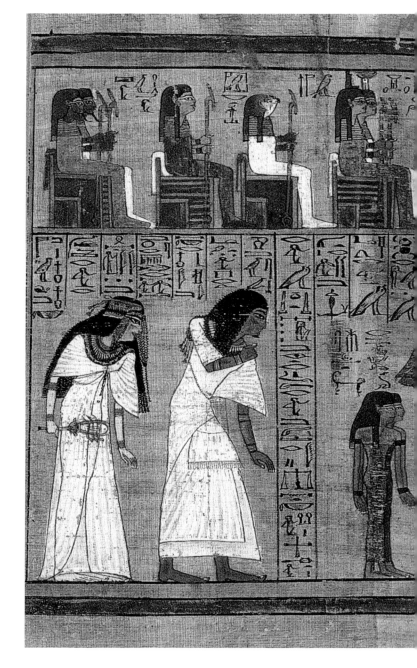

frontal view. (All limbs had to be shown regardless of angle, however, since they would be needed for the afterlife.) And third, Egyptian art employs heavy use of symbolism, which establishes a sense of order and ensures that the image will be understood. For instance, a jackal head symbolizes Anubis (the god of funeral rites), while a falcon head symbolizes Horus (the god of the sky).

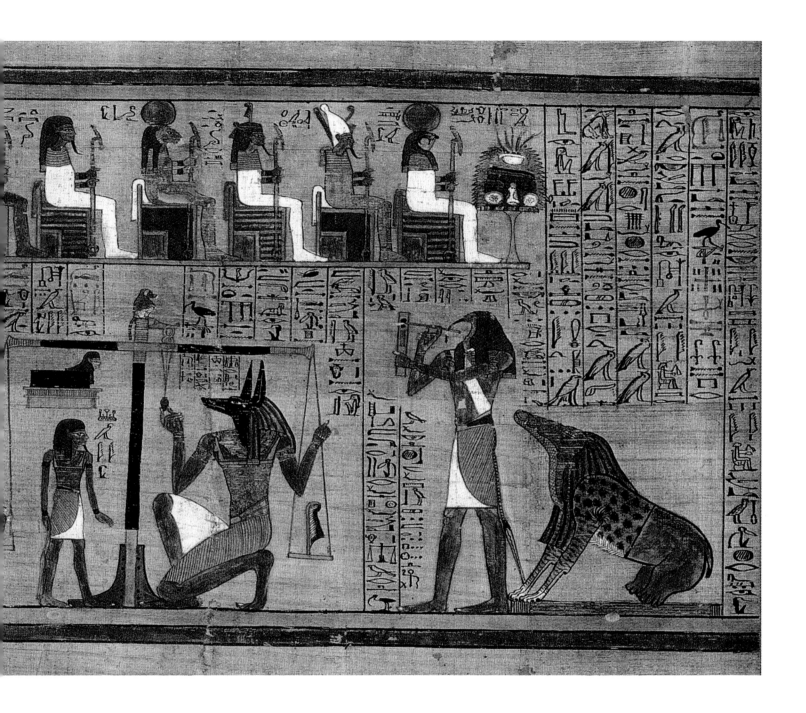

As mentioned earlier, remarkably, these three conventions hardly varied at all for more than three thousand years. The Egyptians "celebrated" death in the sense that everything in their art and culture pointed toward the importance of that event as a stepping-stone to the afterlife. To serve the gods well in this life was to prepare for the next. Although the Egyptians had a very particular aesthetic, this focus on the present world as a setup for the "world to come" was not that different from what the Catholic Church would require of its artists thousands of years later. But the gods were different, of course, and the artists employed by the Church were not nearly as monolithically uniform in technique as the Egyptians.

ABOVE: Artist unknown, *Weighing of the Heart by Anubis,* from the *Book of the Dead of Ani,* circa 1300 B.C., papyrus scroll, British Museum, London

THE ART OF ANCIENT GREECE

While Egyptian art could be described as figurative, and served the gods of that culture's polytheistic religion, ancient Greek art served both gods and men and came to define Figurative Realism in its very first inception, as Classicism. The Greeks were trading partners with the Egyptians, and as such were greatly influenced by them. But unlike Egypt's gods, those of the Greeks looked human. Greek art was centered on depicting either humanity or gods that *looked* male or female. Over the course of roughly one thousand years of their empire, the Greeks went through many different artistic conventions, each building on its predecessor, but their most incredibly unique accomplishment was the Classical Period (480–323 B.C.), and later the Hellenistic (323–31 B.C.).

In keeping with the theme that the ruling class dictates the artistic conventions of its time, let's be clear— the Classical Period in Greek art was financed, at least initially, by two men: Pericles, the Athenian statesman, and Alexander the Great, the king of Macedon. Much has been written about these two men and I cannot go into further detail here. Suffice it to say that their desire for propaganda and self-grandeur paid into the hands of the artistically gifted. In fact, so important was Alexander the Great to Greek culture that his death in 323 B.C. marks the end of the Classical Period for many scholars.

So how do we define the term *Classical*—and what does it have to do with the figure? Sometime around 500–480 B.C., the Greek sculptors entered what came to be known as the Classical Period. The discussion of the birth of a classical understanding of the figure is focused entirely on sculpture because, unlike the Egyptian art that has come down to us, there is virtually no surviving Greek painting to speak of. In short, what we know about painting of the Greek Classical Period is by visual inference— by following the bread crumbs left between the extant Greek sculpture and architecture, and by cross-referencing those works with Greek writing of the time.

Although the order of events is up for debate, we can safely say the following about the formal conventions of the Classical Period: They were Apollonian, built on reason and the careful study of the human form. As Greek artists began to study human movement and anatomy to a greater depth than before, they conceived of a "weight shift," or a slight bend in one leg. This results in the shifting of the axis of the pelvis and rib cage/shoulders in opposite directions to offset that bend. Greek sculpture began to show *contrapposto*.

That study of balance led Greek artists to measure parts of the body in relation to others in order to gauge accuracy. Everything was in play as a unit of comparative measurement. Sternums and heads proved most popular. Soon canons of proportion began to form around these units. One of the main proponents of the use of harmonious proportion was the sculptor Polykleitos, a mathematically precise artist who introduced the (now common) 7½ head lengths as a scale of proportion for the human figure. But study of his sculptures can teach us much more than that about the classical ideal. Polykleitos introduced an overall harmony throughout the smaller sections of the body that added up to a completely congruous and rhythmic whole.

Let's look for a moment at a Roman copy of his *Diadoumenos*, a depiction of a youth tying a fillet around his head after a victory in an athletic contest. In an attempt to perfectly balance the internal structure of the torso, the thoracic arch of the rib cage is stylized and symmetrical, as are the pectoral muscles, which lie across the upper third of the rib cage. The wall of the abdominals ends in the inguinal ligament in a sort of reverse arch, bounded on either side by the two points of ASIS

OPPOSITE: Roman copy of a Greek bronze statue by Polykleitos, *Statue of Diadoumenos (Youth Tying a Fillet around His Head)*, circa A.D. 69–96, marble, 73 inches (185.4 cm) high, The Metropolitan Museum of Art, New York (Fletcher Fund, 1925)

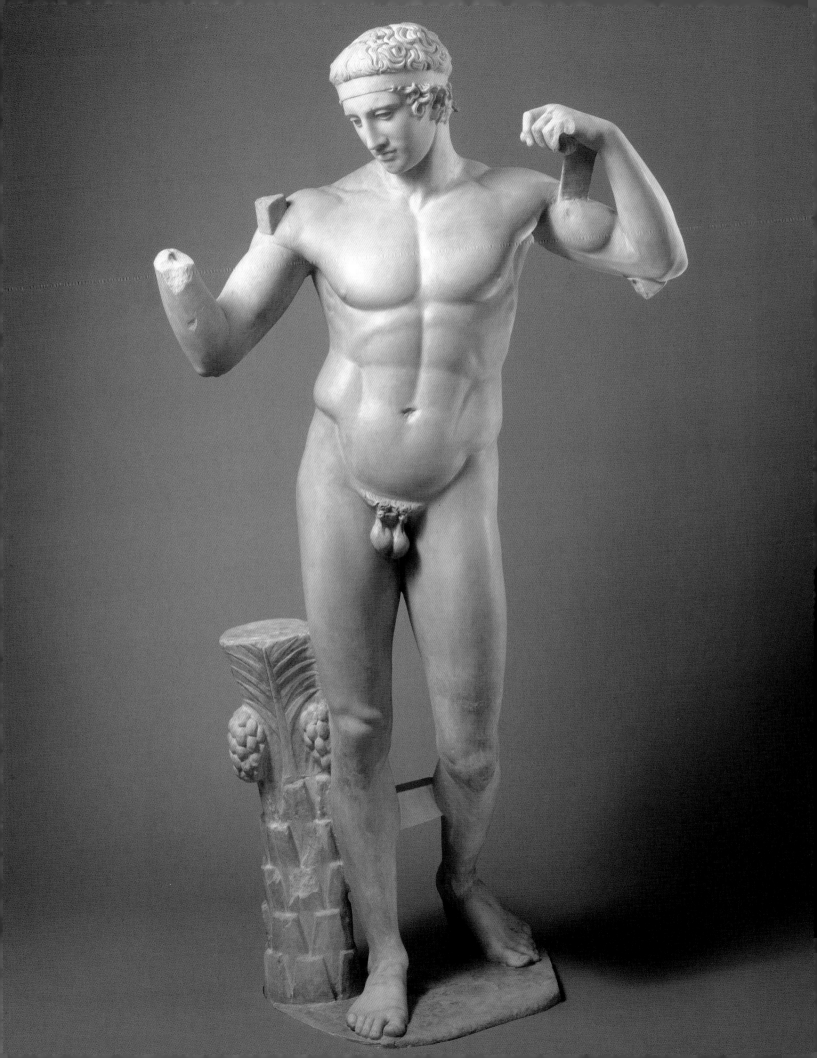

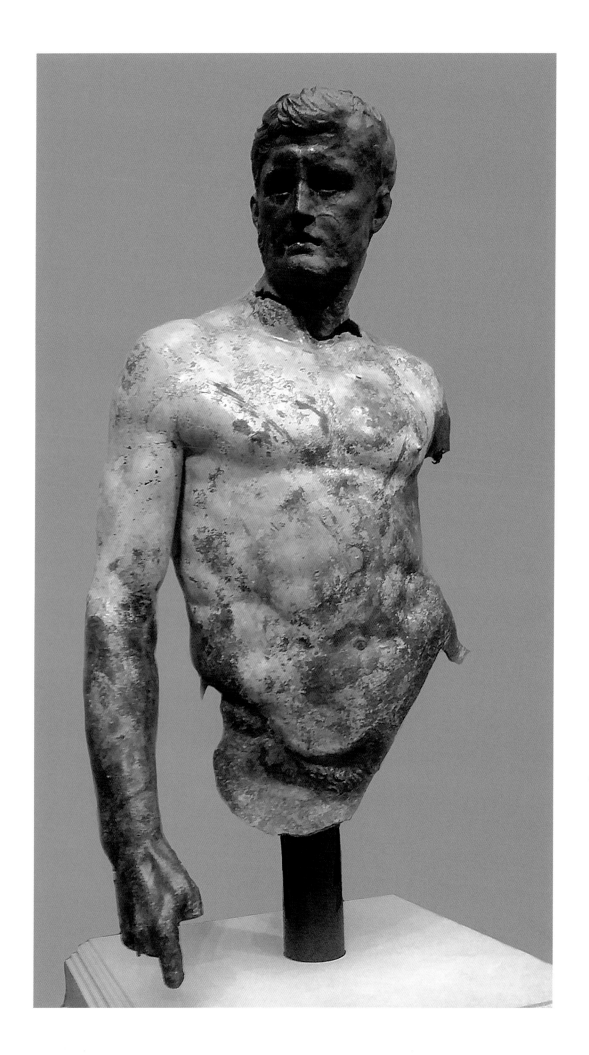

(anterior superior iliac spine). The pelvis, in both front and back views, represents the structural intersection of the supporting twin columns of the legs into a boxlike structure, with the two flanks of external obliques on either side above it serving as a transitional device with the rib cage.

The *Diadoumenos* is an Apollonian idealization of a male nude and exudes a very calm, quiet masculine power. While we need to keep in mind that we are looking at a Roman copy of a lost original, the Roman sculptor was likely very faithful in conveying this aspect of the figure. The Romans subsumed Greek culture and refashioned it according to their own virtues. There is much about the Classical Period that we have to accept through Roman eyes.

In general, the deities of Greek mythology are depicted as human in form but severe and capricious in their dealings with mankind. As a result, there is a detached cruelty to the grandeur of the figure in the Classical and Hellenistic Periods. Acknowledgment of a completely pagan worldview is key to understanding this severity. This is partly why so many contemporary artists misunderstand the term *Classical*. They most often confuse it with French Neoclassicism of the eighteenth and nineteenth centuries. Neoclassicism was contextualized in the heavily Christianized world that it was conceived in. One only has to study a few Classical or Hellenistic bronzes to see how large a difference there really is between the pagan Classical and the Christian Neoclassical.

The Hellenistic Period represents a logical progression in the perfection of the figure by the Greeks. It is in this period that we see more of the sensual and tragic Dionysian influence in Greek art. This is logical because the period coincided with a fall from political and military supremacy against the Romans. Bronze statues of the period saw a change from staid and detached idealization to a more concerted effort to portray naturalism. Although we have precious few left, Hellenistic bronzes often convey an astonishing range of emotions.

A case in point would be *Statue of a Man*, a bronze found amid the remains of a shipwreck on the bottom of the Adriatic Sea. The sculpture is thought to be a portrait of a Roman general named Lucius Aemilius Paullus, who conquered Perseus of Macedon in 168 B.C., but that attribution is not certain. Very naturalistic in its muscular surface forms, the figure is especially notable for its face; with brows knitted and the mouth slightly open, it is a compelling mix of regality and pathos. It conveys many of the virtues that the Greeks and Romans had in common. The figure's gesture is that of a man of authority, disciplined, in good health, with an air of gravitas and respectability about him.

The figurative art of the Greeks and Romans reflected the ideals of both cultures' religion and philosophy of humanity, as did that of the Egyptians before them. As we will see, the art of the Middle Ages did likewise, to very different results. Whether Classical ideals are noble by modern standards or should be emulated by artists working today is certainly debatable. What is not debatable is that Classicism, in both its Apollonian and Dionysian visages, keeps resurfacing in our collective artistic consciousness, only to be lost again for a season, then return once more.

OPPOSITE: Artist unknown, *Statue of a Man*, bronze, second century B.C., 50 x 29½ x 19¼ inches (127 x 75 x 49 cm), Museo Archeologico, Provinciale "Francesco Ribezzo," Brindisi, Italy. Photo copyright © 2016 Paul Loughney.

GOTHIC ART

Giorgio Vasari, the great historian of the Renaissance, holding true to time-tested norms, did not care very much for the preceding era's artistic conventions. Perhaps he was exhibiting a little nationalistic Latin pride and was still sore about the Goths' having sacked Rome and having pulled Europe into the "Dark Ages" for roughly one thousand years (A.D. 476–1450) when he wrote about the "barbarous nations [who] erected buildings in that style which we call Gothic (*dei Gotthi*)."

But, in fact, "dark" is not an apt adjective for that period. The art and architecture from the Middle Ages was hardly barbaric. Though certainly *not* classical, this was an incredibly rich period in art. In terms of patrons, the Catholic Church was the largest, but many works during this time were commissioned privately by wealthy individuals. In his dismissive remark, Vasari ignores a very important point about Gothic architecture— one that was also true of paintings and sculpture of the time. The artisans of the Middle Ages, like the Greeks before them, used geometry to convey sacred theological principles. Vasari, like many scholars of his day, could not see that continuity because medieval artists had abandoned Classical form and anatomy.

Much of Gothic art was intended to convey a narrative to the common people about the Christian religion. Stylistically, it often did so in a very ornate manner, with lots of gilding and rich patterns. The figures present in the narratives were not Classical, but definitely fit within a unique and somewhat uniform style. The female figures usually had elongated and rounded forms. The males were more angular and geometric. A close inspection of *The Annunciation and Two Saints* (opposite), by Simone Martini and Lippo Memmi, reveals a flowing line that swoops down from the wings of the angel Gabriel, across and up through the Madonna, set against a richly gilded background with ornate patterning in the fabric worn by both figures.

Many of the larger paintings that have survived from the Gothic Period were done on wood panels, intended for naves and altars of Catholic churches. And many of the smaller paintings that still exist take the form of illuminated manuscripts. There was considerable overlap between panel painting and illumination. There were no printing presses at the time, so all books were handmade and quite expensive. We call such a book a "manuscript," and being hand done, each is unique in one way or another. When they contain hand-drawn and painted illustrations, we refer to them as "illuminated manuscripts."

Works of art and architecture created during the later part of the Gothic Period are characterized by what is referred to as the International Gothic Style, a broad term for a unified aesthetic that encompassed panel paintings, illuminated manuscripts, stained glass windows, tapestries, and even the craft of glassblowing and tableware. It was a style that began in the courts of France and Northern Italy but soon spread to most of Europe. It began in the late fourteenth century and was an artistic influence lasting until the mid-seventeenth century.

To focus on a particular aspect of the style pictured here, the production of an illuminated manuscript was incredibly laborious and stemmed from the desire of the laity to engage in the devotional life that prevailed in monastic spiritual culture. Illuminated manuscripts contained calendars, Gospel lessons, images, psalms, and copious decorative motifs, some of them quite elaborate. Often commissioned or purchased as wedding gifts, they were usually passed down from parent to child. The breviary was the most popular form of prayer book. It was essentially a shorter form of the psalter, which monks and nuns were required to recite. The breviary contained weekly cycles of psalms, prayers, hymns, antiphons, and readings that changed with the liturgical season.

Visually, prayer books were similar to Gothic paintings in that they emphasized flowing, curving lines, minute detail, and refined decoration, and featured gold, which was often applied to the paper as background color. The most elaborate and artistic of these prayer books was a type known as a book of hours. By the

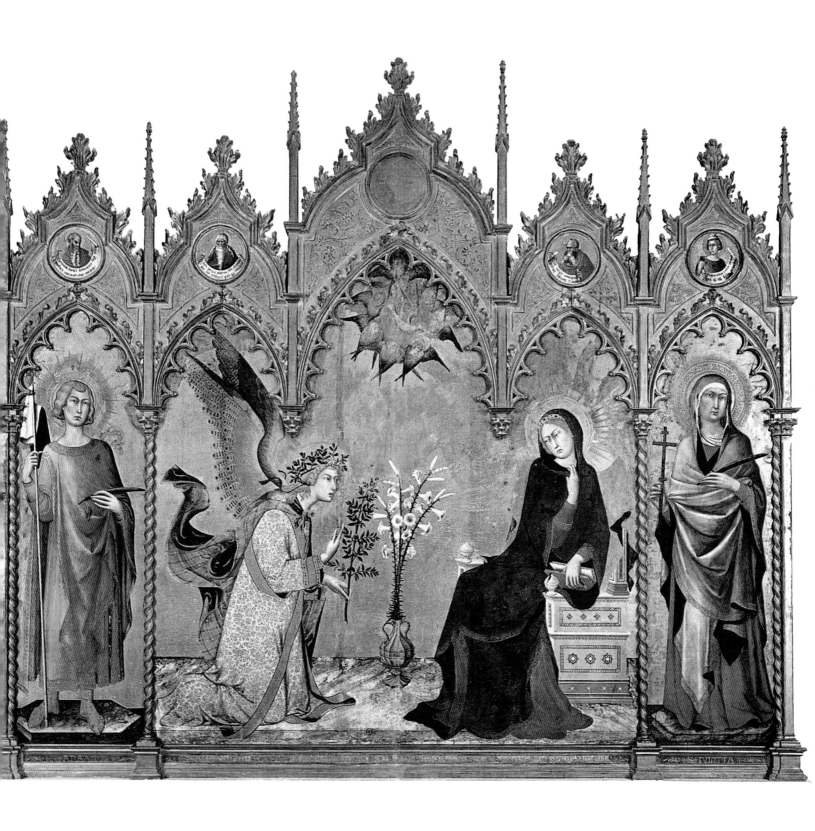

ABOVE: Simone Martini and Lippo Memmi, *The Annunciation and Two Saints*, 1333, tempera and gold on wood, 104 x 120 inches (265 x 305 cm), Uffizi Gallery Museum, Florence

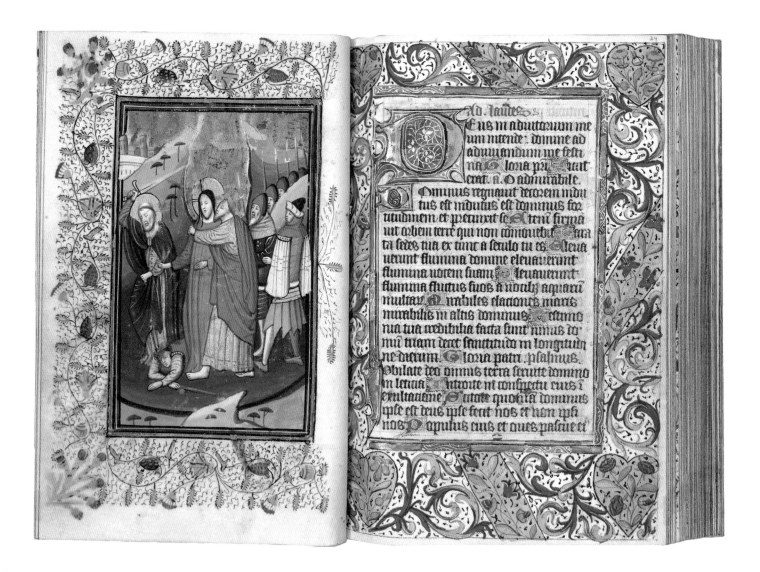

fourteenth century, illustrated books of hours were commissioned largely by nobles and aristocrats and produced by lay workshops headed by celebrated painters, or illuminators. Commissions were often shared between several masters, and the masters rarely signed their work, making attribution difficult; the identities of some of the more significant illuminators are lost. Two examples are shown above and opposite: *The Kiss of Judas* and *St. Christopher Carrying the Christ Child*. Both exhibit the elaborate ornamentation and patterning that was prevalent in the Gothic style. Spatially, both images are separated from the text by the use of an illustrated frame on the page. This frame is identical in appearance to frames that were common at the time, drawing an additional parallel to panel work. While both designs are figurative, one would not call them Classical. The art of the Gothic possesses neither the proportional canon nor the form sense of the Greek ideal. But it does contain much ornate and stylized beauty. Furthermore, the narrative it

conveys, Christianity, is very different from the narrative inspired by the Greek pantheon of gods. And this, in turn, affected the Gothic treatment of the figure.

Some of the finest illuminated work and altarpieces came from France, but also from Northern Europe and the Netherlands. By the turn of the fifteenth century, book dealers and various workshops supplied the growing demand of affluent townspeople all over Europe. But in 1440, Johannes Gutenberg invented the printing press, which changed the market for this type of work drastically. As a result, the market began to shrink for handcrafted devotional books.

ABOVE: *The Kiss of Judas* from Book of Hours, fifteenth century, The National Library of Israel Collection, Jerusalem

OPPOSITE: Master of Guillebert de Mets, *St. Christopher Carrying the Christ Child* from Book of Hours, MS M.46, fol. 23v, 1415–1425, paint on vellum, 7 x 5 inches (18 x 13 cm), The Morgan Library & Museum, New York

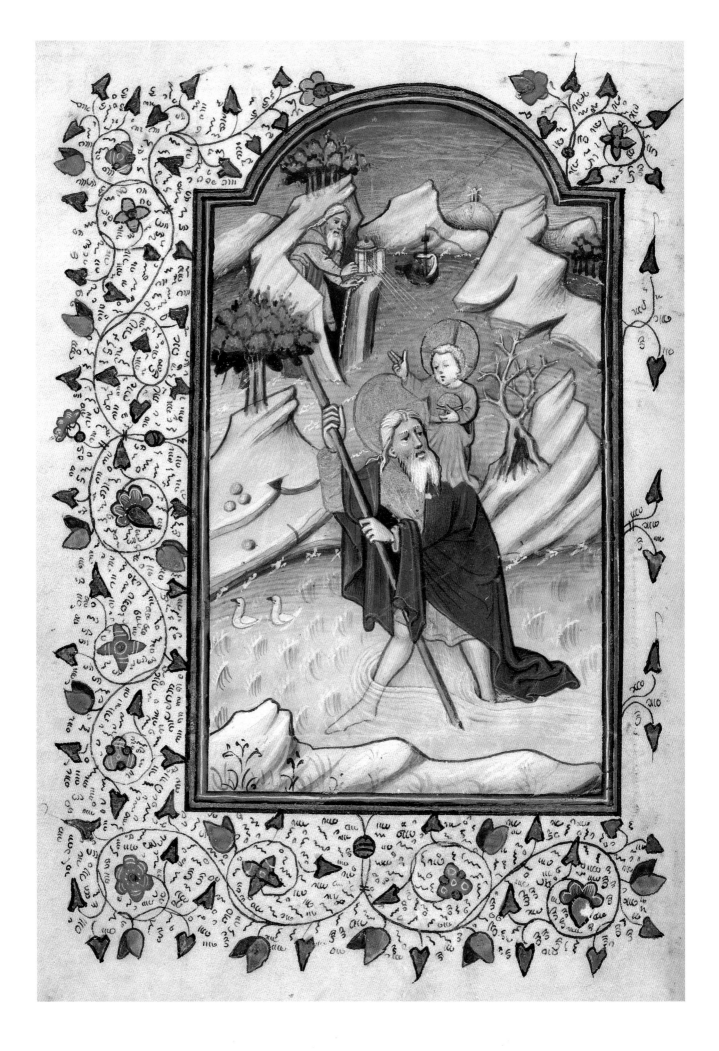

NORTHERN RENAISSANCE ART

I'd like to focus our attention on the northern region of Europe. The Northern artists evolved out of the Gothic Period in a very different manner than did the Italians (whom we will discuss shortly), but the overlap between the two is substantial. Much trade flowed from the north to the south during the Renaissance Period (roughly 1450–1615). Northern European artists were some of the first to use oil paint and explore its technical capacities. Their developments with it helped to further composition and design in unique ways, which in turn had a direct and huge influence on the Italians. Here, we will focus on three artists in particular because they contributed something new to figurative conventions that was not in existence before.

Lucas Cranach the Elder was a German Renaissance artist who worked as a painter and printmaker in woodcut and engraving. He was the court painter to the electors of Saxony in Wittenberg and was known for his portraits, both of German princes and church leaders, during the Protestant Reformation. Cranach used his art as a symbol of the new faith, but he somehow was able to remain popular with both Catholics and Protestants. (In other words, he managed to get commissions from both sides of the divide.) He was one of those politically deft Northern artists, like Peter Paul Rubens a hundred years later, who seemed to have the golden touch.

Cranach created a new type of nude, both titillating and tasteful, that appealed to European sensibilities of the day. And that's quite a feat, considering he was a Protestant, at a time when Protestant iconoclasts destroyed stained glass windows and statuary in Catholic churches all over Northern Europe. Perhaps he was given a pass because he was a confidant of Martin Luther, who was, for all intents and purposes, the "pope" of the Protestants. This mix of the sacred and the profane in figurative art dates back to the Greeks, but it takes on unique form with Cranach.

As we can see in *Venus* (opposite), the proportions of Cranach's women are Gothic. They have a juvenile air about them—narrow shoulders, tiny breasts, a prominent stomach, a slender waist, and long legs. They exist within a sort of rhythmic, undulating outline. To my mind, his figures are oddly contemporary in that they don't seem to occupy real space, yet they somehow lure us into it with their coquettish expressions. This painting is indicative of Cranach's later manner, a period when his figures exist in stylized isolation, separated from their environments; notice here how the background is treated a bit like decor.

Pieter Brueghel the Elder was a Netherlandish Renaissance painter who specialized in genre paintings populated by peasants rooted to the environment in which they existed, notably agrarian landscapes. He also painted religious works for commission from private individuals and churches. In *Landscape with the Flight into Egypt* (page 28), we see some of the same aesthetic treatment utilized in his paintings of peasants applied to a scene from the Bible. Narratives about peasants as a main focus of an artist's body of work were rare in Brueghel's time, and he was a pioneer of that genre. He didn't romanticize peasants, but was instead unsentimental in his treatment of them. In my mind, his unique contribution to figurative art was that he managed to make the surrounding landscape have equal weight in his narrative, which, at that time, was also a new convention. One could make the argument that he was the first Old Master to take on landscape as a primary theme, and that his figures are merely a part of an overall landscape composition. While that argument has some merit, I think rather that Brueghel simply painted the world as he saw it. His vision, at least to our modern eyes, reveals a world where man (the figure) and nature coexisted in a more harmonious fashion than they do now, and one where the agrarian landscape had more of a say in the matter.

OPPOSITE: Lucas Cranach the Elder, *Venus*, 1532, mixed media on beech wood, 14⁷⁄₈ x 9 ⁵⁄₈ inches (37.7 x 24.5 cm), Städelsches Kunstinstitut, Frankfurt am Main

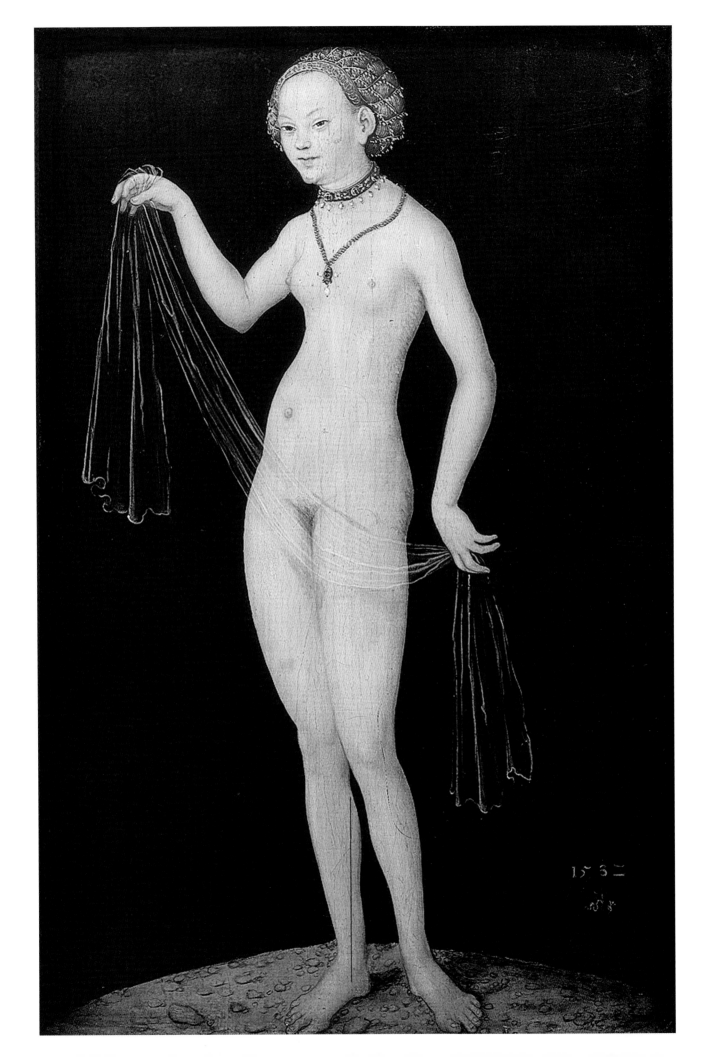

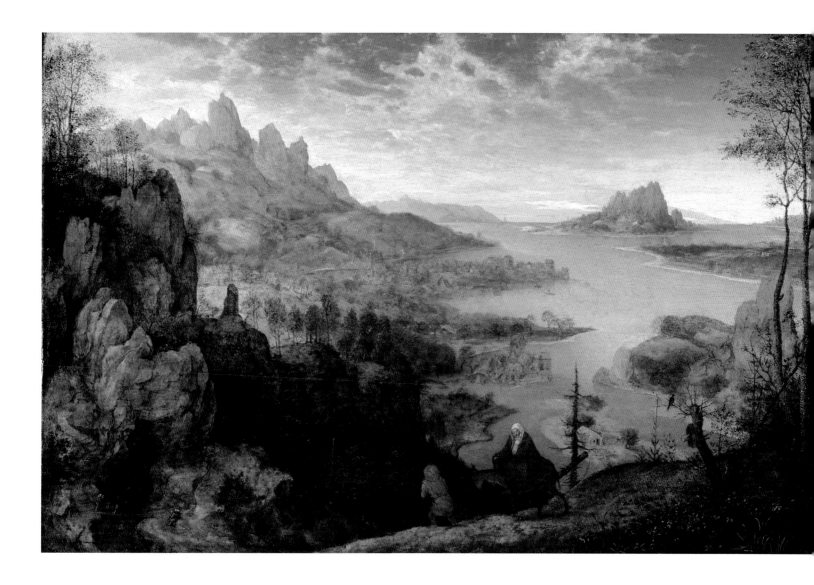

Hans Holbein the Younger was born in Germany and trained as an artisan by his father. While he was exceptionally skilled as a craftsman and worked in many artistic disciplines (he designed jewelry, stained glass windows, altarpieces, and much more), it was as an illustrator that he caught the attention of the famous humanist Erasmus, of whom he would paint three portraits. In turn, Erasmus provided him with a letter of introduction to Sir Thomas More in England. His success with a portrait of More led to two tours of duty as a court artist for Henry VIII. His portraits of the king, his various wives, and other nobility who visited the Tudor court are among the finest paintings in Western art.

Here, we see a portrait of the French ambassador to England at the time, Charles de Solier. It is a great example of why Holbein navigated so easily through important society. He was not simply a painter of external appearance. He was able to capture the intensity of character and confidence of position that governance demands. Holbein painted the noble class with exactly that quality they wished to project to themselves and to their subjects: nobility.

ABOVE: Pieter Brueghel the Elder, *Landscape with the Flight into Egypt*, 1563, oil on panel, 14⅝ x 21⅞ inches (37.1 x 55.6 cm), The Courtauld Institute of Art, London

OPPOSITE: Hans Holbein the Younger, *Portrait of Charles de Solier, Lord of Morette,* 1534–1535, oil on oak, 36¼ x 29½ inches (75.4 x 92.5 cm), Gemäldegalerie, Dresden

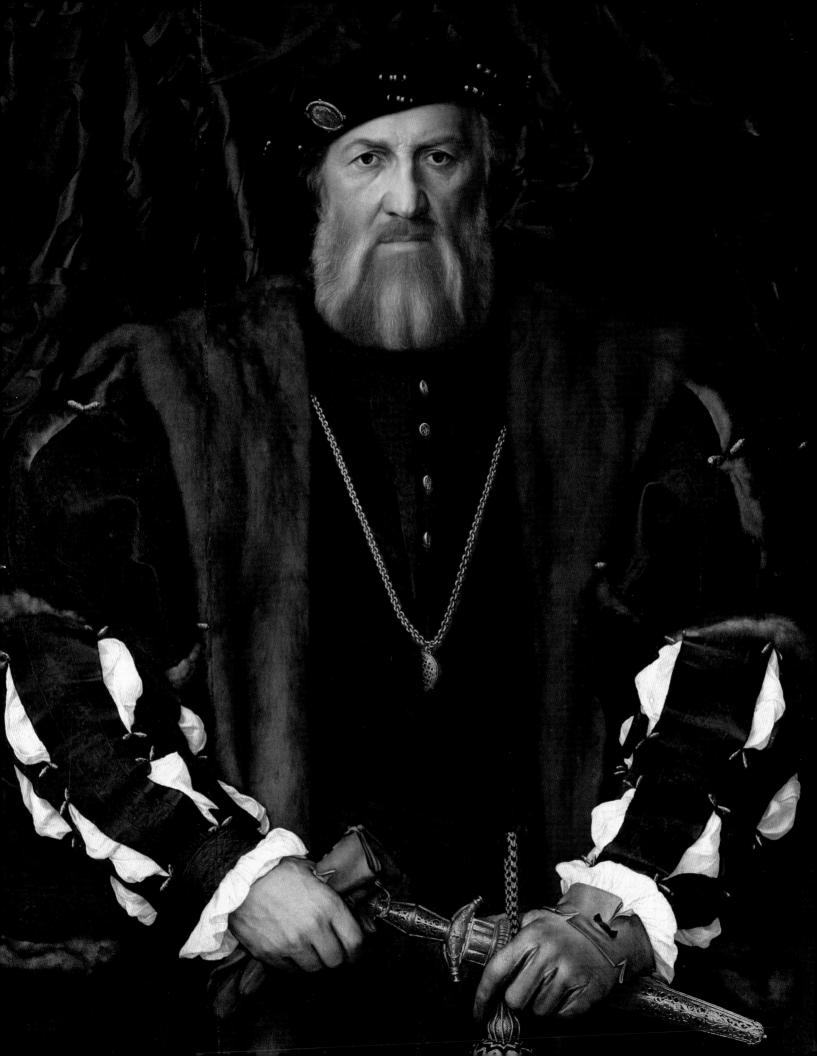

ITALIAN RENAISSANCE ART

So much has been written about the Italian Renaissance that I will be deliberately concise here. We will focus briefly on three key elements that are most pertinent to the development of the figure: namely, the return of Classicism in terms of sculptural form (though our focus will be on how it is interpreted in painting and drawing), perspective, and the use of light and shadow to convey powerful narratives.

In Italy during the fifteenth and sixteenth centuries, the Catholic Church had powerful narratives it wanted to convey and it sought artists who were talented enough to do so. Most of the funding to pay for the masterpieces of the Renaissance came from either the Church or from Italy's fast-growing and wealthy merchant class, including the de' Medici family, who commissioned religious as well as secular works.

Masaccio was the first great Italian painter of the quattrocento period. Like several other Renaissance artists, he died young—at the age of twenty-six. Despite his brief career, he had a profound influence on other artists. He moved away from the International Gothic style and elaborate ornamentation to a more naturalistic mode. He was one of the first artists to use linear perspective in his painting for greater realism.

As we can see in his fresco *The Expulsion from the Garden of Eden* (opposite) for the Brancacci Chapel inside the Church of Santa Maria del Carmine in Florence, Masaccio had a classical understanding of the figure, which he married to a remarkable ability to convey a narrative with extreme emotional power. Taken from the book of Genesis from the Bible, the scene depicts Adam and Eve after they have eaten the forbidden fruit and are being cast out of the Garden of Eden and into a world where they are forced to labor and suffer the consequences of their sin. Masaccio's depiction of naked figures here here was allowable to Catholic tastes at the time because it fit the narrative, but a couple of centuries later his rendering of frontal male nudity was deemed too naturalistic. In 1680 Adam's genitals were covered

with fig leaves (added *al secco*), which remained for more than two hundred years, until the painting was restored in the 1980s and the modification was removed.

As one of the most famous artists ever, the Italian sculptor Michelangelo Buonarroti hardly needs an introduction. He was indeed one of the purest Classicists, as worthy of that title as any sculptor who worked in the Classical Period of Greece. Michelangelo was so innately classicist in his sense of form that he managed to pass off his own sculptures as original Greek pieces *while a teenager*. But as he grew older, his personal challenges began to inform his work. He feuded with the religious and political hierarchy that supported him, and struggled to come to terms with his bisexuality and the male objects of his affection. The latter remained forbidden by his Christian faith; the former was his meal ticket. I include Michelangelo's drawings here because they represent a return to a Classical aesthetic that had not been in play during the art of the Gothic Period, and because this book covers the art of figure drawing in some detail. In my opinion, his are the finest in the world.

Although a sculptor by trade, Michelangelo made the two drawings shown on the following pages as studies for paintings. In *Figure Study of a Walking Man*, page 32, we see a side view of a male nude, done for a larger work that was never completed, *The Battle of Cascina*. (In fact, the only surviving evidence of the total composition is a *copy* of the final cartoon; while done by another artist, it shows us where this figure would have been placed, had it been painted.) *Study of a Seated Young Man and Two Studies of the Right Arm*, page 33, was made for a figure from the Sistine Chapel. When adapting studies into massive narrative frescoes, Michelangelo would position each drawing within the larger composition, tying the entire piece together with rhythm, gesture, and geometry, but without a unifying light source the way a painter would.

In these two drawings, Michelangelo used his brilliant technique to make physical movement reflect his own

spiritual struggle. He is asking the deeper metaphysical questions about humanity from a perspective that is different from that of the Greek artists he is emulating. The Greeks made gods look like men. Michelangelo made men look like gods. The muscular forms are superb. The Classical ideal has returned after a long hiatus. His figures are an interesting mix of both Apollonian authority and Dionysian sensuality. As we have no surviving Greek drawings to speak of, the drawings of the Florentine masters, and particularly those of Michelangelo, are the closest we have to pure Classical perfection.

In the drawings and paintings of Leonardo da Vinci we not only see the rediscovery of classical form, but also observe a new sense of light and shadow as the defining characteristics of that form. Leonardo's work is not imbued with the intense, emotional physicality of Michelangelo, but rather with a calm, almost godlike sense of intellectual perfection.

Leonardo approached the creation of form, like most everything else, from a scientific point of view. He took into account both aerial (atmospheric) and linear perspective, as well as the position of the light source relative to the subjects. This more scientific approach is understandable, given his interest in other disciplines, including geometry, anatomy, and engineering.

The Virgin and Child with St. Anne and the Infant St. John the Baptist (page 34) is one of Leonardo's most famous drawings. He did not execute an exact painting from this drawing, but he did revisit the subject roughly ten years later with a painting in a similar composition, *The Virgin and Child with St. Anne* (page 35), likely a commission for King Louis XII of France. Leonardo never finished the painting, and it hangs in the Louvre.

The group of figures is set in a wild, mountainous landscape, making it a companion piece to another of his paintings of a similar group, *The Virgin of the Rocks*. The Virgin Mary sits on the lap of her mother, St. Anne. The

RIGHT: Masaccio, *The Expulsion from the Garden of Eden*, between 1426 and 1427, fresco, Brancacci Chapel, Church of Santa Maria del Carmine, Florence

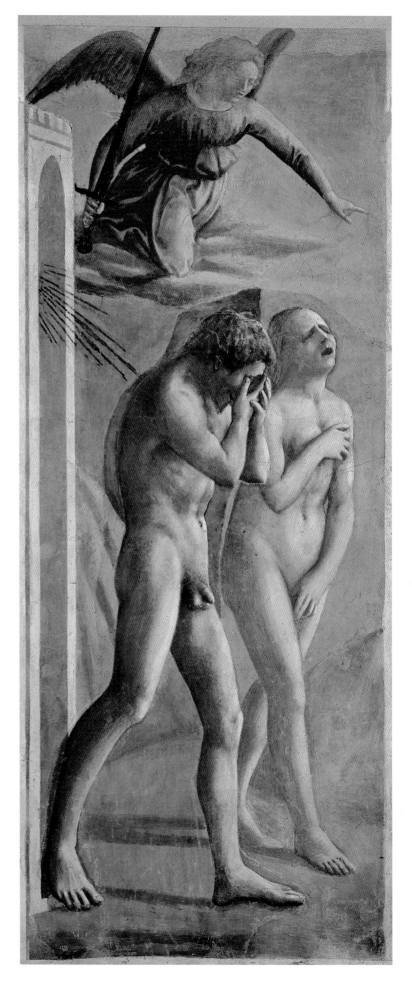

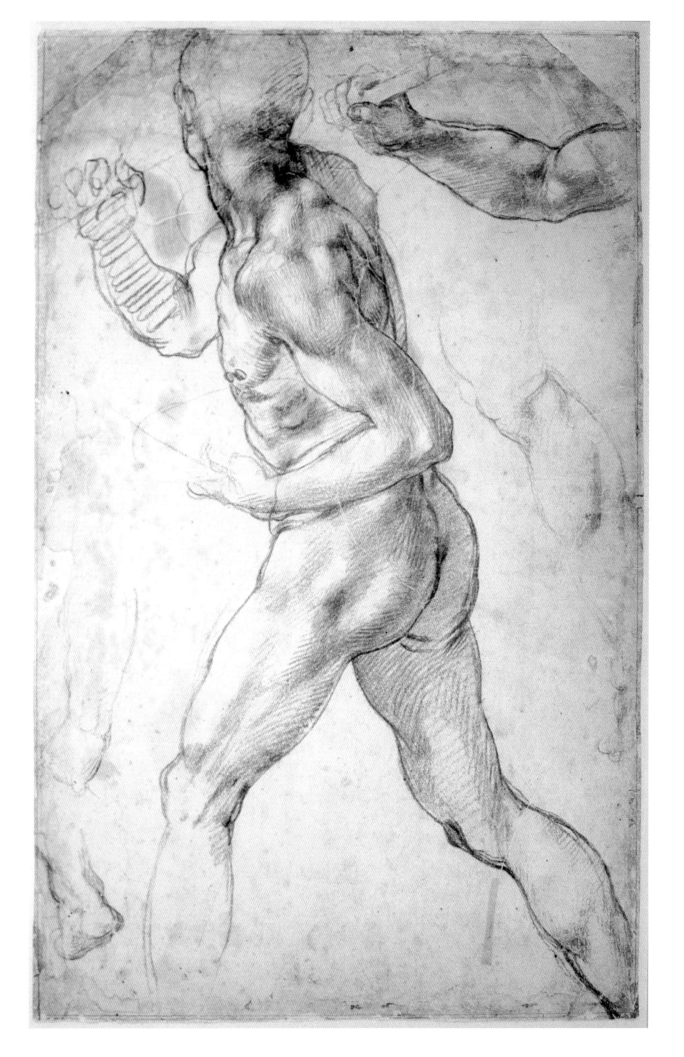

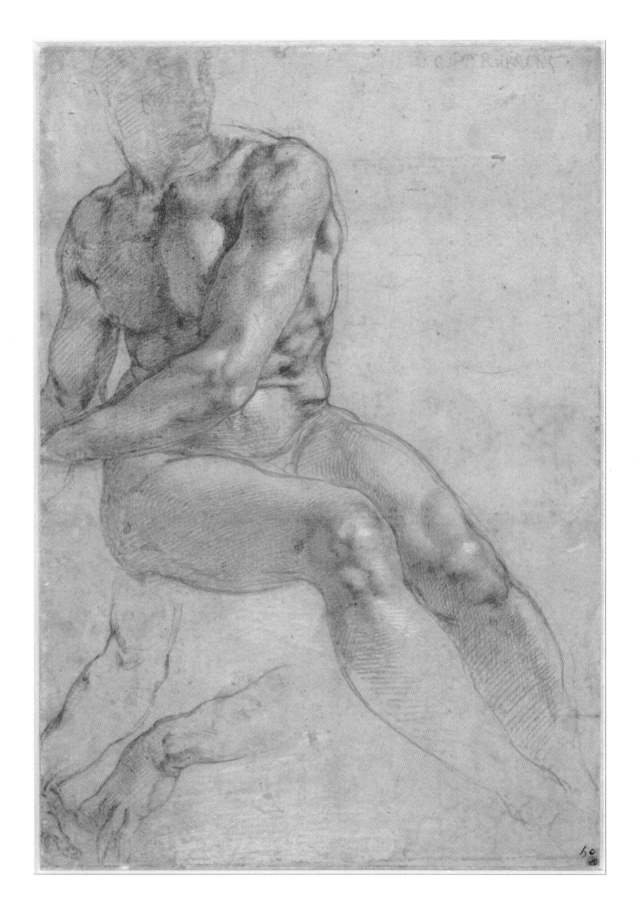

OPPOSITE: Michelangelo Buonarroti, *Figure Study of a Walking Man*, 1504–1505, black chalk, heightened with white, on paper, 15 ⅞ x 10 ⅛ inches (40.4 x 25.8 cm), Teylers Museum, Haarlem

ABOVE: Michelangelo Buonarroti, *Study of a Seated Young Man and Two Studies of the Right Arm*, circa 1510–1511, red chalk, heightened with white, on paper, Albertina, Vienna

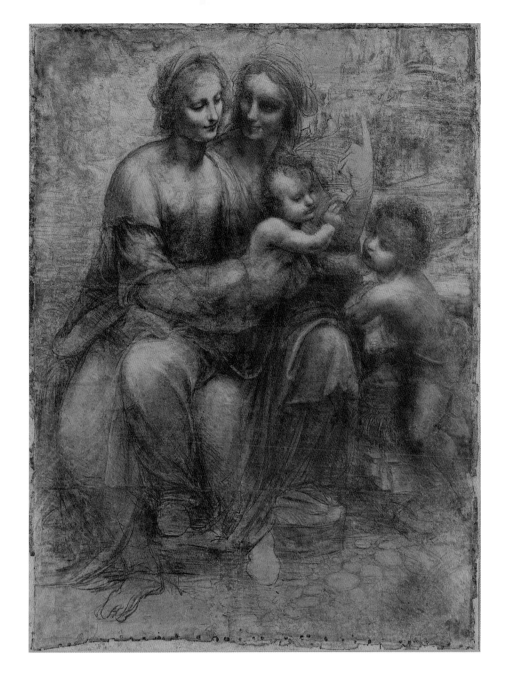

Christ Child blesses his cousin St. John the Baptist (the child on the right). St. Anne's gesture, her finger pointing to heaven, alludes to Christ's future destiny. This drawing employs the subtle sfumato technique of shading that has been widely copied over the centuries. The figures are classical in form, but Leonardo imbues the composition with a deeper sense of affection and spirituality in the way the individuals relate to one another. They are interconnected in a calm and caring way. His sense of the divine is not the merciless perfection of the Greek deities, but rather the loving message of Christianity. Leonardo's work (most especially *The Last Supper*) would, in essence, define Christianity visually for centuries thereafter.

ABOVE: Leonardo da Vinci, *The Virgin and Child with St. Anne and the Infant St. John the Baptist* (*"The Burlington House Cartoon"*), circa 1499–1500, charcoal and wash, heightened with white chalk, on paper mounted on canvas, 55⅝ x 41¼ inches (141.5 x 104.6 cm), The National Gallery, London

OPPOSITE: Leonardo da Vinci, *The Virgin and Child with St. Anne*, 1508, oil on wood, 66 x 51¼ inches (167.6 x 130 cm), The Louvre, Paris

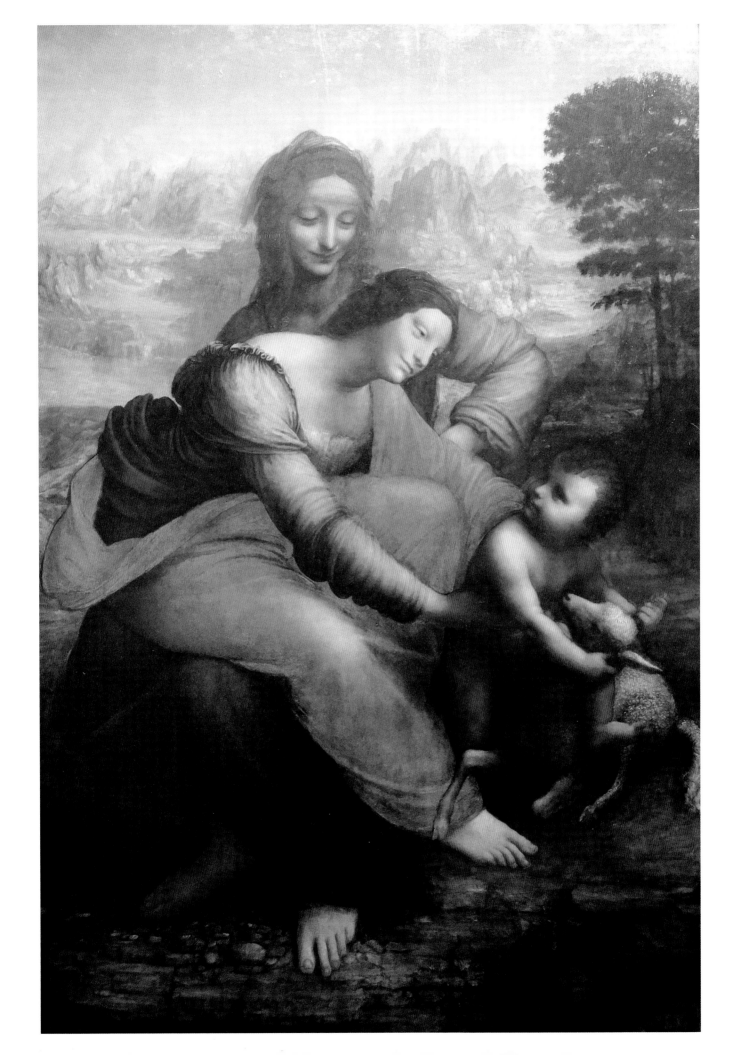

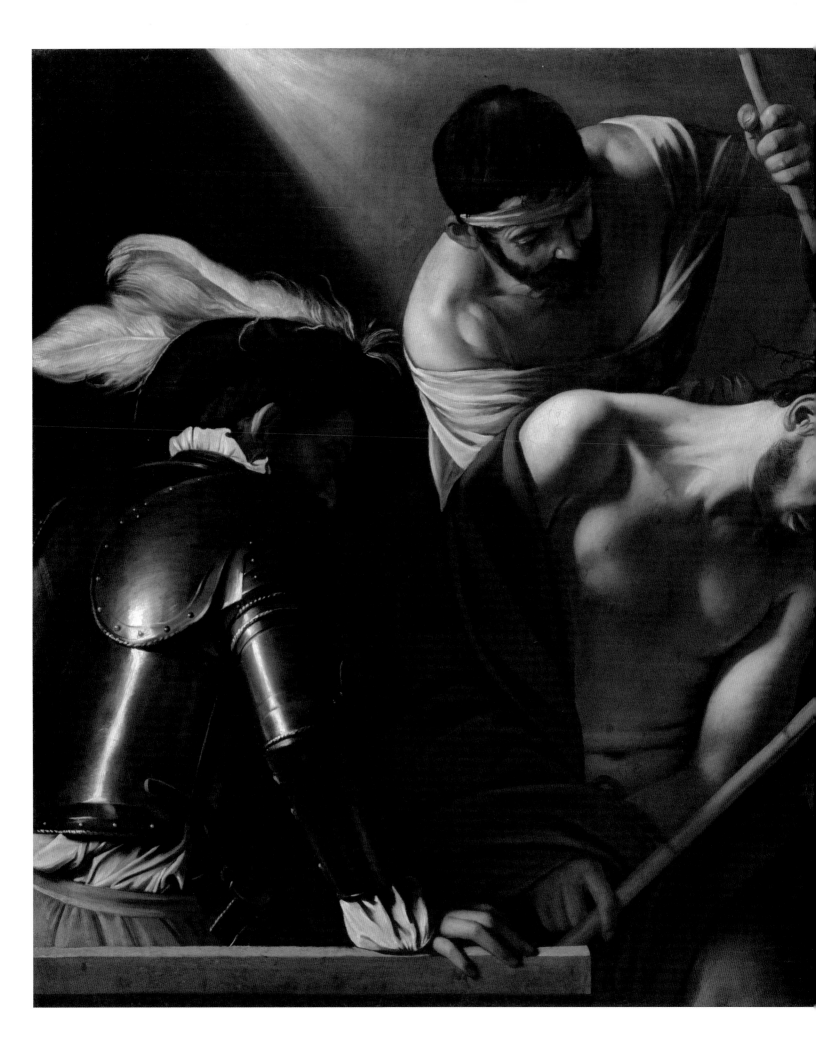

BAROQUE ART

If it can be said that an art movement could start from the decisions made by a governmental body, then the Baroque qualifies as such. At the Council of Trent (1545–1563), the Roman Catholic Church answered its Protestant challengers and called for internal reform. But the Church also addressed the use of the representational arts, demanding that paintings and sculptures in religious contexts speak to the illiterate rather than to the well informed. Church authorities also wanted art that was focused more on religious subject matter and less on material things and decorative qualities. By 1600, an explosion of visual artists working within those strictures came on the scene, but the movement spread to all sorts of secular subject matter and into other disciplines, including music, literature, and theater. Opera was created in Italy at this time, and it is, in many ways, the quintessential Baroque art form.

Somehow, artists during the Baroque Period managed to keep two primary patrons happy: the Church and the state. Baroque art depicted heroes, martyrs, and characters from the Bible, which were useful subjects for both patrons, and did so in a "larger-than-life" style that was easily visible from afar. This grandiosity caused Baroque art to flourish in the courts of Marie de' Medici and her son Louis XIII.

One of the appeals of the Baroque style is that it consciously turned from the dignified and orderly classicism of the Renaissance to visceral and sensual depictions. In trying to impress the common man, Baroque artists employed effects that were direct, dramatic, and obvious in narrative, often with theatrical lighting, known as chiaroscuro.

Many of the greatest Baroque artists worked within the framework of biblical stories for both Catholics and Protestants, but some also adapted secular themes from

LEFT: Caravaggio, *The Crowning with Thorns*, circa 1602–1604, oil on canvas, 50 x 65⅛ inches (127 x 165.5 cm), Kunsthistorisches Museum, Vienna

Greek mythology using Baroque pictorial devices. We shall look at three artists in turn: Caravaggio, Rubens, and Rembrandt. The underlying theme with these three seemed to be that in order to be an interesting painter, you had to be an interesting person.

Caravaggio was popular with the Church because he told the story of Christianity as a series of real events, in a way that connected with the common people. He also often crossed the line between the sacred and the profane. His use of tenebrism (high-contrast dramatic lighting effects) set the stage for exciting narratives. His darks went to black in a very direct way, with no silvery sfumato or murky atmospheric perspective (so popular with Renaissance artists) to soften the blow. In terms of a graphic punch, Caravaggio kept things simple, strong, and clear. You look at the painting, you know the story. In doing so, he bridged the distance from the viewer to the subject. He made the narrative viscerally real, and he did so on a dramatic level, not necessarily a cerebral one.

In the painting *The Crowning with Thorns* (pages 36–37), the predominant theme is physical abuse and sacrifice. The picture tells a story on two levels. Christ is being beaten by two men while a third man officiates. A Catholic looking at this painting in the seventeenth century would see the violence, but would also see willing submission to this humiliation on the part of Christ out of love for his fellow man. And that is why Caravaggio, despite his reputation for being a hothead, a murderer, and an all-around rogue, kept getting commissions from the Catholic Church. Religious scenes were hardly his only subject matter (and the Church knew full well whom they were dealing with on a personal level), but neither party wanted to mess up a good thing.

In a complicated Baroque fashion, the light in *The Crowning with Thorns* tells the story in this painting. The scene is revealed to us via patches of broken light. And while the light is not revealing a beautiful scene by normal standards, it serves to illuminate a very powerful message—*Christ suffered for sinners*—with a spiritual beauty that the Church wanted to communicate to its audience.

In Peter Paul Rubens, we have that rare species: an extremely successful commercial artist who remains a student of his craft. Rubens consistently dedicated himself to copying the works of the great Renaissance artists who preceded him so he could unravel their secrets

RIGHT: Peter Paul Rubens, *Erichthonius Discovered by the Daughters of Cecrops*, 1616, oil on linen, 85¾ x 124¾ inches (217.9 x 317 cm), Liechtenstein Museum, Vienna

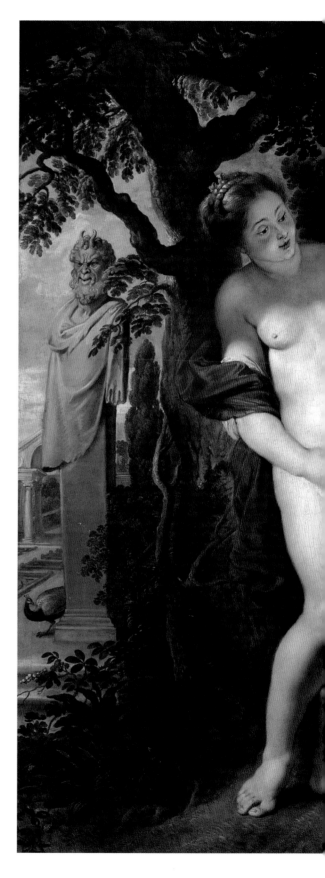

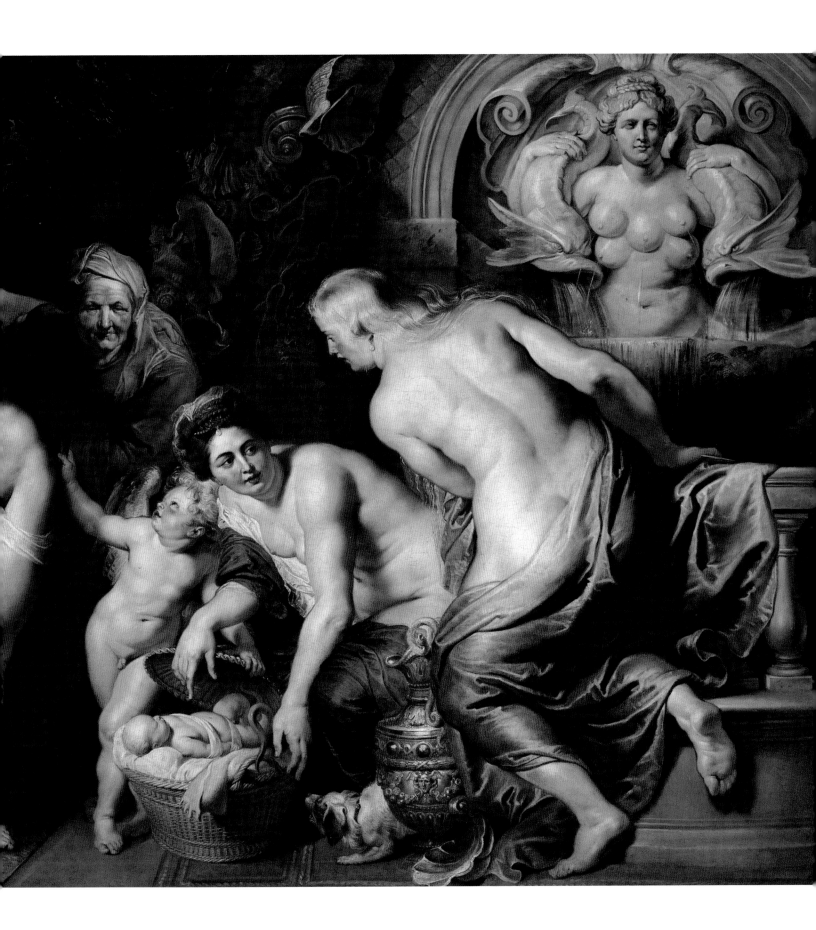

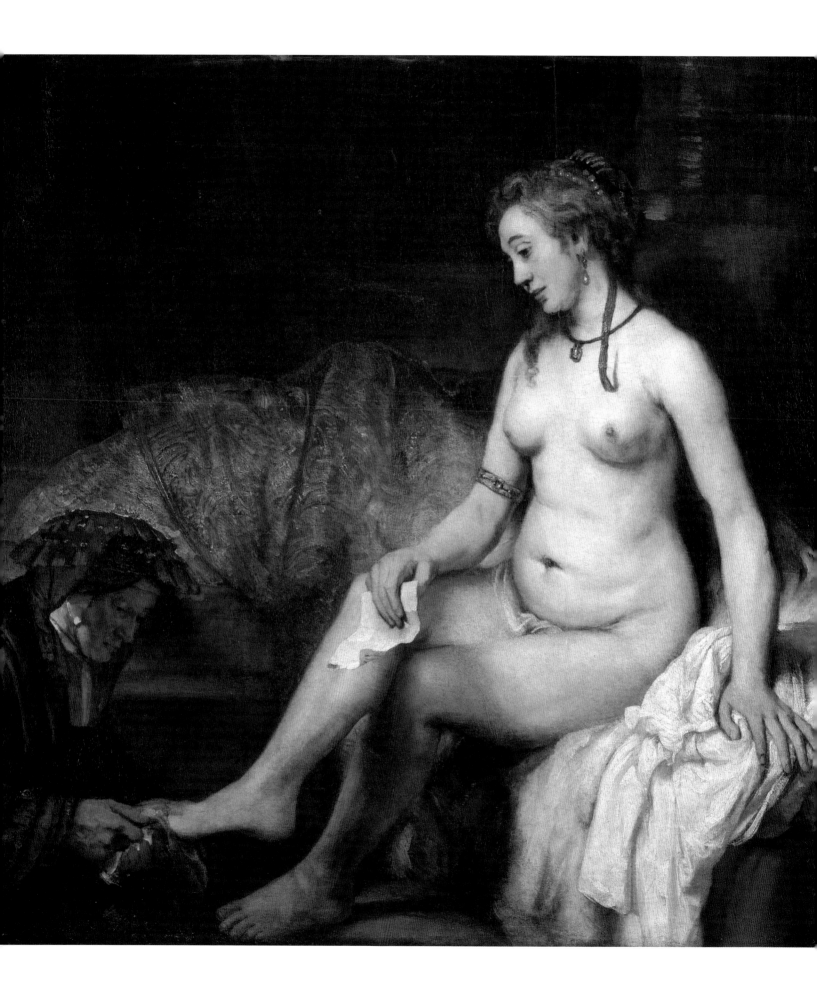

of painting and continue learning. He copied Titian's paintings wherever and whenever he could find them. A man with that kind of thirst for constant improvement will indeed be the best he can be.

A native of Flanders, in Northern Europe, Rubens was a perfect synthesis of both the Northern and Southern Renaissance. He was also a diplomat, a knight, and possibly also a spy for the Spanish Hapsburgs. (The latter activity purportedly occurred while Rubens was in Paris in 1622 to discuss the Marie de' Medici cycle, a large commission he was about to embark on for the queen herself.)

The painting *Erichthonius Discovered by the Daughters of Cecrops* (pages 38–39) is a giant pageant, full of life and drama, as only a Baroque master like Rubens could deliver it. We start in the center with three voluptuous, partially nude females acting out a scene of startled surprise. In the center of their circle is a baby in a basket, accompanied by Cupid and an elderly woman who faces forward but is looking directly at the child in the basket. After we take that in, we look around to the right and the left, and see the other fine details that Rubens threw in for good measure.

The story is one of lust and redemption. Starting from the left, we see a bust of Pan filling in for the lustful Vulcan, who, while attempting to rape Minerva, spilled his seed on the ground, causing Mother Earth Gaia to become pregnant with the child Erichthonius. The child was sent to the Athenian king Cecrops for safekeeping. Cecrops instructed his daughters Aglaurus, Herse, and Pandrosus not to open the basket, *but of course they did.* And therein lies the drama at the heart of the picture. The child is partly serpent, although Rubens seems to downplay that greatly. The nude females are the stars of the show and Herse is the brightest. She coyly plays with transparent drapery over her genitalia, either in the act of covering them or uncovering them. This was not a melancholy, contemplative vision. Rather, Rubens gave his wealthy patrons the image they desired. Like Caravaggio, Rubens conveyed spectacle, not necessarily anything deeper about the inner life of his main subjects.

On the opposite end of the spectrum of these two bombastic Baroque works, we have a painting by Rembrandt that relies on quiet, powerful emotion to tell a biblical story. Rembrandt turned this process into something unique in art up till that point: presenting a nude who has a profound inner emotional life while in the midst of a very complicated decision. We see her mind as much as we see her body. Rembrandt's work is highly unique for possessing this quality. He was also the first artist we have discussed who conveyed his own narratives, at least in his self-portraits. I'm not saying he was the first to *ever* do so, because there is no way to be certain of that, but I think this is one of the reasons Rembrandt resonates so deeply with contemporary viewers centuries later.

Depicting a passage taken from the second book of Samuel (11:2–4), *Bathsheba at Her Bath* tells the story of Bathsheba, wife of Uriah the Hittite, a brave soldier in King David's army. She is spied upon while bathing by King David from his palace roof. When the king asked after her, he was told that she was the wife of one of his soldiers. David made a conscious decision to sin with her. He had his messengers retrieve her, and after they slept together she became pregnant with his child. He, smitten with Bathsheba, sent Uriah to the front lines to die in battle. David was then able to marry Bathsheba.

We can't be sure about the contents of the letter Bathsheba is holding. Rembrandt did not make that clear. So the open questions linger: Is this the moment she gets the summons to come up to David's palace for the first time? Is she sorrowful over the summons to be unfaithful to her husband, or understanding of the futility of resisting the king? Is this the moment she gets the notice that her husband has been killed in battle? We know only that her expression is one of extreme loss and guilt. This is the quiet, powerful side of the Baroque, making for one of the most poignant nudes ever painted.

OPPOSITE: Rembrandt, *Bathsheba at Her Bath*, 1654, oil on canvas, 56 x 56 inches (142 x 142 cm), The Louvre, Paris

ROCOCO ART

It's true that the Rococo Period produced a lot of vain, frivolous fluff, but I believe it's underrated in many respects. It brought back many conventions that had gone dormant in European art. The movement saw the return of compositions that featured figures integrated into natural landscapes, like those of Brueghel, but the people depicted were decidedly not of the peasant class. The Rococo also marks the return of the Dionysian influence with a vengeance, without a trace of Apollonian restraint.

The movement's chief patron, Madame de Pompadour, was also King Louis XV's *maîtresse-en-titre* (chief mistress). Her sponsorship of rococo art pretty much sums up what the movement is about: playful, witty eroticism. Lasting from roughly 1700 to 1780, the Rococo Period could actually be called Late Baroque, as it refined some of the theatricality characteristic of the Baroque, with many of the most notable works incorporating elements of asymmetry and naturalism, and executed in pastel colors with a lighthearted, painterly touch.

Let's first look at Antoine Watteau's painting *The Love Lesson*. This is an example of a *fête galante* (courtship party), a genre that Watteau invented. This painting, and others like it, depicts young and elegantly dressed couples in a leafy, parkland setting, with an intelligent (and romantic) narrative for the viewer to read into. The landscapes have a soft light and even softer brushwork. Like the peasant paintings of Brueghel, the paintings of the Rococo often reveal small groupings of figures in rural landscapes. And, as in Brueghel's work, the scenes are often humorous. But the strata of society depicted are vastly different, and the distance between the observed and the observer is farther. We enjoy the scene, but we are not invited to join in. We are kept at a respectful distance from aristocratic leisure.

RIGHT: Antoine Watteau, *The Love Lesson*, 1716–1717, oil on wood, 17³/₈ x 24 inches (44 x 61 cm), Nationalmuseum, Stockholm

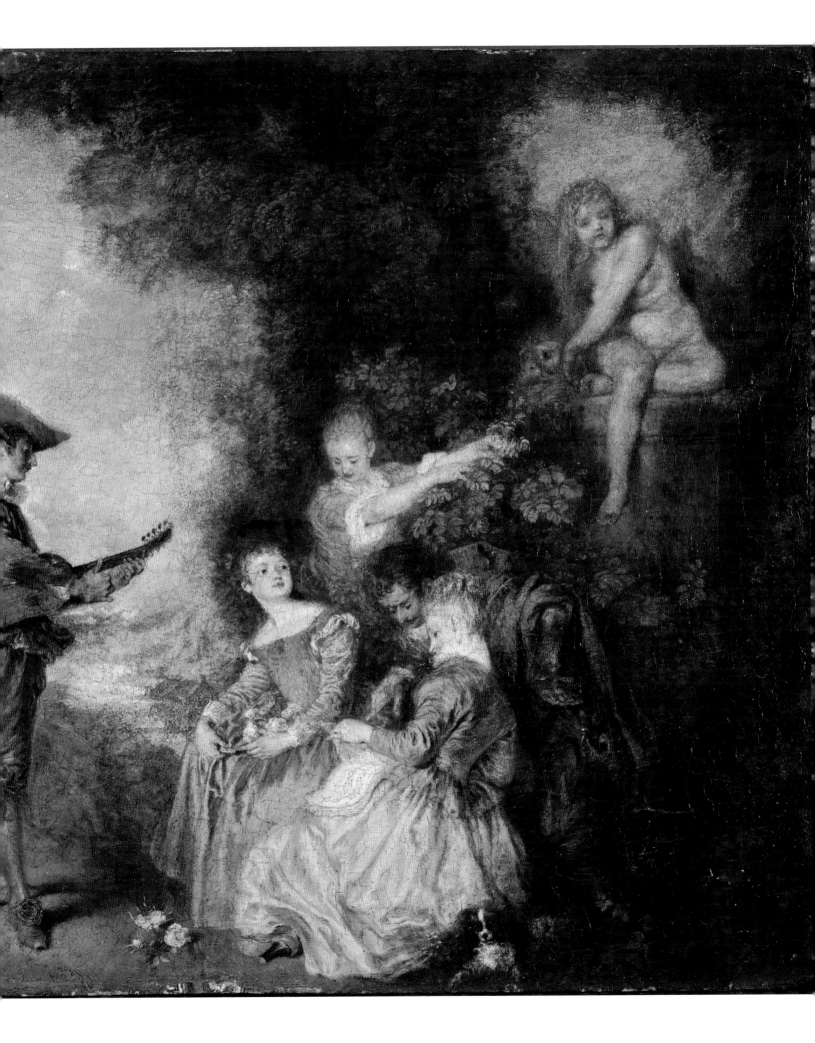

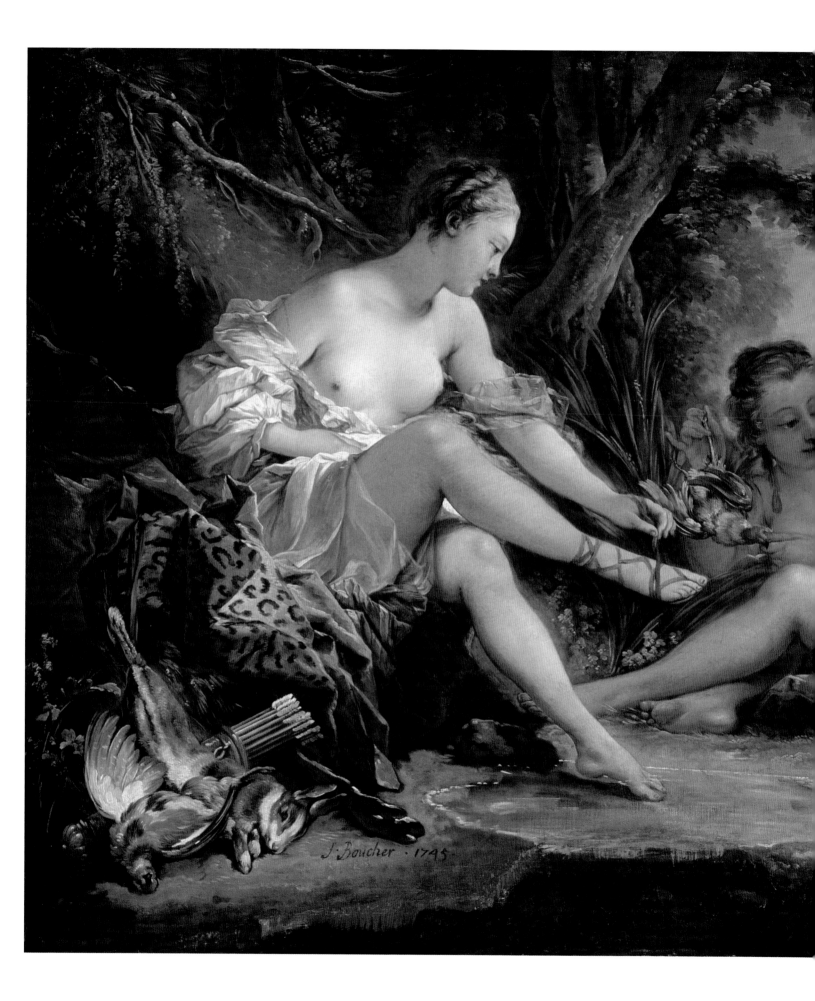

These "gallant parties" of the aristocracy became a popular genre of painting during the eighteenth century. In contrast to the work of the Baroque, these images are notable for their lack of drama or angst. They are pleasant paintings for pleasant society. They are not intended to convey any theological or philosophical message. They are decorative, in the best sense of that word. Usually small, they were pieces of work meant to fit into the private rooms of the rural chalets and hunting lodges of the aristocracy.

François Boucher was one of the favorites of Madame de Pompadour. He was a multidisciplined artist who excelled not only in painting, but also in costume and set design. Boucher invented a new type of female figure: young, lithe, and pretty, in a coquettish sort of way. Boucher's female isn't real—and she doesn't need to be. He was as adept at pastorals as with the subjects of classical antiquity, and had a unified aesthetic between his chosen disciplines.

In the painting *Diana after the Hunt*, we see the goddess in the act of disrobing. Classical symbols are found throughout the image: the spoils of Diana's hunt to the left, a full quiver of arrows to the left and right. Diana herself is not terribly convincing as a huntress and her physical type does not match the character she is portraying. And then there is the matter of Diana's very beautiful hunting companions, none of whom is appropriately dressed for a hunting party. Classicism is used here as a foil, a set piece, an artifice. Its intended audience would have appreciated the conceit in Boucher's having created a sexually titillating work of art. There is legacy to be found in this type of eroticism in Greek art and in Roman copies of it. But its use in a pastoral setting is Boucher's unique contribution.

OPPOSITE: François Boucher, *Diana after the Hunt*, 1745, oil on canvas, 14⅝ x 20½ inches (37 x 52 cm), Musée Cognacq-Jay, Paris

NEOCLASSICISM

A reaction to the excesses of the Rococo, Neoclassicism was born in Rome in the mid-eighteenth century out of a desire to return to a more austere and pure style of art as found in the classical art and culture of ancient Greece. It marked a return to the Apollonian and it spread throughout Europe until the mid- to late nineteenth century. As a philosophical movement, Neoclassicism was very interesting, as some of its humanistic principles led to the Enlightenment. With the French Revolution, which began in 1789, Neoclassicism became the de facto official artistic style of the revolutionary French government, which was its biggest patron. Neoclassicism was the perfect vehicle for validating the government's rule by linking it to the noble themes of public virtue and personal sacrifice from the history of ancient Greece and Rome. While classical art described the Greek gods as human in form, French Neoclassical art acknowledged the state itself taking on the role of god.

Neoclassicism was an incredibly beautiful and important artistic movement, but also a somewhat problematic one. Namely, it was selective in its understanding of Classical art. Neoclassicism cut through some of the florid excesses of the Rococo and the drama of the Baroque. But, interestingly enough, the movement ignored or downplayed other elements of Classical art, such as its unification of rhythm throughout forms and its (occasional) humorously licentious content. In terms of the latter omission, one could conclude that the Neoclassicists made a conscious decision to distance themselves from the excesses of the Rococo Period.

As there weren't any surviving examples of Greek painting around to emulate, eighteenth-century Neoclassical painters had to base their methods on the overarching classical principles from other art disciplines. In essence, painters had the freedom to invent a new form of Classicism. (Neoclassical sculptors and architects, on the other hand, had no such freedom.) So what did eighteenth-century painters do with this freedom?

As the Neoclassical movement began in Italy, some painters solved this problem by emulating sixteenth-century Italian Renaissance artists. But as it became more of a distinctly French movement, and more truthfully a French political movement, Neoclassicism began to mean borrowing Classical *subject matter*. And this mimicking of surface accoutrements became the movement's biggest asset or drawback, depending on your point of view. The spirit and philosophy of Classicism are not to be found in the togas that the Greeks (and Romans) wore, but rather in the aesthetics and humanistic perfection of platonic form.

The best of French Neoclassical painting exhibits a refined, courtly sense of taste, with some interesting forays into compositional geometry. These artists championed a style defined by rigorous contours, sculpted forms, and highly polished, or "licked," surfaces. All in all, they kept their subject matter in good taste, and kept the viewer at a safe distance from events depicted. We are not drawn in for a close inspection, as we are when we look at a Rembrandt.

In *Oedipus Explains the Riddle of the Sphinx*, by Jean-Auguste-Dominique Ingres, we have an incredible image of a classical male nude, done when Ingres was a student in Rome, that he turned into a narrative figure painting some twenty years later. By then, he knew how to synthesize an environment and provide context to match content. The modeling on the figure is very subtle and masterful, remarkably so for student work. It also has none of the distortions that Ingres would introduce in his later figures. The myth of the youth answering the riddle of the Sphinx is taken from Greek mythology, and Ingres's handling of every aspect of the painting is done in a tasteful, neoclassical manner.

OPPOSITE: Jean-Auguste-Dominique Ingres, *Oedipus Explains the Riddle of the Sphinx*, 1808, 1827, oil on canvas, 74½ x 56¾ inches (189 x 144 cm), The Louvre, Paris

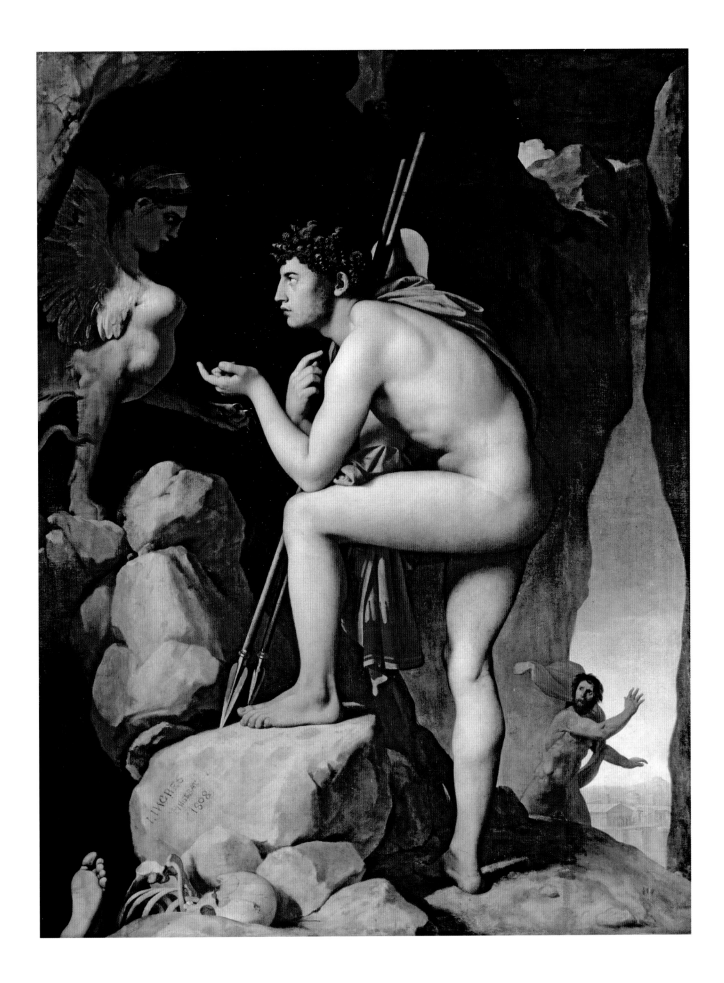

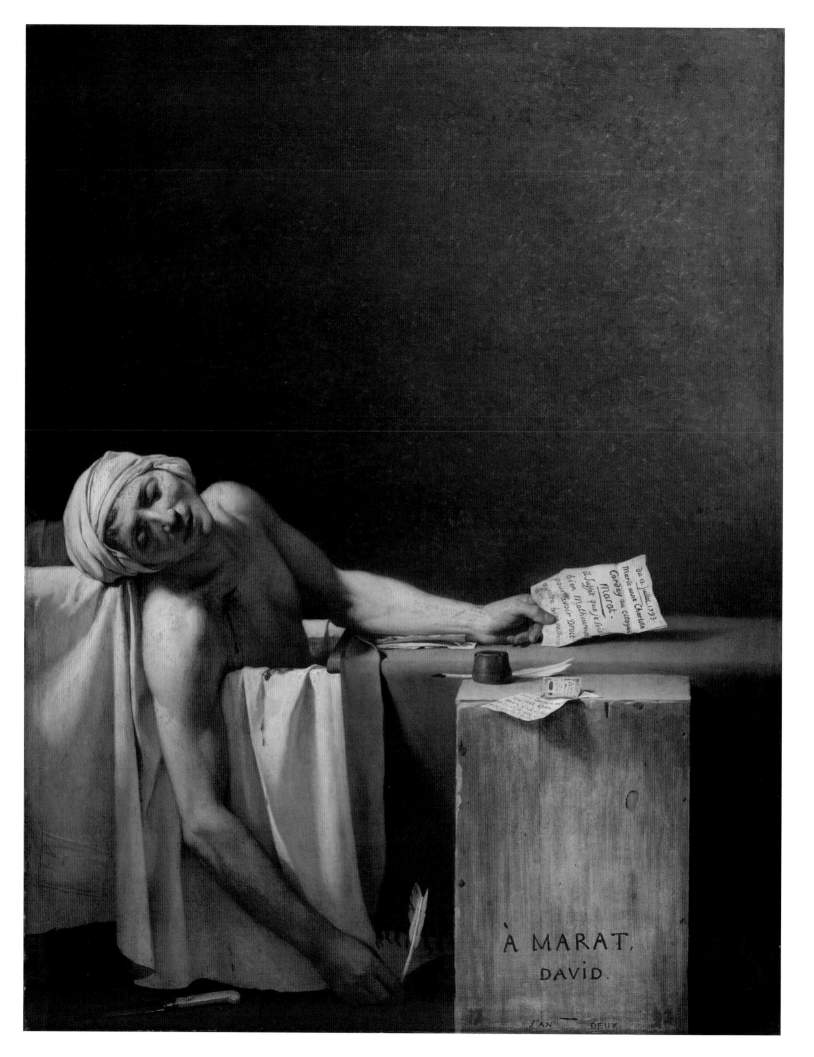

Some critics have pointed to the generality of the handling of the background, the dramatic tonal shifts from light to shadow, and the addition of the highly emotional background figure as being more emblematic of Romanticism than Neoclassicism. While that may be a valid point, I think it misses the greater truth. Labels of movements (mine included) are an art historical imposition *after the fact*. Reality is much more complicated, in terms of the way artists actually work. In this piece alone, we see a dialogue between Ingres the student and Ingres the mature master. I find his recycling process fascinating—like the fact that he actually added linen to an earlier piece he had completed as a student, enlarging it in order to make this composition, rather than starting over with a new canvas and repainting the figure.

In *The Death of Marat,* by Jacques-Louis David, one of the leading Neoclassicists, we see a shift in subject matter from the realm of mythology and the metaphorical to a contemporary, and overt, political statement. A single, iconic figure, a Christ-like martyr, is slumped over in a bath, in a pool of his own blood. A warm light from the upper left illuminates the corpse. He is holding a letter that we are invited to read, one that was part of a ruse that led to his being slain in cold blood. One could argue that such an austere treatment of the subject matter could only be considered Neoclassical. But note that we are right there next to the subject. The "safe" distance is gone.

I would additionally state that painting slain revolutionaries, especially one who was a close friend (as Marat was for David), with the stated goal of furthering the propaganda apparatus for the French Revolution, is a highly Romantic notion. The expression on Marat's death mask is one of noble sacrifice for the cause. It doesn't get more Romantic than that. *The Death of Marat,* in my opinion as an artist, is not ultimately a Neoclassical painting, but rather counts as perhaps the first masterpiece of the Romantic Period. I also think that labels are not particularly useful or important for artists, who simply want to make their work, but are perhaps more useful for art historians or gallery dealers.

OPPOSITE: Jacques-Louis David, *The Death of Marat,* 1793, oil on canvas, 65 x 50½ inches (165.1 x 128 cm), Royal Museums of Fine Arts of Belgium, Brussels

ROMANTICISM

Neoclassicism absorbed the order and design of the art from the Classical Period of ancient Greece, but often failed to convey its emotional or rhythmic power (particularly the power embodied during the later Hellenistic Period), leaving a niche to be filled. Romanticism met that need. The two movements, for all of their ideological differences, complemented each other. Neoclassicists were, in many ways, the philosophical harbingers of the Age of Enlightenment. By contrast, the Romantics grew to detest the Industrial Revolution and the changes to the social order it brought to Europe in the name of "progress." They preferred intuition and emotion over scientific rationalization, very Dionysian principles.

In support of my thesis that these two movements complemented each other to tell the full story of Classicism, let's take a look at *The Barque of Dante*, by Eugène Delacroix. This "Romantic" work adheres to a template that can be found in most successful Neoclassical paintings: It features a tightly organized composition, with good color and form, with romanticized natural elements thrown in. However, the subject matter is drawn from Dante's *Inferno* rather than from the Greek or Roman mythology so frequently mined by the Neoclassicists. (It is worth noting, however, that Dante's work is *itself* rooted in those very myths.) Notice how several of the figures here look as if they came directly from a painting by Rubens, due to their rhythmic power. Also, typical of a disciple of Rubens, Delacroix's use of color is very intense. Each figure displays a unique, individualized emotion, reflective of his or her own experience of leaving one circle of hell and heading to another.

RIGHT: Eugène Delacroix, *The Barque of Dante*, 1822, oil on linen, 74½ x 95¼ inches (189 x 241 cm), The Louvre, Paris

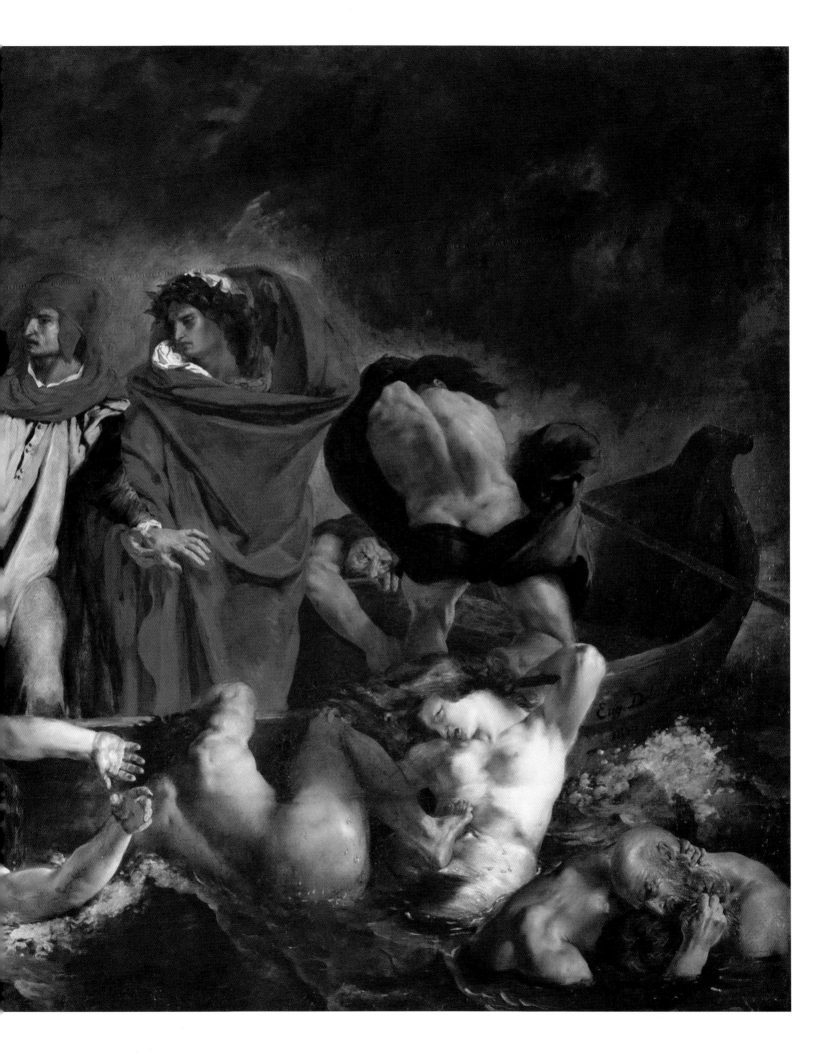

REALISM

Totally rejecting Neoclassicism and its complement, Romanticism, the Realists were concerned with contemporary subjects and situations. They attempted to depict individuals of all social classes in a simple, honest, and unaffected manner. With the Realists, we have the first evidence of a movement that was based on an individual artist's concerns, his or her "voice," or narrative. Gustave Courbet was the loudest and most galvanizing of the Realists—and we will now focus briefly on him.

Courbet believed that the only possible source for living art is the artist's own experience, and that *historical* painting was impossible. Courbet was a delightfully round character who, early in his career, upon rejection from the Exposition Universelle of 1855, took matters into his own hands and opened his own gallery to showcase his art. The Impressionists would steal a page from that playbook with their own Salon des Refusés just eight years later. Courbet is a patron saint, of sorts, of any contemporary artist trying to build up a large social media network either to sell directly to collectors or establish such a large following that commercial art galleries are forced to notice him or her. Courbet demonstrated that an artist can buck the system and win. That said, he did spend his later years in exile. So, there is a price to be paid for originality. And, in Courbet's case at least, originality coupled with a confrontational personality.

In *Nude Woman with a Dog,* the uncomplicated composition perfectly displays Courbet's goal of creating art that expresses "the real." We see a beautiful young woman showing some affection for a small dog. This is a very human moment, captured very simply.

Here, Courbet deconstructs a typical painting convention about the theme of fidelity (dating at least back to Titian), that of a young woman and a small dog, and he removes the glossy, metaphorical layer. The model was Léontine Renaude, the painter's mistress at the time. The painting approaches greatness because of how well it's painted and because it's accessible, *not* because it's making a grand statement. Regarding the female figure, I want to add parenthetically here that Courbet is an underrated draftsman. His contours and his handling of the edge work as forms recede are quite masterly. His technical abilities were rooted in his French Academic training, even if his aesthetic philosophy was not. But, to my mind, there is still a "safe" distance, a lack of an interior thought life to his subject. We are not drawn in, per se, despite the Realistic subject matter.

Subject matter would prove to be a note of dissonance between Realists and the French Salon, the official annual exhibition of the French Academy, for many years to come. Inclusion in the Salon, and where a work was placed within the exhibition, was an indication of an artist's standing in Academy political circles. During the nineteenth century, to gain an advantageous standing with the Academy meant fiscal stability for an artist. Ironically, some artists who drew the ire of the Academy were creating pieces that were significant on an artistic level, yet they were refused entrance to markets that were under Academy control. Courbet fell into this category, as did many of his peers. That said, as we have seen time and again, each generation rejects the previous one, and Courbet's very spats with members of the Academy would serve as the model for success for future artists who desired to make meaningful work.

OPPOSITE: Gustave Courbet, *Nude Woman with a Dog,* circa 1861–1862, oil on canvas, 25½ x 31¾ inches (65 x 81 cm), Musée d'Orsay, Paris

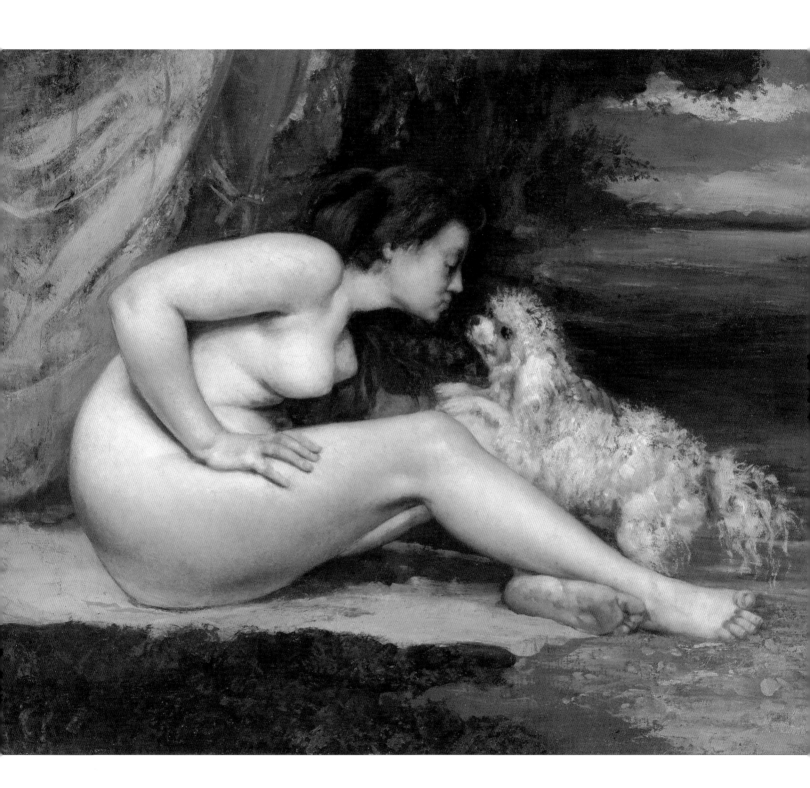

NINETEENTH-CENTURY BRITISH ART

In a book with limited space to discuss the history of the figure, one could do no better than John William Waterhouse as the representative of nineteenth-century British art. Early in his career, Waterhouse's submissions to the Royal Academy caught the eye of important collectors. His painting *The Lady of Shalott* was purchased by Sir Henry Tate, who would later use his wealth to found the Tate in London.

Waterhouse was prolific in oils and watercolors and worked in the manner of the Pre-Raphaelites, a British variant on French Romanticism and Neoclassicism. The Pre-Raphaelites were committed to returning to the "pure" classicism of the Renaissance (to a time before Raphael, who they believed made a hash of it). That notion is somewhat humorous, given the lack of any original Greek painting that might serve by way of comparison or inspiration. Nevertheless, one cannot argue with the lovely work many of the Pre-Raphaelites made. It is always about the work in the end, and *Echo and Narcissus* is one of the best.

I am fully aware that many art historians argue against Waterhouse's being considered a "true" Pre-Raphaelite. It is true that he signed no manifesto. Stylistic differences are acknowledged, but arguments about thematic differences are not particularly convincing. Waterhouse's colors are different from, but still strikingly rich and emblematic of, the Pre-Raphaelites. In addition, he adhered to strict classical (and medieval) themes, and his overall melancholic Dionysian tone is identical to Pre-Raphaelite sensibilities.

This painting captures two tortured souls at the moment of Narcissus's undoing. Punished by a goddess for her constant chatter, Echo was confined to repeating the words of others. Narcissus was the son of the river god Cephissus and the nymph Liriope. He was distinguished by his beauty, but it was foretold that he would live to an old age if he did not look at himself.

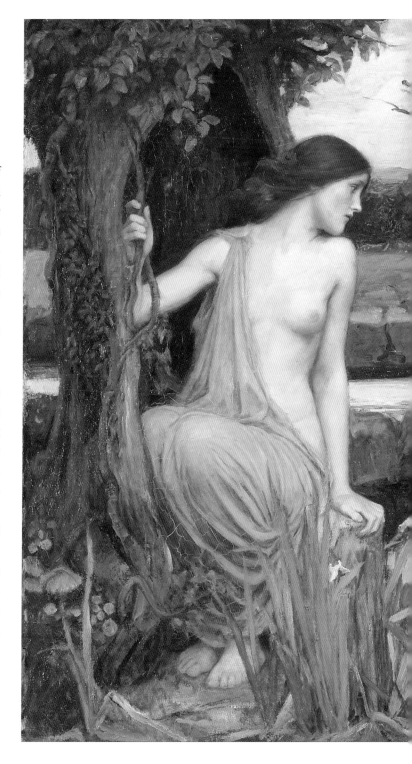

He cruelly rejected all the women, men, and nymphs (including Echo) who fell in love with him. One of the men so rejected prayed to the goddess Nemesis, who caused Narcissus to fall in love with his own reflection. Thus he fawned over himself, wasting away through unrequited love. As we see, a narcissus flower grows on

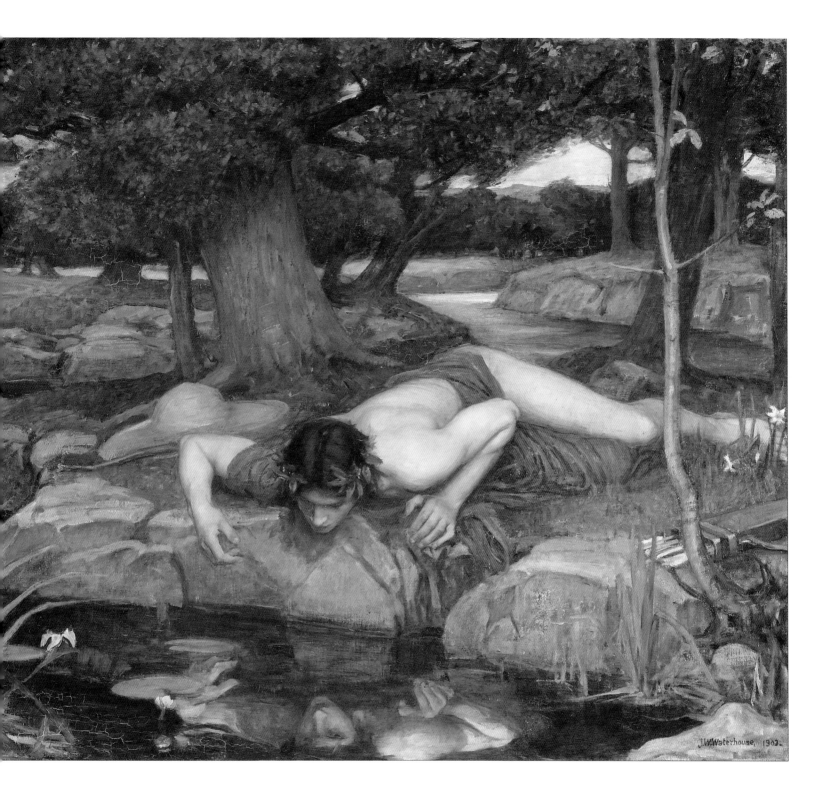

the spot. Perhaps the depiction of a male suitor looking on forlornly was not socially permissible at the time, as homosexuality was illegal in some quarters still, so Waterhouse chose to depict Echo instead.

It is perhaps in this philosophical context that we can say that Waterhouse was not a true Pre-Raphaelite.

Members of the Brotherhood were not afraid to stake out radical positions, especially those in the arena of Victorian era social mores.

ABOVE: John William Waterhouse, *Echo and Narcissus*, 1903, oil on canvas, 43 x 74½ inches (109.2 x 189.2 cm), Walker Art Gallery, Liverpool

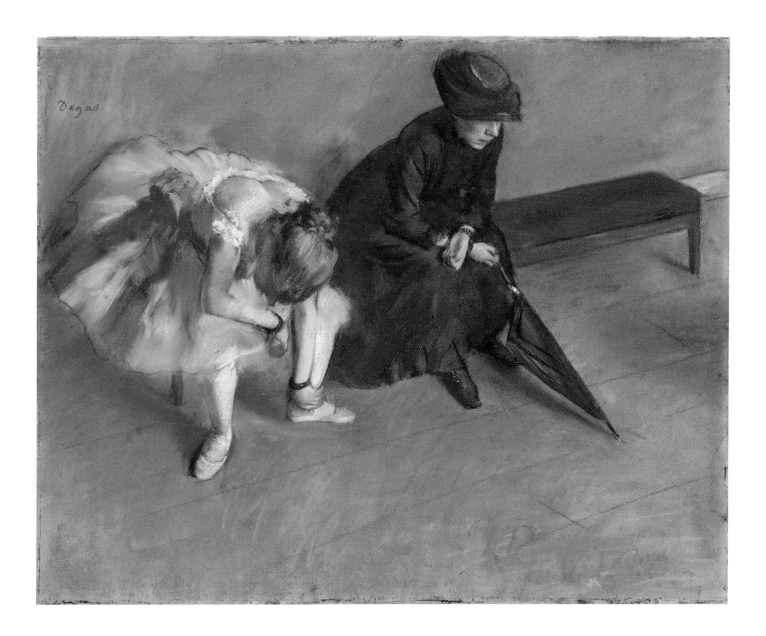

PREMODERNISM

Edgar Degas began his career in good standing with the French Salon, but he gradually chose to go his own way and apply academic methods to contemporary subject matter. Courbet was the founding father of that modality, but Degas perfected it. The desire to paint modern life meant being honest about some of the drudgery associated with it, which was not acceptable subject matter to the French Academy. Its members would not or could not adjust to the times. Degas had a unique voice and exerted an influence that extends to this day. He was an outlier, a modernist ahead of his time, with traditional training.

His style is an interesting mix of the old and new, as we can see here in *Waiting*. While his drawing and perspective

(the grid is still visible on the ground plane, actually) are completely rooted in academic training, his paint handling is rather loose overall. Details are there when he wanted them to be, but most often he didn't. The content of his work is completely realistic. These two women are tired, worn out, and it shows. When looking at his work, one simultaneously experiences an intimacy with the subject and a sense of detachment, a duality that depends on an internal narrative rather than an external one. We are drawn in, only to find that the subjects are bored, tired, or disinterested, which is a very Modernist ethos.

Auguste Rodin was rejected many times for admission into the French Academy, but he would become the

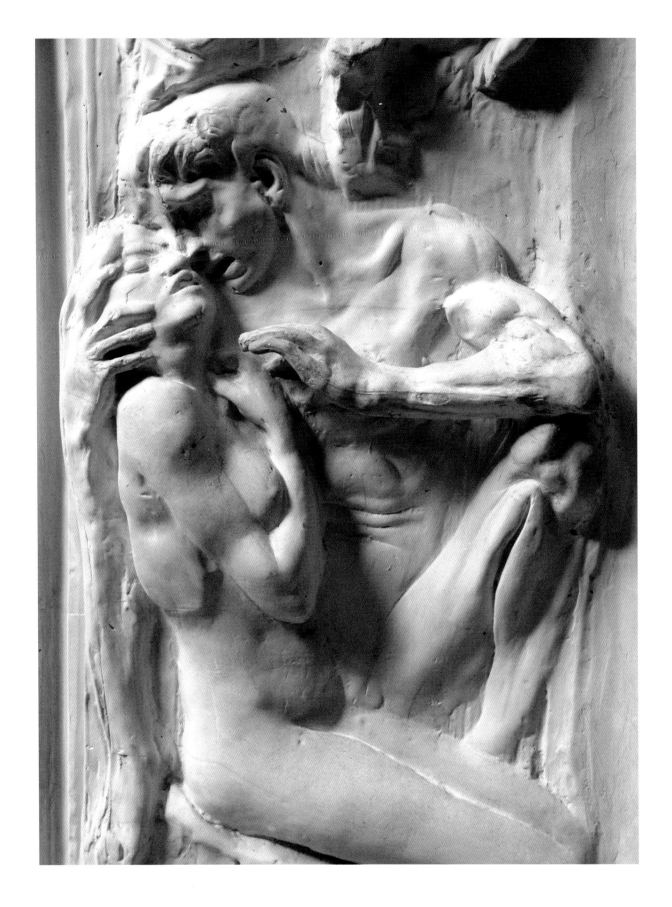

OPPOSITE: Edgar Degas, *Waiting*, circa 1882, pastel on paper, 19 x 24 inches (48.3 x 61 cm), The J. Paul Getty Museum, Los Angeles

ABOVE: Auguste Rodin, *The Gates of Hell* (detail), between 1885 and 1917, plaster, 250 x 157½ x 37 inches (635 x 400 x 94 cm), Musée d'Orsay, Paris

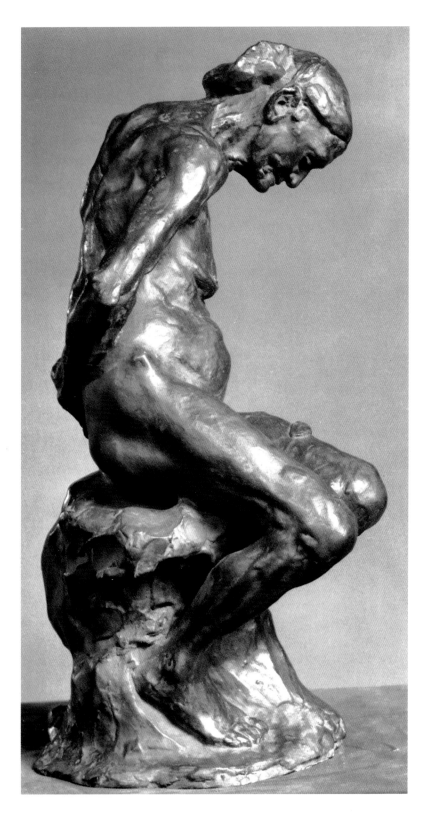

ABOVE: Auguste Rodin, *The Old Courtesan* (from *The Gates of Hell*), modeled 1887, this cast 1910, bronze, 19¾ inches (50.2 cm) high, The Metropolitan Museum of Art, New York

very heir to Michelangelo and the Renaissance that they had tried to re-create for almost a century. Moreover, he did it entirely without them. His artistic and fiscal success signaled the end of the French Academy's dominance. The Academy's output did not capture the changing tastes of the market. The Academy was still enthralled with Neoclassicism, when the market was craving a return of the Dionysian influence. That is what Rodin delivered.

Here we see two small details of *The Gates of Hell*, an enormous project that was never entirely finished. The first image is a cropped view of a low-relief sculpture of a couple in a passionate embrace. The male figure looks like he stepped out of Pablo Picasso's Blue Period, except that he predates that style by fifteen years.

The beautiful expression on the female figure's face is a bit confusing, as she is ostensibly coming to terms with eternal spiritual damnation. Yet she could easily be mistaken for being in the throes of ecstasy. Rodin's work is emotionally complex and marks the return of the full range of the struggle between the Dionysian and the Apollonian on a level not seen in sculpture since the High Renaissance and the Baroque. Her face is reminiscent of Gian Lorenzo Bernini's incredible *St. Teresa of Ávila in Ecstasy*. Rodin's many undulating figures in this massive, unfinished work also evoke Michelangelo's *Slaves* in the Accademia Gallery in Florence. Their rhythmically violent movement is expressive of a battle that is both physical and spiritual.

The second image, *The Old Courtesan*, is a standalone detail copied from a section of *The Gates of Hell*. Here we see the true ravages of time, unvarnished. And yet, thanks to his penchant for conveying emotional power, we feel Rodin's empathy for his subject. It harkens back to studies that Leonardo da Vinci did of the elderly, though its Humanism differs from Leonardo's Christian theology; Rodin's vision is secular in nature.

Political upheaval in Europe would filter its way through the artists living in the midst of it and reveal itself in their work. Käthe Kollwitz lived through both World War I and II. Because of her liberal Christian upbringing, she was a committed Socialist and

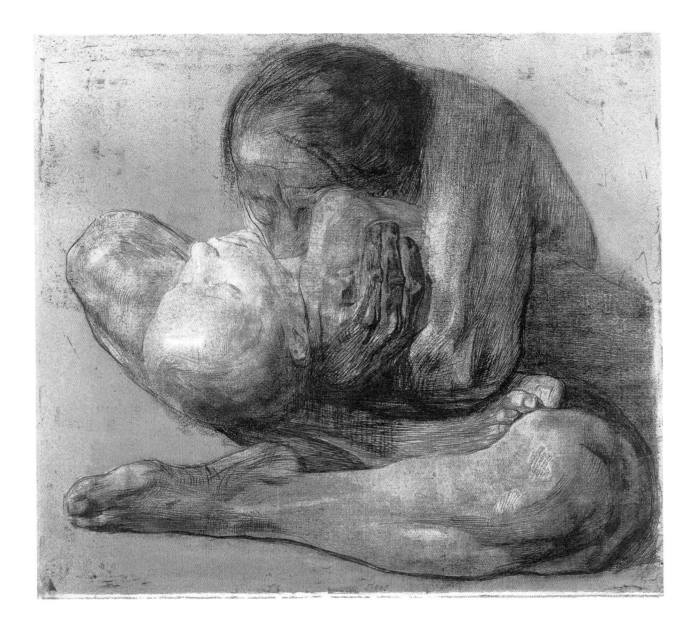

pacifist. She had tremendous compassion for the plight of both urban and rural poor, a Communist sympathizer whose humaneness informed her work while making her an enemy of the Nazi regime. No slouches in the propaganda department, the Nazis appropriated her work to promote their agenda on a couple of occasions. They used her artistic voice to convey their narrative (without her permission), and she was likely spared "Degenerate" status because of this.

In this print, *Woman with Dead Child*, she captures the savagery of the human condition, the inescapable grief of death. Her ability to draw us in and allow us to feel empathy for her subjects is as powerful a tool in her arsenal as her technical abilities.

Like the Rococo, the Fin de Siècle, as this period is often referred to, represents a Dionsyian sensuality with no counterbalance to offset the decadence. Two artists from Vienna (the capital of the Hapsburg Empire) stand out from this time period: Gustav Klimt and Egon Schiele. Klimt began his career as a notable decorative artist and developed his technique and subject matter to include sensual paintings of women, as well as land-scapes that were influenced by Japanese prints. His later

ABOVE: Käthe Kollwitz, *Woman with Dead Child*, 1903, engraving and softground etching retouched with black chalk, graphite, and metallic gold paint on heavy wove paper, 16½ x 18½ inches (41.7 x 47.2 cm), National Gallery of Art, Washington, D.C.

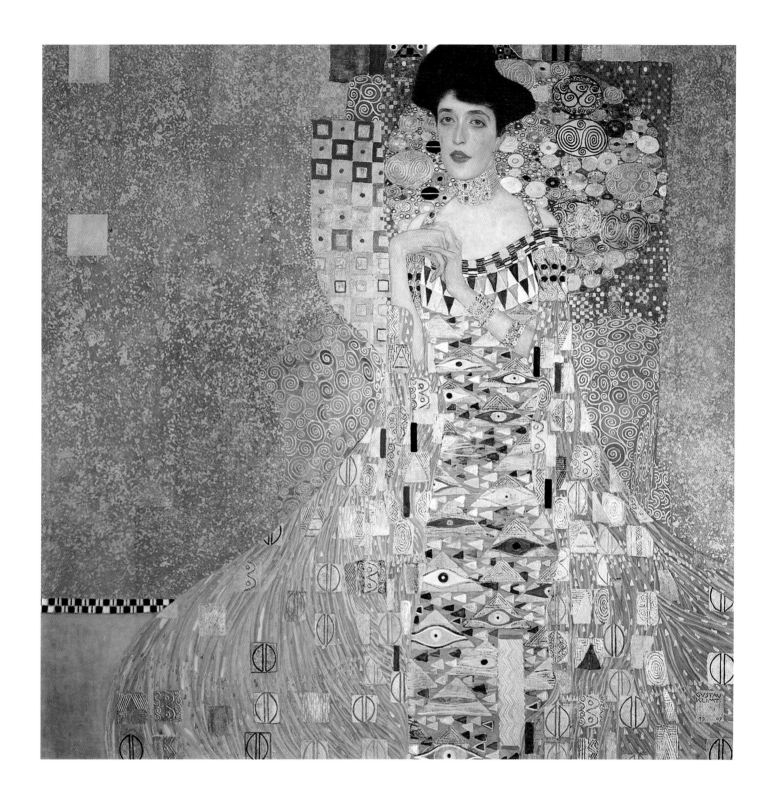

portrait work was often gilded and he was very successful with it. His work was collected by the wealthy merchants of Vienna, and one of them commissioned two portraits of his wife, Adele Bloch-Bauer. The portrait of Bloch-Bauer shown above displays a sympathetic and sensual rendering of both face and hands, set in a sea of intricate and rhythmic, gilded patterns. Klimt was flirting with the mixture of Modernist flatness

ABOVE: Gustav Klimt, *Adele Bloch-Bauer I*, 1907, oil, silver, and gold on canvas, 55 x 55 inches (140 x 140 cm), Neue Galerie, New York

OPPOSITE: Egon Schiele, *Young Woman with Black Hair*, 1910, pencil, watercolor, and white heightening on paper, 22 x 17¾ inches (56 x 32.5 cm), Albertina, Vienna

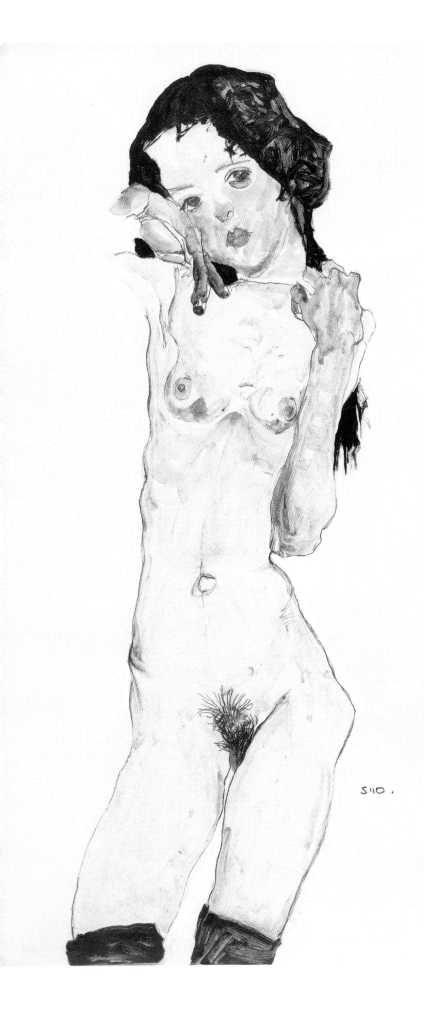

and figurative form long before the Americans would begin to attempt this. His artistic oeuvre was not one of pathos, but rather of sensual love and decadence.

Schiele pushed the envelope in a more daring direction. His personal history contained dark sexuality. He lost his father to syphilis at the age of fifteen. Unable to afford professional models, he often depicted very young, working-class girls or prostitutes in sexual poses. These drawings were much in demand from Schiele's Viennese patrons, despite (or perhaps because of) the strict Victorian moral codes that governed society at the time. Although Schiele was able to sell this type of work, he ran afoul of the law for creating "pornographic" pictures of nude schoolgirls, and was once imprisoned for twenty-four days.

Schiele invented a new type of nude. Though the style of his drawings and paintings was somewhat rooted in Art Nouveau, they were much more erotic. His line quality was uniquely his own. *Young Woman with Black Hair* features some of the characteristics typical of Schiele's female figures, including an arresting face, small breasts, long and slender arms, and a focus, or implied focus, on the genitals. Schiele's work also introduced a voyeuristic quality that was new; specifically here, the subject seems to look back at the viewer (that would be us) with equal power. There is nothing demure or romantic or classical about Schiele's women. Their power comes from their realism, not idealism.

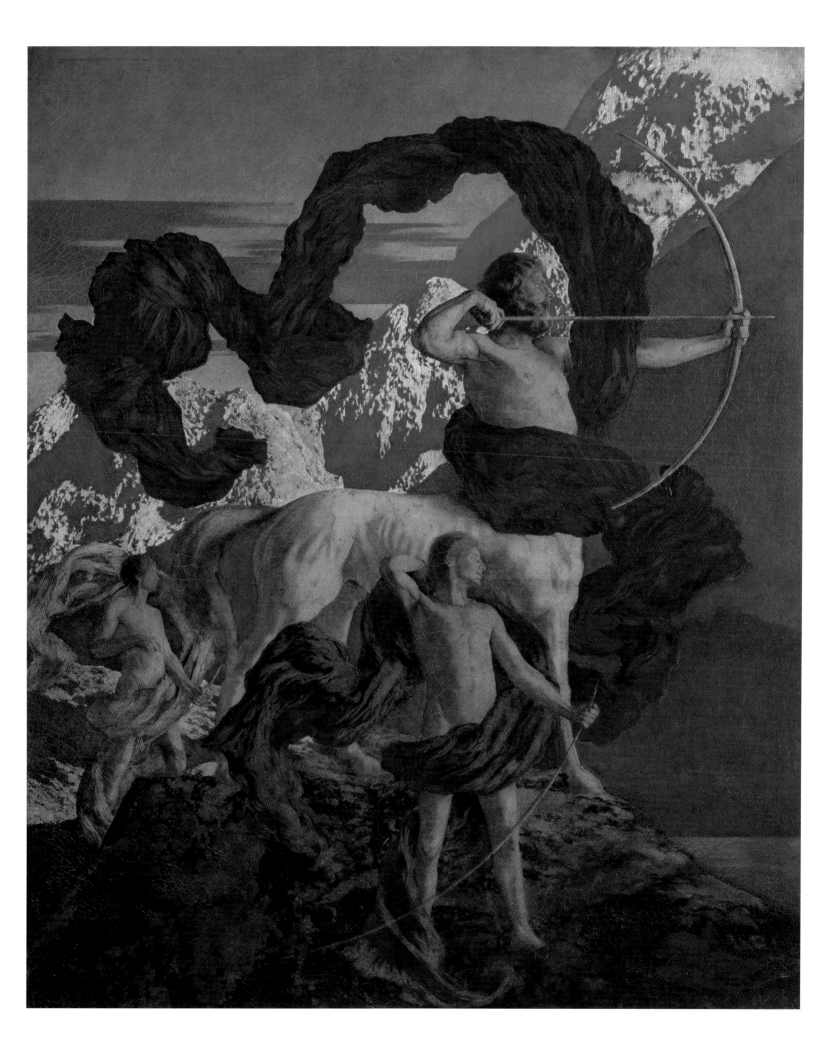

TWENTIETH CENTURY— REALISM FOR HIRE

The French Academic influence on European art was on the wane before being dealt a deathblow by World War I. But this was not the case in the United States. The American publishing and advertising industries knew a good thing when they saw it. Artists trained in the academic system could draw and paint on an exceptional level, and were welcomed with open arms and checkbooks. As the publishing industry grew in the United States, the huge market in print advertising proved to be a lucrative livelihood for many Figurative Realists. We can find a direct lineage of the French Academic methodologies being passed on to the next generation through Golden Age illustrators like J. C. Leyendecker, Maxfield Parrish, James Montgomery Flagg, and many others. Even though the aesthetic attached to those methods changed course under the direction of Madison Avenue ad men and the needs of the U.S. government's war efforts, for the most part the techniques remained intact. A strong argument could be made that the American publishing industry preserved academic drawing and painting techniques through the lean years of the early to mid-twentieth century. The tradeoff: Narrative was brought squarely into the service of selling product or political agendas.

Here we see two examples of illustration done by classically trained American illustrators. Maxfield Parrish was educated at the Pennsylvania Academy of the Fine Arts, which at that time was a bastion of academic technique. Parrish became one of the most influential of the Golden Age illustrators, with a career spanning almost fifty years. He was a self-proclaimed "businessman with a brush." Here we see his illustration *Jason and His Teacher*, used for both *Collier's* magazine and a 1910 edition of Nathaniel Hawthorne's *Tanglewood Tales*.

J. C. Leyendecker's *Weapons for Liberty* was a poster illustration for the Boy Scouts of America's Third Liberty Loan Campaign in 1918 to sell war bonds. Leyendecker initially studied under John H. Vanderpoel at the Chicago Art Institute and then later studied at the Académie

Julian in Paris. He went on to produce more than four hundred magazine covers throughout his amazingly successful career as an illustrator.

But, as we will see in the coming pages, not all American artists were persuaded by the financial lure of the advertising industry. As European artists began to reveal social and political angst in their work, and Cubism and other art forms sprung up, American artists grew more curious about Modernism. The famous Armory Show of 1913 had a huge influence on many American artists and collectors. Increasingly, a subset of American figurative artists felt the need to control their own narratives and abandon academic techniques.

OPPOSITE: Maxfield Parrish, *Jason and His Teacher*, 1909, 40 x 32 inches (101.6 x 81.3 cm)

ABOVE: J. C. Leyendecker, *Weapons for Liberty*, 1918

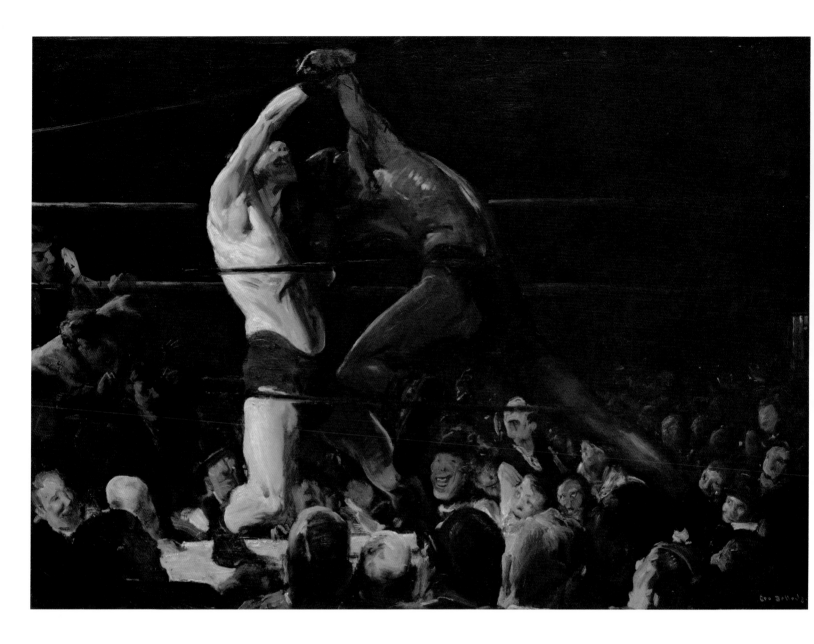

AN AMERICAN NARRATIVE

As the illustration market took off, powered by French Academic drawing and painting techniques, Americans in the fine arts began forming their own narratives and breaking further away from the Academy's methods. The early part of the twentieth century saw Figurative Realism take on a particularly American flavor, one rooted less and less in the Old World. Americans were optimistic and embraced Modernism side by side with Realism, and saw no conflict with doing so. Almost all early twentieth-century American figurative painting was non- "academic," and also regional. In New York, the Ashcan School, led by Robert Henri, with George Bellows, Everett Shinn,

George Benjamin Luks, William Glackens, John Sloan, and others, used Realism as a way of speaking truth and shedding worn-out conventions about appropriate subject matter. While popular with the public, still-conservative American critics referred to the Ashcan School as the "Apostles of Ugliness" because they chose to paint the real lives of the poor in New York, rather than the opulent wealth, escapism, and celebrity that has always been the more heralded part of New York City culture. This appears to be an inherent function of Realism, and as a movement, it always seems to return to its roots, that of the commonplace, the everyday.

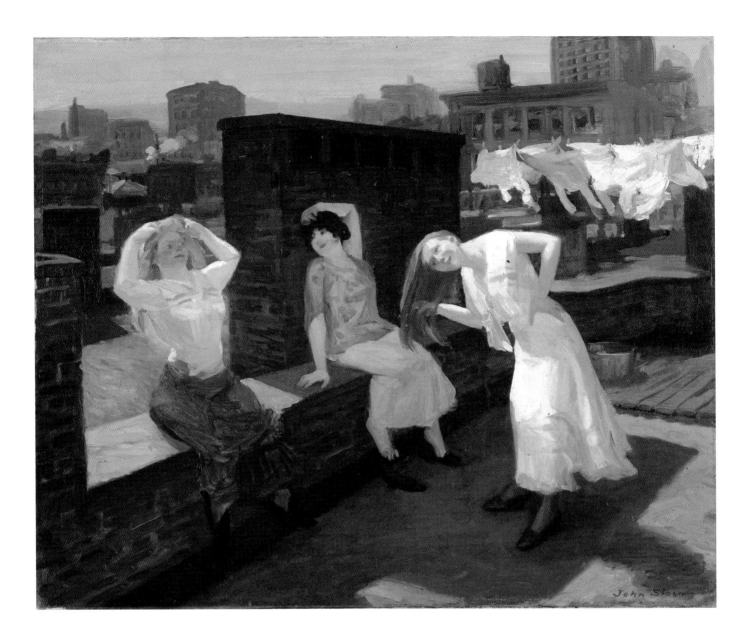

Both of the Ashcan images shown here reflect that celebration of the commonplace, the blue collar, in a uniquely American way. Bellows's *Both Members of This Club* shows an in-flight punch being delivered by one fighter to another. The title of the work is in itself a wry pun on the divide between the "country club" elite, who were mostly likely in attendance, and those inside the ring. Bellows navigated both worlds with ease and was quite successful as an artist, being collected by the Metropolitan Museum of Art at the age of twenty-nine. Sloan's *Sunday, Women Drying Their Hair* is similar in its celebration of the common. It is a subject that Degas painted many times, but without the uniquely American exuberance. These women are happy, not French.

In the Midwest, there was the Regionalist movement with Grant Wood, John Steuart Curry, and Thomas Hart Benton. These artists made paintings that showed "the Common Man," everyday people in scenes of life in the middle states, the heartland of the United States. Benton studied at the Académie Julian in Paris, and upon his return to New York in the early 1920s, he

OPPOSITE: George Bellows, *Both Members of This Club*, 1909, oil on canvas, 45¼ x 63¼ inches (115 x 160.5 cm), National Gallery of Art, Washington, D.C.

ABOVE: John Sloan, *Sunday, Women Drying Their Hair*, 1912, oil on canvas, 26⅛ x 32⅛ inches (66.4 x 81.6 cm), Addison Gallery of American Art, Andover, Massachusetts

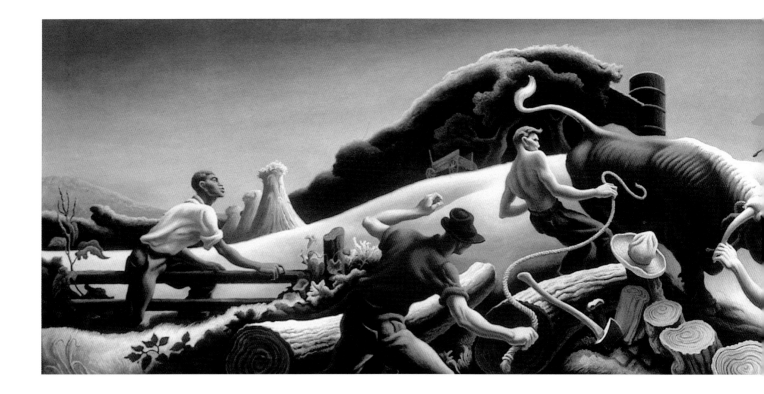

declared himself an "enemy of Modernism." Ironically, his most famous pupil, Jackson Pollock, would forge a very different path.

Modernism, in all of its forms, was an exciting new movement where, at least initially, figurative work stood on equal footing with abstraction. In its early years, Modernism had not yet completely dismantled the traditional structures of representational art. One of Modernism's main tenets was to break down traditional, bourgeois means of representation and open up new ways of seeing. That revolution had already begun in the late nineteenth century and would continue in all forms of art. It would be very easy to picture Aaron Copland's modernist masterpiece "Fanfare for the Common Man" as the soundtrack to Benton's *Achelous and Hercules*, pictured here. They both celebrate simple, heroic Americana.

But the reality was that America had a dark social and political underside that was perhaps every bit as complicated as Europe's. Americans simply didn't talk about it, or sit around philosophizing about it in public to the degree that their European counterparts did. However, the themes were there and a few artists dealt with them in subtle ways. We will focus on the work of two artists who did so.

In Edward Hopper's work, we see an artist having a conversation about America, in both interior and exterior spaces, and in both urban and rural ones. Hopper initially worked as an illustrator, where he learned the craft of conveying a narrative. He was successful in both that industry and in the fine arts. One of his paintings was included in the aforementioned Armory Show in 1913. The narratives he communicated in his own artwork presented a very different version of America, because he was free to express them without fear of upsetting a client or losing an account. Perhaps his most memorable painting, *Nighthawks,* is an urban scene, but Hopper also did terrific work set in rural environs, such as gas stations, highways, lighthouses, and the like.

Hopper's scenes of individuals in isolation often feature either a "working girl," or simply a woman sitting alone, and they can often be read on multiple levels. There is the scene we are looking at, which usually presents a simple, straightforward narrative. And then there is the interior narrative (what is the subject thinking about?). When taken together, Hopper's work often

ABOVE: Thomas Hart Benton, *Achelous and Hercules*, 1947, tempera and oil on canvas mounted on plywood, 62⅞ x 264⅛ inches (159.6 x 671 cm), Smithsonian American Art Museum, Washington, D.C.

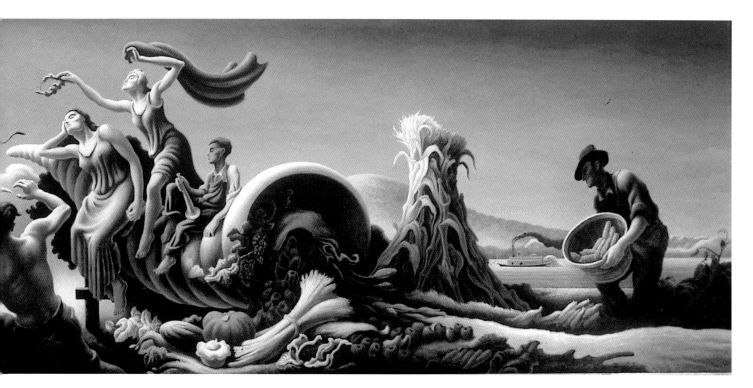

exhibits a sexual subtext, rendering it more sophisticated than just erotic paintings of pretty girls. His women are always *doing* something, either working or thinking.

Girl at a Sewing Machine seems straightforward enough. It's a typical Hopper composition, with the figure a bit below our eye level in an interior that is every bit as important as the subject. Both she and the wall behind her are lit by sunlight streaming through the window. Hopper uses this kind of "establishing" device regularly. He lures us into the scene, and despite the fact that we have no facial contact with the figure (or maybe because of it), we feel a connection, and perhaps even wonder what she is thinking while she is sewing. Degas kept himself, and us, at a cool distance; Hopper brings us in for a closer look.

In *Summer Interior*, on the next page, we have an image that, once again, shows the influence of Degas. Hopper handles the composition in

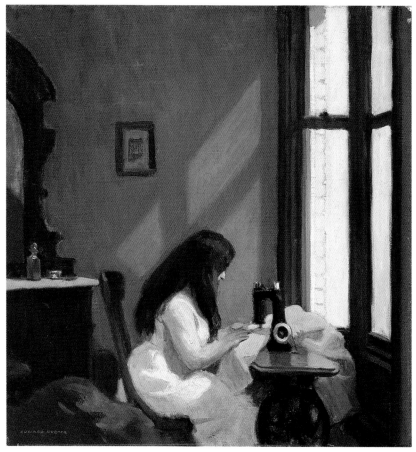

ABOVE: Edward Hopper, *Girl at a Sewing Machine*, circa 1921, oil on canvas, 19 x 18 inches (48.3 x 46 cm), Thyssen-Bornemisza Museum, Madrid

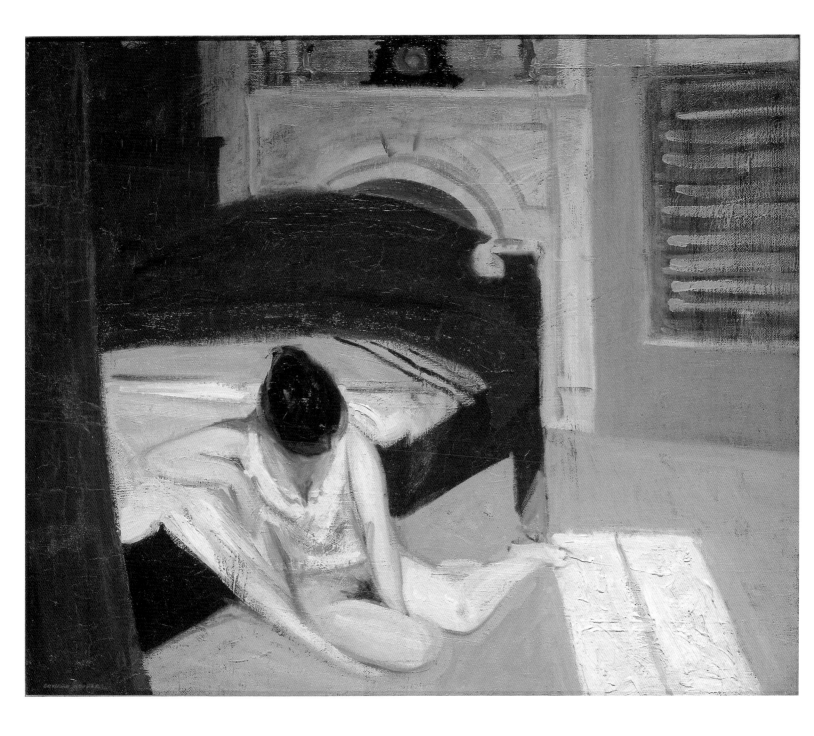

his usual manner: It is a well-lit scene and an unresolved narrative. We see the bright, direct patch of light on the floor, a partially nude subject placed below eye level with a sheet pulled off the bed under her. There is the usual lack of eye contact with the viewer/artist. A bad hangover? A ruined relationship? We can only guess and enjoy the dissonance. We are being offered a peek into an intimate scene, but no resolution.

Another interesting artist at this time was Edwin Dickinson, who pushed things in a much more Modernist direction, in terms of breaking down a representational approach to painting. Dickinson had a superb American Figurative Realist pedigree. He had studied with William Merritt Chase at the Art Students League in New York, and with Charles Webster Hawthorne in Provincetown, yet Modernism had a strong hold on him. He had a foot planted in both camps. His quick sketches, or *premiers coups,* as he called them, are hauntingly enigmatic and deconstructed. His paintings involve figures and objects painted from observation, but they often include strange juxtapositions and imagery that hint at underlying narratives and situations

whose purpose is unclear. In his work shown here, *Shirley*, we can see him deconstructing the picture plane. And although on a formal level this deconstruction comes from Cubism, Dickinson resists the Cubist impulse to also destroy linear narrative. On the contrary, this breakdown serves to draw us closer to the subject.

This fusion is enigmatic, and one is not sure how he pulls it off. It's interesting that, given his Realist pedigree, Dickinson flirted with Modernism to the extent that he did. Perhaps that hybrid quality helped him achieve an outstandingly successful career; he was included in shows at the Art Institute of Chicago, the Corcoran, the Whitney, the Metropolitan Museum of Art, and the Museum of Modern Art.

OPPOSITE: Edward Hopper, *Summer Interior*, 1909, oil on canvas, 24¼ x 29¼ inches (61.6 x 74.1 cm), Whitney Museum of American Art, New York

ABOVE: Edwin Dickinson, *Shirley*, 1945, oil on canvas, 16 x 13⅞ inches (40.6 x 35.2 cm), collection of Gilbert and Ruth Scharf

THE FIGURATIVE DIVIDE

Then an odd thing happened. Soon after the late 1940s, Figurative Realism fell into an almost complete disrepute in the art world. There were always a few outliers who were deemed acceptable by the art establishment, but for the most part, Realist painters were considered déclassé. This chapter opened with a consideration of the boom-and-bust cycle for Figurative Realism. We have arrived at the bust from which it will arise. Many theories abound for the fall from grace. One argument we have discussed is that the genre was coopted by the commercial publishing and advertising industries. The lure of a steady paycheck led the most talented American figurative artists of the mid-twentieth century to put their efforts in the service of selling product, and to give up control of expressing their own narratives.

But while that theory may provide an aesthetic explanation as to why Realism was held in such disdain by art galleries, museums, and so forth, it does nothing to explain the economics of the situation. Why would the market for well-crafted figurative work suddenly dry up? And, if it didn't, why wouldn't those same galleries want to sell work to meet that need?

Regardless of the root cause, this "freeze" had a serious effect on Figurative Realism. Modernism dominated as the most respected and relevant philosophy in the art world. The net result for the fine arts was that many of the narratives that were being explored in Figurative Realism by the likes of Hopper, Dickinson, and others would go into dormancy for nearly thirty years before they were picked up again by contemporary figurative artists. The illustration market continued to take Figurative Realism seriously, but only on a technical level. The narratives were dictated to the artists, not the other way around.

Although the illustrator Norman Rockwell received much scorn from art critics in his day, he is very much in

the midst of being reevaluated as a serious artist. *Peach Crop*, pictured here, was an illustration for *American Magazine* for a Ruth Burr Sanborn story about a young medical student who falls for a sharecropper's daughter. It is a statement of love and virtue, and done here with tremendous skill (and rather thick brushwork, when seen up close). While it was regarded as a mere illustration at the time, we now see its merits as a work of fine narrative art. His vision of America is something many people are nostalgic for.

As an illustrator, Rockwell had a technique and narrative prowess that made him capable of a "direct hit" on the American psyche with his images. He helped to sell many magazines in his time. Part of the reason his artistic career is enjoying a resurgence (complete with several museum retrospectives in major cities around the United States) is that he was not only a technically gifted visual storyteller, but more specifically, an American storyteller.

ABOVE: Norman Rockwell, *Peach Crop*, 1935, oil on canvas, 16 x 36 inches (40.6 x 91.4 cm), collection of George Lucas, courtesy of the Lucas Museum of Narrative Art

BEYOND MODERNISM AND POSTMODERNISM AND INTO THE TWENTY-FIRST CENTURY

I am deliberately compressing much information here to address a few important touchstones. In the early 1980s, some of the themes of American Figurative Realism that had been explored by Edward Hopper and others, and left dormant for thirty years, reemerged within the work of a new crop of figurative artists, often described as Neoexpressionists. We will focus briefly on two of them,

Eric Fischl and David Salle. Both came of age in the early 1980s, and both helped put figurative art back in prominence as being *culturally relevant*.

Fischl's *Bad Boy* shows a scene that could almost be interpreted as picking up where Edward Hopper left off with *Summer Interior* (page 68)—but with a new tone of dark humor. No longer hidden, the deep American

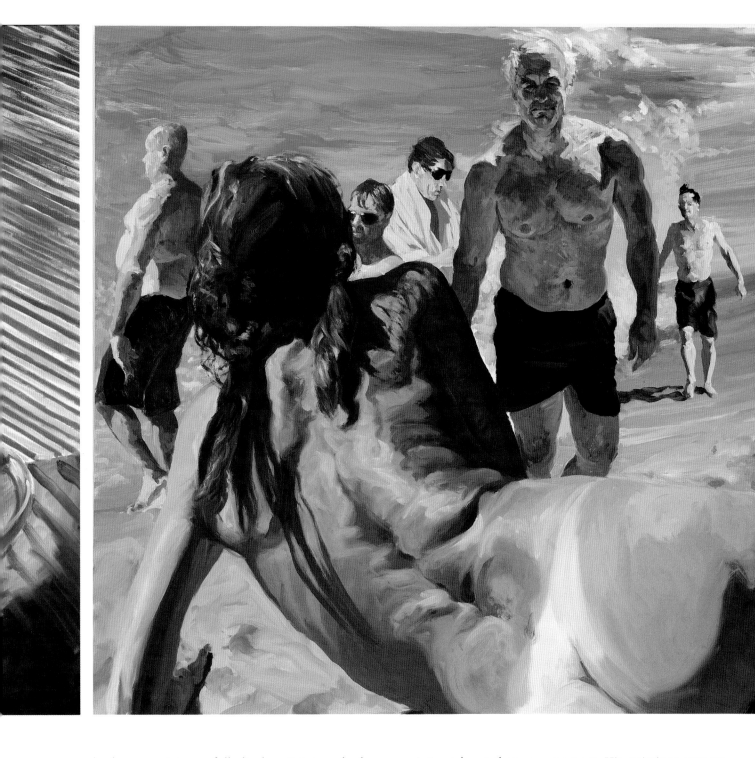

suburban angst is on full display. Set in a bedroom with dramatic, raking light, this painting features a nude woman sprawled on a mattress in a very revealing position. A preadolescent boy, a young voyeur and possibly her son, leans against a dresser, staring at her while he is simultaneously reaching into her purse in an act of theft. A nearby still life (a bowl full of apples and bananas) completes the none-too-subtle sexual narrative.

To me, what gives integrity to Fischl's work is that he is speaking, like Hopper, of a world he knows intimately, at that very moment. His paintings present a Long Island, New York–centric locale, populated by people within his circle. He may reference famous paintings from art history, but you don't need to be familiar with them to understand his narratives. American sexual

OPPOSITE: Eric Fischl, *Bad Boy*, 1981, oil on canvas, 66 x 96 inches (168 x 244 cm)

ABOVE: Eric Fischl, *Scenes from Late Paradise: The Welcome*, 2007, oil on canvas, 78 x 86 inches (198.1 x 218.4 cm)

taboos (or lack of them), narcissism, and materialism are put on full display, without judgment.

More recently, as Fischl has continued to explore America's suburban sexuality in paintings, the protagonists of his work have aged along with the artist himself. The concerns, vision, and humor have expanded as Fischl pokes a bit of fun at some of the indignities of aging, with the less-than-perfect physical specimens on display in *The Welcome*, from his *Scenes from Late Paradise* series. The "bad boy" is now an older, middle-aged man, such as the one we see here. He is no longer coy or deceitful about what he wants, but rather strides with confidence directly toward the nude woman in the foreground of the painting, and also toward us.

David Salle's paintings helped to define the term *Postmodern*, setting it in a figurative context. He recycles past modes of artistic expression and gives them new meaning (or none at all) by juxtaposing them against seemingly incongruous images and styles. Salle's nonnarratives are composed of various images, placed on top of one another with deliberately heavy-handed techniques.

He mixes high and low culture through the use of industrial materials and pop culture imagery. Salle's work is ultimately about the creative process, the assembling of the various elements of an image. In his compositions, such as *We'll Shake the Bag*, above, these elements most often form an unresolved narrative. This type of juxtaposition and layering has also been extensively explored by the German artist Sigmar Polke, but Salle's paintings are more figurative and uniquely American.

Fischl, Salle, and some others reintroduced the figure and the use of narrative into the world of the fine arts. There is much more to say about figurative work in the subsequent twenty plus years that have ensued, and not much space to say it in. But in chapter 8 we will pick up the conversation in a very different context, that of the artist's creative process and working methods.

ABOVE: David Salle, *We'll Shake the Bag*, 1980, acrylic on canvas, 48 x 72 inches (121.9 x 182.9 cm)

OPPOSITE: Matt Rota, *Paris*, 2012, watercolor, ink, and acrylic on paper, 15 x 15 inches (38.1 x 38.1 cm)

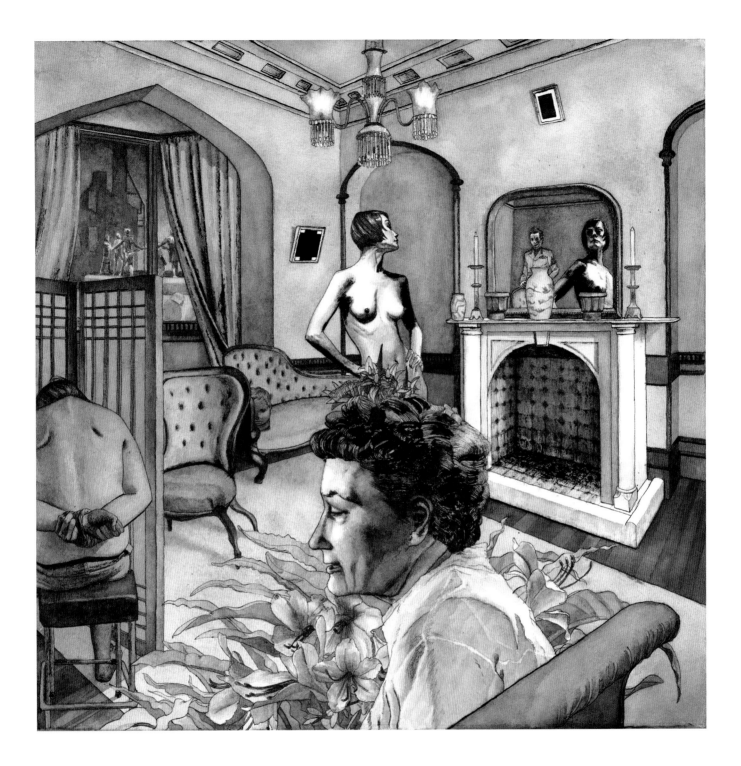

Matt Rota has forged a multifaceted career as an illustrator, fine artist, and author. Here we see a piece called *Paris* from a larger group of drawings called *The City of the Dead*. The narrative he created was that of an imaginary city inhabited by all of the people who died fighting in wars. The piece is named not after the city, but rather Paris, that key figure in the Trojan War from the *Iliad*. This image follows that story after the famed beauty contest. Paris has chosen Helen, embodied by the ghostly, black-haired woman in the center. She's looking in the mirror at herself.

The resurgence of Figurative Realism is increasingly blurring the distinction between the formerly separate realms of fine arts and illustration, and also changing the model of arts education around the world. Some figurative artists receive formal training and others are self-taught. Some work as illustrators and also show in commercial galleries.

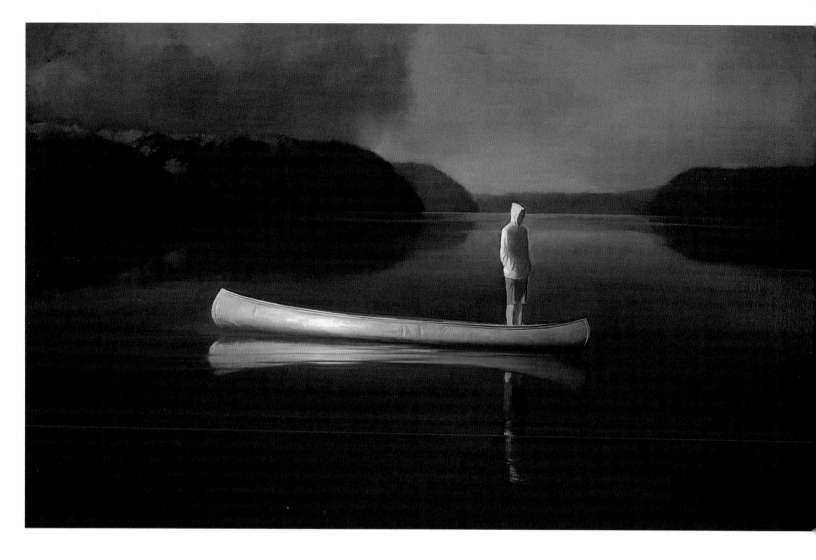

Randall Exon is a tenured professor of painting at Swarthmore College and a continuing Fellow at the Ballinglen Arts Foundation in Ballycastle, County Mayo, Ireland. His work carries forward some of the themes similar to those mined by Andrew Wyeth. He creates quiet, personal narratives of figures connected to rural landscapes like what we see in *Canoe*.

Few artists have recaptured the spirit of the Baroque like Adam Miller. With equal doses of late Mannerism and Thomas Hart Benton thrown into the mix, his talent for telling a narrative using multiple figures sets him apart from many classically trained artists. Miller's artistic education is unique in that he skipped high school and left the U.S. for Europe as a teenager. He has no degree from any accredited institution. He studied briefly at a couple of ateliers in Florence and then returned to the United States to begin his career. Miller has no "formal" education in art, and yet he is one of the most respected Figurative Realists working today. We will study his working process in more detail in chapter 8. Here, in *Apollo and*

Daphne, from his *Twilight in Arcadia* series, he confronts the issues of American mythology and the destruction of Nature by the supposedly "civilized" culture we live in.

Some artists find themselves by delving into the great themes of the human condition on their own, and others apprentice under a master for a season to learn the visual language. Maria Kreyn spent some time with Odd Nerdrum in Norway. Aspects of the epic nature of his work echo in her dynamic compositions, but she speaks in a voice that is uniquely hers. Here, in *Cartography* (page 78), a version of the ship of fools (a Classical allegory, originally from Plato, of a ship with no functional captain and the perilous consequences for humanity that follow), Kreyn successfully manages to work the entire composition into something resembling a

ABOVE: Randall Exon, *Canoe*, 2009, oil on canvas, 36 x 46 inches (91.4 x 116.8 cm)

OPPOSITE: Adam Miller, *Apollo and Daphne*, 2013, oil on canvas, 72 x 48 inches (182.9 x 121.9 cm)

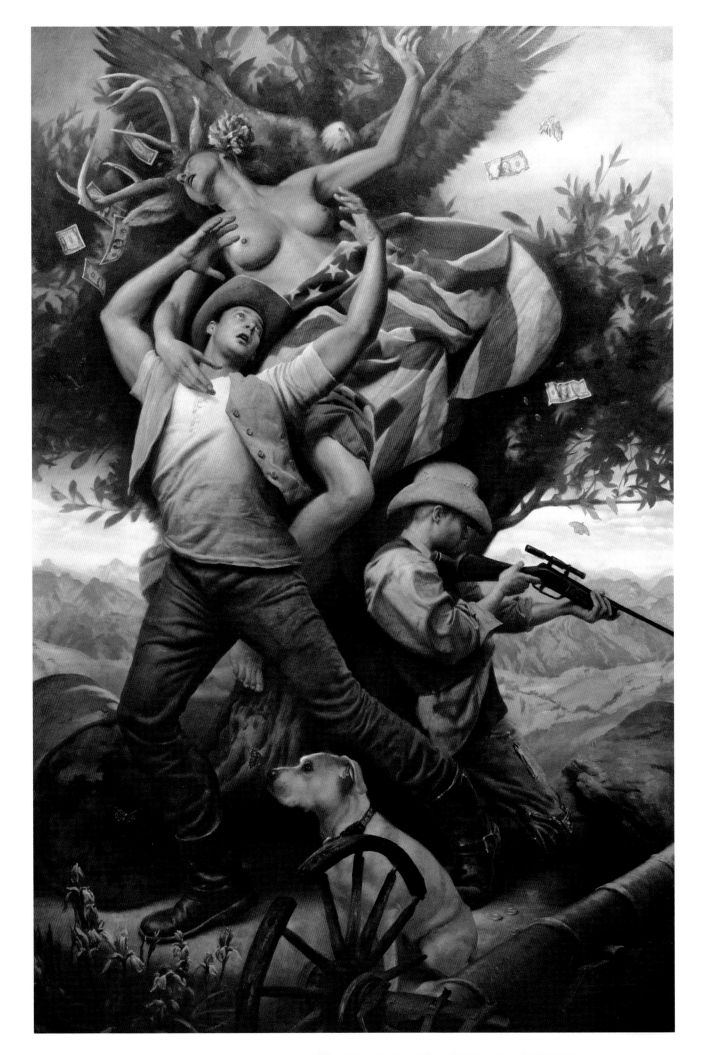

Rorschach test pattern. It's a scene of despair, but a rather glorious one.

Odd Nerdrum creates archetypal compositions that channel the Old Masters in technique, but the power behind his conceptions comes from an elevated sense of Humanism. As we discussed earlier in the chapter, many of the Old Masters (most especially those who lived during the Renaissance) were serving the Church, and consequently their art featured Christian narratives. Nerdrum has a different god, a different narrative. Here, in *Resurrection*, he evokes a common Christian theme, the risen Christ, or Lazarus raised from death, in a way that is not tied to any specific faith, but rather proposes to be universal.

Again, there are many artists making great work that I do not have the space to show here, at least in a historical context. As we move through the rest of the book, you will see what an exciting time it is to be a Figurative Realist artist. There are so many interesting styles, modes of working, streams of thought from art history that are finding their way into the work of contemporary figurative artists.

ABOVE: Maria Kreyn, *Cartography*, 2014, oil on canvas, 102 x 68 inches (259.1 x 172.7 cm)

OPPOSITE: Odd Nerdrum, *Resurrection*, 2006, charcoal on sanded glass, 38¾ x 34 inches (98.5 x 86.4 cm)

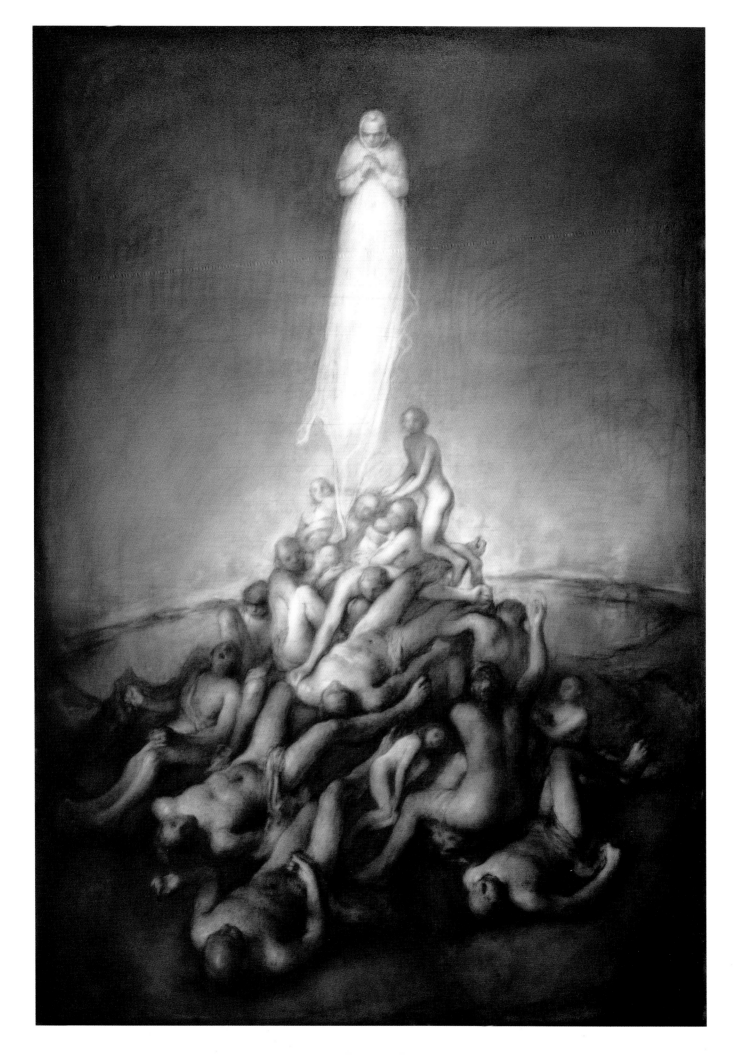

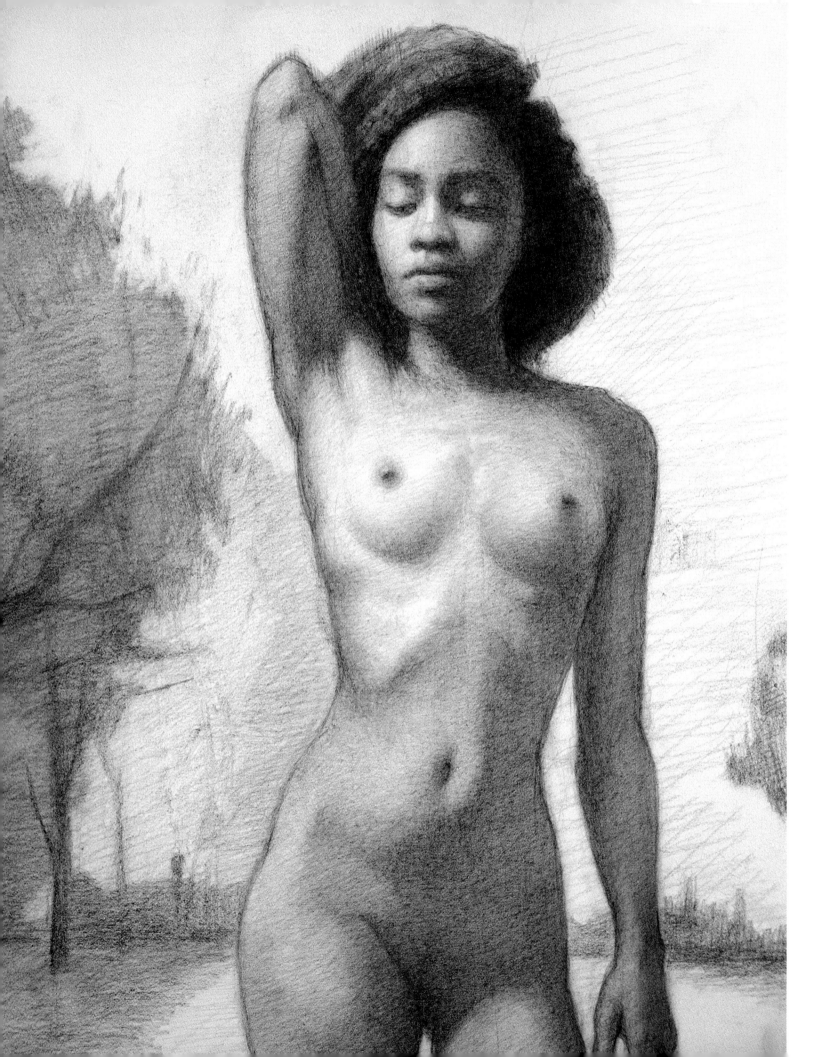

STANDING FIGURE, FRONT VIEW

I made the drawing Tynisha *especially for this book. My method of teaching how to draw the figure will be to walk you through its creation step by step. In the process, you will learn my approach and the questions I ask myself as I progress. What am I looking for from the model? What important information needs to be observed and understood? Should I leave anything out? By observing how I arrive at the decisions I make, you will learn how to make them for yourself.*

OPPOSITE: Rob Zeller, *Tynisha* (detail), 2015, graphite on paper, 24 x 18 inches (55.9 x 35.6 cm)

Begin by *really looking*. I know that sounds obvious, but it's easy to ignore your preconceptions about the figure. After all, you live in one: your own body. Each of us has thoughts about the figure that get in the way of really experiencing the pose of the model and, most important, the *light* hitting the model. If there were no light, it would be impossible to see the model. A strong light source is essential for good figure drawing. It not only illuminates all of the anatomy and structure we will discuss, but it creates form and cast shadows, which allow the human brain to perceive shape and volume. There are as many different light situations as there are artists, and each one is unique and needs careful observation.

Having an open mind and being aware that light is hitting the model are still not enough. You need to be able to capture a gesture, and you need a certain amount of mastery over proportion and anatomy. But learning about light is of paramount importance. Light comes from a certain direction, and that information is key because the light strikes the model at a certain angle, causing parts of his or her body to become really bright, not so bright, or enveloped in shadow.

If you don't take the light into account, you are setting yourself up to be merely a human camera, someone who tries to match values by looking and not really thinking about things. These days a new digital camera is capable of a gray scale with variations in the millions.

You cannot possibly compete with that technology. Why even bother? But you are capable of thinking, looking with intent, and understanding what you are looking at, then acting on that information with skill.

Throughout this book, I will discuss a simplified way of creating form in the classical manner. As I move from sketch to finished drawing, I will walk you through the most important concepts.

The process that I will be presenting—in this chapter and the two that follow, plus chapters 6 and 7— observes these steps:

STEP 1: **FINDING THE GESTURE**

STEP 2: **ESTABLISHING THE BASIC PROPORTIONS**

STEP 3: **BLOCKING IN WITH ANATOMY, LIGHT, AND SHADOW**

STEP 4: **MODELING THE FORM**

STEP 5: **ADDING THE FINISHING TOUCHES AND REFINEMENTS**

STEP 1 | FINDING THE GESTURE

What is gesture and why is it necessary to study?

Gesture is a river of movement, energy, and rhythm that flows through the figure in any given pose. It is the path of alignment through all of the muscles, bones, and areas of soft tissue that allow the pose to happen. It takes some training and practice to see gesture. If you are having trouble, it is sometimes helpful to mimic the model's pose yourself, to see what the inner workings are.

Once you understand gesture you will be able to see the essential rhythm of a pose, which will allow you to properly plan your drawing. Think of gesture as a conceptual road map. Before you start drawing

with your hand, first learn to draw with your eyes. This means looking at the model for specific information related to rhythm and flow.

Begin by scanning the entire figure for gestures that flow through the various forms, learning to see how all of the parts of the figure are connected. In any standing

OPPOSITE: The red overlay lines show gesture, or flow. They are not actually drawn, but rather seen. In the very beginning stage of drawing the model, it helps to look for how the muscles and bones work together to form channels of energy and rhythm that run through the model's body.

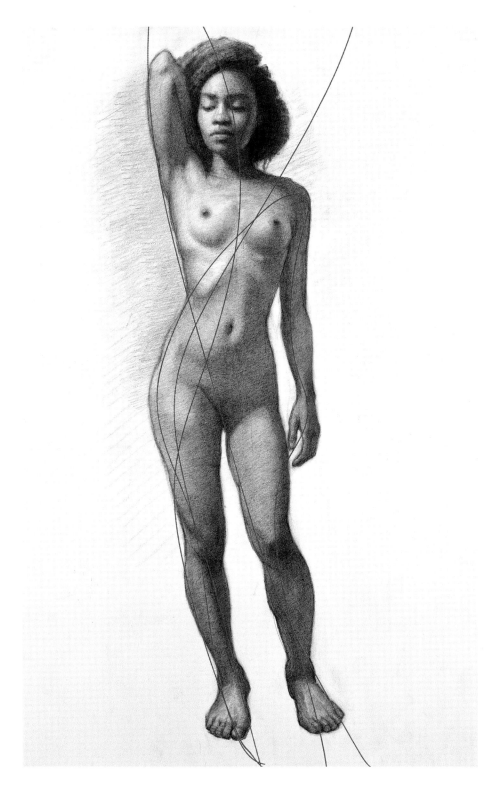

figure, there is a rhythmic line that traverses the figure vertically, from head to toe, smoothly following a path through the anatomy, connecting the musculature of the model's body. Learn to see this axis of energy first so that when you draw, you will be able to forge greater unity among the various parts of the figure.

In the image above, I demonstrate the concept with red, curving lines. Please note: When I am doing a long-pose, refined drawing, *I don't ever actually draw these lines.* I look for them in the beginning, then I look for them periodically the entire time I'm drawing. When you are looking for gesture, you want to practice running your eyes up and down the model as if you were a current of some sort, water or perhaps electricity. Think of the process as a scan, like one done by a medical device, as you quickly make your way though the body.

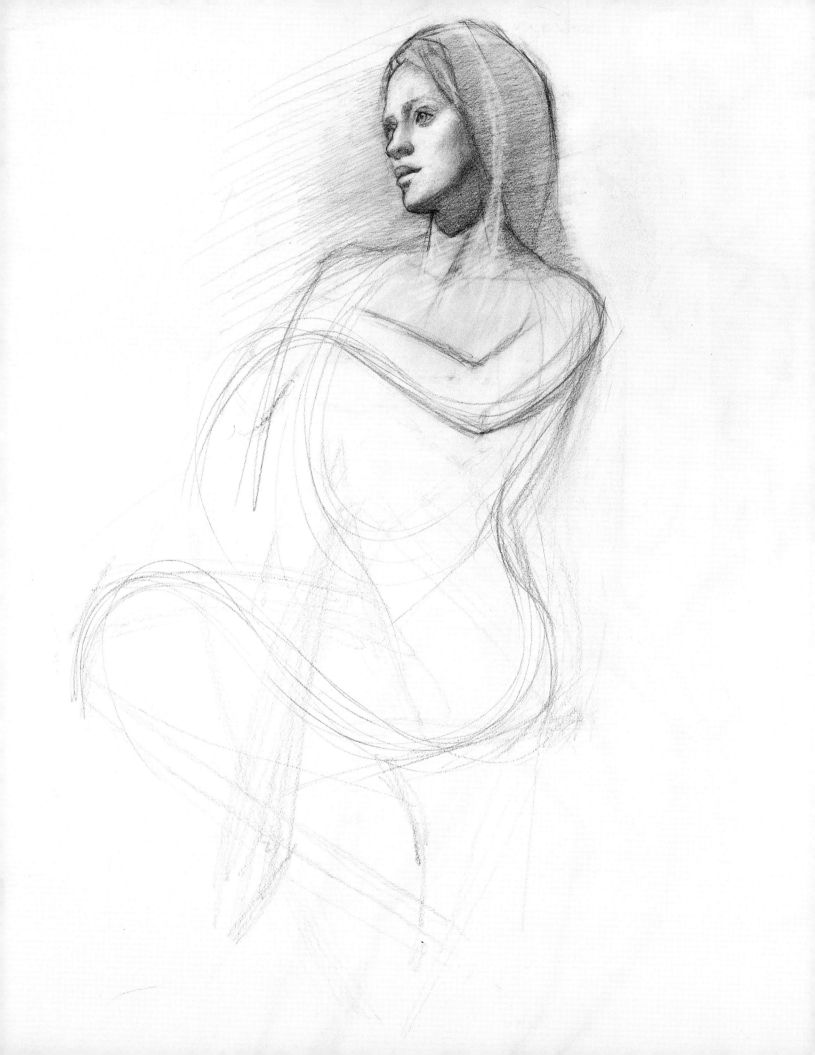

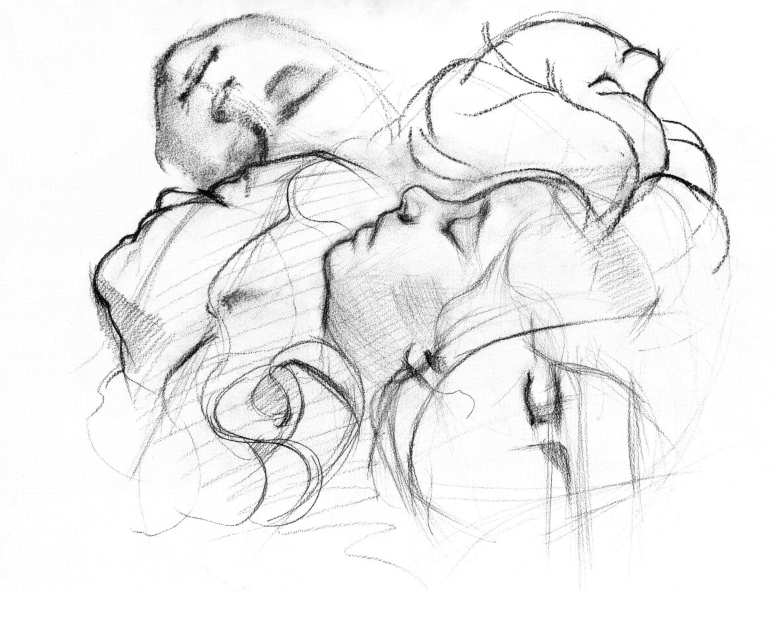

Let's scan the drawing of Tynisha together, beginning at the base of her right leg. When a knee is locked, like hers is here, then you know it is bearing the most weight, in which case it is called the *stand leg*. You'll want to travel very quickly up that, through her pelvis, into her torso, and then out through her upraised arms. Or perhaps you leave her body by arching up around her head. That's an equally valid pathway. You could just as easily start at the top of her upraised arm and flow downward through her arm, rib cage, pelvis, and left leg, exiting through her left foot.

When I teach the concept of gesture in my class, I take a laser pointer and draw various gesture lines through the model. Because there are always more than one, I drew four in the diagram for this book. Can you follow them?

OPPOSITE: Rob Zeller, *Liah*, 2010, pencil on paper, 24 x 18 inches (60.9 x 45.7 cm)

Pressed for time, as the model was an actress and had a performance to go to, I made a quick decision to focus on the portrait and rhythm lines that flowed through this pose.

ABOVE: Rob Zeller, *Sketches of Emalyn*, 2015, charcoal on paper, 18 x 24 inches (45.7 x 60.9 cm)

This is a collection of vine charcoal studies of my sleeping daughter. She moved around quite a bit during the 30 to 40 minutes I spent sketching these, so gesture was the main thing I could capture.

STEP 2 | ESTABLISHING THE BASIC PROPORTIONS

It's important to make sure, from the very start, that the various parts of the figure are to scale with one another. This is referred to as "keeping things in proportion." You do not want to draw the head too large, the arms too long, the legs too short, and so forth. You want to be able to control the scale of your figure, so let's discuss some strategies to do so.

The Head Length Method

Throughout the history of art, various canons of proportion have been popular at different times. Most involve a unit of measurement known as the *head length*—meaning, the figure is measured by how many head lengths tall it is, or how many head lengths wide it is, at any given point. Head length is an incredibly useful tool. I highly recommend it.

Since the ancient Greeks, the standard proportions of the human figure, both male and female, vary between 7½ and 8 heads high. By the nineteenth century, this was backed up by scientific data. I find the head length unit useful as a proportional tool at times, but I favor a method that is a little faster, and I think more effective, at capturing a given model's specific proportions. I will elaborate on this in just a bit.

RIGHT: Noah Buchanan, *7 ½ Head Proportional Écorche*, 2014, graphite on paper, 18 x 24 inches (45.7 x 60.9 cm)
This proportional chart (with red lines added to show head units) displays a classically proportioned, 7½-heads-high figure from various views.

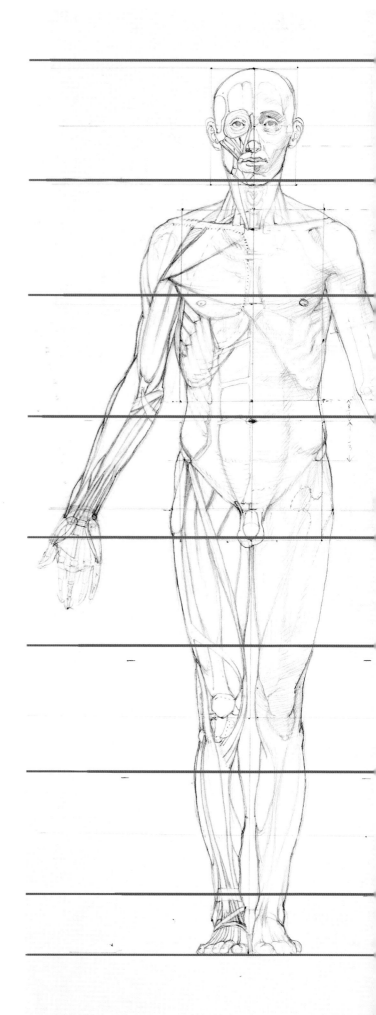

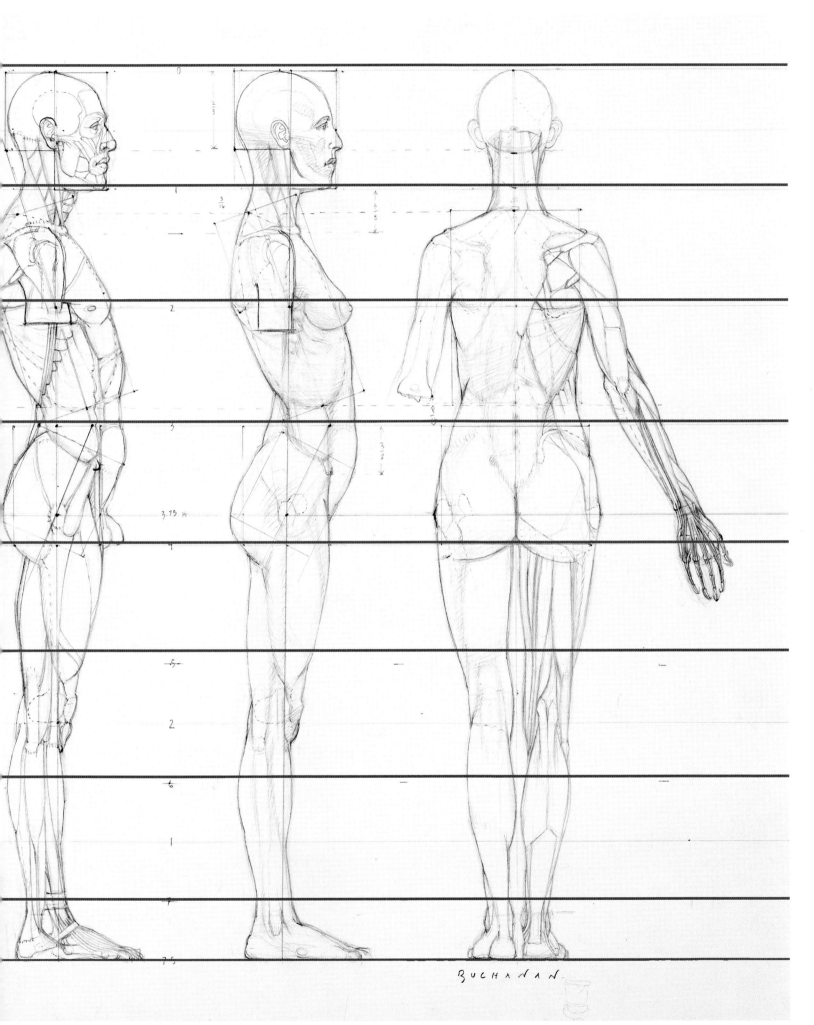

BUCHANAN.

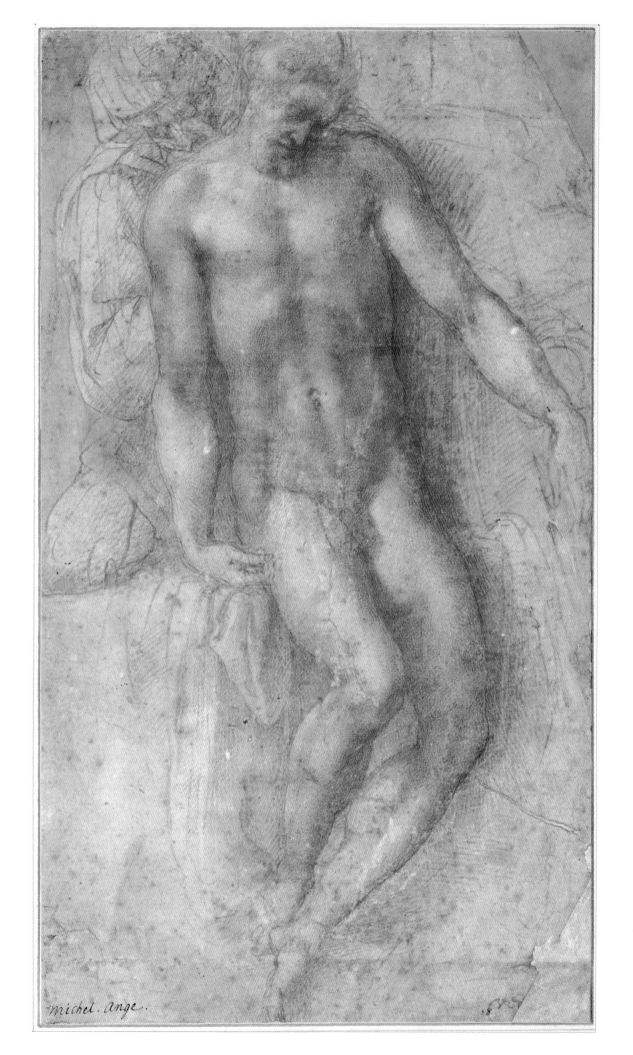

Michel. Ange.

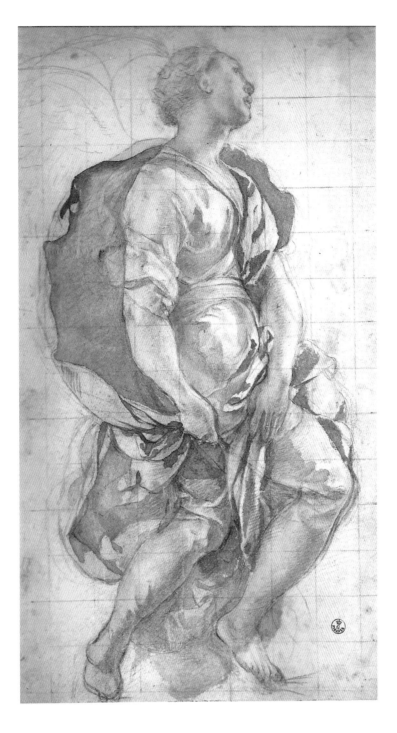

But first, I'd like to address the desires that some artists have to transcend "science," and aim for something more imaginative. While some do argue that we should strictly adhere to nature, other artists believe that the vision of the artist is more important than fidelity to nature.

Some would argue that when first learning to draw the figure, you should aim for naturalism. Become a student of nature. Learn to draw the model as he or she *really* is. Later, your artistic vision should determine which proportional scale you use.

OPPOSITE: Michelangelo Buonarroti, *Pietà*, circa 1530–1536, red and white chalk over black chalk pencil drawing on paper, Albertina, Vienna

The head here is small relative to the body, which is approximately 11 heads high. This helps lend a monumentality and heroic quality to the drawing.

ABOVE: Jacopo Pontormo, *Study of Angel for the Annunciation* (for the fresco in the Capponi Chapel), circa 1527–1528, black chalk and brown wash over red and white chalk on paper, 15³⁄₈ x 8½ inches (39 x 21.6 cm), Uffizi Gallery Museum, Florence

The grid overlay makes it easy to measure the head lengths (8). The swirling, rhythmic lines lead through the legs, up the arms, to the head.

The Quarter System

While I agree that the head length method is a useful way to establish proportions in a figure, I personally employ what I believe is an easier method, called the Quarter System. It involves four simple steps, which, when followed with precision, produce accurate results. Review the image opposite while reading the steps. And, when you start to employ this method in your own drawing practice, *remember to make all of these initial marks very lightly.*

I. ACKNOWLEDGE YOUR PERSPECTIVE

Account for perspective in the very beginning. Asking the right questions is key: Where is your eye level? Can you see over the top of the rib cage, or are you looking up at it? How high up is the model? Is he or she on a stand, or on the ground plane with you? Are you seated or standing? Figuring out your eye level will tell you what you are looking up at and what you are looking down on. You need to know these things to be able to draw the model correctly. In the example here, I noted my eye level. You don't have to make such a mark on your drawing, unless you are prone to forget.

II. DEFINE YOUR PARAMETERS

Make two promissory marks on the page—one at the top and one at the bottom—then place a light mark in the exact middle between those two points. In so doing, you are promising not to let the model get above or below those points. This will prevent the dreaded "run off the page" that some people experience when they do not plan out their drawing properly.

These promissory marks do not have to be perfect, or in the *exact* spot at the top of the model's head or at the bottom of her feet. Approximate is okay. You are looking to "place" the model on the page. The middle mark is going to help you place the center of the model within accurate proportions.

III. EVALUATE YOUR MODEL'S MIDDLE POINT

Now look at the model and determine the middle point on the body. In a standing pose, with a frontal view, that point will always be on the lower third of the pelvis, just above the genitals, in a line that runs horizontally though the *great trochanters* and the *pubic symphysis*. Caution: This line is conceptual. It does not really exist!

Here's a problem that students often struggle with: Many of the things that interest them about the figure (face, breasts, shoulders, and so forth) fall above the midline. Thus they have trouble believing that two-thirds of the pelvis, the entire rib cage, and the head all sit above it. They invariably drop the midline lower to accommodate their misconception of how long the torso really is, and end up with stumpy legs on their figures. In a standing pose, the legs usually make up half the figure. There are exceptions to this rule of thumb, of course, but this is the norm.

I am not a measuring fanatic. I do not think that using external measuring devices in the beginning of a drawing automatically leads to great results. I am speaking of rulers, calipers, and so forth. Learn to use your eyes. It's perfectly fine to be off by a little in the initial stages. You can, and should, refine things later.

IV. IDENTIFY YOUR MODEL'S PELVIC TILT

Determine the tilt, or axis, of the model's pelvis by carefully observing that conceptual line through the lower third of the pelvis. Is there a tilt, or is the line straight? One of the best ways to find the proper tilt is to look for the two ASIS points on the pelvis, which we will discuss on page 98.

OPPOSITE: The essential first steps of establishing basic proportions: First, find your eye level. Then make marks for the top, bottom, and middle of the figure. And finally, mark the pelvic tilt of the model.

TOP

EYE LEVEL

TILT OF PELVIS

MIDDLE

BOTTOM

The Block Concept

The head, rib cage, and pelvis make up the three biggest building blocks of the figure. The pelvis is more or less a horizontal rectangular solid, and the rib cage and head are vertical rectangular solids. Some argue that the head is more of a square than a rectangle. I've noticed that different people have differently shaped heads. The block concept is meant to be a tool, not dogma.

I use the term *rectangular solids* because these are three-dimensional shapes. When you draw them, know that each has a front, back, top, bottom, and two sides (like a regular box). While these building blocks are three-dimensional shapes, in the initial stages, it helps to see them as being flat, as shown in Noah Buchanan's proportional chart below.

Within each of these conceptual building blocks is a much more complicated mass, which we will study in depth later. The central column that holds these three boxes together is the spinal cord, which runs through each. Its base is the pelvis, and its apex is the head. Similar to the foundational supports that hold up a tall building, as goes the spine, so goes the figure.

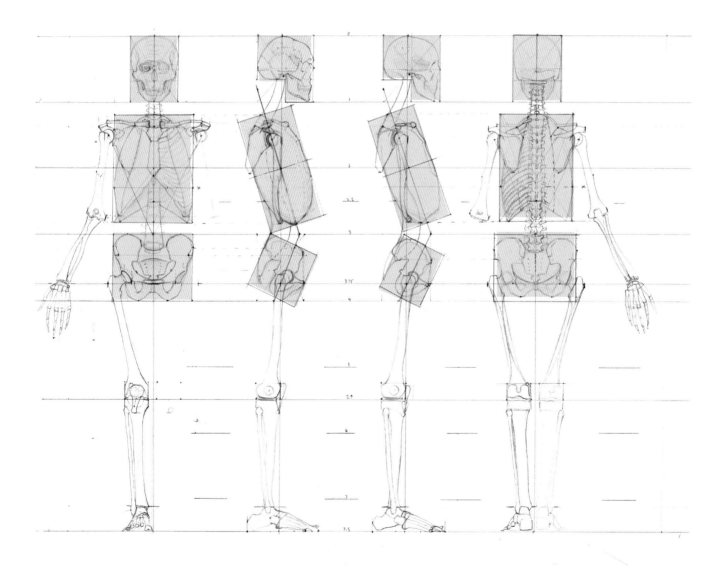

When I am beginning a figure drawing, I do not actually draw these boxes. I simply look for them. But when I am teaching, I sometimes have students draw the model using *only* boxes. It is an amazingly effective exercise that helps students see what the skeleton underneath is doing. There are some great examples in this book of artists who use the box concept to varying degrees, such as Steven Assael's drawing on page 94 or Sabin Howard's on pages 95 and 99. Try it out for yourself, using their images as a guide.

The block concept, specifically focusing on the three great masses (head, rib cage, and pelvis), will enhance your understanding and rendering of light and shadow. This is mainly because you will conceive of the figure in three dimensions. You will see the three great masses as six-sided blocks. Everything else is built around that concept. The anatomy fits inside that geometry. The subtle surface form sits on top of, and ultimately describes, the anatomy underneath.

OPPOSITE: Noah Buchanan, *7½ Head Proportional Skeleton*, 2014, graphite on paper, 18 x 24 inches (45.7 x 60.9 cm)
 Noah Buchanan's skeletal proportion chart for a 7½–head-high figure also features the block concept—with the head, rib cage, and pelvis each fitting inside a block. Red overlays were added for emphasis.

LEFT: George Bridgman's dynamic use of rhythm and gesture bring much-added zest to the block concept. These illustrations are from his fabulous book *Constructive Anatomy*. Bridgman's eye level is often set low, so the viewer looks up at many of the blocks, creating a heroic and dynamic presentation.

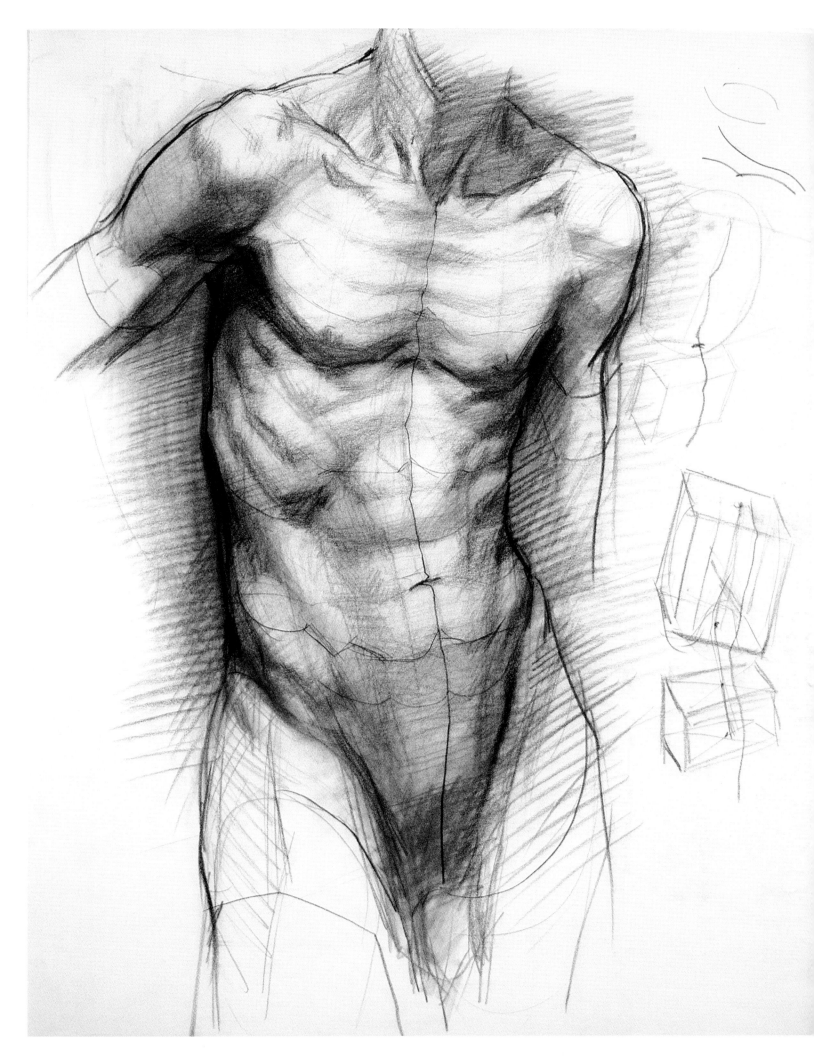

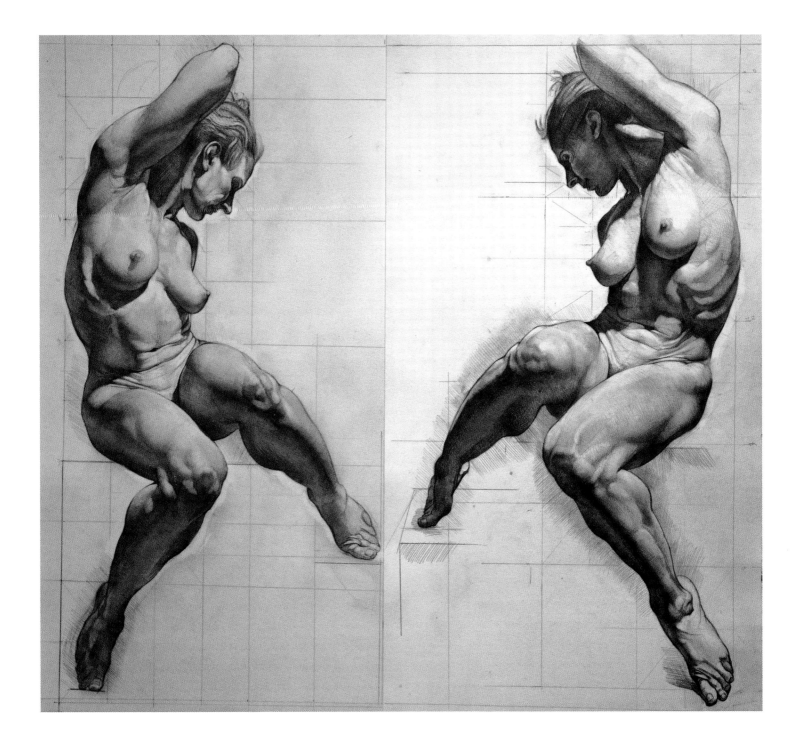

OPPOSITE: In this workshop demonstration drawing, Steven Assael shows the positioning of the major blocks of the pelvis and rib cage, the many facets of the male torso, and the interplay of light across the whole.

ABOVE: Sabin Howard, *Twins (Drawing for Sculpture)*, 2015, pencil, 22 x 24 inches (55.9 x 60.9 cm)

Howard's drawing demonstrates a sophisticated use of surface form, structure, and dynamic rhythm that rests on a firm foundation of the block concept. In essence, this piece displays the attributes of great figure drawing that we have discussed so far. The blocks are not obvious, per se, because their edges have been incorporated into the surrounding form. But the planes and volume of the blocks are still quite visible, if you look for them.

Anatomy within the Blocks

Great figure drawings are informative. They describe a movement from a basic description of the overall geometry of the mass to a more general anatomical description, and then to an even more specific explanation of where the light and shadow fall on those forms. The Block Concept helps with that task by organizing the very complicated anatomy of the torso into simplified geometrical shapes. There are three major blocks: the head, rib cage, and pelvis. However, the arms and legs can be conceived according to the Block Concept as well, so I include them here.

On the surface of each one of those blocks fall important landmarks. Learn the block and you learn the landmarks that go with it. These landmarks will, if carefully observed, reveal what the boxes, and thus the skeleton, are doing. Memorizing these landmarks is a great help to understanding any pose the model may take.

The skeleton, the foundation upon which the figure is built, has many joints. In the beginning of a drawing, only the twelve major ones concern us. The main piece of knowledge you are acquiring is where important bones meet. This "meeting" of bones allows for movement in the figure. Know the location of the twelve main joints and you will be on your way to understanding movement within the figure.

If you look at the diagram opposite, you will see a figure drawing with the three boxes, landmarks (in blue), and major skeletal joints (in red) clearly mapped out. You should memorize the location of all of the key references on the figure. It helps greatly!

We will now discuss each of the three building blocks along with the landmarks and joints that accompany them. In this system, the arms and legs are treated as appendages. We will discuss the joints that fall on them also. Follow along with the diagram to see where these fall on the figure.

HEAD BLOCK

The frontal view of the head has two key landmarks:

- **Top of forehead:** The peak of the *frontal eminence*.
- **Chin:** The *mental protuberance* (the small notch on the front of the chin).

RIB CAGE BLOCK

The frontal view of the rib cage has three key landmarks, one of which appears on both sides of the body:

- **Pit of neck:** The top of the manubrium.
- **Acromion process:** Where the clavicle rests adjacent to the top part of the scapula. This appears on both sides of the body.
- **Xiphoid process:** This is a triangular tip at the bottom of the sternum, which forms the apex of the thoracic arch, at the top of the abdomen.

ARM BLOCKS

The frontal view of each of the arms has three key joints. These landmarks are positioned according to the laws of bilateral symmetry:

- **Shoulder joint:** Where the head of the humerus (upper arm bone) meets the *glenoid fossa* of the scapula. (No, you can't see this joint on the surface. But you should know where it is, and also learn the components that attach themselves to it. When it moves, they move.)
- **Elbow:** Where the humerus meets the radius and the ulna (the two lower arm bones).
- **Wrist:** A complicated meeting of the radius and ulna with the small bones of the base of the hand, the carpals.

OPPOSITE: When establishing the basic proportions, first locate the joints, indicated by the red dots. (There are twelve, but one is hidden behind the model's head.) Next, identify the nine landmarks. And finally, note the center lines of the three major blocks.

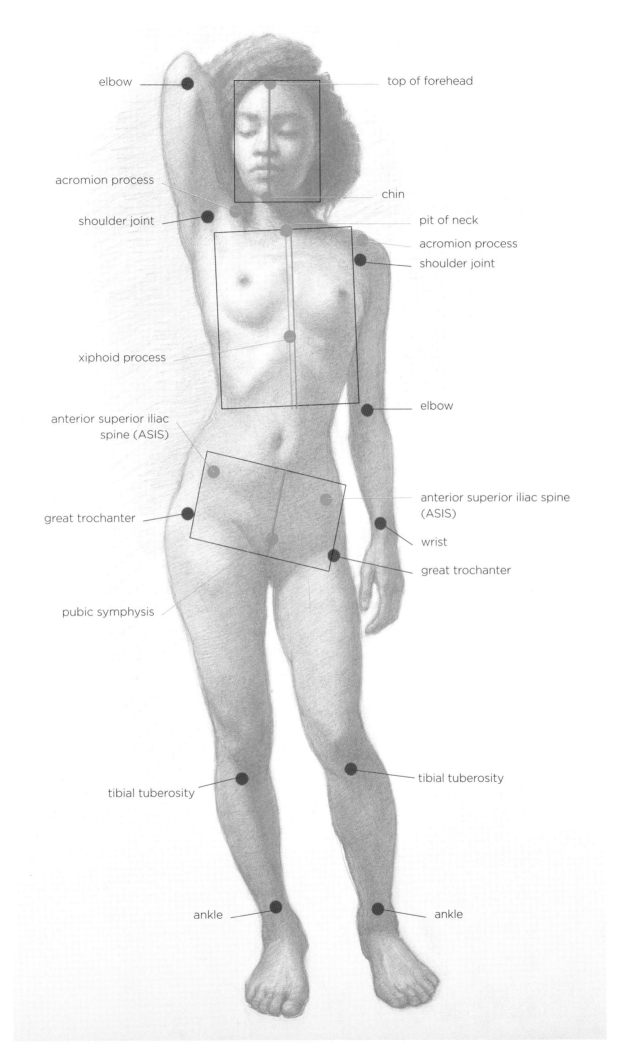

elbow

top of forehead

acromion process

chin

shoulder joint

pit of neck

acromion process

shoulder joint

xiphoid process

anterior superior iliac
spine (ASIS)

elbow

anterior superior iliac spine
(ASIS)

great trochanter

wrist

great trochanter

pubic symphysis

tibial tuberosity

tibial tuberosity

ankle

ankle

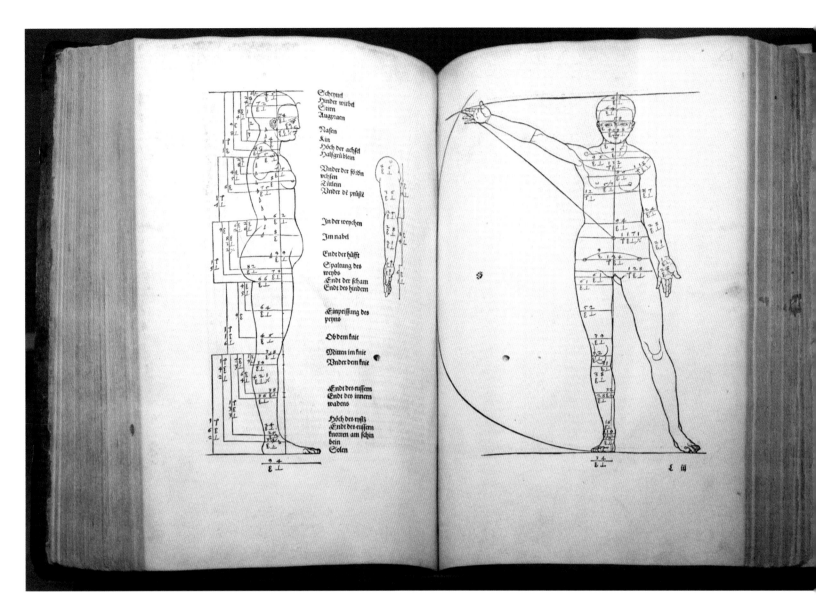

The figure to the left contains the following German labels (top to bottom):

Scheytel
Hinder wirbel
Stirn
Augprawn
Nasen
Kin
Höch der achsel
Halsgrüblein
Vnder der förðn vchsen
Tütlein
Vnder dē prüstē
Jn der weychen
Jm nabel
Endt der hüfft
Spaltung des weybs
Endt der scham
Endt des hindern
Einpeissung des peyns
Ob dem knie
Mitten im knie
Vnder dem knie
Endt des eussern
Endt des innern wadens
Höch des rysts
Endt des eussern knorren am schin bein
Solen

PELVIC BLOCK

The frontal view of the pelvis has three key landmarks, two of which appear on both sides of the body:

- **Anterior superior iliac spine (ASIS):** The front points on either side of the spine of the pelvis.

- **Pubic symphysis:** The junction of the bone of the lower portion of the pelvis, just above the genitals.

- **Great trochanter:** The juncture of the shaft of the femur with the neck that inserts into the pelvis.

LEG BLOCKS

The frontal view of each of the legs has three key joints. As with the arm blocks, these landmarks are positioned according to the laws of bilateral symmetry:

- **Knee:** The meeting of the femur (the long bone of the upper leg) with the tibia and fibula (smaller bones of the lower leg). The joint is covered by the patella, a small, disk-shaped bone that protects the area of the meeting of the upper and lower bones.

- **Tibial tuberosity:** The front notch on top of the condyle of the tibia (bottom of knee, below kneecap). When the leg is bent, this can be a helpful landmark to show the location and direction of the lower leg.

- **Ankle:** This is formed by three bones, but on the surface we perceive only two bumps. The bump on the inside is called the *medial malleolus*, which forms the base of the tibia. The outside bump is called the *lateral malleolus* and forms the base of the fibula.

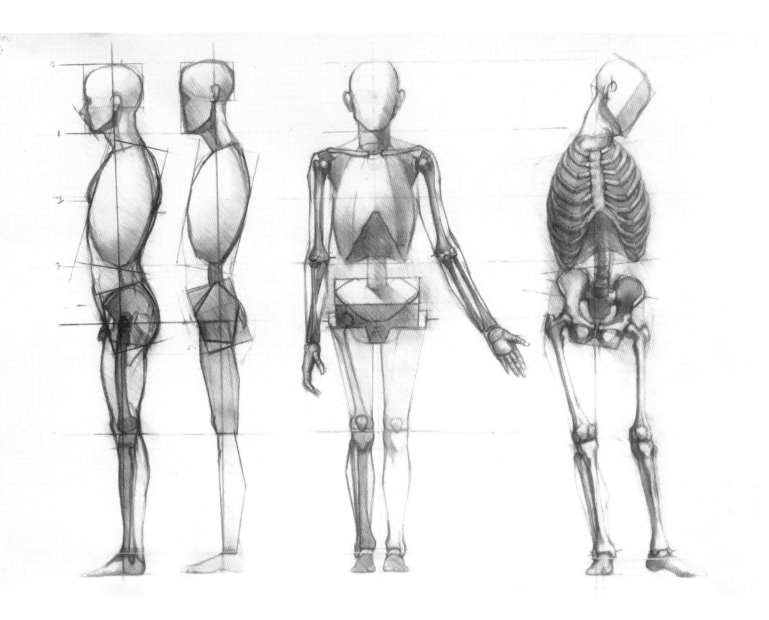

CENTER LINES

Before I get going on a drawing, I also figure out the center line of each of the three major conceptual boxes. You can always do it once you've begun the drawing process, but the earlier you do it, the better. It is very difficult to construct the figure properly without knowing the axis of the masses of the bones and muscles that make up the figure. You will notice that each of the blocks in the diagram has a center line.

OPPOSITE: Albrecht Dürer was thoroughly engaged in the artistic practices and theoretical interests of the Italian Renaissance, and had a keen interest in human proportions, as demonstrated by his nude and antique studies. He wrote *Four Books of Human Proportion* (*Vier Bücher von menschlichen Proportion*), only the first of which was published during his lifetime (1528).

ABOVE: Sabin Howard, *Anatomical Study*, 1992, red chalk and pencil on paper, 14 x 18 inches (35.6 x 45.7 cm)
Howard's drawing represents various proportional strategies, including the head length method and the block concept. In the two left figures, notice how far back the spine sits off the center line that runs down the figure; this causes the block of the rib cage to lean slightly backward.

STEP 3 | BLOCKING IN WITH ANATOMY, LIGHT, AND SHADOW

Blocking in refers to a drawing process that moves from the general to the specific, whereby the largest shapes are first mapped out, and then broken down into smaller, more manageable units. Artists typically use only straight lines until late in the process. In its purest sense, blocking in is a strictly perceptual endeavor. The artist draws only the shapes that are in front of her. She does not think *arm*, *head*, or *leg*. She sees, and thinks, only of shapes. In getting the shape perfectly accurate, the argument goes, you are able to sidestep the distortions that happen when your mind works symbolically ("Oh, I know what an arm looks like") and then you stop really looking at the model and draw your "symbol" of an arm. By avoiding such mistakes, you will begin to learn to draw with an open mind. This is the key to obtaining proficiency with blocking in the model.

However, it is my firm belief that you must also take anatomy into account during the block-in phase. Too much anatomy is never a good thing in the early stages of a drawing, but too little is just as big a mistake. You have to understand how the figure is put together in an architectural sense to create a believable representation of a human. The strictly *perceptual* block in is fine for still lifes, and even (to some degree) landscapes, but when used with the figure it proves insufficient. You must know anatomy and then be able to see and understand the anatomy of the model you are drawing. In the beginning of my drawing opposite, you will see that I have not yet dealt with any specific muscles, or any light or shadow. My focus at this point is on mapping out the basic forms and the central axes of the major masses.

THINGS TO KEEP IN MIND WHILE DRAWING

There is a right way to hold your pencil when blocking in a drawing. The following tips will help you if you are just starting out, or if you have been out of the game for a while and are getting back into it.
• When beginning the basic block in, hold your pencil lightly and near the middle to rear. This will keep you from gripping it too tightly and making marks that are too dark and heavy. Nimbleness is key.
• Draw on the side of the pencil point, not the tip. That way, you won't scratch the surface of the paper, but instead your pencil will glide gently over it. In the initial stages, stay loose and light.
• Use straight lines for as long as you can. This may look clunky at first, but will later lead to curves with more accuracy.
• Do not add details. None. Just stop. If you draw a face too soon, you lose recess.
• Keep moving from the inside of the figure to the outside. Never stay in either place for too long. You want to avoid getting locked into one area at the expense of the greater whole.

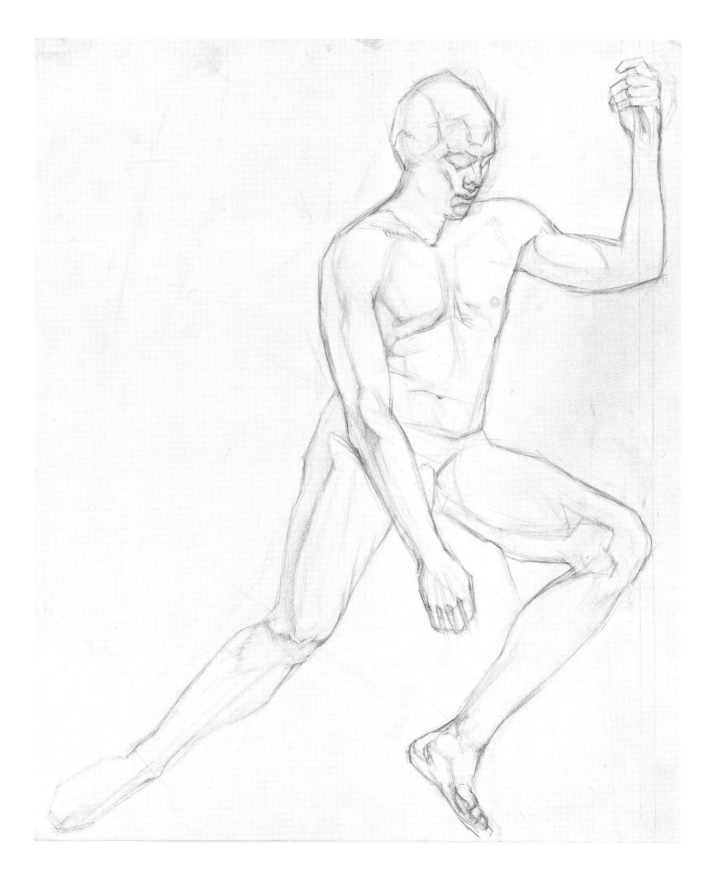

ABOVE: Rob Zeller, *Block In*, 2001, graphite on paper, 17 x 14 inches (43.2 x 35.6 cm)

My block in above reveals the two structural concepts at work simultaneously: anatomical and architectural forms of the upper and lower torso, arms, and legs, and the play of light and shadow across those forms. Notice that you can tell where the shadows are, even though they are not yet completely filled in.

The Basic Anatomical Forms

Notice in the preliminary block in that I mapped out the joints, with light marks that could be moved if needed. I put in the three major masses: head, rib cage, and pelvis. They are all accounted for. The gesture lines I was searching for in the very beginning dictated their positioning.

Within two of the three building blocks (the rib cage and pelvis) I made slight indications of the respective bone structures. However, I left the head very simple. It can be distracting to take the head too far in the very beginning. It is important to stay as general as possible, in order to see the proper proportions.

LEGS AND PELVIS

In a standing pose, once you have mapped out the basic proportions, blocking in the legs takes first priority. How else can the model bear weight, unless the artist gives him or her an architecturally solid structure upon which to stand? As one of the goals of this book is to teach you what information to look for and how to assemble it in your drawing, it bears saying that in a standing pose, you should pay special attention to the structure of the legs and pelvis. As such, you will need to memorize the bones and muscles of the leg.

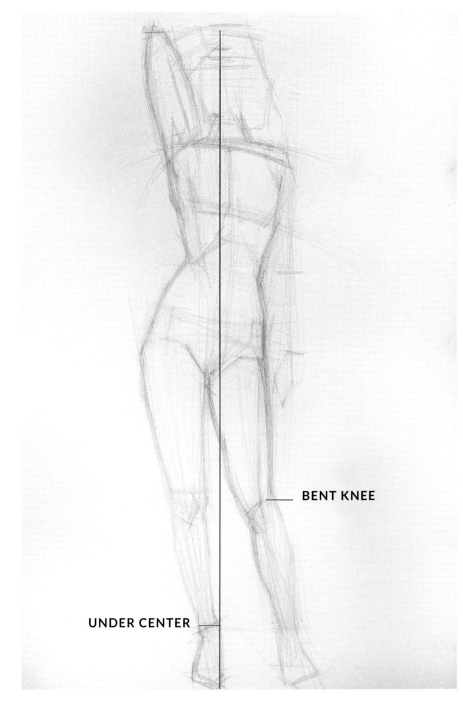

BENT KNEE

UNDER CENTER

ABOVE: The opening moves: Find the leg that falls "under center." That's the stand leg. The other (the balance leg) usually has a bend, of varying degrees, in the knee. Then map out the major boxes and joints.

OPPOSITE: Sabin Howard, *Anatomical Sketch*, 1999, sanguine and pencil on paper, 10 x 8 inches (25.4 x 20.3 cm)

In Howard's drawing of a leg, we can see several components in play: structure, anatomy, and rhythm. Note the rhythm of his contours. They flow around the structure of the form, in some cases cutting in, in others staying on the outside. To create a more finished work, think about and look for these factors, but put them in your drawing with subtlety.

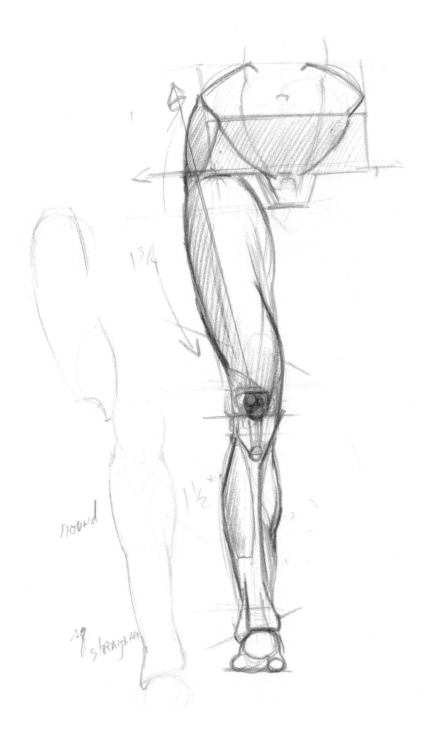

earlier, the stand leg bears the majority of the weight of the body. It will always be found "under center" in a standing pose. In other words, where the foot is planted will be the center of gravity of the pose. Usually, this is directly below the model's head, but not always. If the model is leaning on something (such as a pole or a wall), that can shift the center of gravity. In a normal standing pose with a bent leg, you can drop a straight line (a plumb line) from the head down to the inside ankle of the stand leg, as shown opposite.

Regarding the feet, draw a line, in perspective, on the ground plane that follows the footprint of each foot. Then draw the outline of a foot on top of that line—no toes yet, though you can denote the big toe. The most important thing to capture in terms of the feet, in this initial stage, is in what directions they point. Try to get the perspective correct. This is tricky because they are so far below eye level, usually. But feet are very important. They hold the body up! You want to map them out on the ground plane correctly and in perspective.

At this early stage of the block in, focus on the legs and pelvis till they appear architecturally solid enough to hold the model upright. This simply means determining the correct proportions, tilts, and central axis for each of them. Having fixed the angle of the tilt of the pelvis, next consider what is happening in the upper and lower portions of the legs. You will need to observe the overall shape of each of these masses, but also have a general grasp of the muscles in each area. Again, at this point you are not looking for details in any particular muscle yet, but more for their overall shapes.

Taking the drawing I've started as an example, look first for the bent leg on the model and know that the pelvis will dip toward that leg. This is known as the *balance leg*, and while it does bear some of the model's weight, this leg is used primarily for balance.

If one of the legs on your model is bent, the other leg becomes what we call the *stand leg*. As discussed

TORSO AND HEAD

Next, consider the torso, which is a combination of the rib cage and the head. The rib cage can be seen as essentially barrel- or egg-shaped, existing within a vertical rectangle. This means that first you figure out the angle of the tilt of the rectangle, then you figure out what the various features of the egg within it are doing. Think of this sequence as a progression in geometry: from squares to circles, from lines to curves. In the case of Tynisha, we have a female model. Her ribs are showing in various places because she is thin, and her breasts fall across the mass of her rib cage in a certain way. We need to examine all of those features carefully and draw them in with light lines and minimal shading.

At this early stage, the head should be blocked in as minimally and economically as possible. Do not yet put in a lot of details about the facial features. It is much more important to concentrate on placing the head in space correctly. Ask yourself: Where is the center line and what is its tilt? Which direction? Where is the chin in relation to the pit of the neck? Where are the cheekbones and corners of the jaw in relation to the center line? Once you have answered these questions, you can then lightly indicate the eyes, nose, and mouth.

RIGHT: Note how the legs are developed in advance of the upper torso and face. In a standing pose, build the architecture that holds up the figure first.

OPPOSITE: A gradual progression: The entire figure is blocked in and I have begun to refine the smaller forms, such as the facial features, toes, and fingers. These smaller forms fit onto the larger forms, in proper context. Notice also the sense of light and shadow achieved by clearly defining the terminator lines on the major masses.

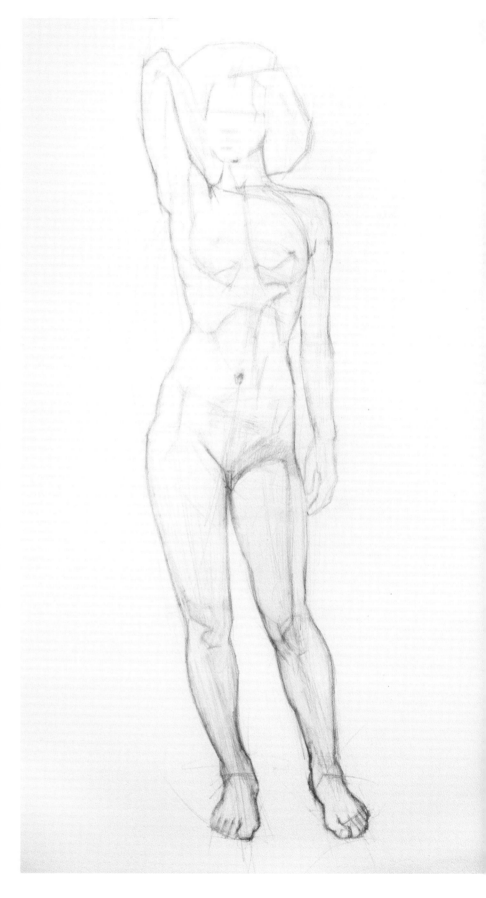

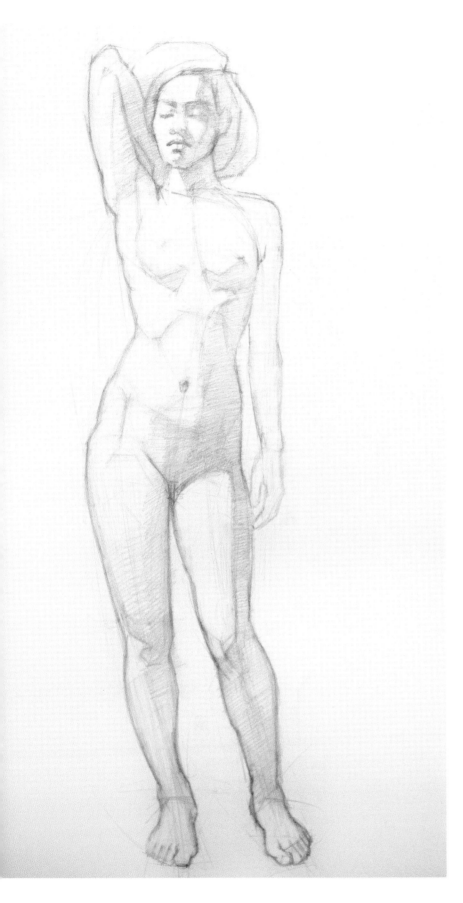

The Separation of Light and Shadow

To the left and opposite are two views of the gradual refinement of the block in of *Tynisha*. At this stage in the process we move from a basic description of the geometry of the masses to a more general anatomical depiction, and then to a more specific explanation of where the light and shadow fall on those forms. Because the light is coming from the upper left-hand corner (her right), we need to make sure that all of her forms are lit from that side.

In classical drawing and painting it's important to let light unify your work. Each of the major forms should have a dividing line between light and shadow. This line is known as a *terminator*. Light does not go past the form at that point. To see this idea in practice, take a look at *Tynisha* on pages 80 and 83, and follow the edge of the shadow along the right side of her body.

Some people have a hard time figuring out how to convert a shadow into a shape. But it really isn't that complicated. Think of it as "outlining" the shadow, in the same way you would outline the shape of an arm or a face. Shadows make shapes that are just as important.

Note how I've put down a very light pass of shadow at this point, with strokes moving in a single direction. I actually consider it only "shading" at this stage. When we really get down to creating form, then we think of it as "modeling."

At this stage, please avoid making contours that seal the form in one giant, unbroken line. Note the rhythm of the contours of my drawing. They flow around the structure of the form—in some cases cutting in, at other points staying on the outside. This allows the figure to breathe. Living forms are made up of large and small convexities.

A Focus on the Face

As you can see in the images here, I use spatial coordinates to put the head in its proper position on the torso. In essence, I am mapping points on the figure's skeleton. First, I try to relate the pit of the neck to the chin. This relationship helps me to align the center line of the chest with the center line of the head. Then I map out the rest of the skull in relation to what's around it. In Tynisha's case, her upraised arm features prominently to the left, so I checked the distance of the face to the arm, as well as the tilts of their two center lines. I located the top of the forehead, the corners of the temple, the cheekbones, and the corner of the jaw and made sure they aligned perfectly with the center line I had laid down.

At this point in the process I'm looking for symmetry and asymmetry. The human figure has both aspects, and these vary from individual to individual. Tynisha is of mixed heritage: half African American, half Japanese. This leads to all sorts of interesting discoveries in her face, especially around her eyes.

After mapping out the skeletal points, I try to chisel out the largest planes and describe their forms by how much light they catch. I also try to observe the way the forms are interconnected among their planes. The ability to switch to an observational mode while simultaneously working conceptually takes time and experience. In short, there is only one way to get good at the observation of light on human form: Study anatomy and practice with a live model. In time, with enough experience working from life, you can work from photographs as well.

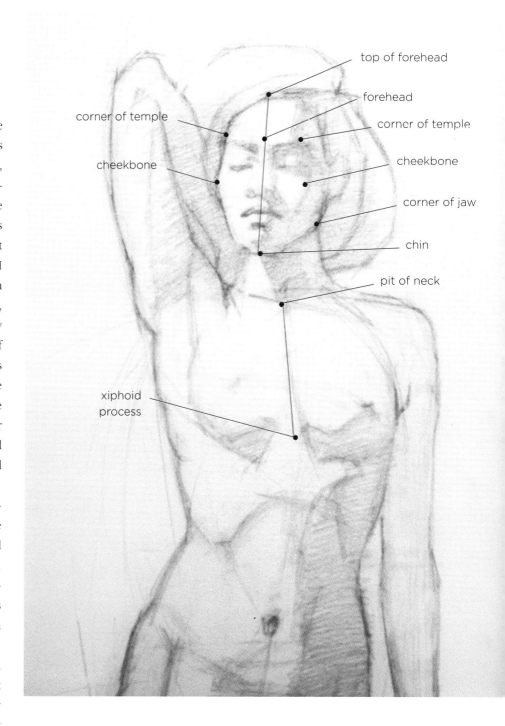

ABOVE: It is important to be able to map out points on the model. These points should always fall on bone. Because bone is not variable like soft tissue, it will maintain its shape, even if its position shifts. I try to align the great boxes—in this case, the head and rib cage—via their center lines.

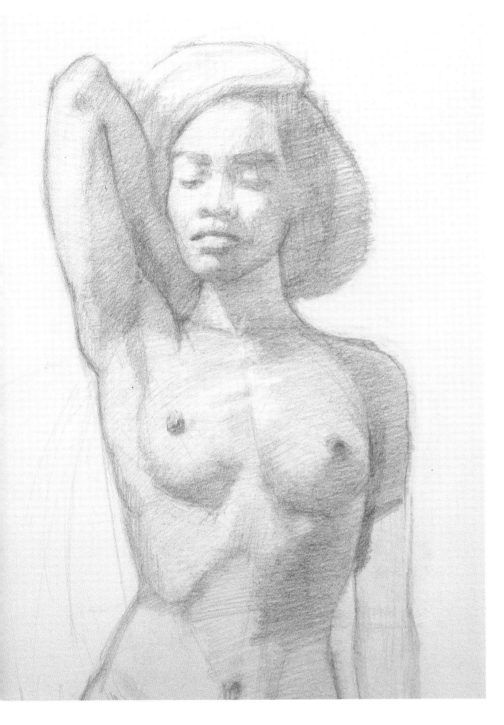

STEP 4 | MODELING THE FORM

Let me mention in review that filling in the shadow flatly is referred to as *shading*. Creating form in the light mass, by carving with directional strokes, is referred to as *modeling*.

Modeling is done in stages in this system. I work up the whole figure to a certain level of completion, then I go back and refine each area. In the first pass of modeling, I'm trying to keep the architectural integrity of my block in. I'm also trying to impart a new structure that relies on the incremental gradation of values. That gradation is affected by several factors: the quality of the light, the surface form that the light falls on, and the local color of the surface form.

Before we go any further with our discussion of the development of this particular drawing of Tynisha, let's take a break for a bit to discuss the essentials of shadow in regard to form.

ABOVE: When starting to model the figure, make sure you have clearly indicated on your initial block in where the light ends and the shadow begins. Then carve out the basic shape of each mass, paying particular attention to how each form relates to the others. Nothing should be drawn in isolation.

The Essentials of Shadow and Light in Creating Form

Human beings can see literally millions of subtle value shifts with the naked eye. But, as artists, we are limited in how much we can execute that range with our pencils and brushes. This means, to model form effectively, we need to simplify the range of values that we can see. In other words, we try to create something parallel, something that contains the essence of what we see. I think numbered value systems are kind of silly, on the face of it. They can in no way approximate that incredible range of values, but they can come close to the truth in another way: Through simplification, they help us create believable surface form.

To do that, the artist divides light from shadow. There is nothing in the middle. Either the light source is hitting the form we are drawing on the model or it isn't. Where it isn't, that part lies in shadow. Everything else is simply a gradation of light. There are no halftones in a classical conception of form. Nothing can be half in light and half in shadow. If it's not dark enough to be shadow, then it's simply a very dark light.

For simplicity's sake, I use an 8-value scale. While some tout 10- or even 11-value scales, I do not think it's worth quibbling over the merits of various systems. They are all an artifice. Reality is more complicated.

THE SHADOW RANGE

The shadow range is divided into three values: cast shadow and accents, shadow, and reflected light. It is important to keep your shadows flat and compressed in a classical conception of form. Most of the value activity takes place in the light mass.

- **Cast shadow and accents (1):** These are the darkest values. They represent the most complete absence of light we usually encounter in a studio setting.

- **Shadow (2):** Next on the value scale is the general shadow, which is just a touch lighter than the cast shadow. No matter how dark the shadow is, there will always be a touch of light in it, due to atmospheric reflections—unless you are in outer space, of course.

- **Reflected light (3):** This is the most misunderstood value on the entire scale. It happens when light is reflected by some adjacent light source, causing it to bounce into the shadow. No light from the light source is hitting that area of the form directly. If it were, it would be in the light. Thus, it's indirectly lit and still within the shadow range. Please remember: The reflected light must always be darker than any of your light values. The value shift from shadow to reflected light is subtle. Do not let it encroach into the light range.

THE LIGHT RANGE

As mentioned earlier, in traditional drawing and painting, all of the really engaging activity takes place in the light range. To say that there are five values to represent the light is something of a bad joke. In truth, an infinite range of values can be found in the light, but for the purposes of teaching the concept of form, I break things down into five values.

- **Transition (4):** This very darkest light value can fool you. It's so close to the shadow that you may think it is actually part of the shadow. But, in reality, it's the very first step in the light direction. This value is likely the one that confuses artists into using the term *halftone*. I think it is best to avoid that term, as it doesn't really say anything. Any given value is either light or shadow.

- **Low light (5) and middle light (6):** These two values are incredibly close to each other in appearance. Depending on the amount of time you have to work on your drawing, you may want to further subdivide

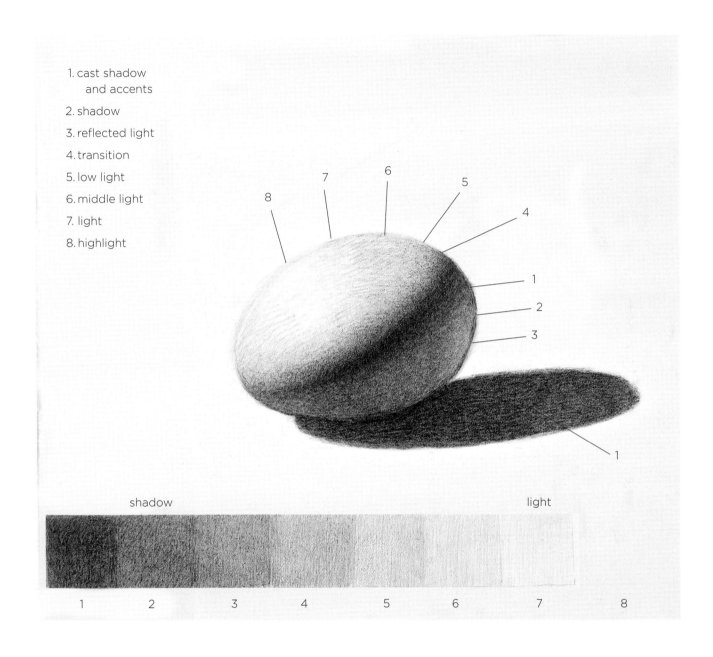

1. cast shadow
 and accents
2. shadow
3. reflected light
4. transition
5. low light
6. middle light
7. light
8. highlight

shadow

light

| 1 | 2 | 3 | 4 | 5 | 6 | 7 | 8 |

them to create even more values in the light range. Alternatively, if you have limited time to work, you might combine them into a single value.

- **Light (7):** This is the greatest area of mass, the part of the form that is directly in the light. If you have a strong light source, you should have a strong, clear light mass on the figure. And vice versa. A weak light source means a weak light mass, full of low and mid-

dle lights. Keep your light source strong and keep your light area clean. Don't overwork it.

ABOVE: This 8-value scale articulates the three values that fall within the shadow range and the five that fall within the light range. Notice the subtle gradations of tone used to represent this egg.

- **Highlight (8):** The brightest of the light values, this is another tricky concept. It can be created by employing the white of the paper, or if you're working on a toned surface, by adding a white medium. A highlight is actually more of an "event" than a value. The location of the highlight will shift with the position of the artist. It does not really exist on the model. It is simply a refraction of the light source, at its most intense, based on the surface texture of the model. Usually highlights happen as a result of a light source hitting a hard surface. As such, you will find lots of them on glass or metal, whereas skin is a soft, non-reflective surface, with few highlights.

OPPOSITE: Rob Zeller, *Francisco*, 2003, graphite on paper, 24 x 18 inches (55.9 x 35.6 cm)

Notice how the block in is very light, and is incorporated into the drawing as I model over it. I start at the top usually, and work my way down. The more accurate the block in, the easier creating the surface forms will be.

THINGS TO KEEP IN MIND WHILE MODELING

When modeling in a realistic fashion, remember that the most important thing is not how smooth you are with your pencil—it's how deeply you really look, and how much you use your mental understanding of the light and anatomy to re-create the surface form. Here are some tips:
- Make your pencil point as sharp as you can. I find it better to use a combination of razor blade (to cut away the wood support) and sandpaper (to refine the graphite). Others use electric pencil sharpeners to good effect. Whatever works for you is fine, as long as you keep the point sharp!
- Start in the shadows and work your way into the lights. Lay in an even, uniform shadow value, with no darker values for the accents or cast shadows. You can add them later. In fact, your initial shadow value should be just about the value for reflected lights. You will simply add darker passes over the top of this uniform value later.
- Pay close attention to the terminator, the dividing line between shadow and light, and be sure never to lose it while you are modeling the form.
- To effectively feel the surface of the form, to conceive of it in a three-dimensional, sculptural way, it helps to role-play: Pretend you are a small insect crawling across the surface of the body. At that scale, it's an enormous landscape that you are traveling across. What shape are the "hills" (muscles and other surface forms)? What is the position of the "sun" (light source)? Where do those "dark canyons" (shadow ranges) go?

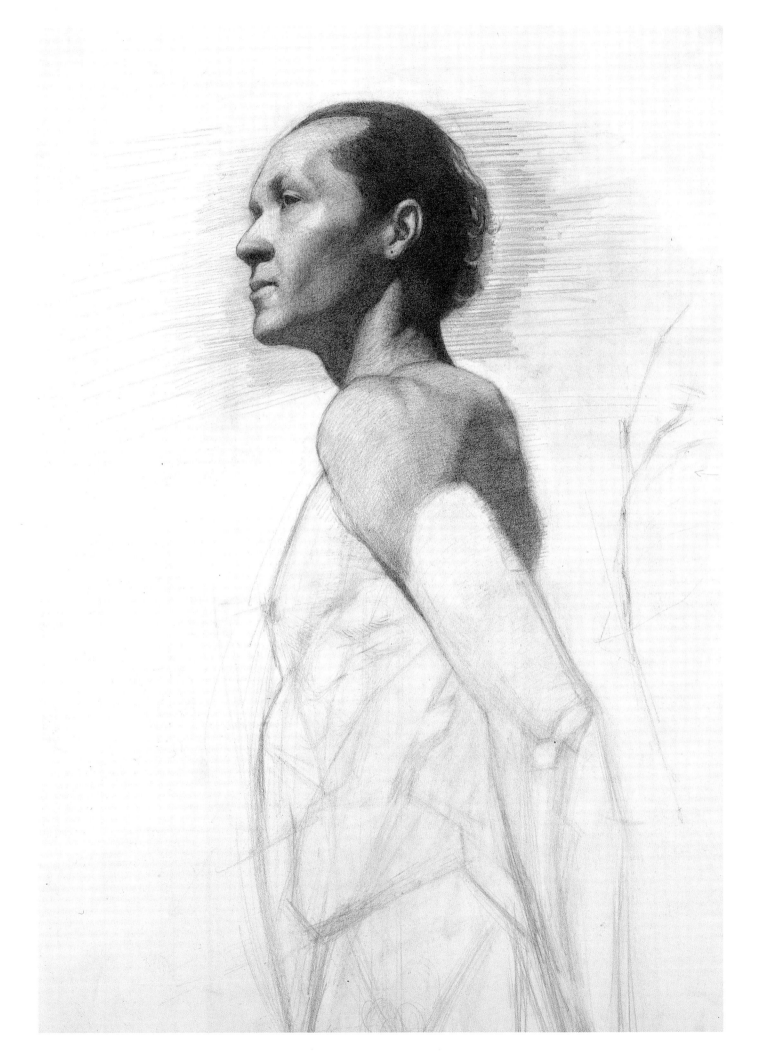

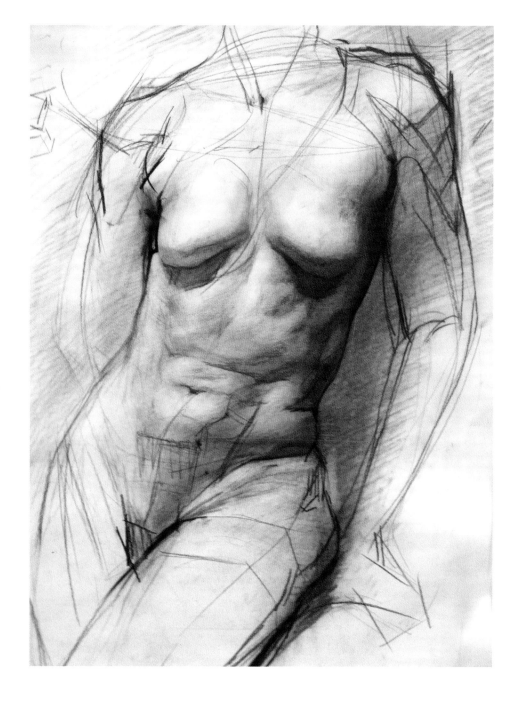

Planar Conceptions

These two charcoal sketches by the artist Steven Assael, one from early in the process and one when he was finished, demonstrate many of the important concepts I discuss in this section of the book. Notice in the image above how Assael first broke down the rib cage, pelvis, legs, and arms into major planes. Then he modeled the forms in greater detail, capturing how the soft flesh of the surface form travels over the top of these planes, rounding off their edges. The intensity of light on these forms was dictated by how much they faced the light source. Great figure drawing always addresses two considerations: the underlying planar/architectural structure, and the structure of the light and shadow hitting the softer surface forms.

ABOVE: This workshop demonstration drawing by Steven Assael shows the early stages of his process. Note the areas where the planar conception will (ultimately) evolve into anatomical and surface morphology.

OPPOSITE: Light on form cannot be properly rendered without first understanding the surface planes that make up the largest masses of the figure.

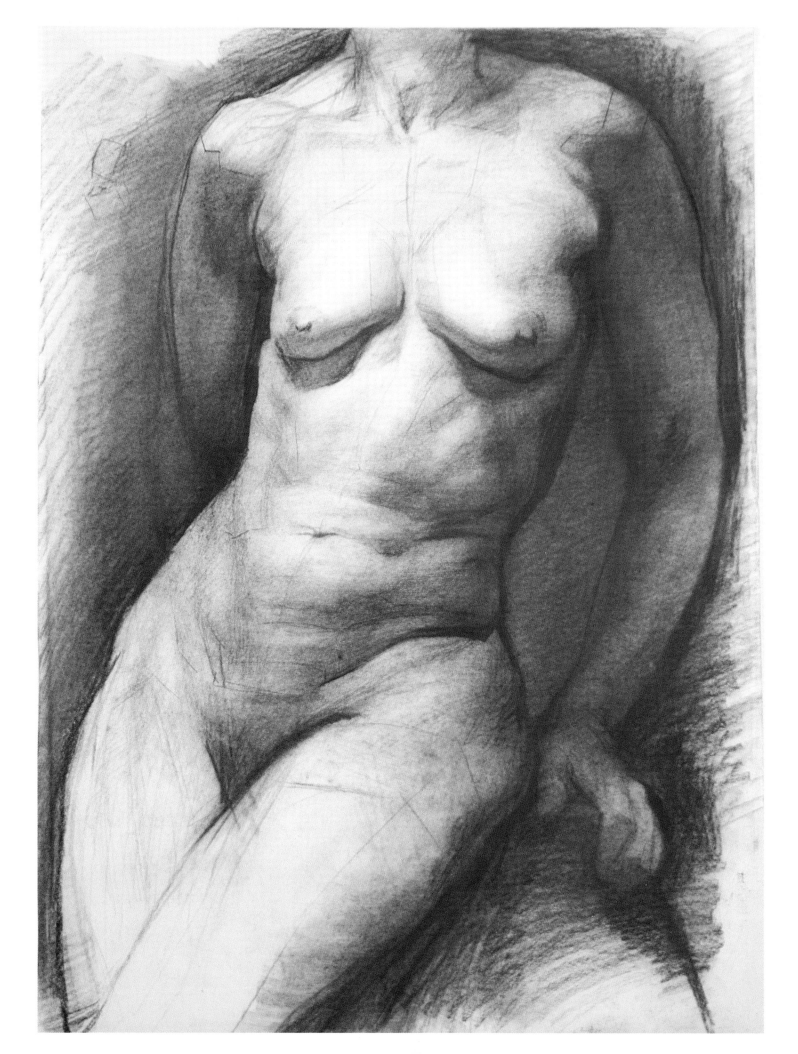

Essential Bones and Musculature

These diagrams represent sections of the body that I scan over when taking anatomy into consideration. I look for how an area is put together as a whole. At minimum, you should know these bones and muscles.

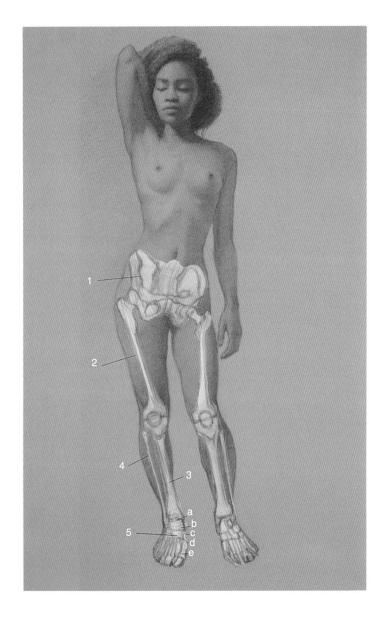

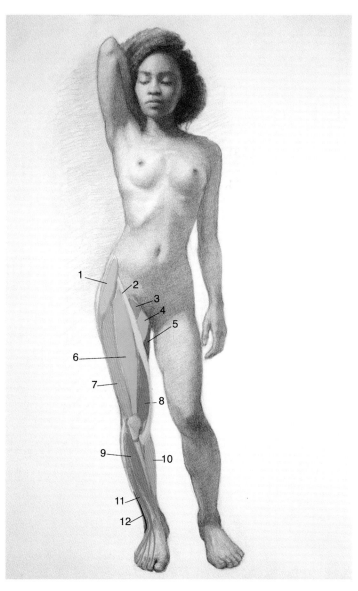

THE BONES OF THE LOWER BODY:

1. pelvis
2. femur
3. tibia
4. fibula
5. various foot bones: a. talus, b. cuneiform, c. metatarsal, d. proximal phalanx, e. distal phalanx

THE MUSCLES OF THE LOWER BODY:

1. tensor fascia latae
2. sartorius
3. pectineus
4. adductor magnus
5. gracilis
6. rectus femoris
7. vastus lateralis
8. vastus medialis
9. tibialis anterior
10. gastrocnemius
11. extensor digitorum longus
12. fibularis

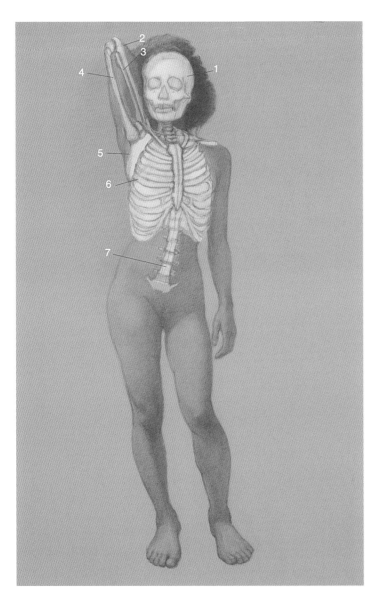

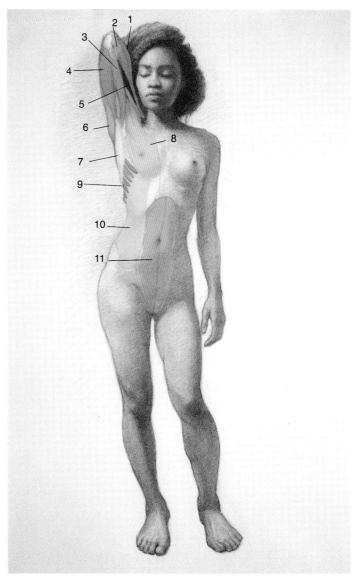

THE BONES OF THE UPPER BODY:

1. skull
2. ulna
3. radius
4. humerus
5. scapula
6. thorax (rib cage)
7. spinal cord (vertebrae)

THE MUSCLES OF THE UPPER BODY:

1. extensor carpi ulnaris
2. flexor carpi ulnaris
3. biceps
4. triceps
5. flexor digitorum superficialis
6. deltoids
7. latissimus dorsi
8. pectoralis
9. serratus
10. external oblique
11. abdominals

Surface Form

Picking up exactly where we left off (on page 107) with the process of drawing *Tynisha*, at the initial stage of the modeling process, I aim for a 4-value scale with an eye to rendering shadow, transition, low light, and light. Later, I will expand my scale to include darker accents in the shadow, cast shadows (which are darker than regular shadows), and highlights in the light. But keeping to a 4-value scale in the beginning helps me not to overdo things.

Already, as you can see at right, a sense of light and shadow are clear on the drawing of Tynisha, because I have kept things very simple. No matter how much detail you introduce into a drawing, it is important that you never lose a sense of the major planes and how they face the light. In particular, it is a huge mistake to lose your terminator. My focus now is on how the great masses align with one another, in particular the head–rib cage–pelvis trio. Try to show how they are lit as a unit, and then how they are lit individually. Look for transitions between them.

Remember, light radiates across the entire figure at once while simultaneously hitting each detail individually. There is a technique known as *window shading*, where the artist tries to capture that great sweep of light and render all of the details in one single pass. The name comes from the motion of pulling a shade down over a window, and thus the artist would model form in the exact same manner, from top to bottom. There are some who believe this method to be reckless, in that the entire figure is not considered as an ensemble. As you gain more experience, you will learn your strengths and weaknesses in terms of working methods.

I think it is a far better strategy to break the figure into logical units and work them up progressively, in a modified form of window shading. One advantage of window shading is that you start at the top and work your way down. I don't like to smudge my drawing as I work, so I employ this method often.

In the image opposite, you can see that I'm about halfway through my first pass of modeling the figure. It

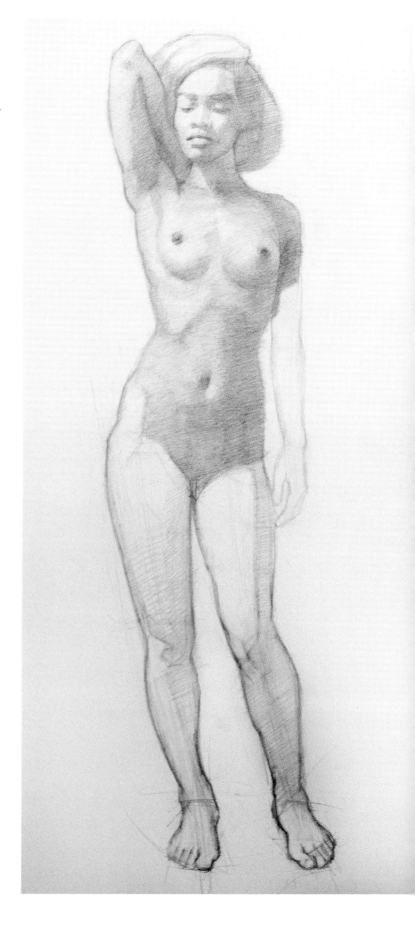

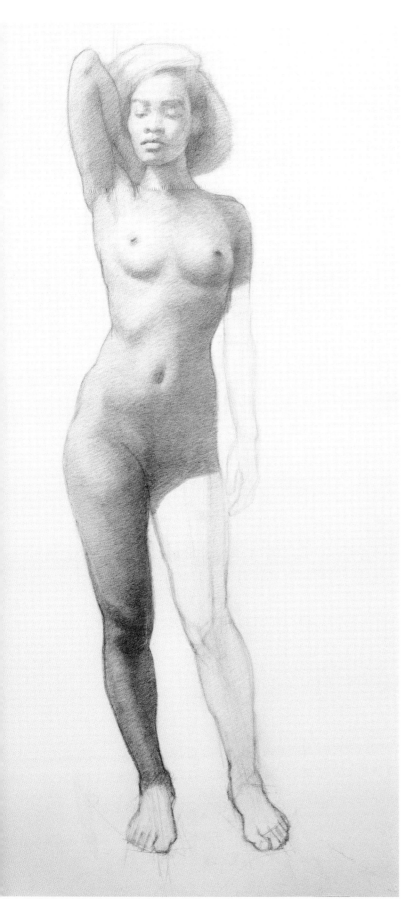

was very hard to leave the face only partially rendered. But it's important to do so. If you overdevelop the face too soon, you will be locked into a value structure that might not fit the whole figure.

Moving down into the torso, I want to draw what the light reveals—an egg-shaped rib cage that is lit strongly on the left side of the model. Her breasts and left side need hints of modeling in the light, but nothing too strong. The basic architecture in my block in is solid, so the next step is to begin looking for the subtle ways the muscles and tissue in that area move between those two large, bony masses.

Again, this requires some knowledge of anatomy and an open mind about what I'm actually seeing. That region of the body is made up of what are known as the *core muscles*—the abdominals, external obliques, and (in the back) the *erector spinae*. In this situation, I didn't have to worry about the back view.

OPPOSITE: In this halfway point of the modeling process, I try not to lose the gestures I saw earlier by locking in the forms too tightly. The model in the drawing needs to breathe and seem alive. Keep a light touch and don't lose the structural integrity or the sense of light. One key to achieving that is to unify your shadow values.

LEFT: Here I have captured the silhouette shadow from the model's head down to her feet. I created darker accents on the knees to give them some structure.

Unity in the Shadow Values

I was able to see many more values in the shadows on Tynisha than the few I used here. But in order to achieve unity, you need to simplify the shadow values across the entire figure. This is known as the *silhouette shadow* concept. In short, if the model is lit from one side, one shadow will travel the entire length of the figure, from head to toe. Once you have established it on the first pass, you then go back and refine its edges and contours, and then its internal value shifts. But when you do this last stage, remember to continue to compress the values into a very close range.

This idea of limiting the range of the values in the shadow is a cornerstone of traditional drawing and painting. In fact, one of the hallmarks of traditional painting is that shadows almost always take a back seat to the light areas with respect to dynamic range. In simplest terms: The lights are more exciting.

I fully admit that this does seem to fly in the face of what you actually see in front of you when you look at a model. You will most likely see a wide range of values in the light and the shadow. But to work in a traditional manner, you make a conscious aesthetic choice: The greater activity of value and color will happen in the light, not the shadow—*because you make it that way.* With this philosophy in mind, the artist who is working in a traditional manner tries to forge the entire shadow in the figure into one, unified whole.

Don't be afraid that you don't know enough to figure out the anatomy and geometric masses of the model on your own. While you draw the model, you should feel free to leave your anatomy books open on the floor in front of you. In fact, I can't think of a better open-book test for anatomy than drawing from the live model. Remember, mistakes are opportunities to make your knowledge stronger. They work against you only if you can't fix them in the drawing. So keep a light touch. Light marks are easy to erase.

Like everything else on the figure, when it comes to modeling the legs, you have to understand them first. The leg is built almost exactly like the arm. The main

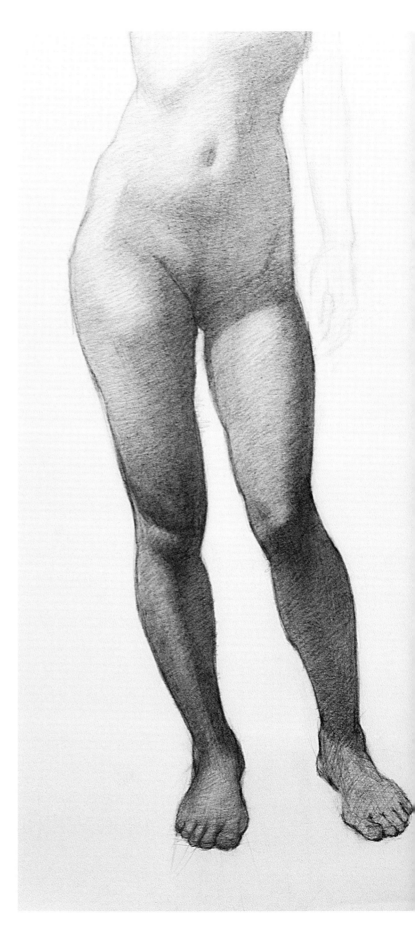

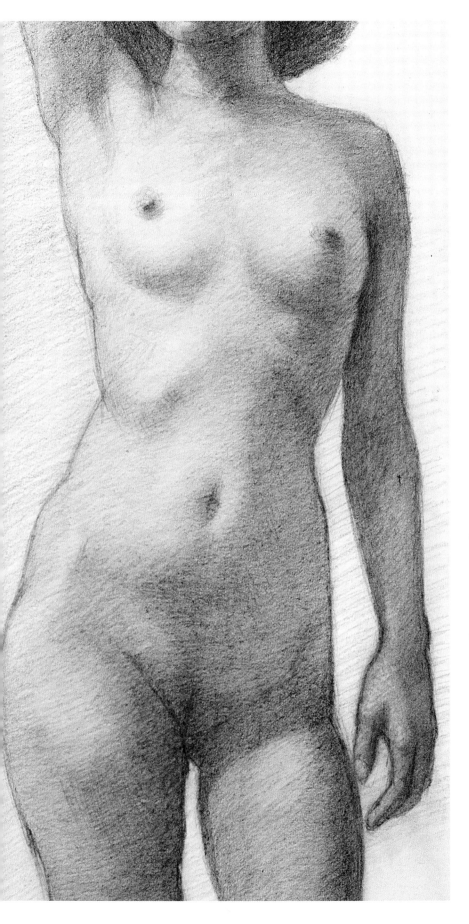

difference is that it is more than twice as large and it bends the opposite way at the joint. (The arm bends forward and the leg bends backward.) On the arm, the biceps is on the front. On the leg, the *biceps femoris* is on the back. The *triceps* extends the arm into a locked, straight position. On the legs, three muscles extend the leg into a locked position—the *rectus femoris*, the *vastus lateralis*, and the *vastus medialis*. On the leg, the patella, known as the kneecap, covers the front of the platform where the condyle of the femur meets the condyle of the tibia. On the arm, the ulna has a slight protrusion of bone that forms what we call the elbow. It is fused, not a floating piece of protective bone like the patella.

I started modeling the legs by looking at the transition from the pelvis into the legs. Because of the *contrapposto* of the pose, there is a wide swing of the hip to the figure's right side. That fullness is made up of the *tensor fascia latae, rectus femoris,* and the *gluteus medius* muscles. Each of those three muscles has a unique peak that catches the light at a certain angle. From there I move down the front of the leg, taking into account the *rectus femoris, vastus medialis,* and *vastus lateralis,* until I get to the knee. There, I pay special

OPPOSITE: It is important to achieve architectural integrity of the forms and anatomy, and keep a strong sense of light. Note the accented darks on the knee joints, which indicate the structure. Note also how the light on Tynisha's left thigh wraps around the muscles of the upper leg.

LEFT: To effectively show light across the various forms of the torso, you have to model the surface in a unified way. The anatomies of the rib cage and pelvis have to be connected.

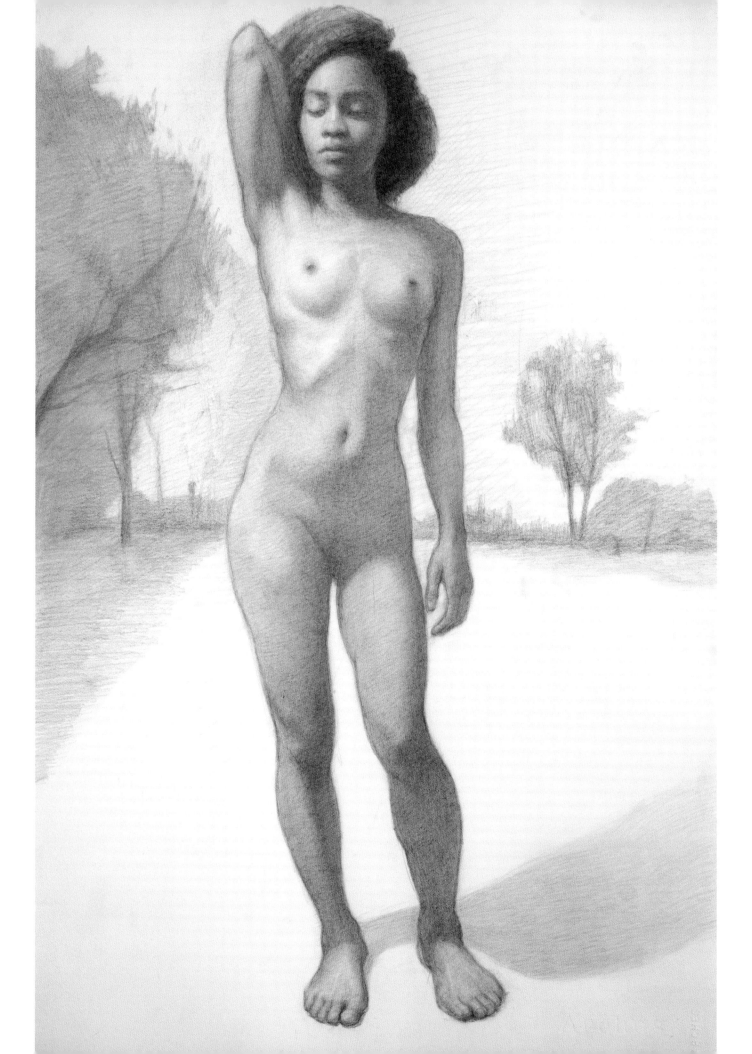

attention to articulating the joint. Drawing the knees properly is key, and to do this I needed to understand that one of them is bent and facing the light slightly more than the other.

Think of the joints as hubs. All the paths of the muscles lead to them. Some muscles stop at the threshold, and others cross over to the next part of the limb. All of the gestural lines we looked at on page 83 cross over joints on their way through the figure. As a result, joints provide an opportunity to use gesture to connect the various forms and subforms of the anatomical structure of the figure.

Once the legs and feet are finally modeled, I then start moving up the body again, refining the work I did earlier. I move back up into the figure to do two things: carve out more details and unify everything as much as I can. I am trying to achieve a natural flow from form to form, like a river of light moving over the various muscles that make up the torso. I do not want Tynisha to look like a crude mannequin or a robot, with seams of her various body parts looking sewn together. I'm aiming for smooth transitions between masses, with no breaks except for the natural folds of skin that happen when the body moves into certain positions.

Again, modeling form is dependent on many factors. How strong is the light source? What is the local value of the model's skin? Tynisha's skin is dark, so I had to darken the lighter areas of the drawing to compensate. In doing so, I had to be careful not to push the light areas into the dark range. One easy solution would have been to push her shadows *really* dark, but I opted for staying in the middle-dark range, as this creates the effect of greater volume that I was trying to achieve. Pushing the overall drawing to either extreme, light or dark, tends to flatten out the form.

STEP 5 | ADDING THE FINISHING TOUCHES AND REFINEMENTS

After I had finished the modeling of Tynisha, I realized that I had simply not made her dark enough. She is not a very dark-skinned woman, but she isn't a light-skinned one, either. So in the finishing touches stage, I went back into the shadow areas of her torso and head and pushed the values slightly darker. I thought the legs looked fine.

When drawing dark-skinned people, be aware that the dark range is relatively easy to navigate. If you make a mistake and go too light (like I did!), you can always make it darker. Creating the mid-range values on dark-skinned people, however, is much more challenging, since there is a huge drop-off in value after the highlight. If you look at the 8-value scale I showed you on page 109, you will notice that values 7 and 6 (light and middle light) don't appear at all in this drawing. After the highlight, it drops down in value to a 5. In other words, with *Tynisha* I had to model the light range with only three values. Not the easiest task. But doable, with a little focus.

One of the key things to keep in mind is that light striking the model should be global and consistent. As you scan your finished drawing up and down, nothing in the modeling should call attention to itself. The light source, not your perception of it, should dictate where the brightest light will be. Sometimes it helps to turn your drawing upside down and look at the form that way. Other times it helps to look at it in a mirror, to see a reversed view. If something jumps out of place when you use these methods, model it back into the proper range.

You can see that I have placed Tynisha in an environment, a pastoral. I incorporated a scene from one of my favorite Barbizon painters, but modified the perspective to accommodate Tynisha accurately. I'm a big believer in establishing a figure-ground relationship. We'll take a look at other artists who do that as well, but with different strategies from mine.

OPPOSITE: Rob Zeller, *Tynisha*, 2015, graphite on paper, 24 x 18 inches (55.9 x 35.6 cm)
 The final drawing is the result of an understanding of gesture, proportion, blocking in, modeling, and refining touches.

ADVANCED LESSONS | OTHER ARTISTS' PERSPECTIVES ON THE FRONT VIEW

What follows are some additional concepts we should discuss. I wanted to feature the masterful art of some of the best figurative artists who are working today, and one famous inspiration from the past.

The Figure-Ground Relationship

One of the most important aspects of figure drawing is the relationship between the figure and its surroundings. The fancy term for this is *figure-ground relationship*—what type of background the figure exists in, and how the figure relates to that environment. Even if you don't consciously take this factor into account, you will create an environment by default.

The two artists featured here each have well-formed figures that relate to their grounds in different ways. In Zoey Frank's *Robin* we see the figure gently emerge from a soft, effuse, and fairly high-key shadow. The drawing moves quickly and beautifully from abstraction to an intense subtlety of form on the model's thorax, face, and hand. The artist places the greatest contrast on the figure's face and rib cage.

In Daniel Sprick's *Loni*, we see a much more rhythmic relationship of smooth, platonic form coming to life "from the whirlwind," so to speak. In taking this dramatic approach, he evokes a more abstract relationship. Sprick's range of values is dynamic and reminiscent of Michelangelo, with dark accents on the peaks of the muscles and their various cast shadows completing the illusion of form. Notice how he "pulls" across the form in his modeling.

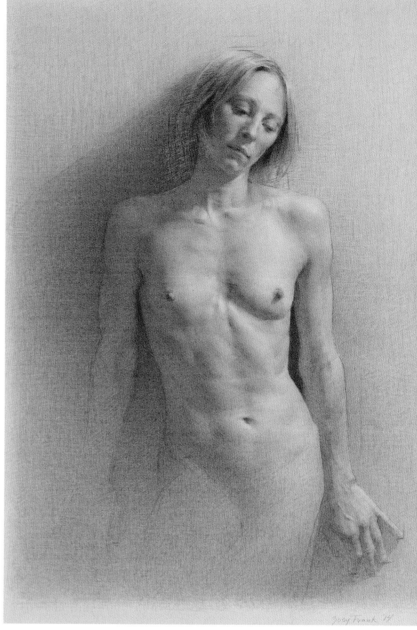

ABOVE: Zoey Frank, *Robin*, 2014, pencil on paper, 16 x 11 inches (40.6 x 27.9 cm)
 This drawing reveals the subtle passage of light across the large masses of the face and torso. The shadows integrate the figure into the background.

OPPOSITE: Daniel Sprick, *Loni*, 2014, charcoal on paper, 22 x 19 inches (55.9 x 48.3 cm)
 The dark accents of the terminator lines form a highly energetic, rhythmic pattern across the figure.

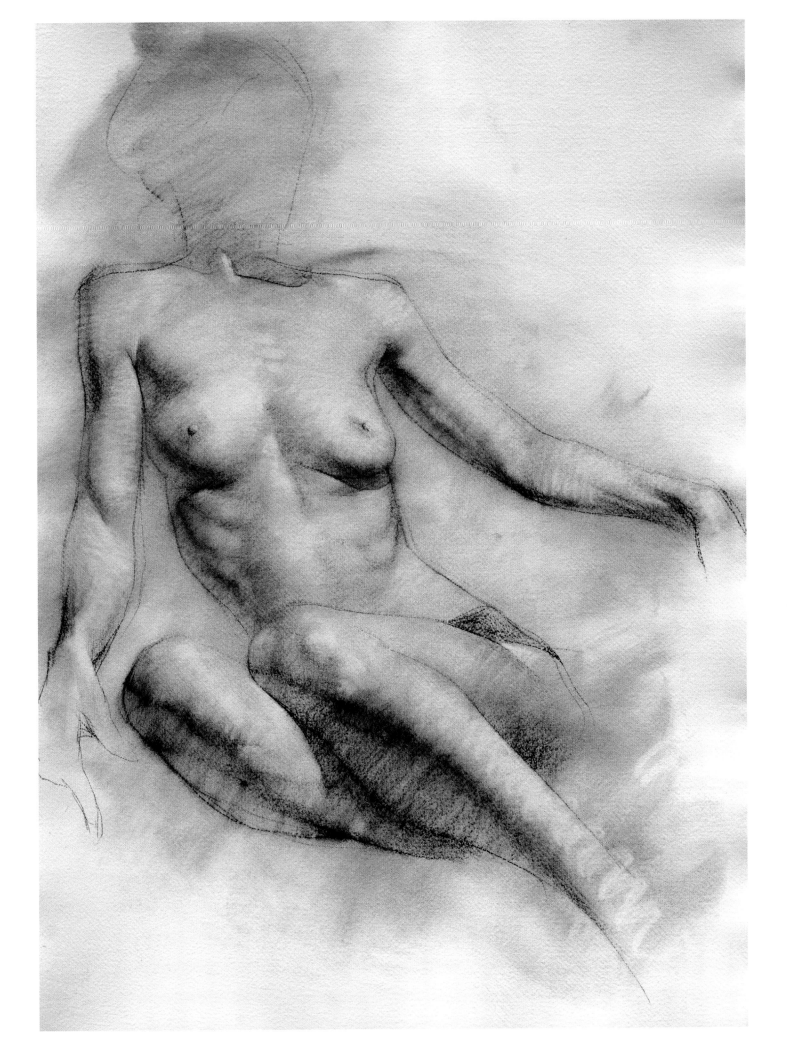

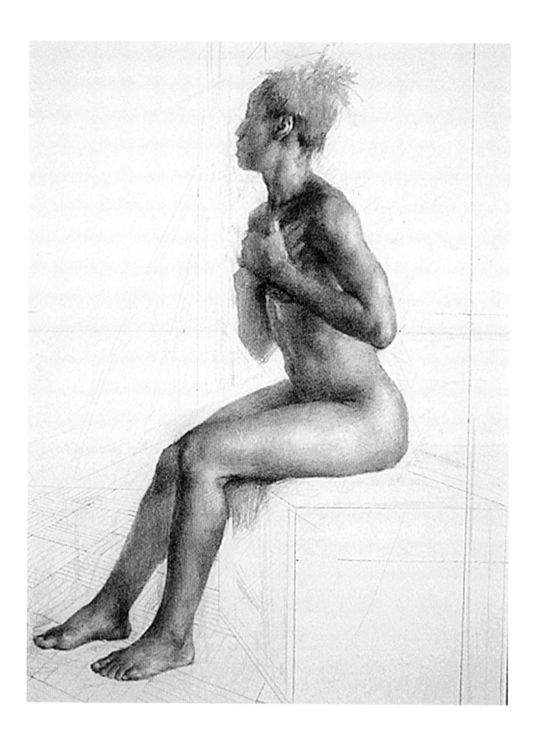

Seated Variations, with Gesture

What you want to say about the model dictates what you put in and what you leave out of your drawing. Seated poses can be difficult, but both of these artists added gesture to what could have been a very static pose.

In Dan Thompson's *Study of Andrea for Announcement*, the model makes a poignant gesture of placing both hands over her heart. She is leaning forward just slightly, with her head turned away in a classic "lost profile," with the emphasis placed on the neck muscles,

jaw, and ear. Even though he has worked out the trunk she is seated on in careful perspective, Thompson does not render it. The focus of this drawing is the figure, and is a study for a larger work. The light bathes her from behind and the forms are modeled in a way that reflects her dark local color.

By contrast, in Hollis Dunlap's *Helen* every element of the model's environment is assigned a wash of value with kinetic strokes and integrated with the figure itself.

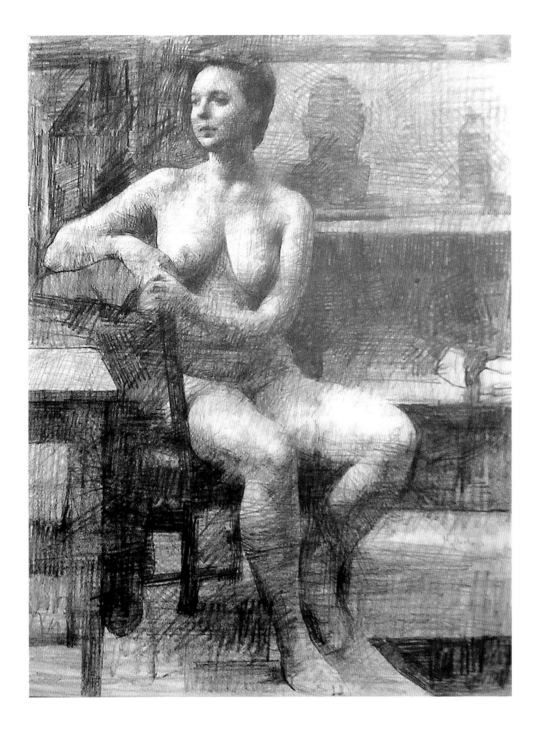

The pattern of the light mass leads up and down the triangle of her face, shoulders, breasts, and arms. Notice the way the top of the chair completes the gesture of her arm, which then flows into the other arm and around her shoulders. The passages of value that move through the figure and background work in a manner not unlike what you would find in a painting.

OPPOSITE: Dan Thompson, *Study of Andrea for Announcement*, 2010, graphite on paper, 22 x 15 inches (55.9 x 38.1 cm)

Thompson worked out the perspective of the environment carefully, but left it understated in this study. Instead, the forms and gesture of the model are his focus.

ABOVE: Hollis Dunlap, *Helen*, 2015, graphite on paper, 14 x 11 inches (35.6 x 27.9 cm)

The figure and her gesture are completely integrated into the background in this composition. The many drawing strokes form a kinetic whole.

Balance and Weight Distribution

One of the most important concepts for a figurative artist to learn is that of balance and weight distribution. Proper understanding of this will give your figure drawings vivacity and a sense of animation that living humans possess. In short, get this concept straight and you won't draw people who look like mannequins.

In Elizabeth Zanzinger's drawing *Fallon III*, the gesture lines flow through the figure in an arc, up through her legs and spine and out through her head. The arc through the model's right arm and the hand holding the skull forms an exact counterbalance. The model's weight is borne by her legs and by her spine, allowing her to lean back from the center line. The tuck of the model's chin allows the plane of her face to be perfectly vertical as she looks at the skull. The direct line from the eyes of the animal skull to the eyes of the model goes straight through to intersect at a 90-degree angle to the line made by her left arm and scapula and back.

In Chris Pugliese's *Figure Study*, we see a more lyrical approach to weight distribution that relies as much on the contour line as it does on value. Notice the backward arc of the stand leg and the forward arc of the rest of the figure. He counterbalances that with the gesture of the model's right arm and the slight turn of her head. Pugliese models the major forms of the pelvis and rib cage, and gives the figure a lively expression. But he chooses to let the nonessentials fade out. His contours reveal his thoughts about the rhythms traveling down her leg.

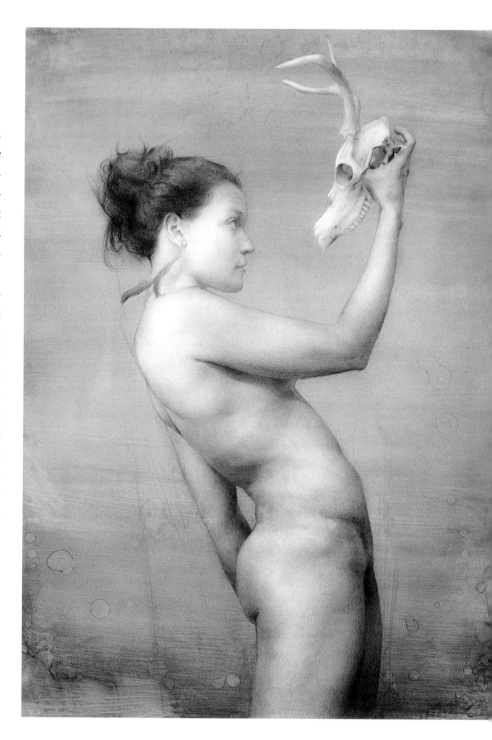

ABOVE: Elizabeth Zanzinger, *Fallon III*, 2015, graphite on Mylar, 18 x 14 inches (45.7 x 35.6 cm)

The power and rhythm of the lines the model created resonated with the artist. To Zanzinger, her body echoed the remnants of the animal skull she's holding.

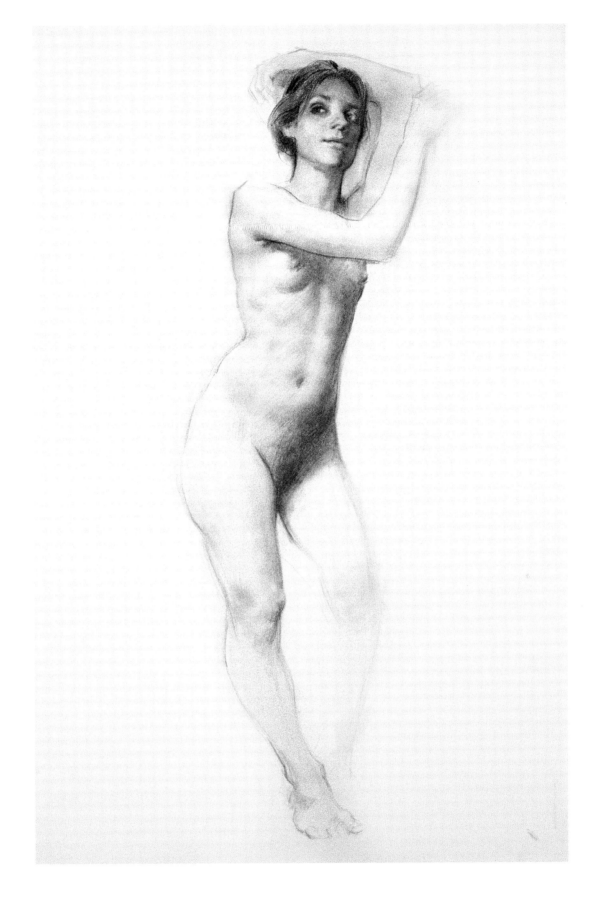

ABOVE: Christopher Pugliese, *Figure Study*, 2015, pencil on paper, 24 x 18 inches (55.9 x 35.6 cm)

Notice how the contour of the model's back mimics the contour of her stand leg. This repetition enforces the structure and balance of the stand leg as being one unit with the spinal cord.

Drawing with a Range of Tone and Accents

These two images by Andrew Loomis are terrific examples of drawing with tone and accents instead of simply line. *Tonal Study—Female* shows that one need not rely on contour to convey rhythm in a figure. The contour line is merely hinted at in places, yet the rhythm flows from head to toe. A deceptively simple value scheme is in play here, three or four values max, with mostly soft, effuse edges. Loomis adds dark accents with hard edges to make things pop.

In the nineteenth century the word *tone*, a musical term, was often used interchangeably for what we now commonly refer to as *value*. The terms mean the same thing, which can be confusing at times. Some of the Golden Age them trace their artistic lineage back to the Académie Julian, and thus older, nineteenth-century terminology was common among them, as you can see by the title of Loomis's piece at right, just above his signature.

Loomis keeps the composition structurally sound in *Tonal Study— Male* with the use of a tightly compressed 4-value scale. Each value is used to form definite shapes, almost like a woodcut. If you squint while looking at it, you can see how flat the shapes actually are. The drawing as a whole is incredibly volumetric, and relies on subtle use of line. His book *Figure Drawing for All It's Worth*, published by Titan Books, is one of the best ever written, and worthy of your time if you are looking for additional reading on the subject. The instructional section of this book is a meager attempt to walk in that book's footsteps.

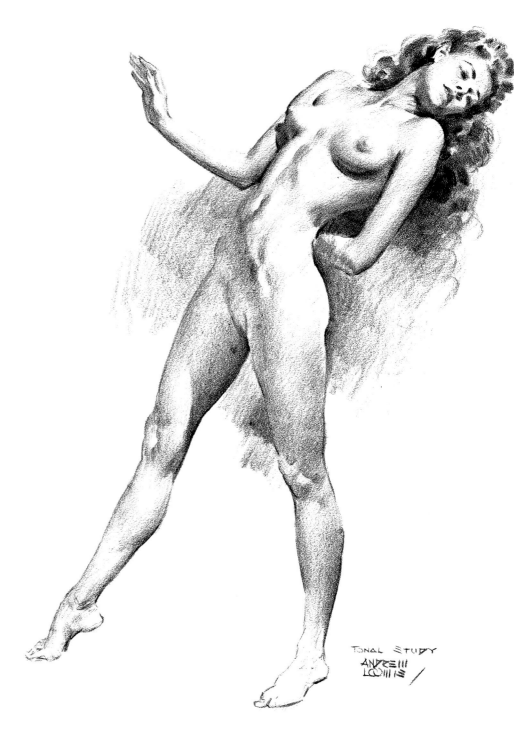

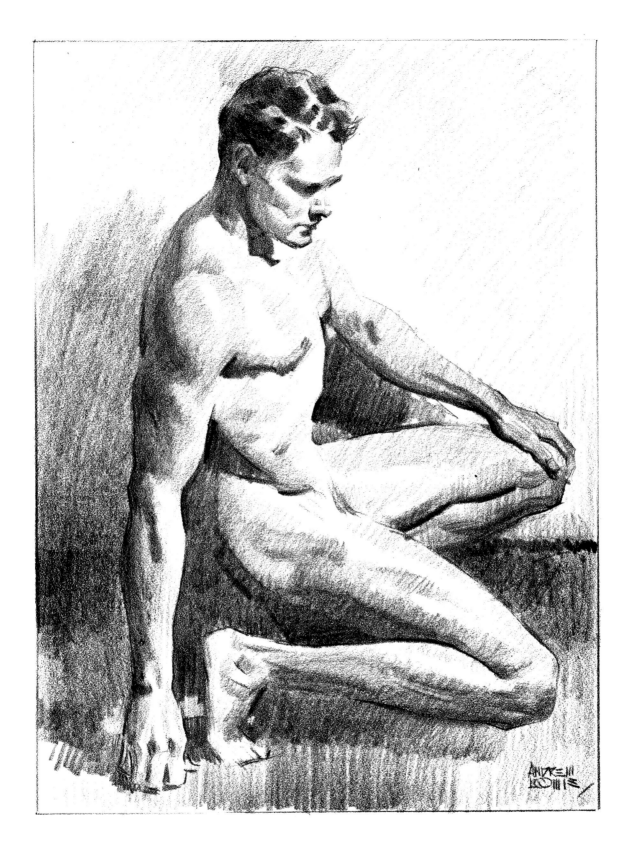

OPPOSITE: Andrew Loomis, *Tonal Study—Female*, 1943, pencil on paper. Reprinted courtesy of Titan Books.

Loomis is famous for his "form principle," and rightly so. His modeling of form hinged on his understanding of the context of the light source and the quality of light it created. His handling of values is exquisite.

ABOVE: Andrew Loomis, *Tonal Study—Male*, 1943, pencil on paper. Reprinted courtesy of Titan Books.

Both of these images appeared in Loomis's groundbreaking book *Figure Drawing for All It's Worth*.

Different Kinds of Rhythm

A comparison of these two drawings by Colleen Barry and Steven Assael yields many similarities between them. In fact, they initially seem to be bookends of the same pose. Both are focused on a male torso that is leaning on one arm. The modeling of internal subforms of both figures reveals a sophisticated understanding of anatomy and the directional quality of light.

The eye level in Barry's drawing is lower, and she looks up at the model. Her thought process is clear as she assesses the muscle masses that flow between the major forms of the skeleton. The surface form is extremely subtle as she models the subforms that make up the major bundles of muscle. As we move down the center line of the head, down the rib cage, and down the abdominals, the gesture of the model's left hand captures our attention. The wrist is very powerfully articulated. The gesture of Barry's figure is quite stylized, evocative of sixteenth-century Italian art.

Assael's model exudes a less stylized sense of gesture and is positioned just a tad above his (and thus our) eye level. Assael's use of red pencil, with graphite for the shadows, creates a diamond shape of light on the head, shoulders, and rib cage. We follow the spine up from the pelvis, through the rib cage and up through the taut muscles of the neck, into the head. The gesture of the hand is more subdued also.

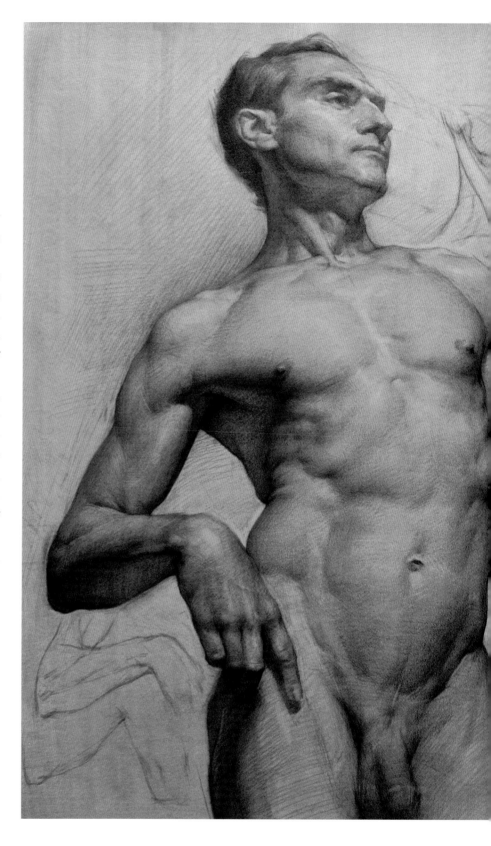

ABOVE: Colleen Barry, *Male Nude Study*, 2012, brown pencil on toned paper, 17 x 11 inches (43.2 x 27.9 cm)
When the paper is toned, its color usually forms the middle value. One "pushes down" to the darks by adding charcoal or graphite, and "pulls up" to the lights by erasing an unfixed tone (to reveal the color of the paper) or by adding white chalk.

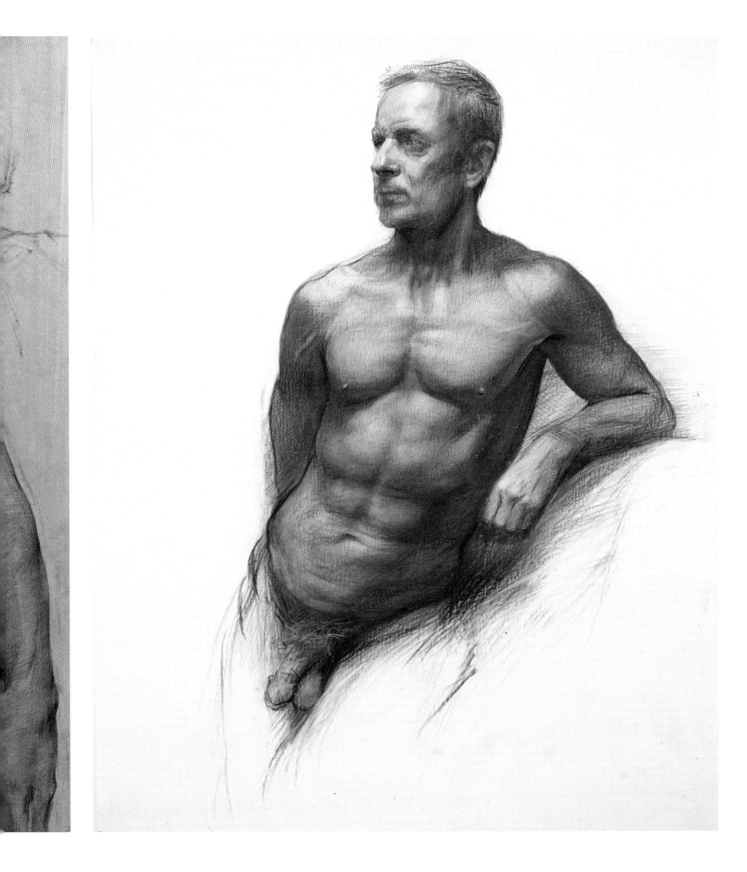

ABOVE: Steven Assael, *Male Nude*, 2014, red and graphite pencil on paper, 24 x 18 inches (55.9 x 35.6 cm)

Assael pushes the red in both the darks and the low lights, erasing back to the white of the paper for highlights and adding graphite for the shadows.

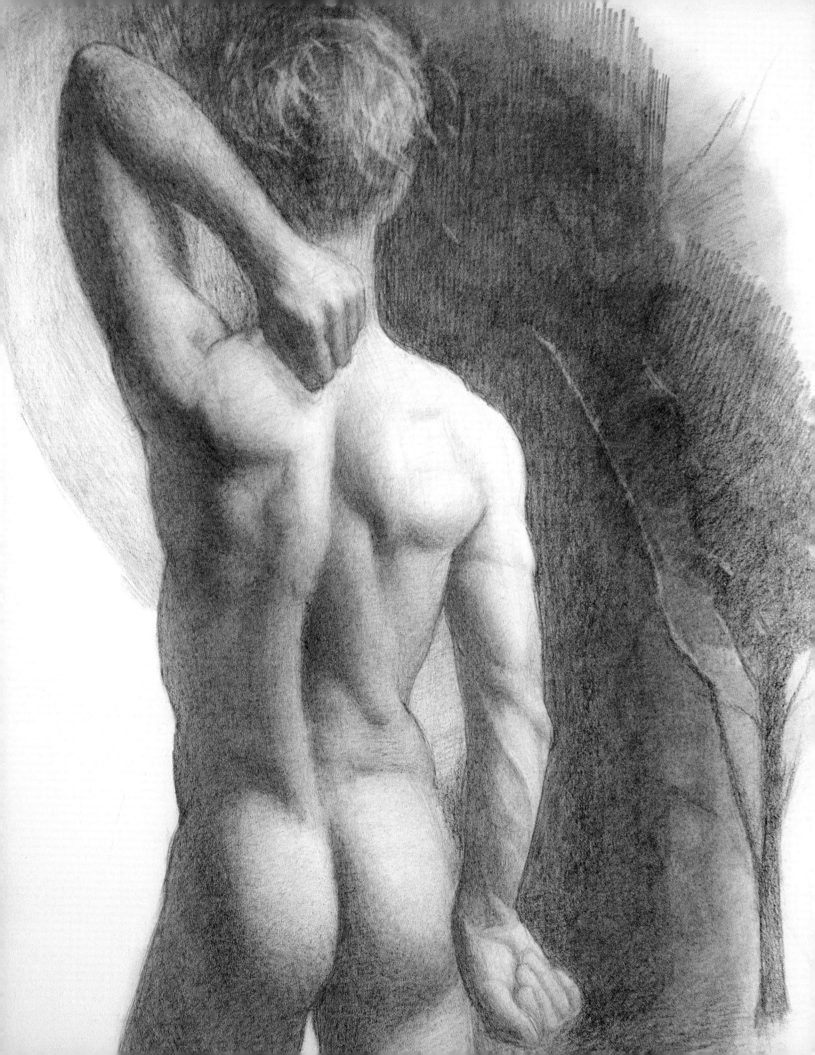

STANDING FIGURE, BACK VIEW

s in chapter 2, my method of teaching you how to draw the figure will be to walk you through the creation of the drawing shown opposite, Dmytri. In the process, you will learn my approach and the questions I ask myself as I progress. This time we will tackle a back view of a standing pose. Once again, we will follow the same five steps presented in the previous chapter: finding the gesture, establishing the basic proportions, blocking in with anatomy, light, and shadow, modeling the form, and adding the finishing touches and refinements.

OPPOSITE: Rob Zeller, *Dmytri* (detail), 2015, pencil on paper, 24 x 18 inches (61 x 45.7 cm)
This drawing was an attempt to strike a balance between the static and the rhythmic, between architectural construction and ovoid surface forms.

Let's take a look at Craig Banholzer's drawing, shown at right, as a form of review. *Shoulder Study* is all about form and construction. Using straight lines, Banholzer carves the many smaller subforms of musculature out of the larger mass of the rib cage, not unlike the way a sculptor would work. His concerns aren't merely with copying the light, but rather about re-creating the convex shapes that make up the model's back. There is a shadow shape along the bottom of the form, as he takes the more sculptural view that we discussed in the preceding chapter.

STEP 1 | FINDING THE GESTURE

In the very beginning of the drawing process, let your eyes find the pathways that connect all the parts. As I mentioned in the previous chapter, looking for gesture lets you see and understand the totality of the figure. It also lets you plan out your drawing. Think of gesture as a conceptual road map. In other words, draw by looking before you actually start drawing.

What exactly are you looking for? Gesture is a river of energy and movement that ties the various parts of the body together. It can be found by sight, along various pathways of light on forms of bone and muscle. But where to begin? Where to start looking for gesture? I usually start at the top or the bottom of the figure and work my way down or up accordingly.

The red lines in the left-hand image opposite show a couple of gesture scans. Starting at the head, I begin to travel down the spine through the pelvis, then down the left leg to the foot. It's the "passive" leg, since the knee is bent slightly. From that, I know the pelvis will dip down in its direction. You could just as easily do the opposite and start at the foot and move upward, exiting through the head. The key is unity. We are looking for paths that

unify the energy and motion of the pose. I try to note the subtle curve down the spine through the leg, looking for unifying pathways of light on the various muscles.

I next let my eyes scan from the upraised left arm down over the top of the right shoulder and along the right arm. I then take that down through the right leg to the foot. This particular gesture articulates a path that gets a good deal of light, I notice. Almost all the planes

ABOVE: Craig Banholzer, *Shoulder Study*, 2012, graphite on paper, 12 x 9 inches (30.5 x 22.9 cm)
Every mark in this beautifully sparse drawing is dedicated to structure and form.

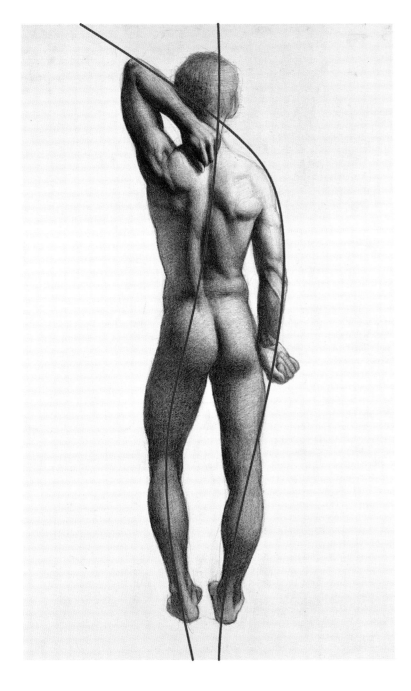

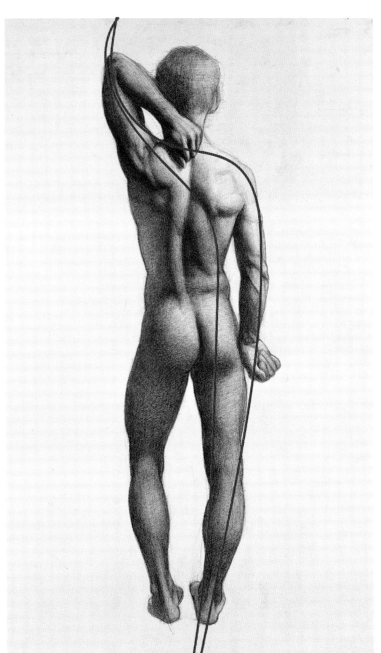

on this path face the light till I get to the lower leg, where the values get much darker.

The red lines in the image at right above show a second set of scans for gesture. Usually several circuits flow through any figure, regardless of the pose, and this one is no exception. Beginning with the upraised arm, I come across both shoulders, along the lower arm and hand, into the stand leg, and then down through the foot. I allow myself a final scan for gesture before I begin. This time, I move down the upraised arm, across the spine of the scapula, down the rhomboids and latissimus dorsi, through the pelvis and down the stand leg.

Now, having seen how the gesture moves through the entire figure, in two different (but connected) circuits, I'm ready to consider the proportions.

ABOVE LEFT: These gesture lines, in red, represent the rivers of energy and movement that tie the various parts of the body together. They represent a first glance at the flow of the figure.

ABOVE RIGHT: Gesture lines are not actually drawn, but rather are seen and felt. They provide you with a greater understanding of how the various parts of the figure fit together.

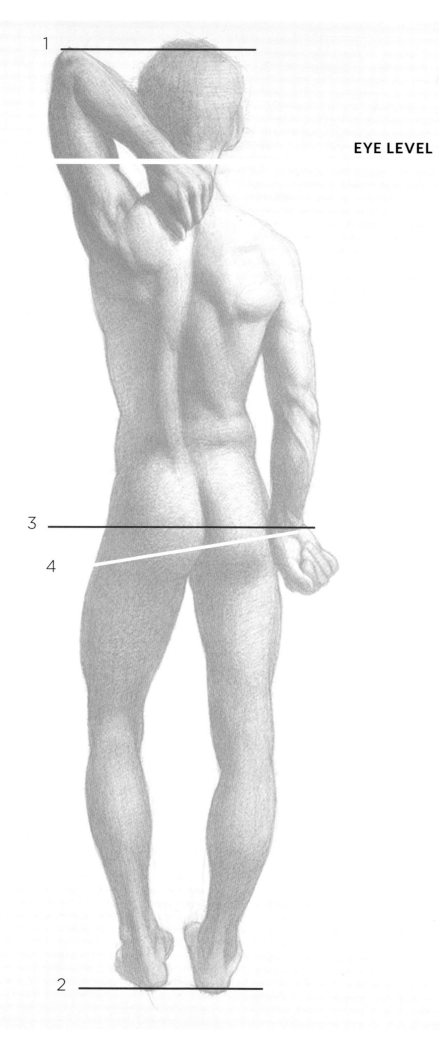

1

EYE LEVEL

3

4

2

STEP 2 | ESTABLISHING THE BASIC PROPORTIONS

Before we get started, we need to take a moment to tend to some preliminaries, just as we did in chapter 2. But we will move a bit faster this time around. We will still need to account for your perspective in the very beginning. So ask yourself: Where is eye level? And mark your drawing paper accordingly.

Note: When I created this drawing the model was standing on the same floor I was standing on. (He was not up on a model stand.) So my eye level was very close to his. If you are not aware of your eye level, you will make mistakes in perspective.

Now place your promissory marks on the page, both top and bottom (1 and 2). Then place a light mark in the exact middle between those two points (3). Next, look at the model and determine the middle point on him (4, but notice the tilt). In a standing pose, front view, that point will always be on the lower third of the pelvis, just above the genitals. But you can't see genitals in the rear view. In fact, the gluteal muscles dip quite a bit below the center line. In the rear view, find the *great trochanters* of the two femur bones. Where they insert into the pelvis is the halfway point.

Finally, try to determine the tilt, or axis, of the pelvis by carefully observing the conceptual line that connects the two *great trochanters* through the lower third of the pelvis. Is there a tilt, or is the line straight? There is almost always a tilt of some sort. Here, it's rather slight. Remember, the tilt always leans in the direction of the bent knee. The exact tilt is easier to see on the front view due to the ASIS points we learned about in chapter 2. But in this view, we do not see them.

Anatomy within the Blocks

As we learned in the previous chapter, at this stage in the process it is useful to envision the figure as three rectangular solids (the head, rib cage, and pelvis), each of which needs to be accurately positioned in space. Memorizing key reference points will greatly expedite this process, as these points will reveal what the conceptual boxes, and thus the skeleton, are doing. Particular care should be taken to determine the rotation of each solid along a central axis.

In keeping with the Block Concept (introduced on page 92), we will now discuss some of the anatomical reference points that occur in a standing pose, back view, within each of the foundational blocks of the figure. These points encompass both joints and key, bony landmarks. Knowing these points helps when rendering any pose the model may take. In the diagram on the following page, I have marked the joints in red and the landmarks in blue to avoid any confusion. The boxes they fall within are outlined in black.

Remember to find the center line of each of the boxes. In the back view, this means finding and following the spine as it moves from its base in the pelvis, up through the rib cage and head. It seems to curve a bit because the pelvis dips slightly toward the bent leg, while the rib cage is very level and straight. The spine thus curves in transition between the two accordingly.

OPPOSITE: Rob Zeller, *Anatomical Drawing for Students*, 2012, charcoal and white and red chalk on toned paper, 24 x 18 inches (60.9 x 45.7 cm)

To find basic proportions, first make marks at the top (1) and bottom (2) of the figure and then find the midpoint (3). Next find the center tilt of the pelvis (4), if any. Finally, determine your eye level.

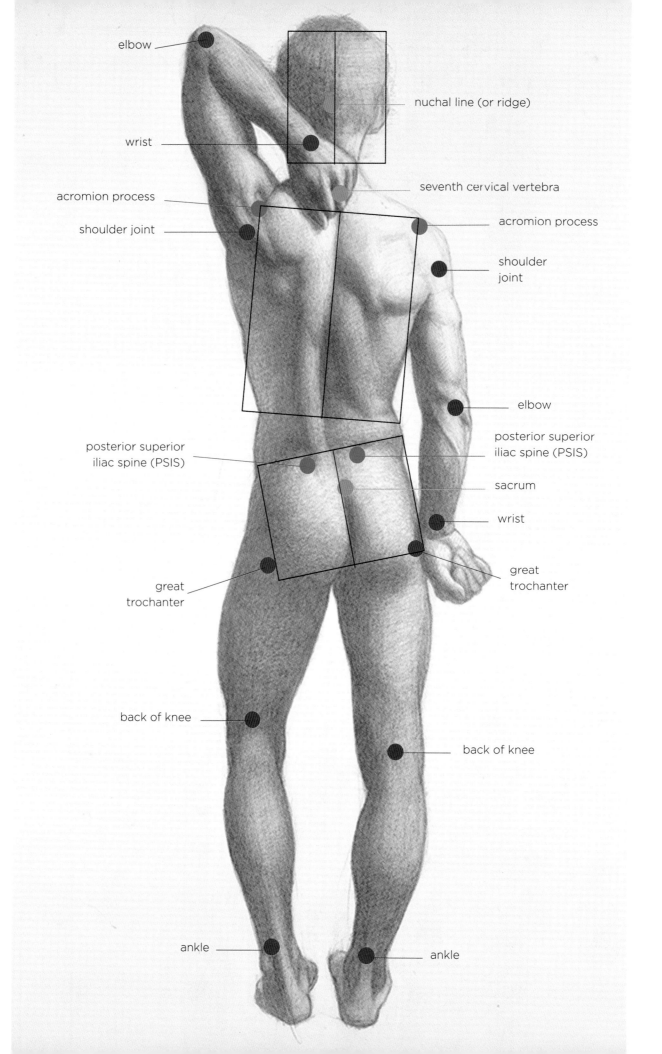

elbow

nuchal line (or ridge)

wrist

seventh cervical vertebra

acromion process

acromion process

shoulder joint

shoulder joint

elbow

posterior superior iliac spine (PSIS)

posterior superior iliac spine (PSIS)

sacrum

wrist

great trochanter

great trochanter

back of knee

back of knee

ankle

ankle

HEAD BLOCK

The dorsal view of the head has one key landmark:

- **Nuchal line (or ridge):** Where the back of the neck meets the back of the head.

RIB CAGE BLOCK

The dorsal view of the rib cage has two key landmarks, one of which appears on both sides of the body:

- **Seventh cervical vertebra:** This is the last of the vertebrae of the neck. In this case, it sits right below the left hand (of the upraised arm).

- **Acromion process:** Where the clavicle rests adjacent to the top part of the scapula. This appears on both sides of the body.

ARM BLOCKS

The dorsal view of each of the arms has three key joints. These are positioned according to the laws of bilateral symmetry:

- **Shoulder joint:** Where the head of the humerus (upper arm bone) meets the *glenoid fossa* of the scapula. (No, you can't see this joint on the surface. But you should know where it is, and also learn the components that attach themselves to it. When it moves, they move.)

- **Elbow:** Where the humerus meets the radius and the ulna (the two lower arm bones). In the dorsal view, the olecranon process, which is the rear portion of the ulna, functions as a "kneecap" of sorts. It's the bony triangle that sticks out when you bend your elbow.

- **Wrist:** The meeting point of the radius and ulna with the small bones of the base of the hand, the carpals.

PELVIC BLOCK

The dorsal view of the pelvis has three key landmarks, one of which appears on both sides of the body, and two joints:

- **Posterior superior iliac spine (PSIS):** The rear points on either side of the spine of the pelvis.

- **Sacrum:** This inverted triangular-shaped bone forms the base of the pelvis. Together with the two PSIS points, the median crest of the sacrum makes up the sacral triangle.

- **Great trochanter:** The juncture of the shaft of the femur with the neck that inserts into the pelvis.

LEG BLOCKS

The dorsal view of each of the legs has two joints. As with the arm blocks, these joints are positioned according to the laws of bilateral symmetry:

- **Knee:** This is puffy and not particularly bony in the rear view.

- **Ankle:** This is formed by three bones, but on the surface we perceive only two bumps. The bump on the inside is called the *medial malleolus*, which forms the base of the tibia. The other, on the outside, is called the *lateral malleolus* and forms the base of the fibula. The *medial malleolus* is always a bit higher than the lateral, so look for that angle.

OPPOSITE: Find the big three masses of the body (head, rib cage, and pelvis) by using a block conception. The red dots represent joints, which are important to note in the early stages of the drawing. There are twelve. The blue dots represent the bony landmarks that are key to figuring out the axis/tilt of each of the big three masses. There are seven, but one of them (the seventh cervical vertebra at the base of the neck) should be hidden behind the model's hand in this view.

Essential Bones and Musculature

These images provide an important overview of the muscles of the human body that you need to know. But to truly draw the figure well, know that these are just a touchstone, to help get you started. You must go deeper into anatomy than this.

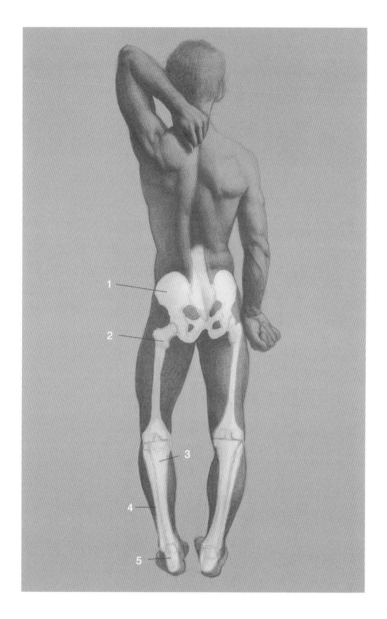 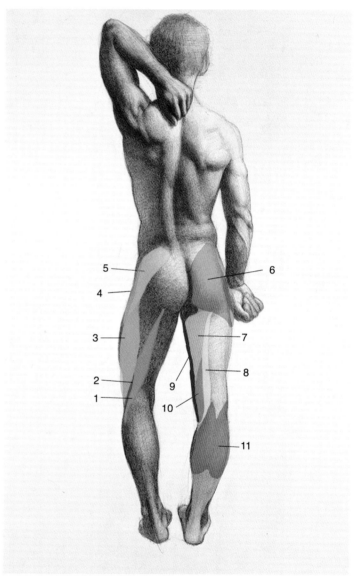

THE BONES OF THE LOWER BODY:

1. pelvis
2. femur
3. tibia
4. fibula
5. various foot bones: talus, cuneiform, and many others

THE MUSCLES OF THE LOWER BODY:

1. biceps femoris short head
2. biceps femoris long head
3. vastus lateralis
4. tensor fascia latae
5. gluteus medius
6. gluteus maximus
7. adductor magnus
8. semitendinosus
9. gracilis
10. semimembranosus
11. gastrocnemius

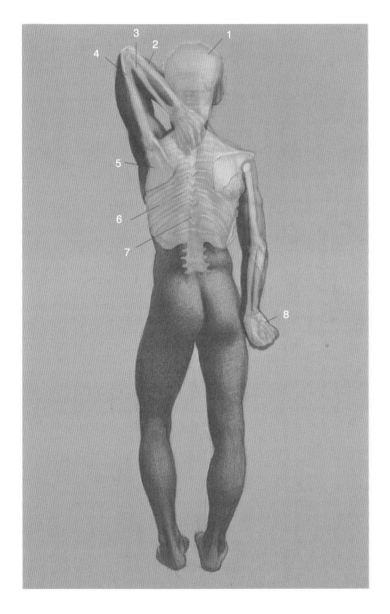

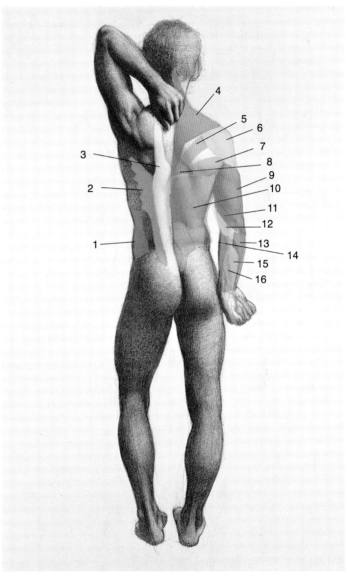

THE BONES OF THE UPPER BODY:

1. skull
2. ulna
3. radius
4. humerus
5. scapula
6. thorax (rib cage)
7. spinal cord (vertebrae)
8. bones of the hand

THE MUSCLES OF THE UPPER BODY:

1. external oblique
2. iliocostalis
3. longissimus
4. trapezius
5. infraspinatus
6. deltoid
7. teres major
8. rhomboid
9. triceps
10. latissimus dorsi
11. brachialis
12. biceps
13. flexor carpi ulnaris
14. brachioradialis
15. flexor digitorum superficialis
16. flexor carpi radialis

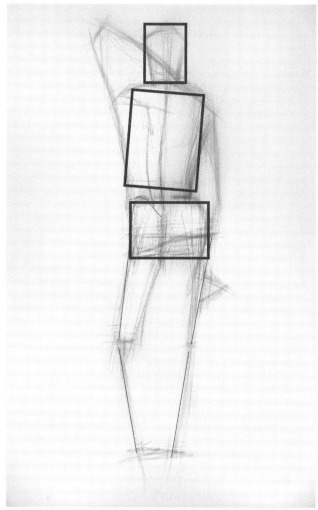

STEP 3 | BLOCKING IN WITH ANATOMY, LIGHT, AND SHADOW

When you begin to block in the figure, do not start on the outside. Begin instead with the internal, structural lines. These may seem to follow the skeleton, but they involve much more than just drawing bone. The structural lines, in fact, flow through the various masses and their alignments. As you move through the form of the figure, the various shapes present themselves.

To make it plain, I do not *draw* blocks at any point in the process, but I *think* of the blocks that we examined in Step 2. This process is similar to not actually drawing gesture lines, but thinking about them. As my eyes follow a particular path, I lightly draw center lines through each form, at the same time very delicately trying to gauge its positioning. In my mind, I know

that all of these lines will be covered by further blocking in and modeling. None of them will be visible in the end.

Often, a block can be rotated a bit, in addition to having a tilt in a certain direction. You can try this out for yourself. Tilt your head to the right, then rotate it slightly to your left. In addition to gesture, tilt, and rotation, I'm also looking at anatomy. How are the three big building blocks (head, rib cage, and pelvis) aligned? In this particular pose, there is a tilt in the pelvis, resulting in the bending of the left knee. The rib cage is tilted slightly to the right, resulting in a bit of compression on the right side of the figure. The head, at the top of the spine, is more or less straight.

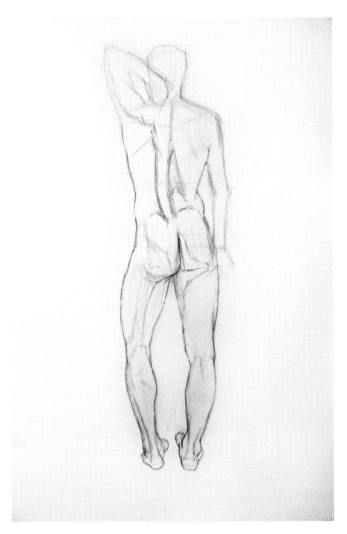

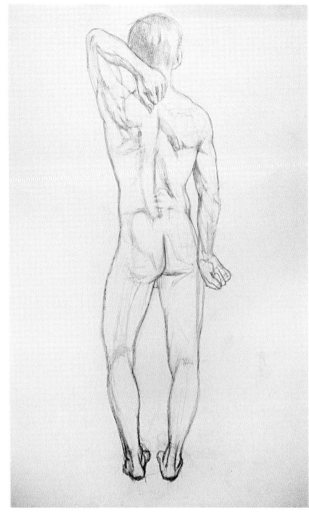

OPPOSITE LEFT: In the beginning, I work lightly. All of my initial structural lines will be covered eventually, integrated into the drawing. I am looking for a combination of abstract shapes and a geometric understanding of the figure, and also for structural anatomy. I try to simplify the opening moves to show how the figure is standing, and where the weight gets distributed among the various building blocks. This takes practice!

OPPOSITE RIGHT: The block concept helps make sense of the structure. This view of my sketch features graphic overlays that indicate the three main building blocks of the figure (the head, rib cage, and pelvis). This lets you see what I was thinking about at this stage in the process. Remember: "The big three" fall above the midline of the figure.

ABOVE LEFT: In a standing pose, focus on the legs first. This makes sense architecturally. How else can the figure stand? As I begin to refine the shapes of the block in, I take both anatomy and light source into consideration, making sure that the feet are placed correctly on the ground plane, in perspective.

ABOVE RIGHT: At the final stage of the block in, notice how the overall emphasis is on structure. I wanted each section of the figure to feel volumetric and reveal the anatomy. There are also clear indications of where the light and shadow fall on the figure. I leave the light areas as clean as I can. I leave the shapes of the shadow areas hollow at this point, with no shading in them at all. I think this stage is really interesting. Drawings often look like solarized photographs, where the darks are blown out to look like lights. If you get the shadow shapes perfectly correct, you often describe anatomy likewise.

The Block In

When you begin to refine the shapes, try to work from the interior forms outward. Inside out is always a good way to think about the figure. Once the major sections are blocked in, and the proportions are accurate, you can then begin to refine things. At this refining stage, as long as you stay with the original general proportions, do not fear to change *anything* as needed. Everything is expendable. One should maintain a Zen-like calm about moving things around as necessary.

When refining the block in you need to perform two activities simultaneously—or nearly simultaneously. First, you need to look at the anatomy of an area, and see how the muscles flow into each other and fill out, or construct, the volume. Second, you need to study the play of light on the major forms and subforms in each area. When I am at this stage I oscillate quickly between the two modes of thinking, in essence mixing anatomical knowledge with direct observation of light on form. To draw the figure well, you do need both.

As I draw a particular part of the body, I look at the basic thrust of the center line of that area. And then I look for the largest planes that form the part, bound in space. Next, I try to look at the body closely and think through all of the muscles in that area. How are they arranged? How do they present themselves in the pose? Which are facing the light the most? Which are in shadow?

You may have heard the phrase "move from the general to the specific." This is an excellent concept to keep in mind when rendering the figure. I do not draw any shape (muscle or otherwise) unless I understand where it fits in the larger context of the greater mass. I would not focus on the *pectoralis* (chest muscle) unless I had a good sense of the rib cage under it. The same goes for any other part of the body. You would not focus on the biceps necessarily, unless you have fully understood the underlying vertical rectangle of the upper arm, with the humerus running through it. The biceps is a part of the upper arm, so it needs to reside in that context. That said, once you have established the context, knock yourself out drawing the various smaller components that make up that larger mass. Every part of the body consists of larger masses that can be broken down into smaller masses.

As mentioned in chapter 2, the dividing line between shadow and light is called the *terminator*. When modeling the figure, focus on that line. It will vary for every single area of the body. Squint often, and it will become very apparent to you. Never lose sight of it!

A Word about Contours

Children draw contours all the time—and have fun doing so. Contours encase things in a definite way that appeals to children. They can take a sheet of paper and carve out a face, with eyes, nose, and lips. Most important, the "idea" of a given contour comes from within the child's mind. They are not actually looking at a reference to gauge nuances or subtle shifts. Rather, they are using contours to draw symbols of things. That is the very approach most of my teen and adult students take also, unless properly coached otherwise.

As adults, we know the reality of contours is a much more complex situation. Namely, they don't actually exist in nature. Nobody I know is walking around with a perfectly visible contour line around him or her. Yet we need to use contours to draw the figure. So, how do we proceed?

You need to remember that each part of the body is a convexity. Each has a curve that moves upward, peaks, and then descends again, like a mountain range. Also, various forms overlap each other, depending upon the vantage point from which you are looking at the model. It would be naive and childlike to draw a single line, with no overlap, or without consideration of the various peaks and valleys of the forms below.

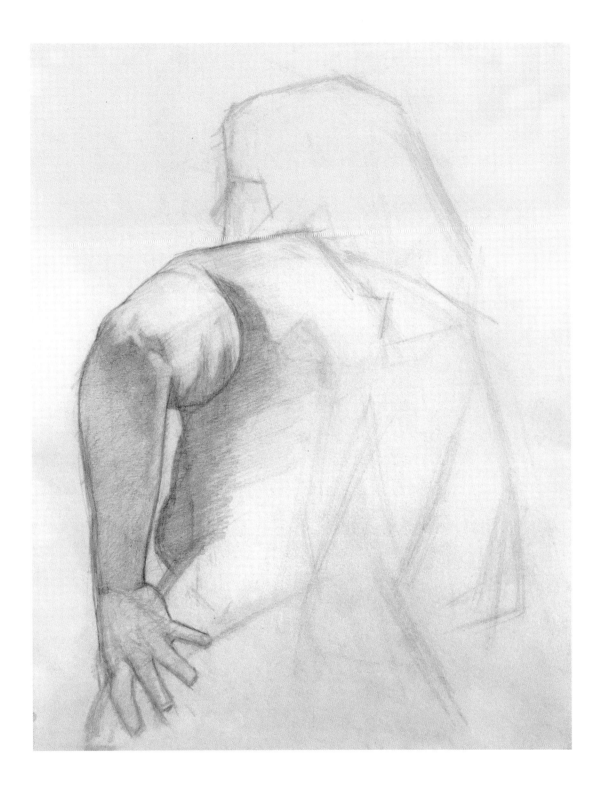

Drawing a contour correctly takes much concentration. It's not something you do at the end of the drawing to "tie the whole room together." It needs to be integrated as you progress. I recommend lightly marking the high points of each form along the edge of your block in. Then lightly erase where the form descends back into the mass. Next, make a slightly darker line that travels along the edge of the

different forms, with line weight varying to show overlap. If one thing passes in front of something else, give that area a slightly heavier line weight. If it recedes behind something, give it a slightly lighter line weight.

ABOVE: Rob Zeller, *Block In, Back View*, 2003, pencil on paper, 17 x 14 inches (43.2 x 35.5 cm)

In this block in, I focused on the foreshortened arm that was closer to me from the model's back.

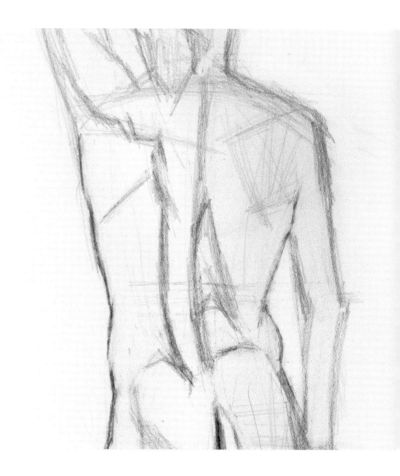

From Blocking In to Modeling Form

There is a huge jump in terms of focus and refinement between each of the four stages illustrated here. Each stage brings a new, more intense focus to a specific area. The initial construction lines in the first drawing set things up for the intermediate block-in stage of the second drawing, and so on. In fact, when you get used to working in this way, you flow from one stage to the next pretty intuitively. Eventually, you know when to shift gears without even thinking about it.

The key thing to establish is whether your drawing is about the light or not. If it's not so much about the light, then you do not need a strong light source. But if you want clarity of form, you will need a strong light source. The figure should be modeled uniformly, meaning the value range in one area should be working from the same value range as another area. If the light source is close to the model's head, then her feet should not be lit as strongly as her face. Controlling the light, understanding it, is just as important as getting proportions or anatomy correct.

From the intermediate block-in stage (above right) to the refined block-in stage (opposite left), there is a huge jump in the use of contour, as well as a refinement of light and shadow. In the intermediate block-in stage, you can see that the focus is on the larger geometric

ABOVE LEFT: This is the initial block-in stage.

ABOVE RIGHT: This is the intermediate stage, showing the division of light and shadow.

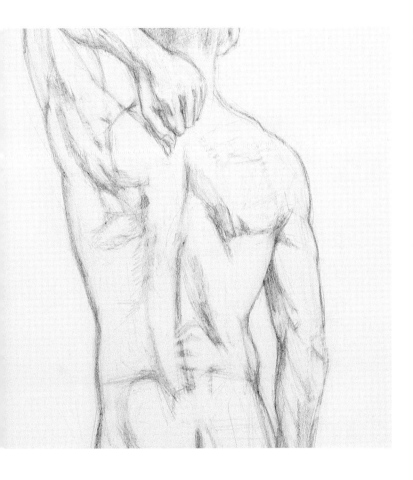

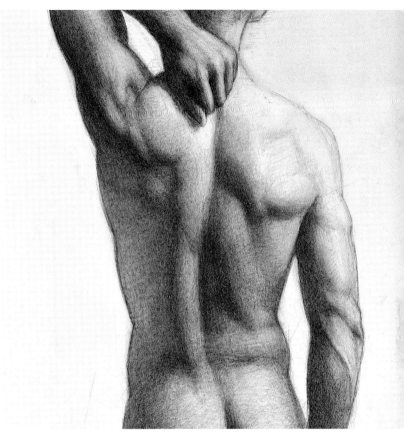

shapes and a basic division of light and shadow. There really isn't much of a contour because there isn't a need for one yet. I've barely worked out the larger forms, much less the subforms.

By the time we get to the refined block-in stage, however, the contour lines help to describe the convexity of the forms. Notice how the muscles related to the scapula (shoulder area) bulge a bit on the more refined drawing. They are convex, and feel alive. To draw them properly, you need an understanding of their movement, and how the light is hitting them.

And this is key: You do not have to draw the entire muscle to achieve convincing realism. In fact, subtle descriptions are often better when it comes to using anatomy in realistic figure drawings. It is far better to draw the light hitting the muscle than to draw the

muscle itself. Try to draw the movement and action of the muscle more than the muscle itself.

Once we move from the refined block-in stage to the modeling-of-form stage (above right), yet another huge shift of focus happens. At this point in the process, I almost become a sculptor. My pencil strokes follow the shape of the surface I'm trying to create. In my mind, I'm carving. My pencil is a sculptural tool that I use to break through the planes of the image to carve the figure out of the paper. Only instead of clay, I am working with graphite (or charcoal or paint). The full range of values now comes into play.

ABOVE LEFT: This is the refinement of the block-in stage.

ABOVE RIGHT: And here I am modeling form, refining contours.

STEP 4 | MODELING THE FORM

When I'm drawing, I don't work from an Impressionist's mind-set. I am not trying to copy exactly what I see. Much time is wasted in figure-drawing classes trying to copy the values present on the model. I ignore the myriad values I see in the shadow and aim for simplicity. Using only one value for the shadow, uniformly, is an important skill to learn. Leave the real diversity, excitement, for the light areas. Remember: You are not a camera. You are not recording the model. You are rebuilding, synthesizing information into *your own* creation.

It's very important to be able to control the range of your modeling. You have to make the shadow value dark enough to leave room for modeling in the lights, but not so light as to have no room for reflected lights.

As the artist, *you* decide what the shadow value will be. Don't simply copy what you see on the model. Wherever there is shadow, it should be *that* value in your drawing, *whether you see it that way on the model or not.*

When modeling Dmytri, as I move from the shadows into the light, I move across the forms, not up and down. Moving across, sideways, forces me to pretend I'm walking along the surface (maybe as an ant?), and I'm taking in the surrounding topography.

I do not draw individual muscles, but rather the whole surface of the back. I'm looking for unity and an overall sense of light as it is striking this subject. As I move across the forms, I am keeping my touch light, working on the point of the pencil. I'm trying to model each subform (smaller shape) while maintaining the overall sense of light on the major forms. This simply takes practice.

Alert: If you're working in pencil, be aware that it will dull quickly. Keep several sharp pencils at the ready. The moment one loses its edge, switch it out.

At this stage, I move down the drawing, carving form as I go. I am seeking to re-create the gesture I saw earlier in my initial scan. So I travel down the stand leg, looking for ways to unify the rhythm by modeling the muscles in harmony.

I am always asking myself questions: How do his muscles flow into one another? How are they holding him up? Which ones are bearing the most weight? How much light is hitting the larger forms as I descend the figure? Am I being consistent with what I'm saying about the light as it strikes the figure?

There are many things that factor into unifying the treatment of form: You must understand the direction of the light, the local color/value of the surface, and the overall position of the plane of the form being lit. Lastly, the use of contour lines that wrap around the surface of the forms helps to show both overlap and where edges meet.

OPPOSITE LEFT: I'm beginning to refine the masses into smaller subforms as I move across the figure. Even though the artist usually starts at the top and works down in this system, it is always better to work across the figure as you model the form. As I'm typing this chapter, the cursor is moving on my screen from left to right, even as it moves down the document, line by line. Modeling form is very similar. You can move in a few directions at once. You get a better feel for the terrain that way.

OPPOSITE RIGHT: As I move down the figure, I'm trying to unify the various parts of the body by having a consistent value for the shadows and a strong sense of the direction of movement of form in the light areas.

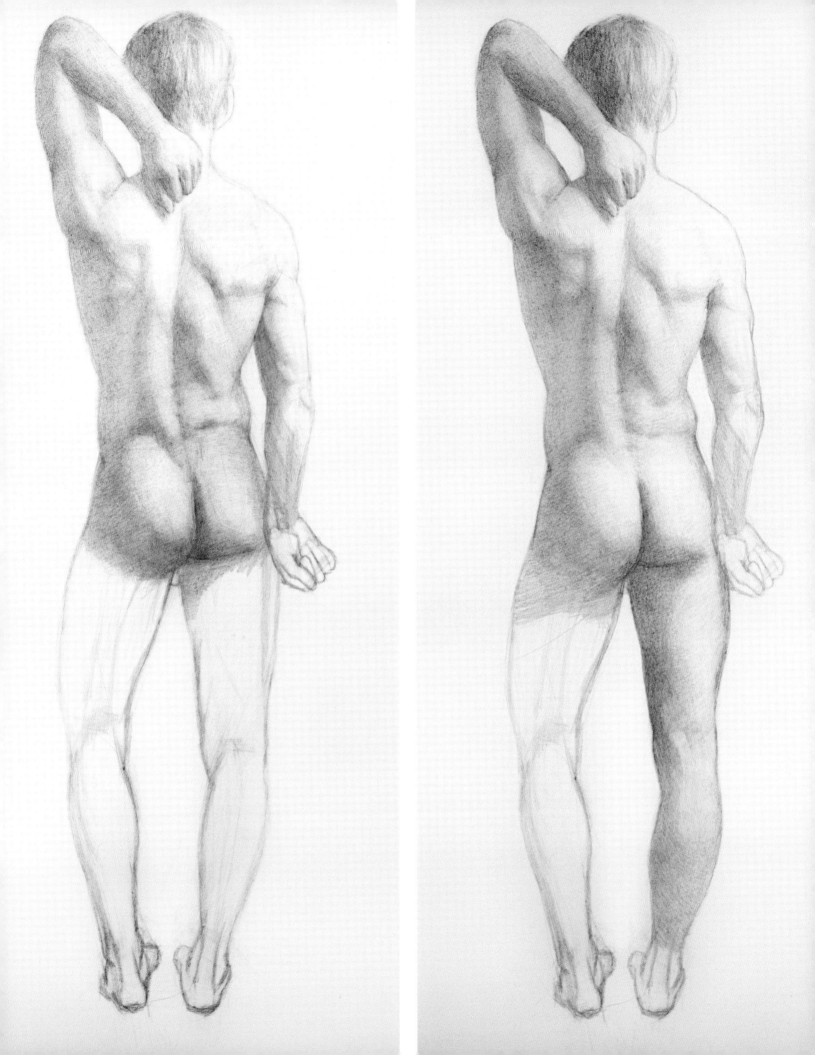

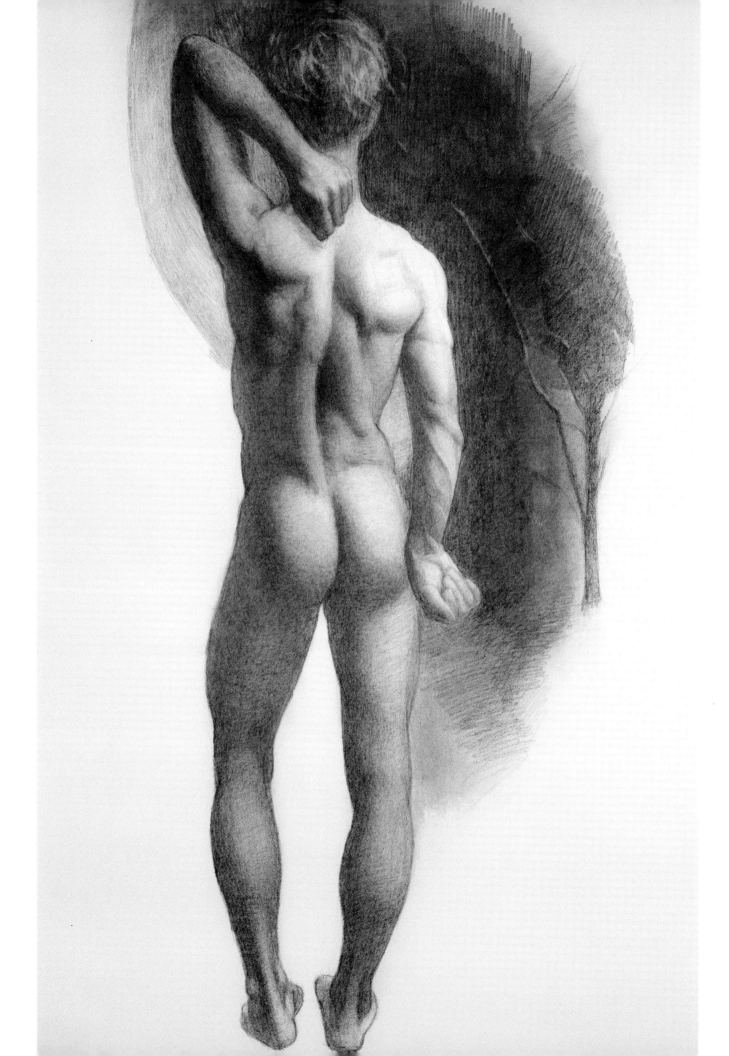

STEP 5 | ADDING THE FINISHING TOUCHES AND REFINEMENTS

To finish the drawing, you have to be able to take the whole into account and to have a vision, or an idea, of where you want to take the drawing. There are several ways of doing this:

- **Take a break from the process:** I think the best way to achieve a fresh perspective is to take a few days off and give the drawing a rest. Put it somewhere out of sight. Once you have a fresh set of eyes, many things can become obvious that were not so before.

- **Reduce the drawing:** Most artists find it incredibly useful to see a reduction of the image. If the drawing (or any other work of art) works well when seen on a very small scale, then you know you have something viable. If it doesn't work, the reasons are usually pretty obvious. There are many ways of reducing. The easiest is to step as far away as you can from the drawing itself. You can also take a photograph of the drawing with your mobile phone and look at it on the device's small screen. You can also use a reduction glass. In appearance, it's identical to a magnifying glass, but functionally it reduces instead of magnifies. This device is also useful for getting more distance between you and the model if you are positioned very closely.

- **Gain clarity by squinting:** If you squint when you look at the nearly finished drawing, you should clearly see a light side and a shadow side of the figure. This type of clarity comes from being focused on a well-defined set of objectives. In essence, a focused mind produces a focused drawing. Squinting helps you see the overall value structure.

In aiming for an overall unity of form, anatomy, and light, the final step can be a precarious one. You don't want to push things too far. You don't want to be too timid if boldness is what is called for.

Here are some questions to ask of the drawing at the final step: Does the light source strike the surface in a believable way? Does the light dissipate as it travels down the figure (in a standing pose)? Is there one area that you fixated on obsessively that calls too much attention to itself? (This area varies by the drawing. There may often be one area that you just never feel you "got.") Are there too many details? Should you eliminate some? Are there not enough? Should you add more? Do the transitions work between the great masses? Does the overall gesture work?

The key to answering many of these questions is to have an overall sense of purpose and focus. When you are a student of someone, your instructor often asks the questions. You need to give the teacher the answers she or he is looking for. Eventually, however, you begin to ask these questions on your own, and then come to your own conclusions. This is when you start to develop your own style.

I have been increasingly incorporating landscape elements into my figure drawings. Part of this comes from a desire to fuse two distinct artistic practices: plein air painting and drawing the human form. Both disciplines require careful and thoughtful observation from nature. Bringing the two together seems only natural, no pun intended. I find the Barbizon School of landscape painting something I return to again and again, as well as the American Tonalists.

OPPOSITE: This is a later stage of the drawing, almost done. I was satisfied with the overall unity of form, anatomy, and light. But I felt that it needed more drama, more presence. So I decided to push the darks a bit further.

ADVANCED LESSONS | OTHER ARTISTS' PERSPECTIVES ON THE BACK VIEW

You have seen how I have handled the back view of a standing model; now let's take a look at some back-view drawings by some other artists. I'm using their work to illustrate concepts that are important for every artist to learn.

Tangents and Peaks of Form

Both of these artists provide terrifically divergent styles and strategies to create form on a back view. Dan Thompson's *Pencil Study for James in Pen and Ink* (right) presents a figure seated on a stool with his back turned to us. The lighting situation provides no large silhouette shadow shape running the length of the body. Instead, we see the large masses broken into smaller subforms, all done in a middle to light value range. Each subform has its own unique peak that faces the light and then turns away from the light (and the viewer) at differing speeds. Due to foreshortening, the model's left shoulder recedes much more quickly than his right. Thompson is aiming for anatomical accuracy in the observation of the hierarchy of larger forms and subforms. The model's left scapula spins forward obliquely on the rib cage, while the right scapula is foreshortened.

In contrast, George Dawnay's *Seated 3* (opposite) features a silhouette shadow that runs the length of the figure. The terminator line that we first discussed in chapter 2 is perhaps better thought of as a *tangent line* in this instance. Not only does it represent the various peaks of form as they turn away from the light source, it also conveys rhythm that does double duty as a terminator and a gesture line. Dawnay denotes it with cool, gray accent

marks, which contrast with the inherently warm sanguine that he uses elsewhere for his transitions. That cool/warm duality is an especially effective means of creating beautiful form. If you squint while looking at this drawing, you will notice how dark those accents are and, conversely, how bright the unfinished shadow portion on the left is. (Squinting always reduces color and allows one to focus on value.) His rhythmic use of contour provides both gesture and transitions between the major forms.

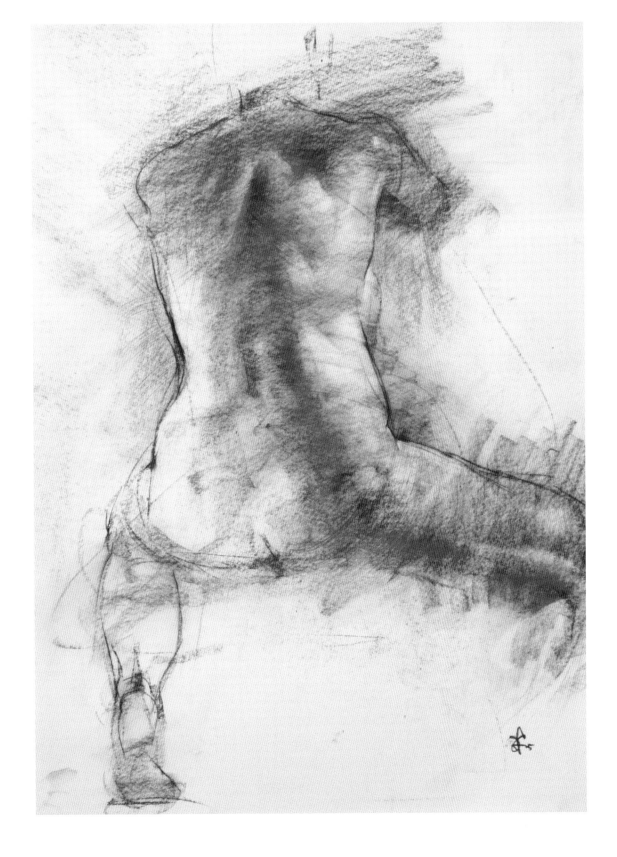

OPPOSITE: Dan Thompson, *Pencil Study for James in Pen and Ink*, 2015, graphite on paper, 24 x 18 inches (60.9 x 45.7 cm)

Thompson's block-in method is rooted in nineteenth-century French Academic techniques. The straight, angular tilts and axes reveal a perceptually based approach. He is looking with intent, and it shows.

ABOVE: George Dawnay, *Seated 3*, 2015, sanguine and pastel on paper, 24 x 18 inches (60.9 x 45.7 cm)

Dawnay has tapped into Renaissance draftsmanship. His drawings are alive with rhythm and dynamism.

High-Contrast Modeling

Both these drawings show a mastery of gesture, proportion, and anatomy. I'd like to call attention to another element that I think they also do exceptionally well: modeling human form with a full range of value.

When instructors teach students to draw in the classical system, they often introduce the basic concepts using form balls and eggs, because the creation of form requires roundness and convexity. When working with a female model, one is often struck by the similarities between the elementary lessons of form creation and basic female morphology, because the forms found on a female figure are oftentimes archetypally rounded.

In Colleen Barry's *Female Figure* (opposite), the notations of the center axis of the figure along the right margins and the skeletal study to the left show her understanding of the fundamental principles of anatomy and structure. But the forms on the figure itself are conceived as overlap on top of that structural platform. Oval subforms that catch light in a scientifically accurate way soften a planar conception of the head, rib cage, and pelvis. Note that the light on the model's shoulders is twice as bright as the light on her pelvis. To finish off the form, Barry also works in touches of reflected light.

In David Gluck's *Katie,* we see similarly masterful handling of light cascading down the major blocks of the body, each with softly rounded transitions. Gluck also took the additional step of pushing the ground to a deeper, darker value, which in turn pushed the light mass on the figure to greater prominence. Gluck's presentation of the gesture of the pose is very clear, as then we follow it up from the stand leg, through the pelvis, along the spine, and across the model's shoulder.

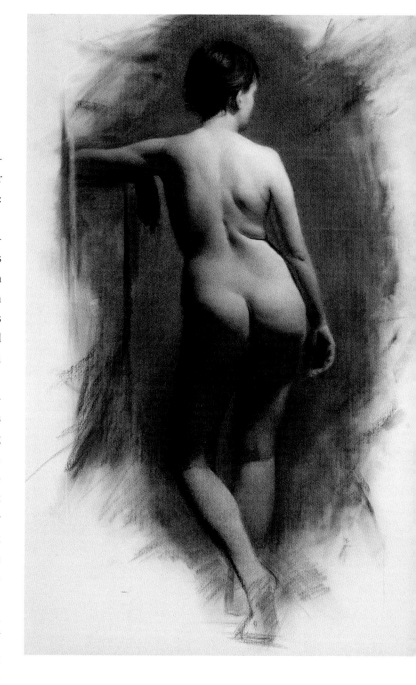

ABOVE: David Gluck, *Katie*, 2011, charcoal on Roma paper, 28 x 20 inches (71.1 x 50.8 cm)
 Gluck's work is exceptional in its use of a full value range to create contrast.

OPPOSITE: Colleen Barry, *Female Figure*, 2009, graphite and white chalk on toned paper, 24 x 18 inches (60.9 x 45.7 cm)
 Barry's work presents an excellent synthesis of French Academic training with an Italian Renaissance understanding of anatomy and rhythm.

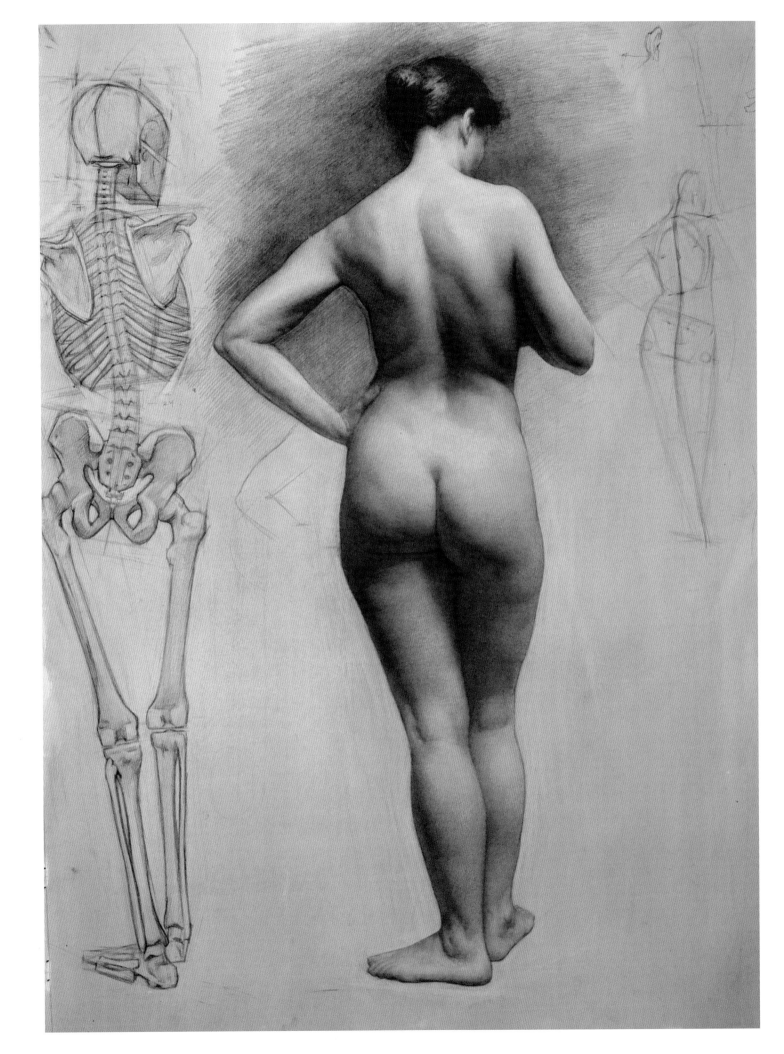

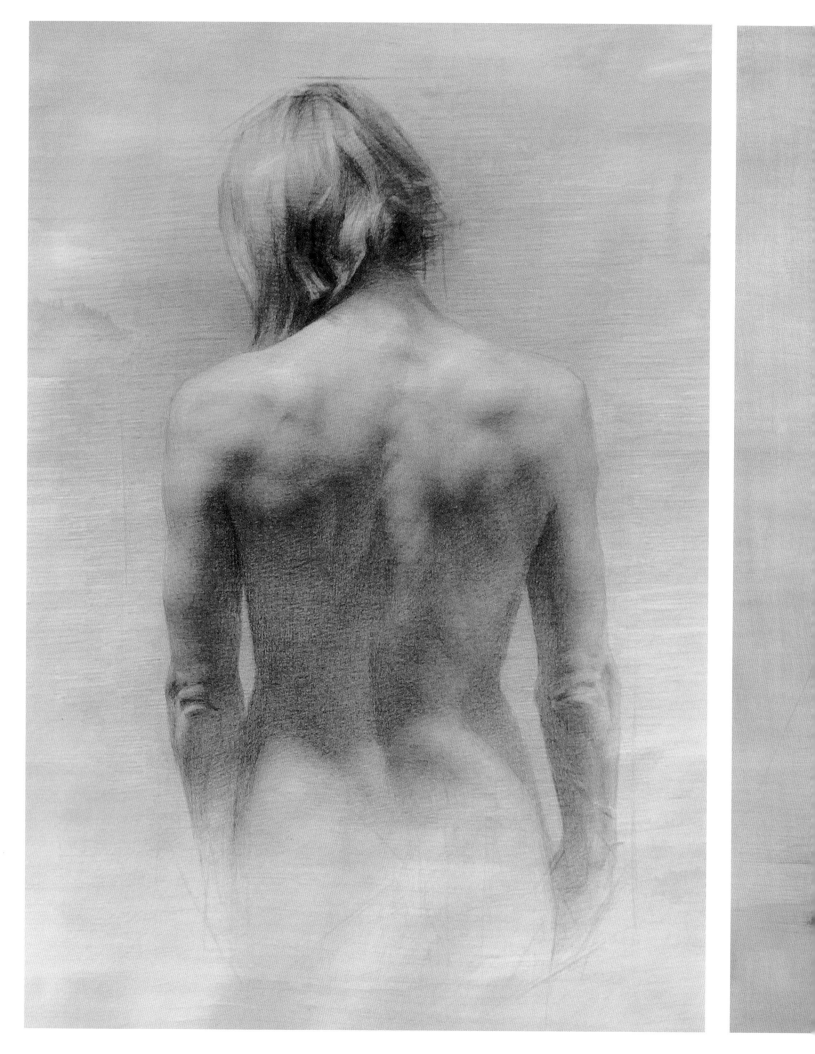

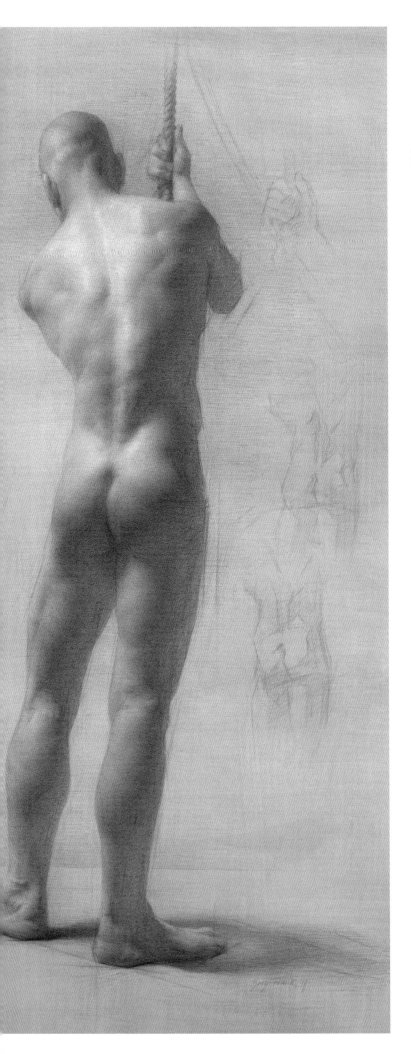

Subtlety in the Light Mass

As opposed to the previous two drawings, Zoey Frank's works pictured here demonstrate how to subtly model form in the light mass without a lot of contrast. Her lights are all in the midrange. Frank pushes the contrast in the shadows. Her form is sculptural and her drawings are primarily about the quality of the light striking the model. While there is a clear distinction between the light mass and the shadow mass, the subforms are modeled in a very compressed value range. But there is still clarity. None of the values in the light mass approaches those of the shadow mass.

Her female figure emerges from the midtone of the paper in a figure-ground relationship that is completely integrated into a believable space.

Her male nude makes use of the silhouette shadow. This large shadow mass runs the length of the figure, clearly dividing it into light and shadow masses while simultaneously unifying all of the major building blocks. Within that shadow, she puts in just a touch of reflected light on each major mass, completing the form of each.

OPPOSITE: Zoey Frank, *Female Back*, 2012, pencil and white chalk on toned paper, 16 x 11 inches (40.6 x 27.9 cm)
 This drawing is particularly notable for the sensitivity with which Frank rendered the transitions.

LEFT: Zoey Frank, *Male Back*, 2012, pencil and white chalk on toned paper, 27 x 13½ inches (68.6 x 34.3 cm)
 In this drawing Frank employed a silhouette shadow that moves from head to toe, successfully unifying the figure's major and minor forms.

Observed versus Conceptual Structure

When we study figure drawings, the philosophy of the artist is often on full display for us. Christopher Pugliese works in a completely perceptual-based system of drawing in *Female Nude*, seen at right. Pugliese sensitively models forms moving over delicate rhythms of the female figure. He uses contour to contain the internal forms, and also to show movement in a subtle way. Notice, for instance, how the contour vanishes into the background in portions of the light and shadow side of the figure. This integrates the subject in a classic figure ground relationship. His subject has internal structure, but it is subservient to the structure of the light.

Sabin Howard's *Back Study*, by contrast, is primarily conceptual, an architectural statement first and foremost. The major masses of the pelvis and rib cage are solid, structural forms, with ovoid subforms of various sizes bursting therein. One can feel the movement of the skeletal substructure underneath the muscle. Dynamic spirals run through the figure from head to toe. The contour contains the forms in a very stylized rhythm. The light is certainly present, as the major forms are lit in a logical and consistent way, but light plays a subservient role to architecture and torque in Howard's drawing.

RIGHT: Christopher Pugliese, *Female Nude*, 2013, pencil on paper, 24 x 18 inches (60.9 x 45.7 cm)
Note Pugliese's subtle shift of the pelvis and stand leg, and his extremely refined modeling.

OPPOSITE: Sabin Howard, *Back Study*, 2014, graphite on paper, 28 x 22 inches (71.1 x 55.9 cm)
Howard favors a much more dynamic, rhythmic, and linear flair, with strong lighting.

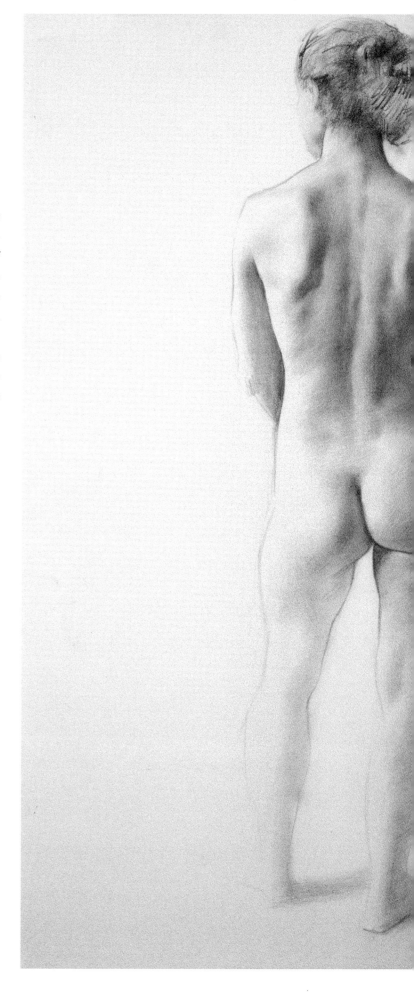

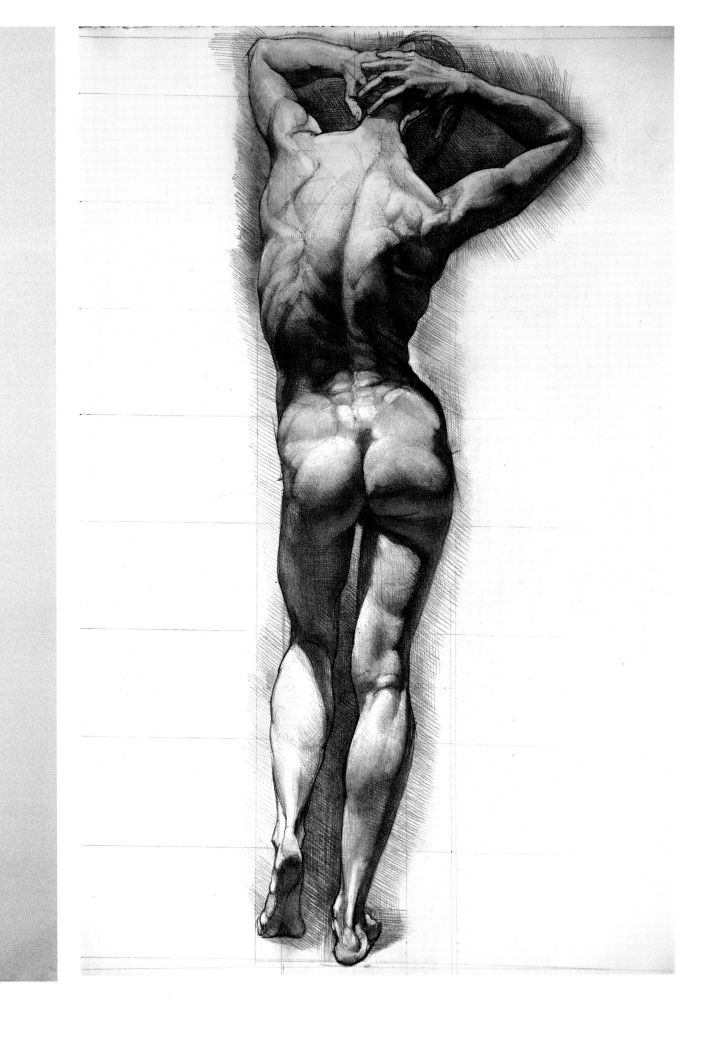

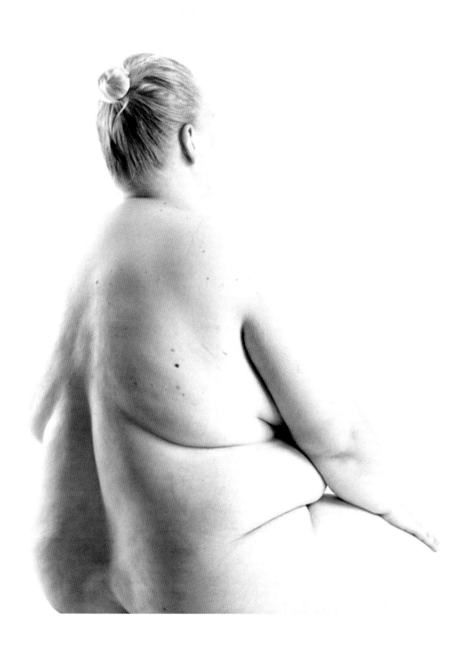

Emotive Qualities

In both of these back-view drawings, the models' faces are not visible, so we have to infer their emotional states from their posture and body language.

There is a long tradition of artists' responding emotionally to the suffering of others, and translating that into their art. But no Photorealists come to mind. Ashley Oubré creates emotionally charged photorealist drawings. She is one of those very rare birds, a self-taught artist who is technically exceptional. In formal terms, her drawings push contrast, the way a photograph would, but she also accentuates the camera-conditioned deviations from reality to create a hyperrealistic image. She includes lens distortion and allows the focal point

ABOVE: Ashley Oubré, *Alicia*, 2014, graphite powder on paper, 17 x 13 inches (43.2 x 33 cm)

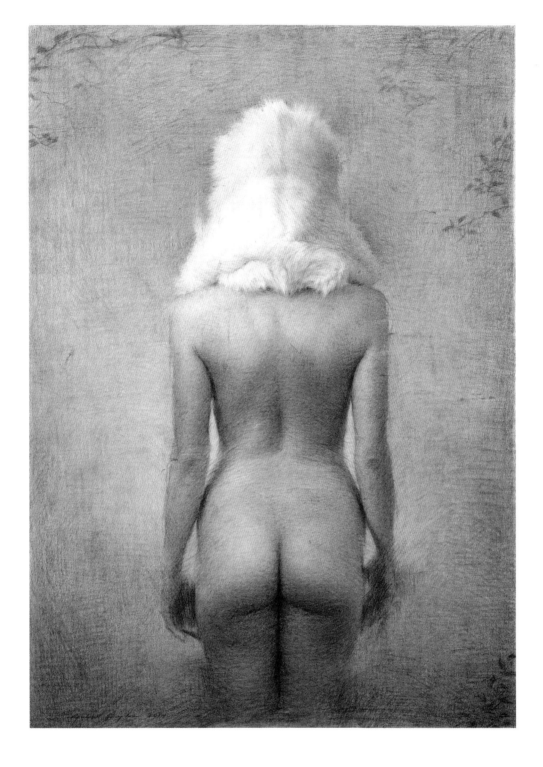

of her source images to dictate the level of detail in a given area. She favors subjects that are socially damaged in some way. Sometimes uncomfortable to look at, her work has a deep power that impacts viewers on an emotional level that moves them to either revulsion or compassion.

Solitude is a major focal point of Julio Reyes's work. He creates quiet moments of personal introspection, often drawing a single figure in a barren landscape, an aesthetic he says he picked up from Andrew Wyeth.

But, unlike Wyeth, the overall aesthetic of Reyes's work is lush, and greatly romanticized. In this drawing, *Tundra*, we see the back view of a model who is nude except for a furry hat. To me, this seems to evoke some of the playful eroticism and frivolity of the Rococo.

ABOVE: Julio Reyes, *Tundra*, 2014, charcoal on paper, 24 x 17 inches (60.9 x 43.2 cm)

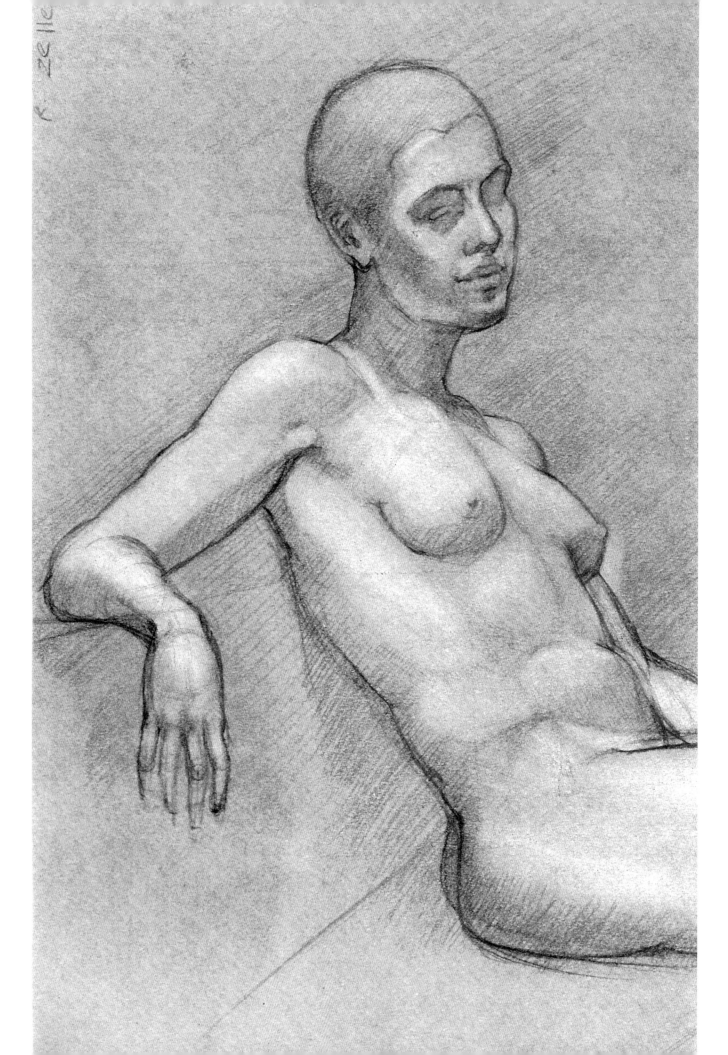

RECLINING FIGURE

The reclining nude has a long historical precedent in Western art. Indeed, there are as many variations on the pose as you can possibly imagine. In this chapter, we will again walk through the creation of one of my drawings, Megan (pages 168–169), step by step. We will follow the same five steps established in the previous chapters. However, some of the steps have been modified a bit, since a reclining view presents unique challenges and, therefore, requires equally unique strategies. In short, the end result looks much the same as the earlier drawings in terms of quality, but how I arrived there is a bit different. And we will be combining steps, so the process will move along faster.

OPPOSITE: Rob Zeller, *Figure Study in Blue* (detail), 2001, pencil and blue pigment on paper, 18 x 24 inches (45.7 x 60.9 cm)
In this drawing, the focus is on the compressed relationship of the head, rib cage, and pelvis.

So what are the modifications specific to a reclining view?

For starters: In a reclining pose, everything is compressed vertically. What is normally the width of the figure becomes its height, because the figure is now lying horizontally. This brings about more of a challenge than you might imagine and changes the first two steps of our method significantly. The gesture lines that normally go from head to toe still go from head to toe. But in a reclining figure they travel sideways, not up and down. The midpoint is more abstract in its location, and not necessarily related to skeletal structures like the pelvis. And there are some other interesting differences, as we shall see.

STEP 1 | FINDING THE GESTURE

In the image here, you see that the gesture lines travel horizontally through the figure. This changes things a bit from the poses we saw in the previous chapters, but is not that big an adjustment conceptually. Notice that the model's left arm becomes the "stand leg" of this pose, bearing much of her weight. Because the legs are foreshortened, they aim away from the viewer and are largely hidden.

Again, when I'm working, I don't actually draw these lines. I see them in my mind and play off them. I do require my students to show them, though, so I know that they have understood the concept.

BELOW: The gesture lines flow horizontally through the pose in a reclining view, but still from the head down through the torso. Notice, though, how the left arm functions as a "stand leg."

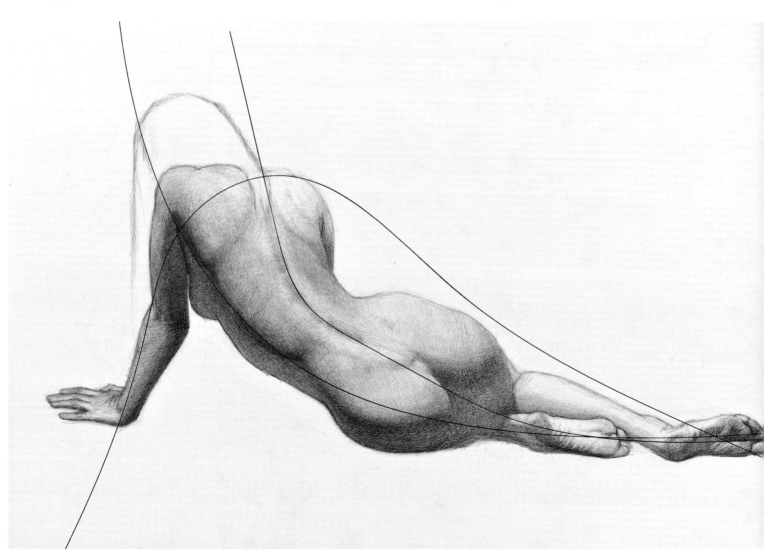

STEP 2 | ESTABLISHING THE BASIC PROPORTIONS (AND A BIT OF SPATIAL MAPPING)

The Quarter System, the proportional system that works on a standing pose, needs to be recalibrated to function well on a reclining pose. With most of the figure in a horizontal position, it would be too complicated to find the middle of the figure vertically. Nor would it be very useful with such a small mass to work with. The bulk of the model's mass lies horizontally. So it's better to find the middle from that axis.

But first, determine the eye level. In this case, I had the model on a raised platform and I was seated at my easel to ensure that I was not looking down on her. This was a personal preference. I've seen many successful reclining nudes where the eye level was high, and the artist (and thus the viewer) was looking down on the model. Per usual, make your promissory marks at the head and feet, ensuring that you fit the model on the page by keeping her between these two points.

Finding the midpoint on your page, between those two points, is quite easy. But finding the midpoint on the model can be tricky when he or she is not vertical. This is a good time to use some measuring. I recommend using a full-length pencil to help with this. Hold it out straight with your drawing hand, elbow locked. Lay one

BELOW: In a reclining pose, the promissory marks are still made at the head and feet, but in a horizontal position. Likewise, the middle is still a focal point, but since it is oriented horizontally, it can be tricky to find. The overlay in red along the top and bottom shows the exact middle point. Even so, it takes a moment to actually believe it.

end (point or eraser end) on the feet, and the other end on the head (or through it, if the pencil is longer than your figure). Make sure the pencil is perfectly sideways and horizontal. Close one eye and then look straight ahead at your pencil. "Clip off" the excess of the straight, where it leaves the figure on either end, by covering it with your thumb, and focus on the portion that traverses the figure. Where is the middle of the pencil? Then, look up from that point to the model. Where are you looking on the model? Then lay a light mark through the middle, vertically, as you have determined it.

Look for the middle in the previous image. This can be tricky, so I set up a grid for you (page 165) with a midpoint marked on the top and bottom. Notice how light the sketch lines are, and that I used only straight lines to gauge relationships between the various points of the pose. This is called *spatial mapping*. It requires a combination of careful focus and an ability to abstract the model.

Spatial mapping, as I practice it, can best be described as making a series of very light lines that are diagonal or perpendicular to each other. These lines are intended to map out, or study, the relationships between various points on the figure to other points in the pose. Some artists call this *triangulation*. Spatial mapping is a little different from triangulation, in that the latter process involves identifying three points at a time, whereas spatial mapping can use any number of points.

Most artists are familiar with the plumb line (a string with a weight attached to one end). When you are spatial mapping, plumb lines can be useful tools. But they are limited in that they guage only verticality. In a reclining pose, it is essential to map the diagonals.

Some artists like to use knitting needles, or even souvlaki skewers, to help with spatial mapping. Those tools are convenient in that they are longer than pencils. But I prefer to use my hand and eye. Personally, I find things more easily by searching with line, rather than by using external devices. However, if you find these tools helpful, by all means use them. The use of external devices to aid in drawing is no crime, and reclining poses are challenging.

STEP 3 | BLOCKING IN THE FIGURE

When considering the reclining view, conceive of the figure as a landscape, with hills and valleys. Foreshortened parts of the figure must be taken into account. In this position the model's legs are almost entirely foreshortened. This is an instance when it is initially helpful to think in terms of pure shapes, almost abstractly.

After mapping out the largest geometric shapes, I immediately shift to thinking about the big three blocks—the head, rib cage, and pelvis—and consider what they are doing in the figure. Because of the foreshortening I mentioned earlier, a different strategy is needed. The legs recede into the distance quickly. In essence, you are looking at the upper part of the model's legs for what seems to be a very short distance, and then suddenly the lower part appears. This type of problem is best solved by drawing the exact shape you see in front of you. Don't think of it as a set of legs. Just objectively draw the overall shape as best you can. Look at that shape and try to conceptualize the anatomy that makes up that shape. Then tweak accordingly.

So now let's review the process up to this point:

- **Find the gesture of the pose, the main conduits of rhythm and flow.**

- **Employ a modified version of the Quarter System to get accurate proportions.**

- **Use spatial mapping to help plot out relationships and coordinates of the block in.**

Thus far, the process has not been radically different from what we have done before, but the next step *will* be, by default. Many tasks will be completed in conjunction with others, rather than in isolation.

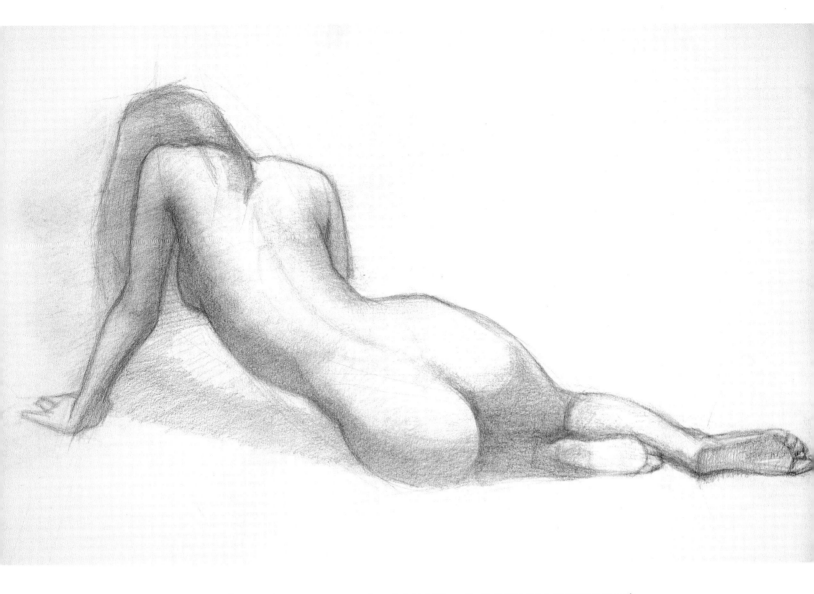

STEPS 4 & 5 | MODELING (AND CONNECTING) THE FORMS & ADDING THE FINISHING TOUCHES

I executed the modeling process here differently from how I did it in the previous chapters. It was a gradual refinement, done in stages, not window shading.

I realized that the rib cage was not massive and barrel-shaped enough. I also needed to be more accurate about the placement of the ribs as they came off the spine. So I mapped out the twelve ribs in the context of the overall shape I had drawn. I had to modify the shape slightly and then place the ribs in with subtlety. Next, I analyzed the *erector spinae*, latissimus dorsi, and rhomboids. Then I placed the scapula on top of the upper portion, in perspective. And finally, I repositioned the "stand arm" just a bit and ran the muscles from the upper arm back up into the scapula region.

I also darkened the shadow considerably on the rib cage and the arm. I made sure to leave ample reflected light bouncing back up onto the rib cage. I left the accent quite dark along the terminator line, just as I did on my egg diagram on page 109.

In this situation, using the dark accents helped me define the full range of form for the enormous eggs of the rib cage and pelvis.

ABOVE: At this stage, I was simultaneously blocking in and engaging in more than a bit of modeling. But two things will change before the final version on the next page. The model's "stand arm" moves into a locked position, and I will essentially erase her head (but leave an outline).

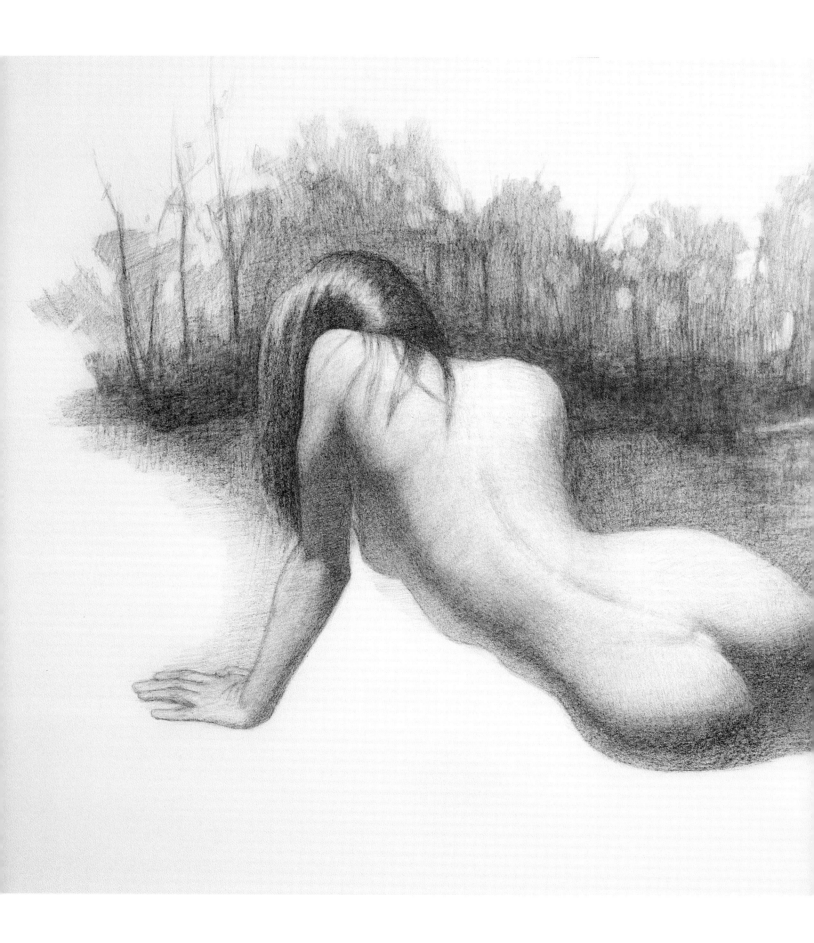

The transitions between the major blocks are important, and I kept that in mind as I modeled the subforms on the rib cage and pelvis. These are the *erector spinae* and the external oblique muscles. The *gluteus medius* and gluteus maximus both form a giant ovoid shape on each side of the pelvis in this pose. The key to situations such as this is fitting the minor shapes into the overall context of the larger shape in which they reside, as well as into the composition as a whole.

To refine the form, I took advantage of the massive shadow shape on the underside of the pelvis area to compress the details of the foreshortening of the legs. I did this by flattening the value range to one, even tone, with just a hint of reflected light. I thoroughly enjoy the effect that a flat shadow has next to giant egglike forms. It makes them pop even more. Just keep the transitions short, and the form in the light area will be clearly defined.

Modeling the lower legs was simply a matter of patience. Feet and hands are never easy. I practice the philosophy of divide and conquer when it comes to feet and hands. Draw a "shoe" or a "mitten" first. Then add the details, like the heel and fat pad of the ball of the foot. Lastly, toes. Then go back and add the various other details, like wrinkles and shadows. As with all extremities, focus on the joints. It makes the feet and hands more believable if the wrists and ankles are well conceived. Here I paid close attention to how Megan's ankles connected her feet to her lower legs.

LEFT: Rob Zeller, *Megan*, 2015, pencil on paper, 18 x 24 inches (45.7 x 60.9 cm)

The artists whose work appears on the pages in this section deal with the subject of the reclining nude using their own unique vision and creative process. Whenever possible, I point out the commonalities. But often, the subtle differences are what make the discussion enjoyable. As in the preceding chapters, this section will allow you the advantage of seeing more than one method of dealing with the concept at hand.

Dynamic Rhythms

Many things can be said about the beautiful poses on these two pages, but I wanted to focus on one aspect of them, mainly the rhythm flowing through the figures. In Alex Kanevsky's *J.W.I.* (below), we see a reclining figure drawn in a kinetic rhythm of staccato movements. In his method, Kanevsky leaves behind both the evidence of a grid and the ghost contours of the model's previous positions. It is as if we are watching her movements through time-lapse photography. The grid marks notate the placement of an object or person. Kanevsky's intent is to capture not specificity, but rather movement. Eschewing the use of value to create form, he instead relies on his line quality, which is such that he also captures life, because it is particular to revealing the model's forms.

In *Deposition of Christ* by Colleen Barry (opposite), let's focus on the lyrical rhythm that permeates the main drawing. This rhythm separates her work from that of most atelier-trained artists. Atelier training relies heavily on the nineteenth-century French Academic system, which has much to recommend it, as it has brought back a focus on craft and incredible attention to detail that was missing from much "modern" art education. But instruction on how to convey rhythm and gesture is often missing from the curriculum

LEFT: Alex Kanevsky, *J.W.I.*, 2013, pencil on paper, 22 x 30 inches (55.9 x 76.2 cm)
The reclining figure is seen here in motion, as Kanevsky tracks the movements via a roving contour. In his method, Kanevsky leaves behind both the evidence of a grid and, through careful observation, evidence of previous positioning.

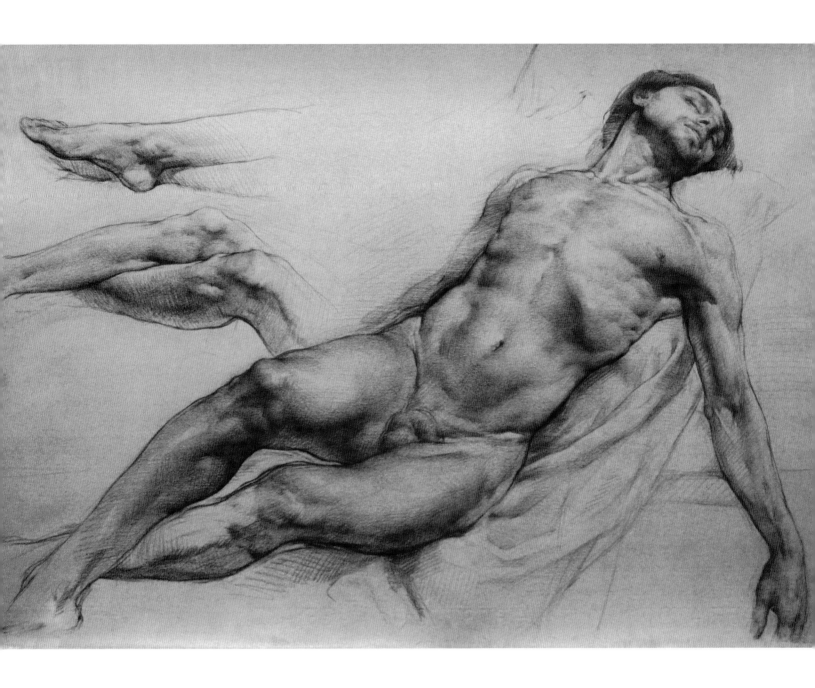

of traditional ateliers. Barry, to her credit, takes many of her cues from sixteenth-century Italian artists. They understood and executed rhythm and design in ways that the French atelier system simply could not codify, being too rooted in staid Neoclassicism. The modern resurrection of the atelier movement will have to recover this somewhat abandoned element of artistic training. Barry has found it again like few others I've seen.

ABOVE: Colleen Barry, *Deposition of Christ*, 2012, brown pencil on toned paper, 11 x 17 inches (27.9 x 43.2 cm)

Here, the body reclines with a dynamic diagonal and rhythmic pull that permeates the figure and drapery. Each muscular subform fits into the pattern of the greater whole. The largest shapes are made up of well-defined smaller shapes. This creates a composition that works as a rhythmic whole.

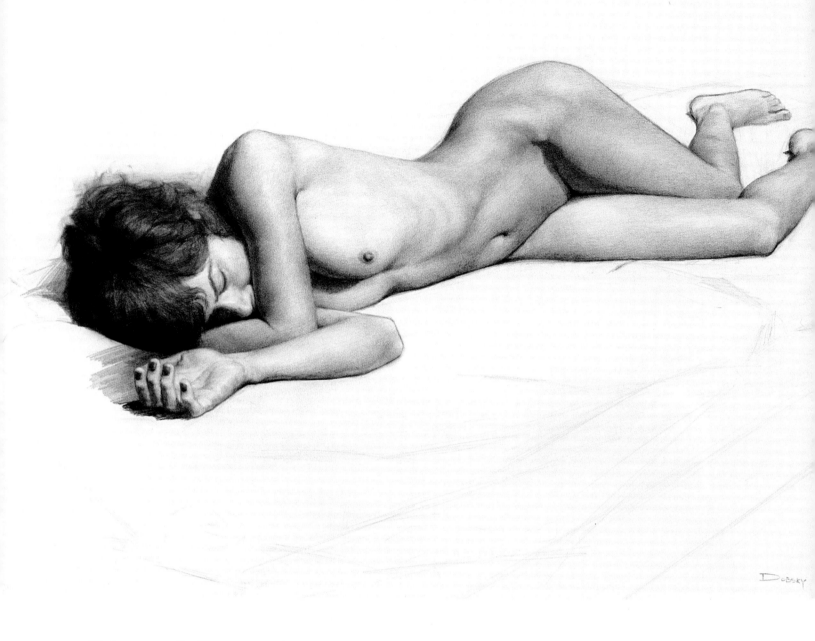

Diagonal Compositions

As artists who work in two-dimensional formats, it's important for us to remember that our eye level will be the viewer's eye level. In sculpture, you can walk around a piece and admire it from many angles. For the viewer to be sold on the accuracy of a drawing, however, there needs to be an accuracy of perspective. Where are you standing in relation to the model when you create the piece? Proper understanding of this is one of the things that helps an artist graduate from creating obvious student work to creating images that carry his or her own artistic vision.

In addition to eye level, the artist needs to understand the ground plane in perspective. In both of the drawings shown here, the figure moves away from the viewer at a diagonal angle. Foreshortening is the ability to "sell" the viewer on how quickly the forms recede from their vantage point. Notice the size of the head of the figure versus the size of the feet in Carl Dobsky's piece (above). In Steven Assael's drawing (opposite), notice how you see the underside of the model's breasts and just over the top, but her neck is

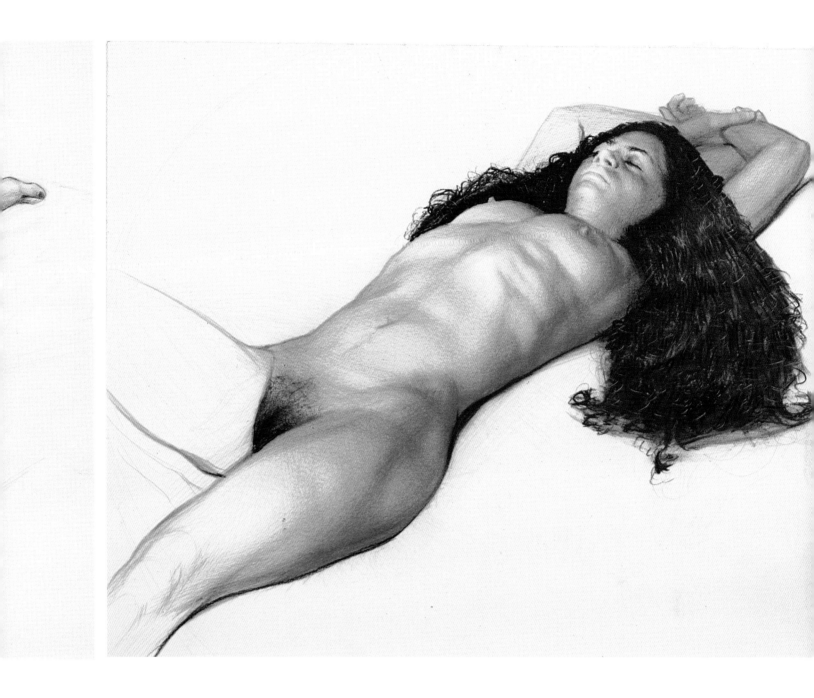

completely obscured. The viewer accepts that it's really there, but is simply not visible because of perspective.

Although my purpose here is to discuss the use of perspective, it seems a pity to regard these drawings in merely a spatial sense. In both, you can feel the skeleton come to the surface of the model's skin, as the anatomy is well understood. Both of these artists have a unique sense of form and of modeling of light and shadow.

OPPOSITE: Carl Dobsky, *Reclining Female Nude*, graphite on paper, 18 x 24 inches (45.7 x 60.9 cm)

The artist is standing above the reclining model, and a bit off to her left. Can you tell the visual clues that give the perspective away in this drawing?

ABOVE: Steven Assael, *Reclining Figure*, silverpoint and stabilo on paper, 18 x 24 inches (45.7 x 60.9 cm)

Assael is famous for his rendering of hair. Very few artists have his ability for describing every curl, and in a full value range. Here, the model's hair moves back in perspective around her head in a believable way.

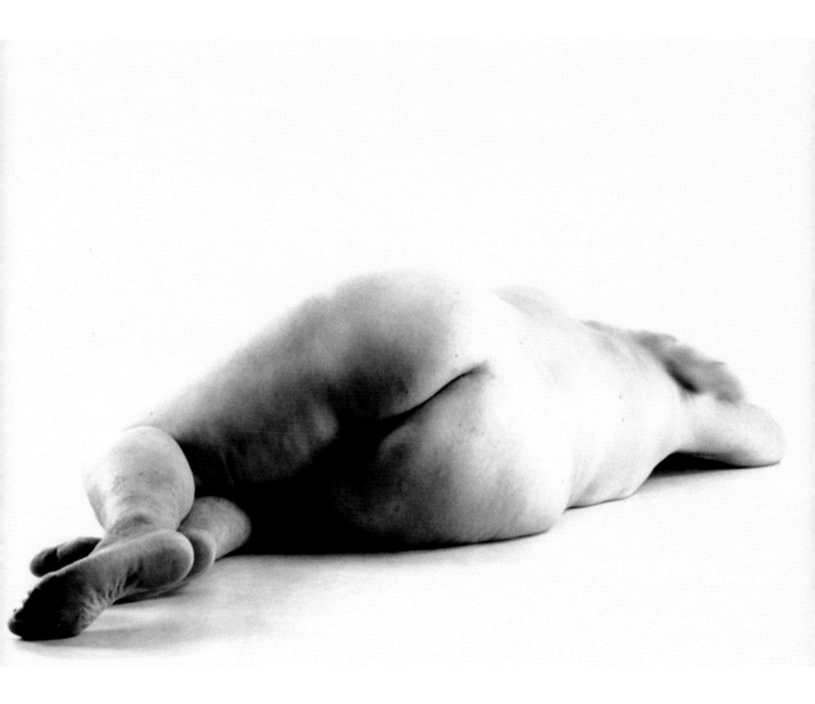

Emotive Qualities

Reclining poses are quite effective at conveying an emotional quality. In the works on these two pages we are not looking at mere figures, *we are looking at people*. The artists have imbued their subjects with a real presence that makes us have empathy for them, although their emotional states are very different.

In *Agony II*, Ashley Oubré brings the viewer down to the eye level of the figure, using foreshortening to give her subject a monumentality that one might feel when looking at a mountain range. At the same time, she creates an intimacy between viewer and subject of being in the same space and on the same ground plane. The figure is handled in an unidealized and realistic manner, not classicized in the least. She is beautiful, but in a somber, tragic way, conveying a sadness and sense of defeat that is unusual for a photorealist work.

Julio Reyes's *Moonlight Poppies* exudes a strong and sensual Dionysian quality. We hover over the figure,

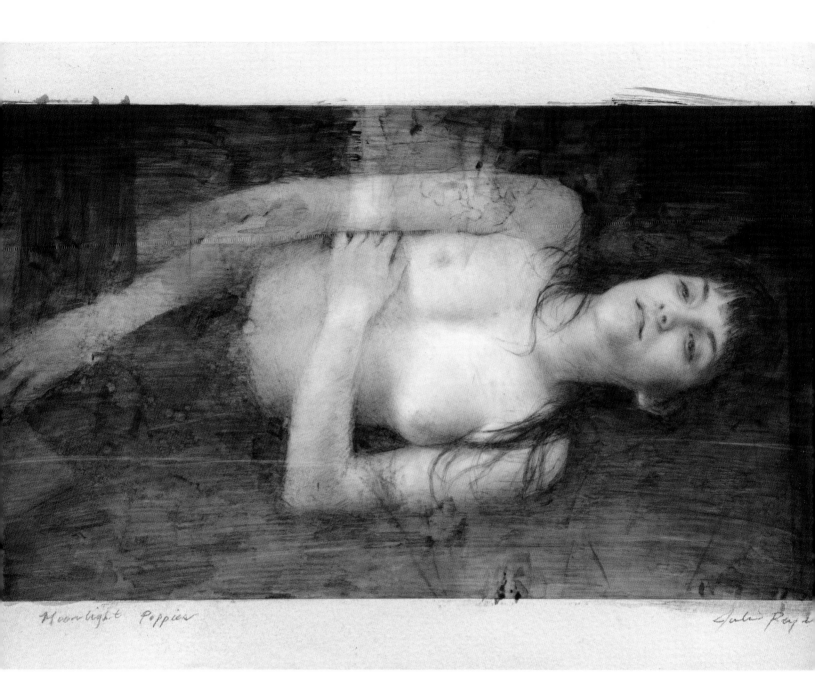

Moonlight Poppies

looking down on her from above, slightly voyeuristically. The contrast of lights and darks is quite strong, the edges of the forms soft and effuse. Technically savvy, Reyes achieves the appearance of part of the model's being submerged, as well as the play of moonlight on the surface of the water.

OPPOSITE: Ashley Oubré, *Agony II*, 2015, graphite powder, carbon pencil, and India ink on paper, 44 x 60 inches (111.8 x 152.4 cm)

Oubré documents the tragic, the broken, the individuals full of pathos. That she does so by working in Photorealism, a style famous for its detachment, is quite a feat.

ABOVE: Julio Reyes, *Moonlight Poppies*, 2015, charcoal, carbon pencil, and black gesso on Mylar, 6 x 9 inches (15.2 x 22.9 cm)

Reyes's emotional content in this piece, the "beautiful pathos," is straight out of the Romantic movement.

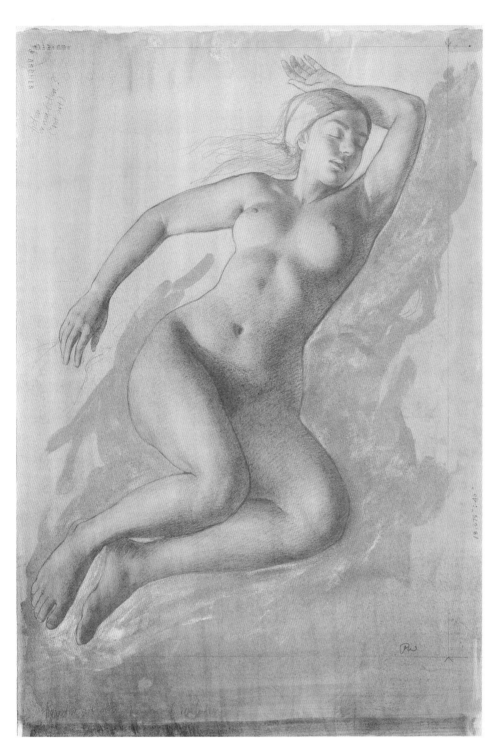

Foreshortened Views

Both of these drawings are wonderful because of the simultaneous use of classical form and abstraction. But the artists' intentions are very different. Patricia Watwood's intention in *Study for Sleeping Venus* was to work out a composition for a larger painting. It's a means to an end, but still showing a beautiful sense of rhythm and form. We look down on Venus as she sleeps, with the light source coming from the left, but the gold paint used to frame the figure ignores the traditional rules of light and shadow, offering a slight touch of Fin de Siècle sensibility.

In *Megan Twice*, Kent Bellows uses many abstract organic elements to create a patterned depth in which to set the two figures. Both figures are well realized in

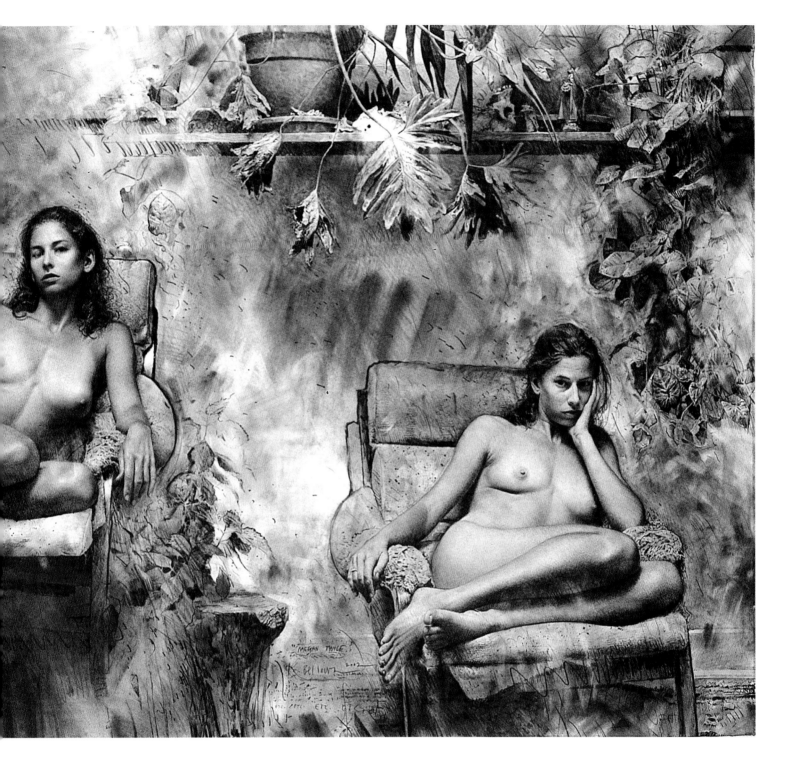

a classical sense, but are offset by the chaotic surroundings. The viewer can see that it's a dual portrait of the same woman, in two different poses. Interestingly, Bellows puts one directly on our eye level, and one below it. He is playing visual games with traditional realism with much the same formalism one would find in an Abstract Expressionist.

OPPOSITE: Patricia Watwood, *Study for Sleeping Venus*, 2012, pencil and gold watercolor on toned paper, 22 x 15 inches (55.8 x 38.1 cm)

ABOVE: Kent Bellows, *Megan Twice*, 2002, graphite on paper, 26 x 41 inches (66 x 104.1 cm), courtesy of the Joslyn Museum of Art, Omaha, Nebraska

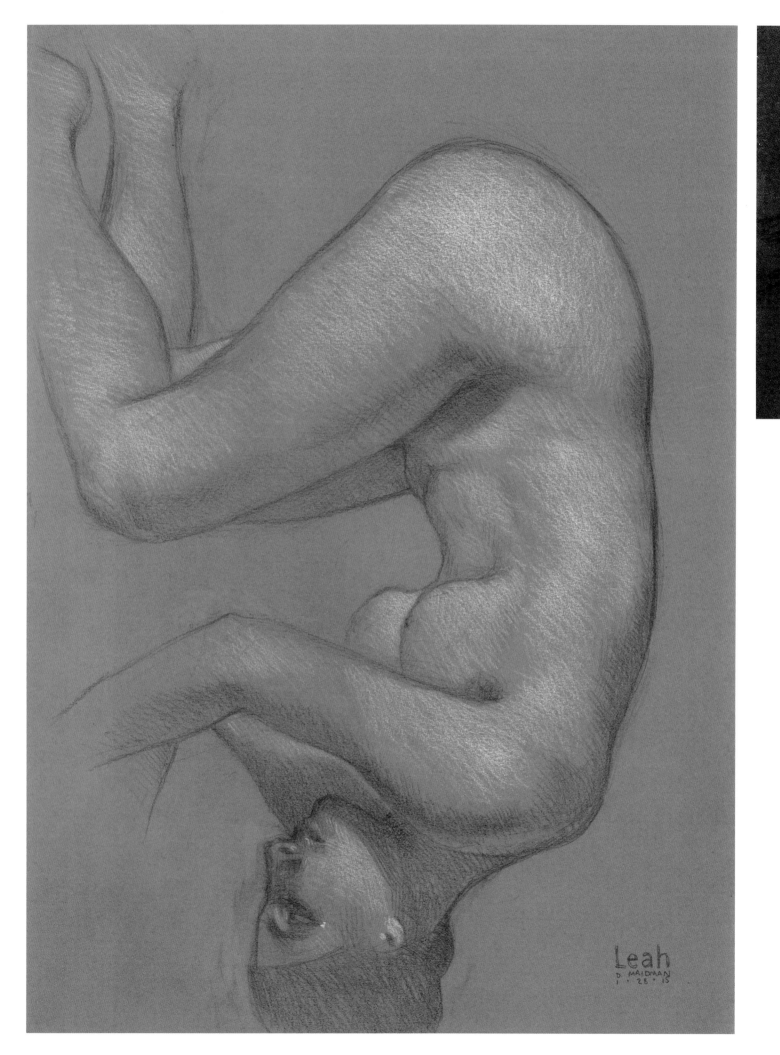

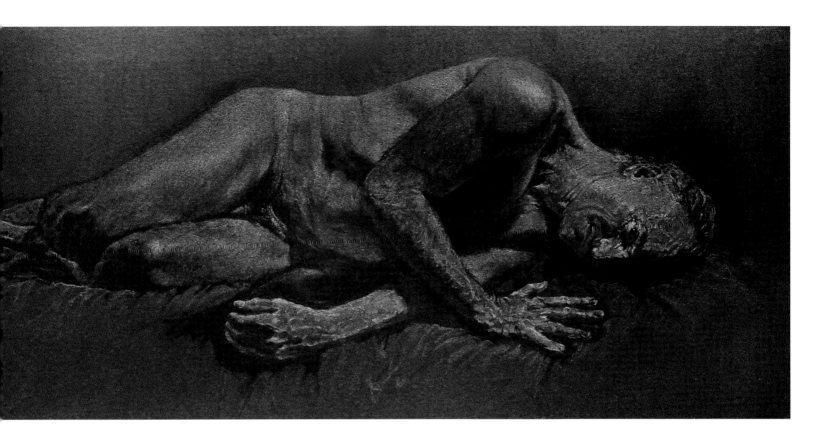

Toned Paper and Modulated Form

Toned paper facilitates the creation of form using another value structure entirely. Instead of white paper as a background, and adding a darker value to create shadow, toned paper allows for a middle value to serve as the foundation of the drawing. The artist then adds a lighter value (usually in white chalk or pastel) to create form in the light range and then a darker value (in charcoal, pencil, or pastel) to modulate the shadow range. When the concept of color is added to the mix, you have a situation that works in a manner similar to painting.

These two artists do a wonderful job in creating form within that framework. Daniel Maidman is very subtle in the modeling of form in his drawing *Leah*. Figuring out exactly where eye level is here is quite the task. Are we looking down on the model as she lies on her side? Did the artist turn the drawing sideways and then sign it, to throw us off? One thing is certain: He has given the viewer a clear direction of light, as all of the forms are lit from the same direction. Key section: On the model's right thigh, observe how Maidman slowly moves from the tone of the paper (just above the knee) to a bright highlight on the muscles of the pelvis (gluteus maximus and *gluteus medius*).

Sherry Camhy's *Father Time* is as dark as you can get and still perceive form. Camhy confined herself to the low end of the spectrum of light, which is not easy to do. She added no lights at all. The black of the paper is lighter than the graphite drawing. This is the dark night of the soul that we all hope to avoid, shown in plaintive, heartfelt language through the exceptionally dark value range and the physical struggle evident in the figure's pose.

OPPOSITE: Daniel Maidman, *Leah*, 2015, graphite and white Prismacolor pencil on blue Rives BFK heavyweight printmaking paper, 15 x 11 inches (38.1 x 27.9 cm)
 Daniel Maidman works the lights in soft and subtle ways in this drawing.

ABOVE: Sherry Camhy, *Father Time*, 2007, graphite on black paper, 15 x 30 inches (38.1 x 76.2 cm)
 Working black on black with this drawing, Camhy added no white at all.

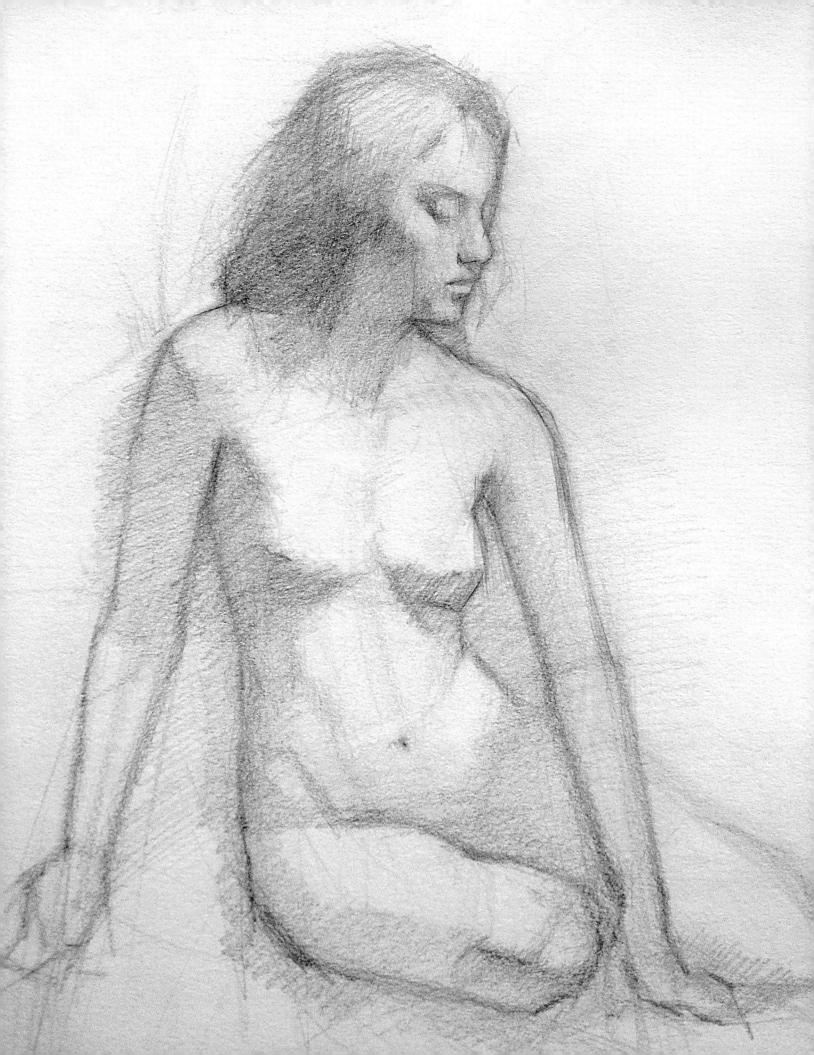

THE ARTIST'S SKETCHBOOK

Making figure drawing a part of your regular routine is a primary means of truly mastering it. Maintaining an artist's sketchbook and quick figure sketching from the live model are both key practices in achieving that goal. Similar to keeping a diary, maintaining a sketchbook can be a personal way to foster your creativity, providing a place to work out concepts and compositions for new ideas. Sketchbooks also help you stay engaged in a perceptual way in the world around you. Similarly, drawing the live model in a quick-sketch format on a regular basis will help you learn to ignore details and discern the essential, keeping your figure-drawing skills sharp.

OPPOSITE: Rob Zeller, *Kate*, 2014, pencil on paper, 17 x 14 inches (43.2 x 35.5 cm)

KEEPING A SKETCHBOOK

It is eminently practical to keep a sketchbook going at all times. It does not require a huge investment of money. You need some pens, some pencils, a sketchbook. Any combination of wet or dry mediums will do. We sketch to interact with the world around us. In doing so, we learn about ourselves. This is why sketching is as key a practice to an artist as praying is to a religious person. It's an act of being engaged with what one believes in.

My own sketchbooks are usually very personal. I do not show them to many people. I often sketch my daughter while she is asleep, as seen in the images on these two pages. I find it an incredibly moving sight, one that I'd rather immerse myself in than take a photograph of.

Sometimes I even write diary entries directly onto the pages, next to or over the images, adding a verbal layer to them. This helps me understand the issues at hand better. I treat my sketchbook as a stream-of-consciousness aspect of my creative life, separate from my professional career. But one invariably feeds into the other.

It is acceptable to mimic your teacher's style, to a point, when first starting out. But in regard to depicting the human figure, it is very important to develop your own aesthetic. The lessons in chapters 2, 3, 4, and 6 will

ABOVE: Rob Zeller, *Emalyn and Sasha Sleeping*, 2016, pencil on paper, 8 x 10 inches (20.3 x 25.4 cm)

be helpful in providing you with a solid foundation for figure drawing, but to really express yourself, you will find keeping a sketchbook vital. Your own creativity can be both overwhelming and elusive. Sometimes it whispers and other times it shouts. I've heard artists describe it as a state of being that comes from deep within. Others describe it as something that is outside oneself, a sort of ether *up there* from which one pulls ideas. Without regular practice, it's easy to lose connection with your own creative voice, and to put off the hard work of creating your *own* figurative compositions.

In school, an artist learns to draw the model on a model stand. This is a necessary construct to teach students the rudiments of depicting the figure. Even in non-traditional art schools, there is an academic aesthetic to

this. The best way to step outside making student work is to stop making it. By observing people in everyday situations and trying to sketch them as they are in reality, you remove the academic layer. Drawing clothed figures is another challenging aspect to sketching from everyday life. It is also a very good practice to copy from the Old Masters in your sketchbook. Few of the Old Masters made purely academic studies in their sketchbooks. You will find their compositional schemes most helpful to repurpose for your own ends. They did the same thing with their heroes, so you needn't consider it stealing.

ABOVE: Rob Zeller, *Emalyn Sleeping*, 2014, pencil on paper, 14 x 17 inches (35.6 x 43.2 cm)

Using a Sketchbook to Help Find Your Voice

A common misconception about traditional atelier training is that becoming an excellent figurative draftsman, on a purely technical level, is the key to breaking out of the "student" mold and transforming into a real artist. That mind-set has some merit, but is only partly true. Discovering something unique to say is just as important, and that part of your training, personal creativity, is not teachable. You must learn it for yourself. A good program can provide the environment for you to do so, or you can build your own "creative space." Once your training is completed, you must take the time to set up your own system, *your* way of working. The artist's sketchbook is a key means to that end.

As a teacher, I often have students come to me to evaluate the work they are making outside of class. They need a person of authority to tell them whether their efforts are any good. Imagination is powerful but incredibly sensitive to external influence. A good instructor will provide encouragement, but maintaining a sketchbook is very important in furthering your own progress as an artist. It is a uniquely personal place, not subject to criticism, in which to explore creative concepts. An artist who keeps one going is much more likely to have a degree of independence from outside authority. How many people would you share your personal diary with to see if it was any good? You alone

would be the best judge of that. After all, what is the measure of an effective diary? Honesty, perhaps? Only you know how true you are being to your own ideas. Sketchbooks are self-validating.

If students go to their instructors for affirmation of their efforts, then working artists often go to the market for the same. If they sell work, they feel validated. There is certainly something practical to this. But that is not how the creative process works. Rather, it is how the art market works. Whether you sell work or not, your creativity needs no outside endorsement. It is rooted inside you. A sketchbook is your conduit to that core. Its pages may be filled with imperfections. But in them, you will find what you need to say by staying engaged simultaneously with yourself and the world around you.

OPPOSITE: Steven Assael, *Church Drawing—Spread 3*, 2015, graphite and stabilo crayon on paper, 6 x 8½ inches (15.2 x 21.6 cm)

ABOVE: Steven Assael, *Church Drawing—Spread 1*, 2015, graphite and stabilo crayon on paper, 6 x 8½ inches (15.2 x 21.6 cm)

The artist Steven Assael often sketches in a church. He attends one that has a high balcony that allows him to sketch various congregants below. As seen in the images here, he often draws groupings of people, or, in the case of one pregnant woman, draws the same person in various positions within a single composition.

ABOVE: David Bell, *Charlie*, 2016, pencil on paper, 10 x 8 inches (25.4 x 20.3 cm)

A film director and stop-motion animator by trade, David Bell fills his sketchbooks with drawings of interesting characters from everyday life in Brooklyn, New York, and from his travels. Mainly interested in colorful character studies, he is constantly taking in life around him, recording it in his sketchbook, always on the lookout for new material for both personal and commercial projects.

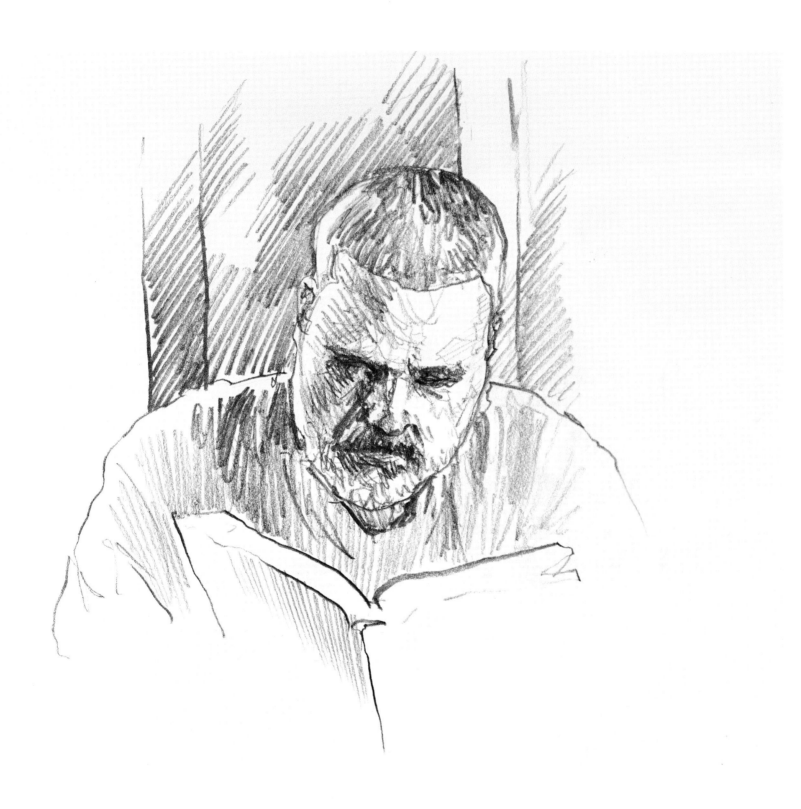

ABOVE: David Bell, *Café Patron*, 2016, pencil on paper,
8 x 10 inches (20.3 x 25.4 cm)

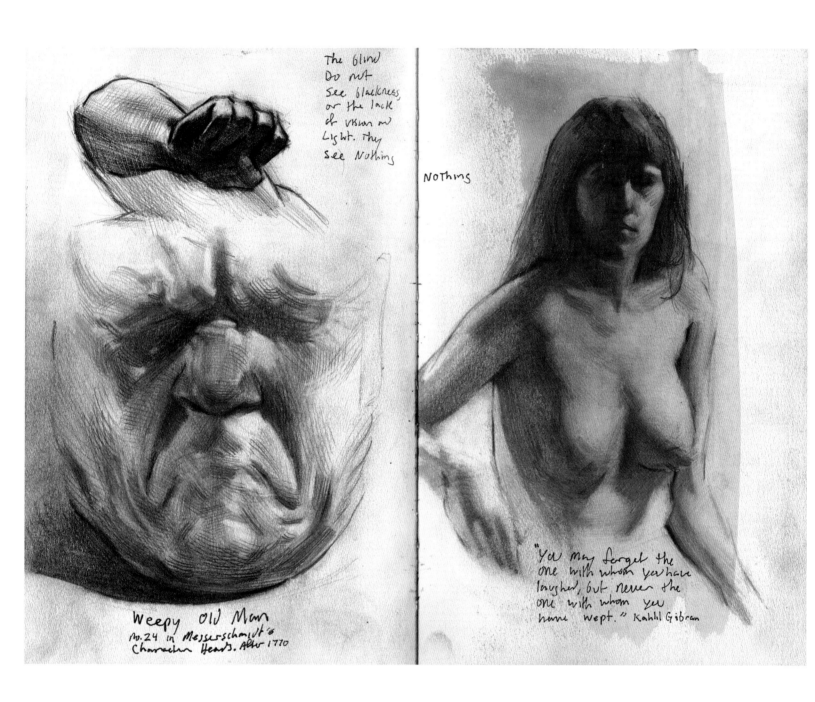

The Blind
Do not
See blackness,
or the lack
of vision or
Light. They
See Nothing

Nothing

Weepy Old Man
no. 24 in Messerschmidt's
Character Heads. After 1770

"You may forget the
one with whom you have
laughed, but never the
one with whom you
have wept." Kahlil Gibran

Evan Kitson creates epic sketchbooks that are filled with drawings made from both observation and imagination. Largely uninterested in purely academic studies, Kitson takes many liberties with color to suit his reaction to the subject matter. He executes his forms with layers of cross-hatching, creating bold, high-contrast masses. He treats a given page in his sketchbook like a complete composition. A two-page spread may feature portraits, figures, written text, and more. He likes to mix in silverpoint as a drawing medium, and sometimes shellac, or even gesso, to stress the surface of the paper and provide depth and texture. Kitson studied with Odd Nerdrum at his home in France, and some of Nerdrum's influence is visible in his work. Kitson lists Käthe Kollwitz and many other artists as inspirations to him.

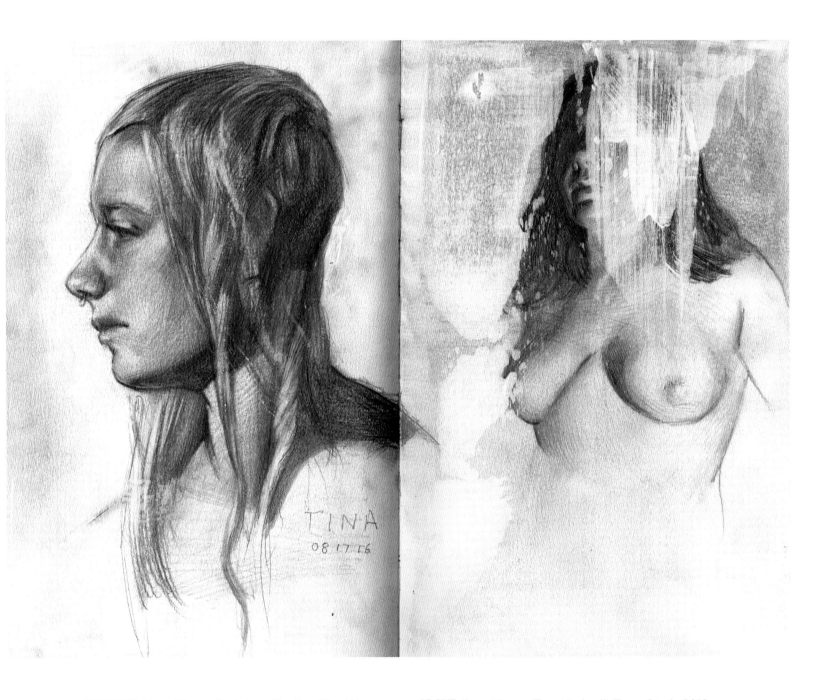

OPPOSITE: Evan Kitson, *Sculpture Studies (The Wrestlers and Weeping Man), Quinn*, 2016, colored pencil, graphite, acrylic, and ink on sketchbook paper, 9¼ x 12 inches (23.5 x 30.5 cm)

ABOVE: Evan Kitson, *Tina, Under-lit Torso Study*, 2016, graphite and acrylic on sketchbook paper, 9¼ x 12 inches (23.5 x 30.5 cm)

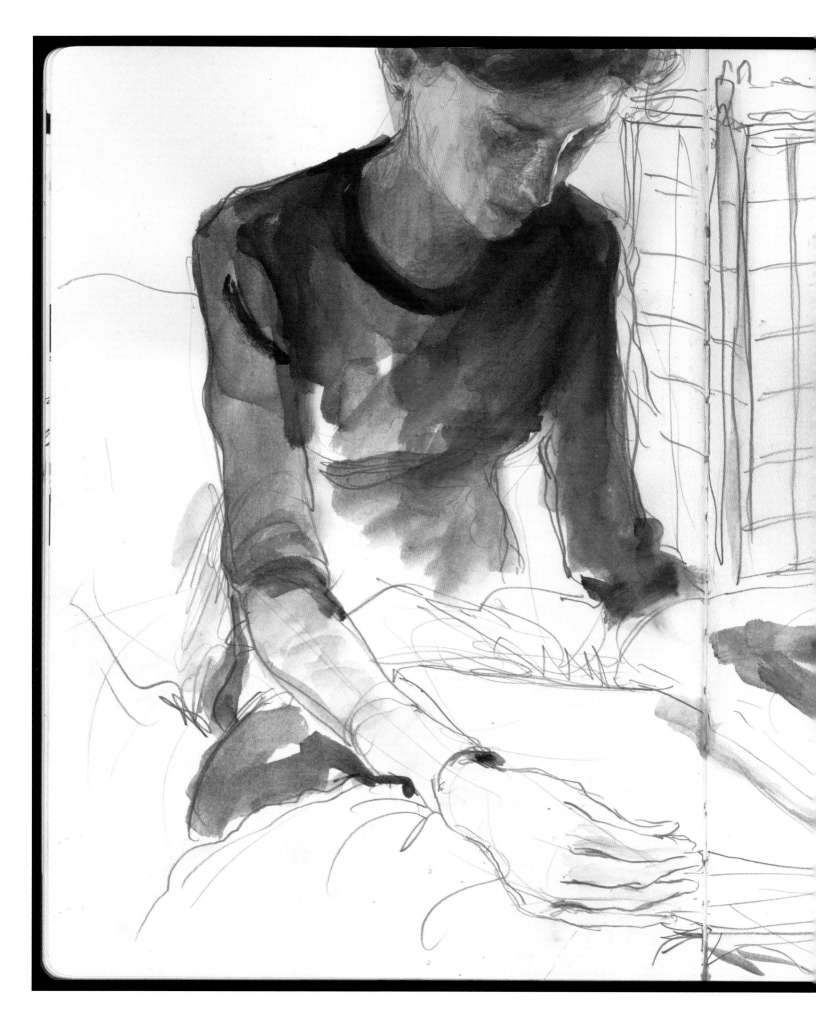

LEFT: Dorian Vallejo, *Art history before sleep—Washington D.C.,* 2016, pen and ink on Moleskine sketchbook paper, 11½ x 16½ inches (29.2 x 41.9 cm)

Dorian Vallejo's sketchbooks are full of conceptual drawings that are a mix of imagination and observation. He combines lush illustration techniques with careful, intuitively drawn faces and hands. While most of his more finished creative work depicts figures in a dream state, his sketchbook often shows them engaged in the simple, realistic activities of everyday life.

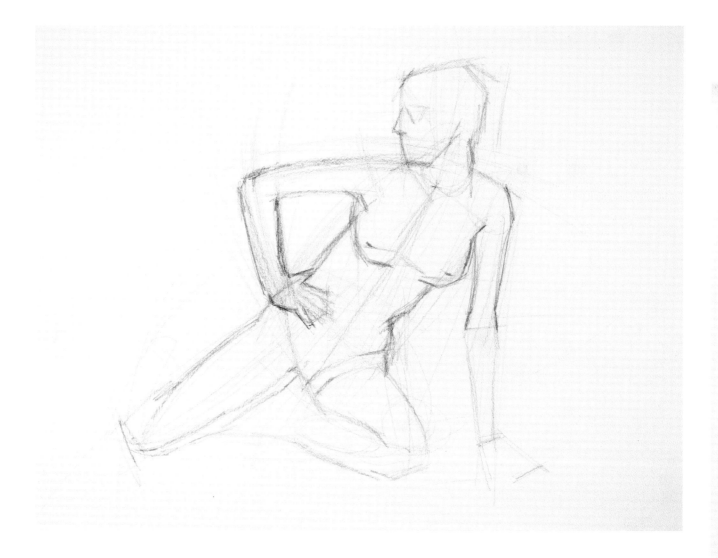

Quick Sketches from the Live Model Are Important

Maintaining a sketchbook for your creative ideas is best augmented by the practice of quick figure drawing from the live model. This helps keep your figure-drawing skills sharp, which is important because when not in use, these skills decline rapidly. Due to financial constraints, many students immediately start to work from photographs after they finish their training. This is understandable, but working from photographs will not prevent your figure-drawing skills from diminishing. Photographs are missing much valuable information in regard to form and structure. Photos may help you see and capture refined details, but not the essentials of rhythm, proportion, and geometry. Working from a live model continually is key to both maintaining and improving these skills.

Open figure-drawing sessions have become ubiquitous for two reasons: a resurgence in the popularity of the figure in art, and the fact that such sessions are

usually very reasonably priced. They play an important part in meeting the needs of artists who are interested in drawing the nude figure but cannot afford to hire a model. Their communal nature helps keep costs down and also gives artists some company (and in some cases, competition) while they work from the model. The shorter poses that are usually the focus of such sessions provide unique challenges on a technical level.

Atelier training relies primarily on the long, sustained pose. This allows artists to slow down the process of both observation and conceptualization of the figure. And there are many good reasons for doing this. But quick sketches work entirely different artistic muscles, and are an excellent way to build up one's conception of the whole figure quickly.

In everyday life, we naturally focus on one thing at a time. But you can focus on something in its entirety if you practice doing so. Gesture, which I discussed at

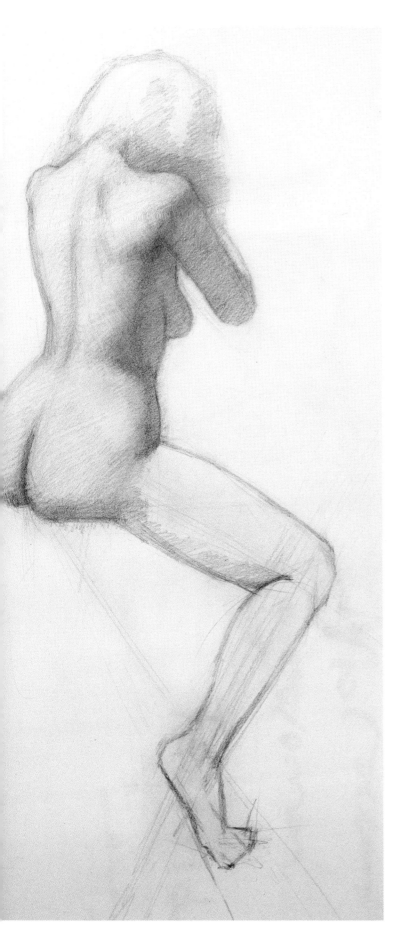

length previously, is a great way to start looking at the whole figure. By trying to see the entire figure at once, you can understand the relationship of all the parts to the whole. The first few times you do this will likely not go well, but stick with it.

If I'm overwhelmed by detail, I can't always find the essential. So I've learned to ignore detail and focus on the big sweep, the major masses, the tilts and axes. Smooth pencil shading is nice on long-pose drawings, but always remember that focusing on detail at the expense of structure is fraudulent. The house needs to be able to stand on its own. In the images of Alanna and Lilly shown here, you can see the hierarchy involved in building up the figure in quick-sketch format. In creating *Lilly*, I was able to take things much further, as I had roughly four twenty-minute sessions on one pose to add some level of "finish" to the drawing.

To wrap things up on a personal note, as of this writing, I have four sketchbooks in active use. This is an accurate reflection of my life and the various spheres I need to navigate, both personally and professionally. One I keep as my creative journal, another for sketches when I visit art museums, another as a sort of visual diary about day-to-day personal and artistic activities. I added a fourth to write down ideas for the Teaching Studios of Art. I used to write those ideas in the other three, the moment they occurred to me. But then I had trouble finding them when I needed them, so the fourth was added. For someone with a different temperament, perhaps only one sketchbook is necessary. Keeping all four going takes commitment on my part. Somewhat paradoxically, creative freedom requires a commitment to process. Your process of working with the figure will become *yours* if you commit to it, and it will likely look different from mine or anyone else's. I encourage you to get a sketchbook going if you haven't already, and to *keep* it going. The important step to take is to integrate figure drawing and painting into your routine.

OPPOSITE: Rob Zeller, *Quick Sketch of Alanna*, 2013, pencil on paper, 14 x 17 inches (35.6 x 43.2 cm)

LEFT: Rob Zeller, *Lilly*, 2011, pencil on paper, 24 x 18 inches (60.9 x 45.7 cm)

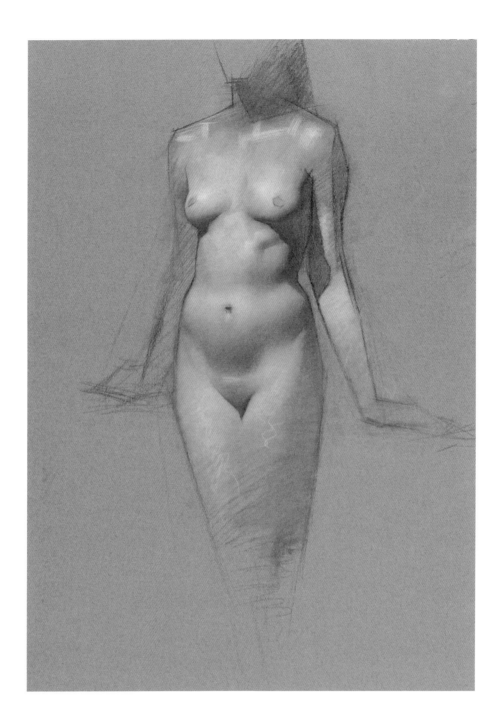

ABOVE: Craig Banholzer, *Torso Study*, 2016, charcoal and white chalk on toned paper, 20 x 16 inches (50.8 x 40.6 cm)

Craig Banholzer works in a clean, economical style, heavily influenced by nineteenth-century French Academic techniques. He initially works with lightly drawn, abstracted shapes that look like puzzle pieces, which remain visible right through to the later stages. These shapes show very precise decision making regarding the division between light and shadow. The way he models form in the light mass is very subtle, synthesizing the many small, abstracted shapes into a recognizable whole.

OPPOSITE: Craig Banholzer, *Back Study*, 2016, graphite and white chalk on toned paper, 18 x 15 inches (45.7 x 38.1 cm)

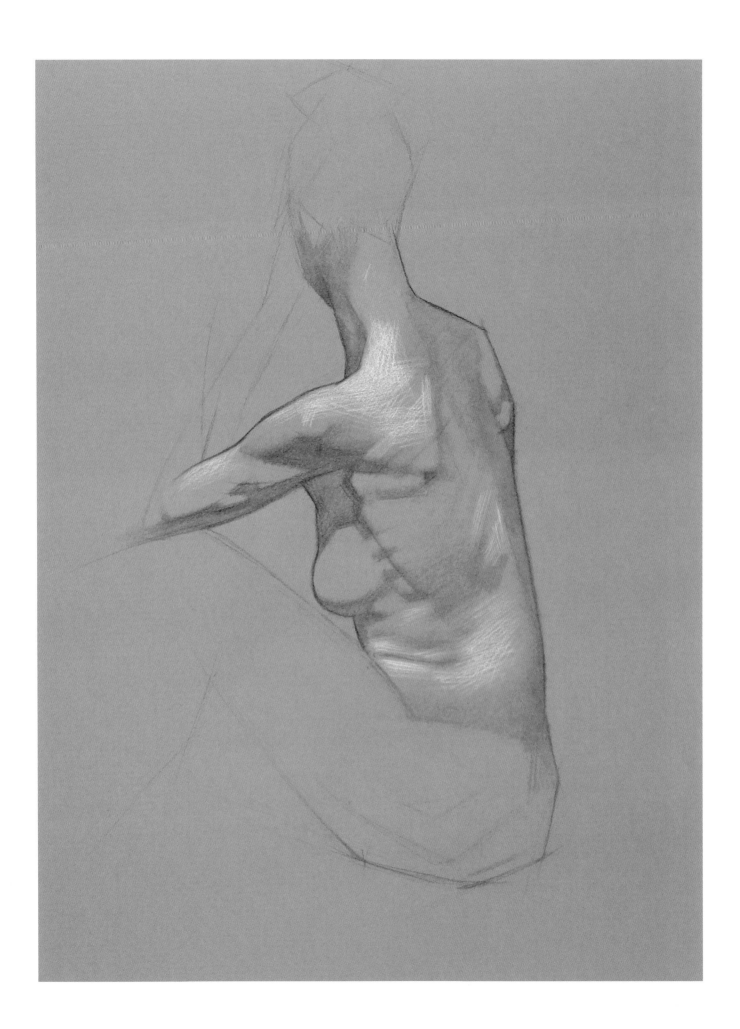

ABOVE: Alex Kanevsky, *T.S.*, 2012, pencil on paper, 30 x 22 inches (76.2 x 55.9 cm)

Alex Kanevsky's drawings are inquisitive, perceptual searches that rely a great deal on objective mapping and carefully observed, kinetic contour lines. The figures are in motion, spinning, taking the central figure's contour lines with them. Kanevsky is neither constructing a figure nor copying it. He is experiencing it, and documenting that experience.

OPPOSITE: Alex Kanevsky, *Diego with His Knives*, 2012, pencil on paper, 30 x 22 inches (76.2 x 55.9 cm)

Diego with his knives 2011 Alex Kanevsky

ABOVE: Guno Park, sketchbook drawing, 2012, ballpoint pen on paper, 8¼ x 23¼ inches (20.9 x 59.1 cm)

Guno Park works primarily in pen and ink. As is common for artists who work in ink, he uses cross-hatching to model form. He lets figures overlap across the page in a type of collage, using inks of various colors. The figures are usually from a single open-figure modeling session. Each of the figures on the page represents a different pose from the same session. He uses the two-page spreads in his sketchbook very effectively as entire compositions.

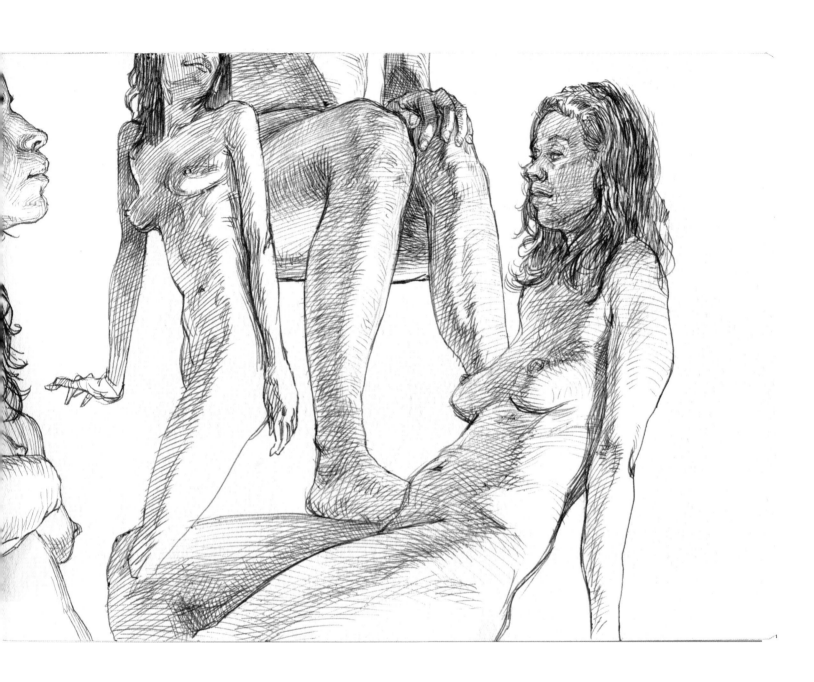

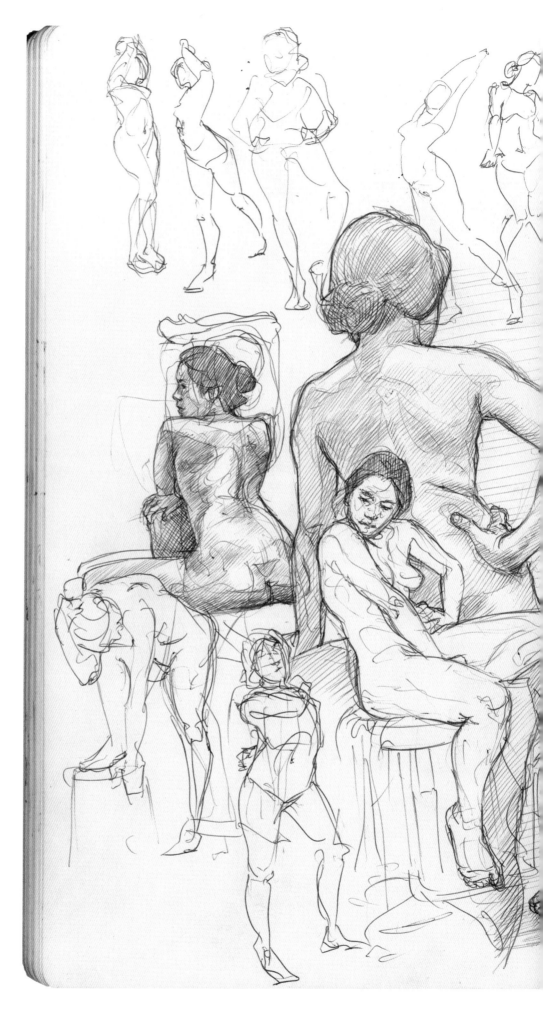

RIGHT: Michael Fusco, *Untitled 1*, 2014, ballpoint pen on paper, 12 x 18 inches (30.4 x 45.7 cm)

Similar to Guno Park, Michael Fusco also works primarily in pen and ink, using two-page spreads. His design sense is more centralized, as revealed in the circular pattern of smaller figures that surround the larger figures. His line quality is rhythmic and lyrical as he moves from the contours of the figures to mapping out internal forms with light and shadow.

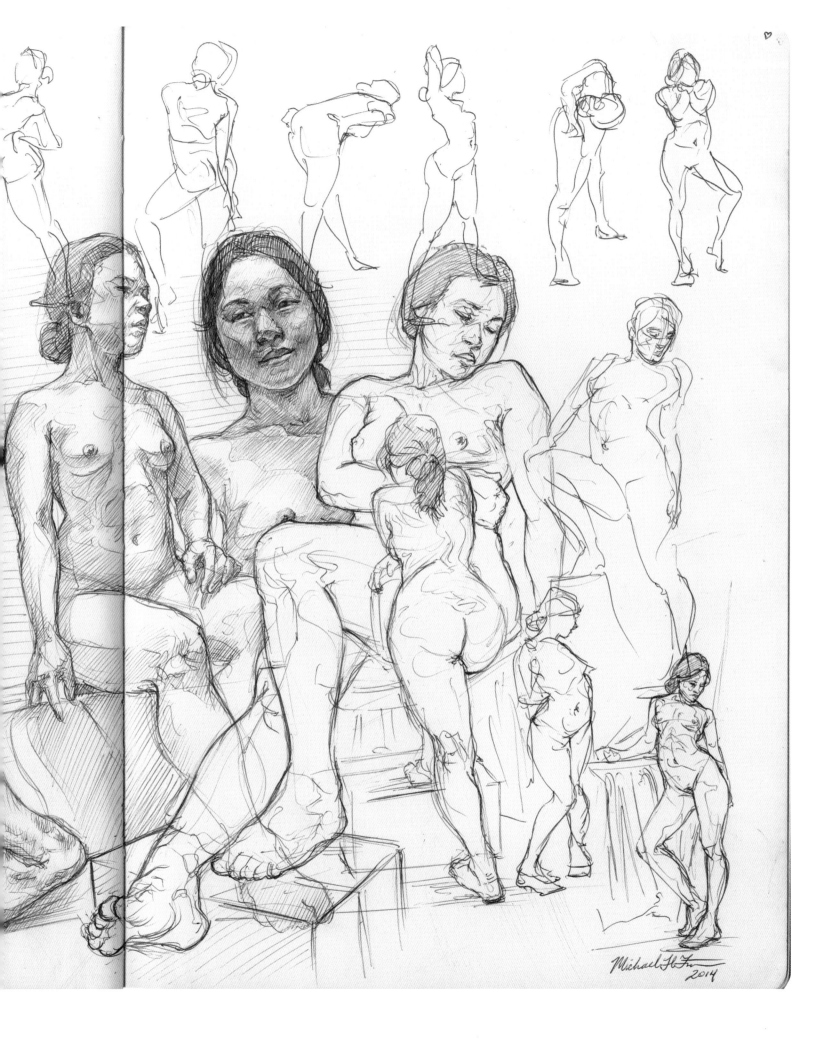

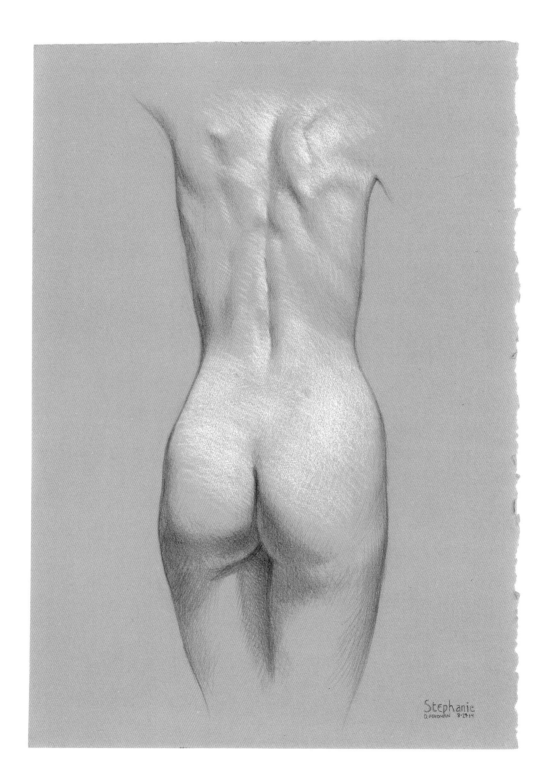

ABOVE: Daniel Maidman, *Stephanie*, 2014, graphite and white pencil on tan Rives BFK paper, 15 x 11 inches (38.1 x 27.9 cm)

A self-taught artist, Daniel Maidman trained himself how to draw and paint the figure by attending weekly open-drawing sessions in New York City for more than 15 years. Maidman's forms are both soft and volumetric. He primarily works tonally, with graphite and white chalk or white pencil on colored paper. Due to the time limitations inherent in quick poses, he usually favors cropped views of the figure.

OPPOSITE: Daniel Maidman, *Leah*, 2014, graphite and white pencil on blue Canson paper, 15 x 11 inches (38.1 x 27.9 cm)

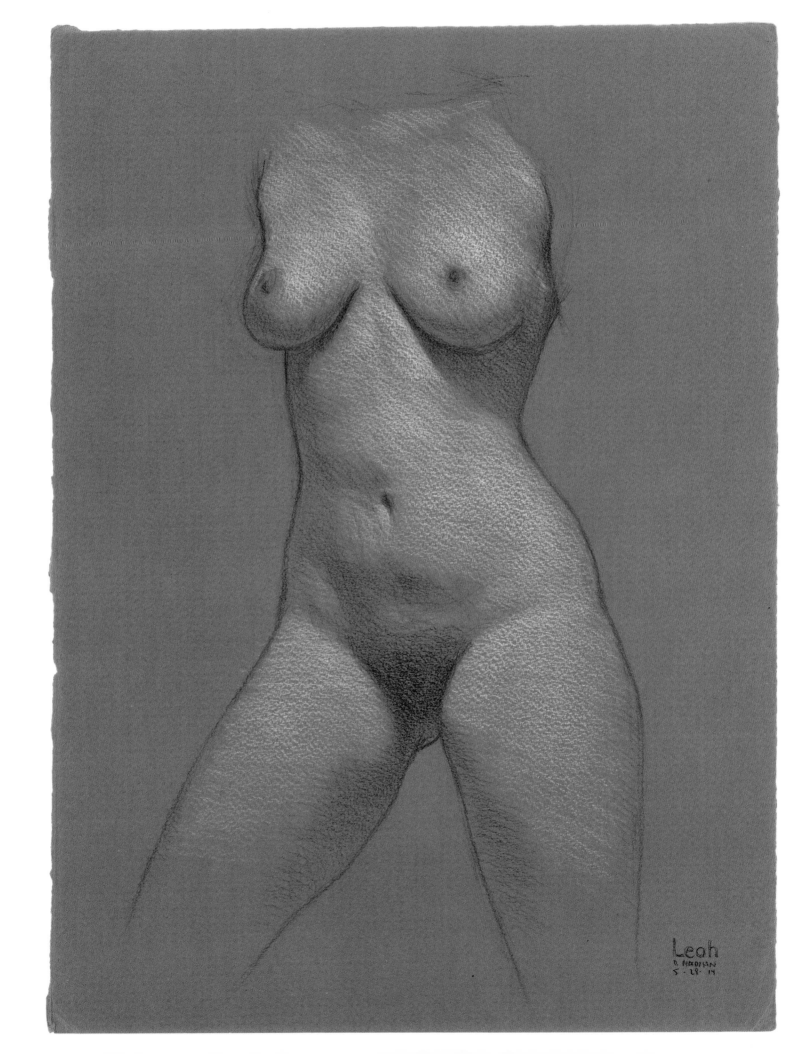

Leah
D. HADEN
5-28-14

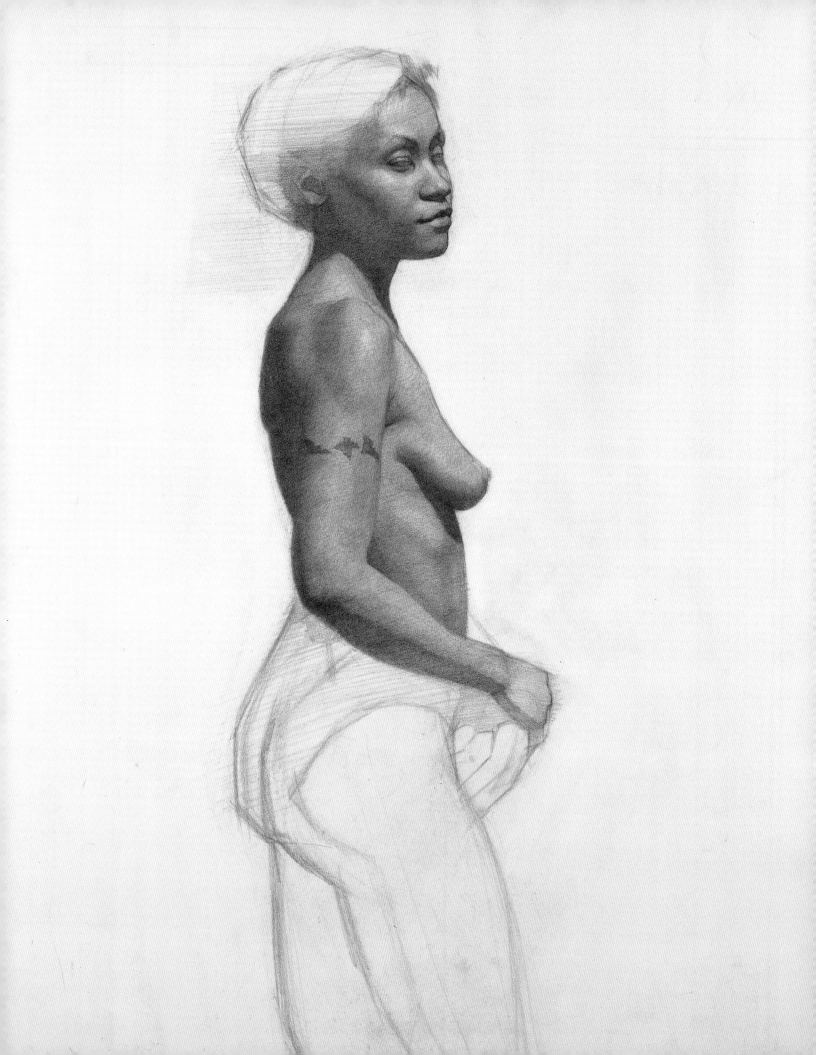

PORTRAIT DRAWING FOR THE FIGURE

Faces are one of the things that excite artists the most about drawing or painting people. I can tell this is universally true because of how often my students focus in on getting a good portrait on the figure model. In theory this is great, but in practice they often do it much too soon in the process. Rendering the head is certainly an important part of the progression of setting up a complete figure. But I often tell my students not to develop the portrait in the initial stages. There is a difference between a head and a portrait. In the beginning, you should block in the head, but not the face itself.

OPPOSITE: Rob Zeller, *Sally*, 2003, pencil on paper, 24 x 18 inches (60.9 x 45.7 cm)
 This drawing reveals one of the primary advantages of window shading: Once you have modeled the torso well, you can leave off the drawing at any point and it will still work. My primary goal was to try to capture the model's attitude. I didn't need to draw her entire figure to do so.

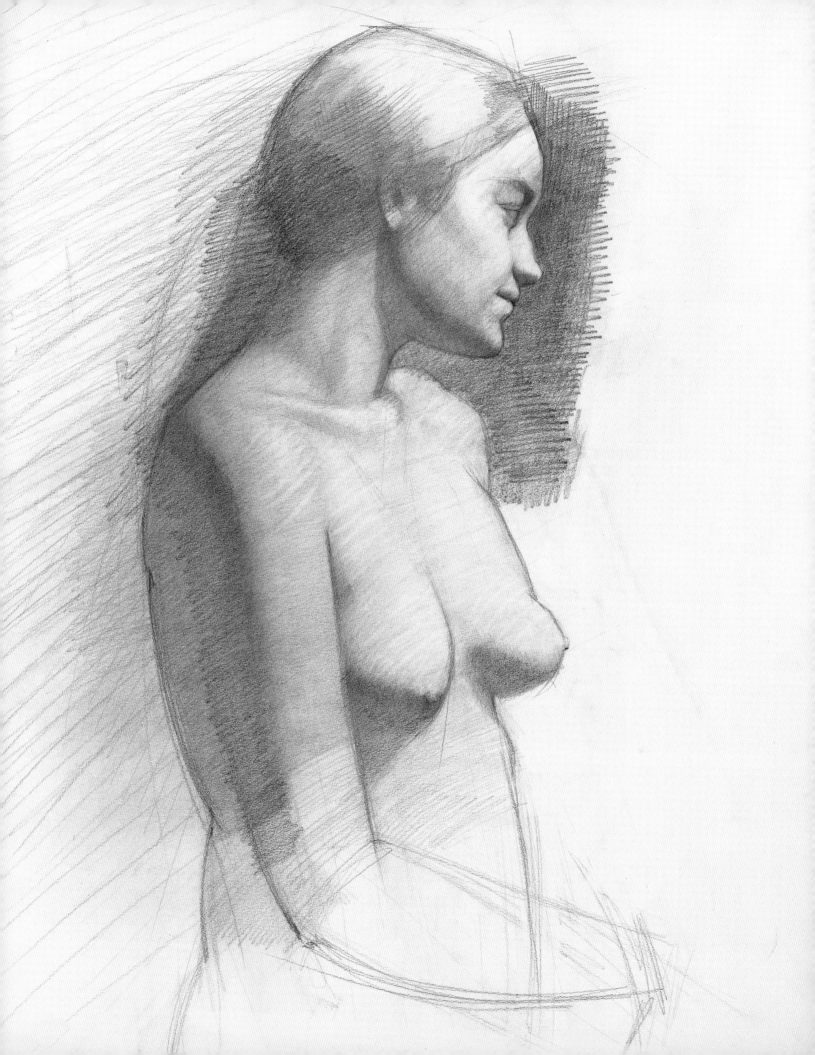

Why do I say that? Why is it important to refrain from finishing the face until you have the whole figure blocked in? Because an early focus on the face usually leads to a poorly constructed overall figure.

It almost never fails. As I move from one student to another in the classroom, making sure they are off to a good start, I usually come across one student who has not yet placed the model's feet on the ground plane, but she is giving her drawing a beautiful set of eyes, a large nose, and a small mouth. Rather than making sure she has established a sound figure, she has succumbed to the lure of the portrait. Her figure is floating in space, not properly constructed.

That said, as an artist, you *do* need to learn how to draw the face, and draw it well. By well, I mean incorporating the five elements that I have discussed previously: gesture, proportion, block in, form, and finishing touches. But they may not occur in the order that was required earlier, nor do they have to. I just want to clarify at the outset that, like most things in life, it's all about context. Every situation is different. Think about the task at hand and be flexible. In general, this order of events is true: Set up the figure first, and then finish the portrait.

STEP 1 | FINDING THE GESTURE

Setting a head on the figure in a believable fashion is very important. Like most things on the figure, first you will need to establish rhythm. In this case, that means determining where and how the spine flows into the skull. The pelvis is the base of the spine and the head is its apex, so how the spine moves from one point to another says a lot about how the figure is constructed and where the head should be placed.

As you see with my drawing of Holly, the contour lines flow up from her back right into the base of her skull. The gesture of her head, tilted just slightly to her left, stems from that gesture.

But this drawing also says much about form. You can see the block of her head is broken down into one large sphere with several smaller egg shapes as subforms. Her breasts form egg shapes also, though I did not carry the modeling of them very far. I wanted most of the subtle modeling to be on her face. This is considered a portrait bust. I do them often, as I enjoy the relationship of head to rib cage. (We will get into detail on that subject with a graphic on page 210.)

STEP 2 | BLOCKING IN

This step in the process is all about mapping out important points and finding relationships. When you are drawing a head on a figure, or a portrait bust (as the drawing of Holly is), you will need to begin by determining where your eye level is, from where you are at your easel. Are you looking up at the box of the head, even with it, or down on it? Where is the center line in relation to the pit of the neck? Knowing these things will help you to put the box of the head in space correctly.

OPPOSITE: Rob Zeller, *Holly*, 2010, pencil on paper, 24 x 18 inches (60.9 x 45.7 cm)

This drawing is a great example of using contour to good effect. It sets up the rhythms that flow through the torso up into the head. The window shading of the form is most intense on the face and slowly fades as it works its way down.

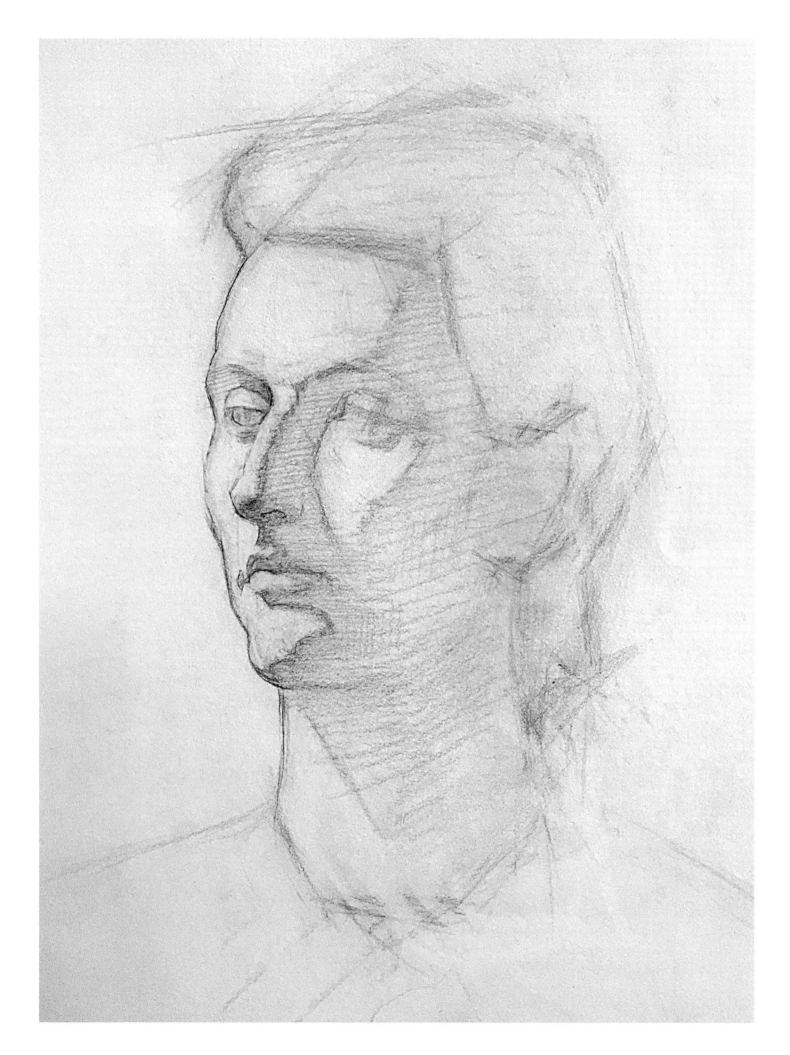

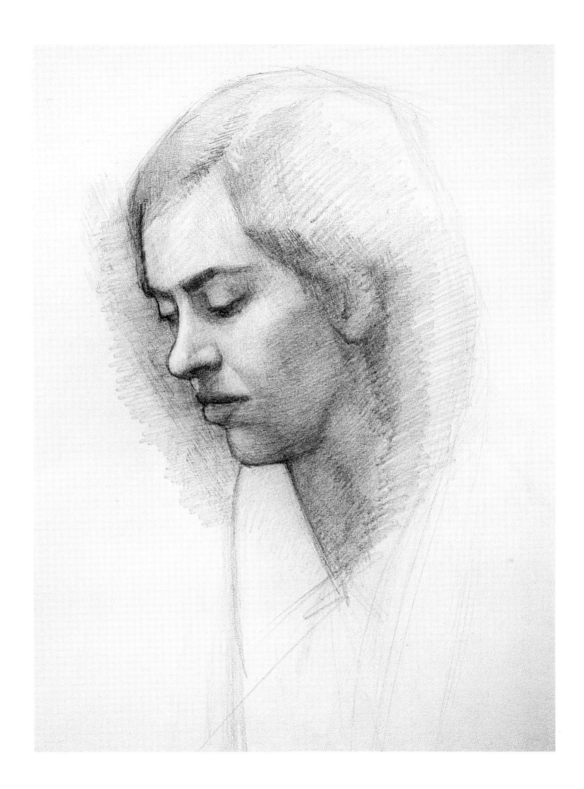

OPPOSITE: Rob Zeller, *Ben*, 2007, pencil on paper, 24 x 18 inches (60.9 x 45.7 cm)

This drawing is an excellent example of a refined block in. It very clearly shows the division of light and shadow, with a strong terminator line. It stops exactly short of beginning to turn form.

ABOVE: Rob Zeller, *Alexis*, 2013, pencil on paper, 20 x 16 inches (50.8 x 40.6 cm)

This drawing shows the block-in stage to great effect. You don't need to finish much in terms of rendering if you have established a nice composition.

Portrait Landmarks

Take a close look at the image to the right. Here I've positioned graphic overlays on top of my drawing of Holly (page 206) to help teach you some landmarks to consider when you're in the process of placing the head on the figure. This image is similar to the block concept from previous chapters when I put the landmarks on the blocks, but without the block this time. As I said before, I do not actually draw blocks on my paper. I conceptualize them.

The red triangle articulates the front plane of the face. Notice how the face makes up less than a quarter of the mass of the whole head. This represents such a tiny fraction of the whole figure! So remember to get the context of the head correct, in proportion and in perspective, before you begin to draw the face.

Follow the movement of the spine from the base of the pelvis up through the rib cage and into the back of the head. This is very easy from the back view, but from a front view or a reclining pose, it's more challenging (unless you have X-ray vision). But you simply have to follow the center line of the pelvis up through the rib cage. That center line follows the path of the spine.

In a standing pose, look at the model and drop a conceptual straight line down from the chin to the floor. What do you intersect along the way? Then look at your drawing. Some artists do this same exercise by using a plumb line, but you can simply use your eyes, or a pencil. Now check your drawing. Are you intersecting the same things with your drop line? In a reclining pose, the drop lines go sideways, running from the chin straight

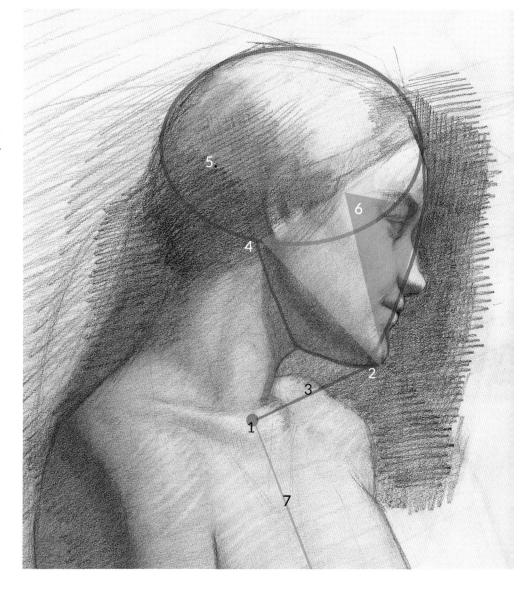

out horizontally. Plumb lines can't do this, due to gravity, so I think it's better just to train your eyes to work without devices like that.

Run a line from the chin to the pit of the neck, at the top of the sternum. This will tell you the relationship of the center line of the front plane of the face to the center line of the front plane of the rib cage,

ABOVE: The major landmarks on a profile view of the head include the pit of the neck (1), the chin (2), and the condyle of the mandible (4). Other areas and relationships to identify include the skull (5), center line (7), various planes that make up the face (6), and the distance from the chin to the pit of the neck (3).

as both points represent the end and the starting points of those two lines, respectively.

The Block Concept

In Steven Assael's demo drawing shown here, we see a three-quarter view of a head inside a box, with the eye level at mid-forehead. The box is tilted slightly and the rotation is such that we see very little of the right side of the face. Note the center line that runs down the forehead, through the nose, mouth, and chin. Note also how focusing on the large planes gives his drawing three-dimensional value.

When presented with a block concept like this, we can understand that the head is a rectangular solid, with a top, bottom, front, back, and two sides. However, from any particular vantage, we are likely to see only three of these planes. In Assael's drawing we see the top, front, and one side. If the eye level were lower, we'd be looking up at the box, and the bottom plane would be visible (but not the top). Beginners tend to focus only on the front plane and neglect the others; they also tend not to take perspective into account. When you focus only on the front plane and ignore perspective, distortions will creep into your drawing. If not kept in check by careful observation of the side planes, the facial features often grow too large for the actual size of the head.

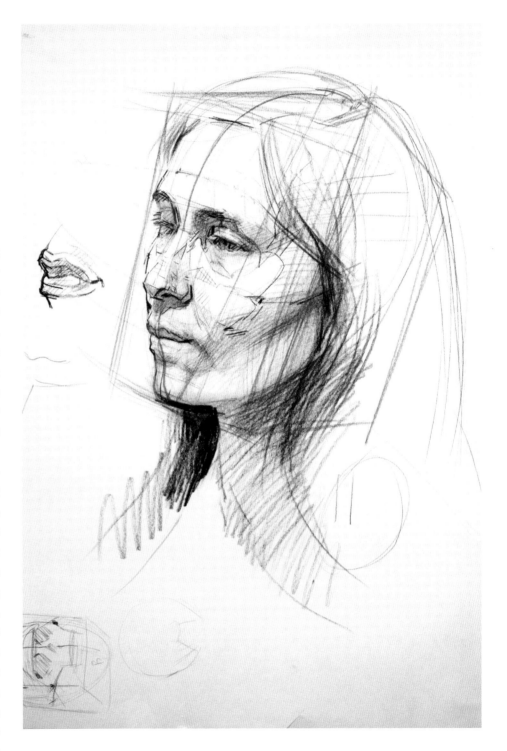

ABOVE: Steven Assael, *Portrait Structure Demonstration*, 2015, charcoal and red chalk on paper, 24 x 18 inches (60.9 x 45.7 cm)

Assael has provided us with a brilliant demo here. The block concept is on full display, as are the various concepts of gesture, block in, and form. Note the center line of the face, and how all of the features (eyes, nose, and mouth) are anchored to it, in perspective. The expression of the eyes is subtle, especially for a demo.

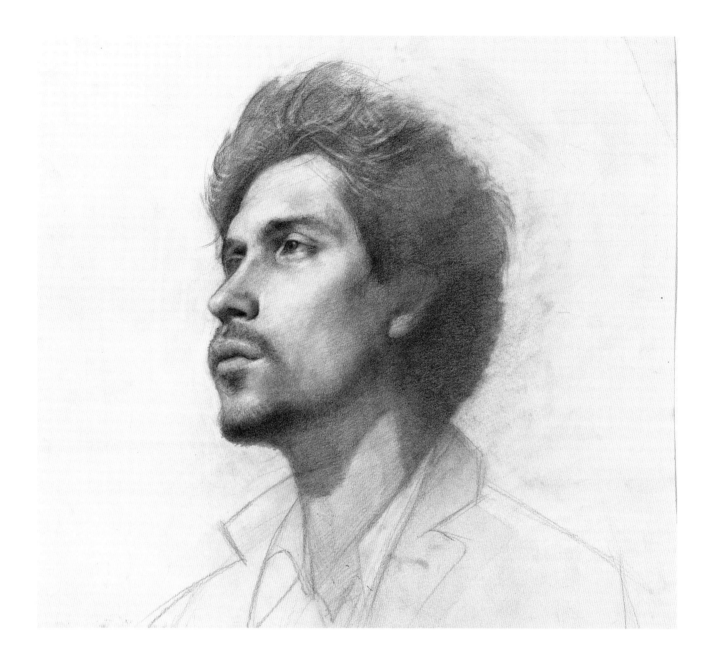

STEPS 3 & 4 | DIVIDING LIGHT FROM SHADOW & MODELING THE FORM

One of the most important things to learn as a figurative artist is how to create a sense of strong light on form. This helps with modeling, as it provides a greater range of values to work with. In both of these drawings the oval of the skull is lit from above, with light coming from one direction. If you squint and look at these drawings, you will see clearly where the light is concentrated.

I highly recommend squinting often when you are working from the live model. I treated the shadow side

of the skull in this drawing of Jason in one even, flat tone that spans from the back of the skull and along the

ABOVE: Rob Zeller, *Jason*, 2011, pencil on paper, 18 x 18 inches (45.7 x 45.7 cm)

As director of the Teaching Studios of Art, I sometimes sit in on workshops we conduct. I created this drawing of my friend Jason while sitting in on Maria Kreyn's portrait workshop. Jason is a poet. I tried to give him a Romantic-era look, though he's more of a medievalist.

jawbone to the chin. As the light comes from above, all of the down planes are in shadow.

Figure out the largest planes and how they face the light. This is important to establish in the very beginning of the drawing, before you put in a lot of detail. The diagram and demo drawing on pages 210–211 are key to helping you understand the biggest, simplest shapes and the axes of the largest forms. The subforms all play off those larger forms. It's a mistake to work on isolated details without having a larger sense of how the light hits the whole form. Any figurative artist keeps such things in mind as he or she is working from a model.

In each of the two portraits shown here, the model's head was a little above my eye level. That meant that I was looking up, slightly, at the head. The underside of each jaw is just barely visible, and that is usually a good place to throw a little reflected light to complete the full range. The reflected light usually comes from the light bouncing off the chest or shoulders.

Value range is important in portraiture. These two drawings are fairly high contrast. Higher contrast means more drama, more punch in the graphic quality of the image. Lesser contrast makes things more subtle graphically, less dramatic. Here, I aimed for the middle.

Before drawing Mary, I made a decision early on that I was going to create a "wipe-out" image. In this method, the artist first tones the paper with some type of powdered pigment, and then proceeds to create the light range by removing the pigment in the desired areas.

At the beginning stage of this portrait I did a basic block in of her and then rubbed some sanguine chalk over the whole thing. Next, I took an eraser and removed the lights in a general way. I then went in with pencil and more sanguine to carve out all of the large forms and

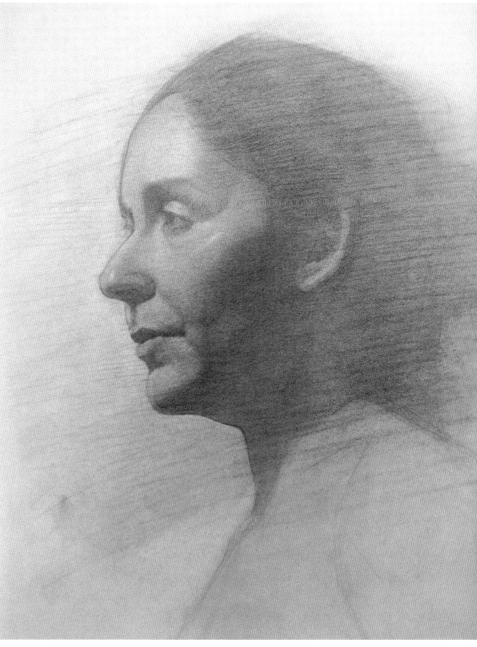

subforms on the triangle of the front plane of her face. Notice that I completely compressed the shadow side of her face and her hair into the same shadowy shape. After I had established the level of detail I wanted, I went in with an eraser and lifted out some key highlights. Please remember, working first with the largest planes, and then moving to subforms, is a time-tested, historically proven technique. You really can't go wrong with it.

ABOVE: Rob Zeller, *Mary*, 2003, pencil and sanguine on paper, 17 x 14 inches (43.2 x 35.6 cm)
The use of sanguine chalk over pencil is bulletproof. It works every time. Note here how I let the shadow mass stay extra flat, with no reflected lights at all.

ADVANCED LESSON | SYNTHESIZING YOUR DRAWING SKILLS

This view of a reclining pose was intended as a study for a painting. There was a strong overhead light on the model and I wanted to capture that effect. As you can see, I did not follow my own advice regarding promissory marks. Therefore, the hands ran off the page. But I made up for it by doing a nice study of the hands themselves.

Ironically, although my intention was to describe the light, at my eye level what I saw was mostly shadow on the head and torso. But much can be accomplished with reflected light, if you know how to control it. The pelvis and legs got a fair bit of light. So I paid special attention to the smaller subforms that made up the rib cage and where it turned away from the light. That edge between shadow and light contained many subtle shifts. Notice the rhythmic lines that run through the torso and the legs, in a sort of figure-eight pattern.

Notice also that the head on the figure flows out of the rib cage, the spine coming into the back of the head. Due to the face being in shadow, I had to work in an extremely compressed range. However, the model had a beautiful face that seemed a pity to subvert, so I did a separate study of it on the page, with a slightly larger range of value for the reflected lights. The smaller study is a head, the larger study, a portrait. Freed up from the rest of the figure, the portrait works quite nicely—particularly in the way the reflected lights and accents within the shadow create form. In the portrait I also created a warm tone by using sanguine chalk in the overall shadow.

RIGHT: Rob Zeller, *Candace*, 2003, pencil and sanguine chalk on paper, 14 x 17 inches (35.6 x 43.2 cm)
I did this drawing while a student at the Water Street Atelier, and my student status perhaps explains why I let the hands run off the page.

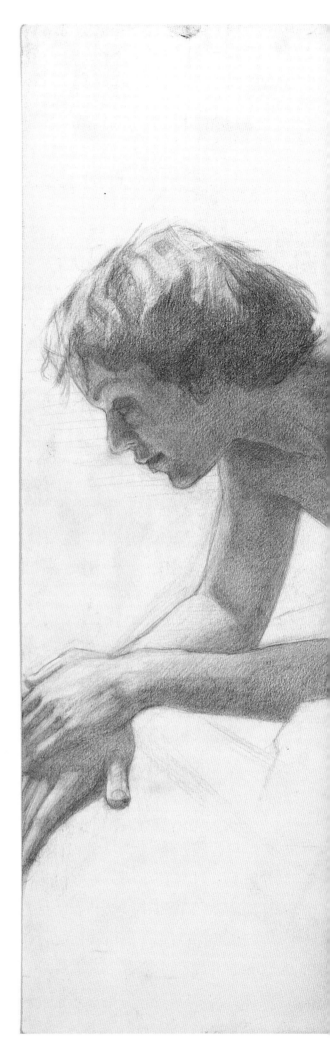

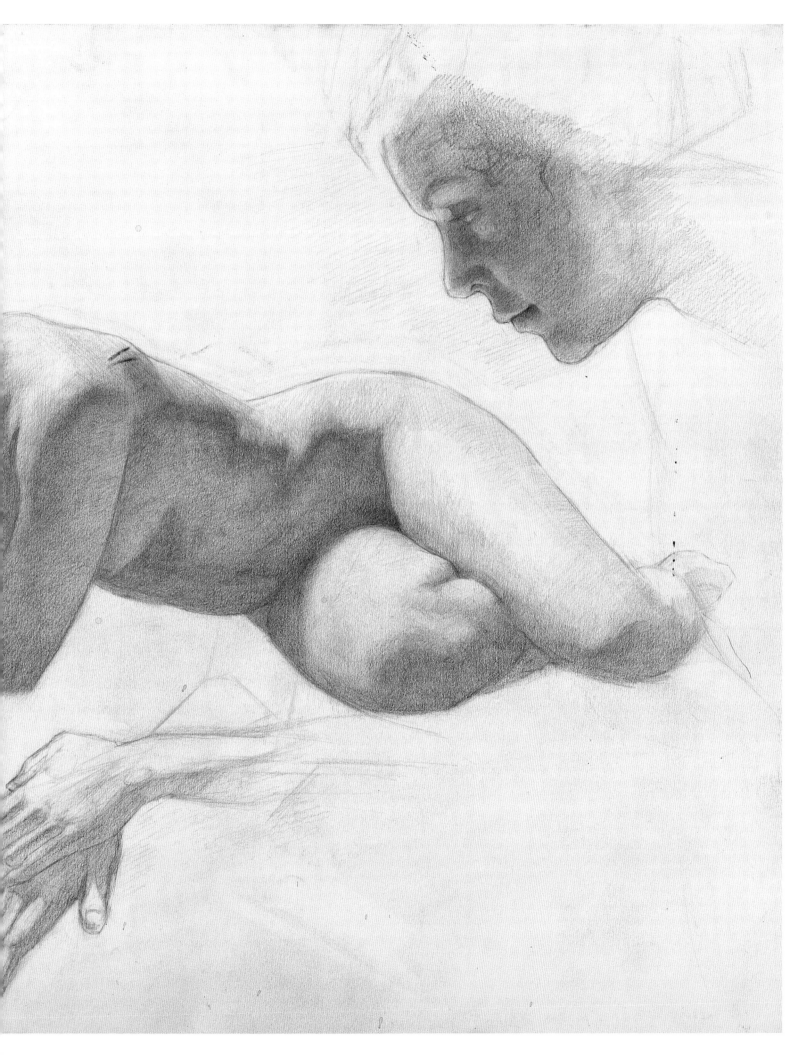

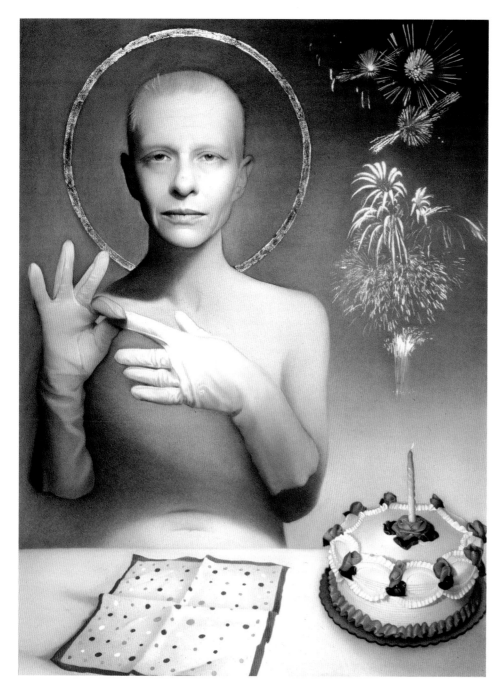

Portrait in Mixed Media

Both of the artists whose work is shown here use various forms of traditional drawing mediums in unique ways, and to very different results. That we know of, self-portraits date back to the Egyptians, but perhaps they come from earlier than that. In terms of Western art and Figurative Realism, we know the personal appearance of many artists, and at different stages of their lives, as the result of the genre. Many of them are regarded as very personal statements. Rembrandt's come to mind, of course. Susan Hauptman's *Self-Portrait as a Prima Donna* is simultaneously frivolous and full of grandeur. Light reveals the space to be quite shallow, and the various design elements in the composition seem to float. Hauptman's self-portraits are androgynous and often confrontational. The gesture of the hands suggests a haunting invitation to a very personal and unique creative space. We are invited, but are we welcome?

Some artists are process oriented, and make work about the act of making art. Others are materials oriented. In other words, they are constantly reacting to new mediums, substrates, which bulbs to use for lighting when making their work, and so forth. Candice Bohannon is inspired by the divine in nature, and also by her materials. She experiments quite frequently with a variety of challenging mediums and enjoys that tactile connection with her work. With *Ascend*, she wanted to a try out some new material combinations for drawing on Mylar: liquid graphite versus traditional graphite versus carbon pencil. She hoped to create a piece about breath and atmosphere by using materials and colors that implied wind and air. She had the model pose with an open mouth, to be obviously breathing. The idea was that if Bohannon could paint breath, then the model would be physically and spiritually one with the background.

She gave the model a crown of golden ginkgo leaves for a touch of the classical divine that she feels is in

ABOVE: Susan Hauptman, *Self-Portrait as a Prima Donna*, 2000, charcoal, pastel, and gold leaf on paper, 54 x 40 inches (137.2 x 101.6 cm), copyright © Estate of Susan Hauptman, courtesy of Forum Gallery, New York

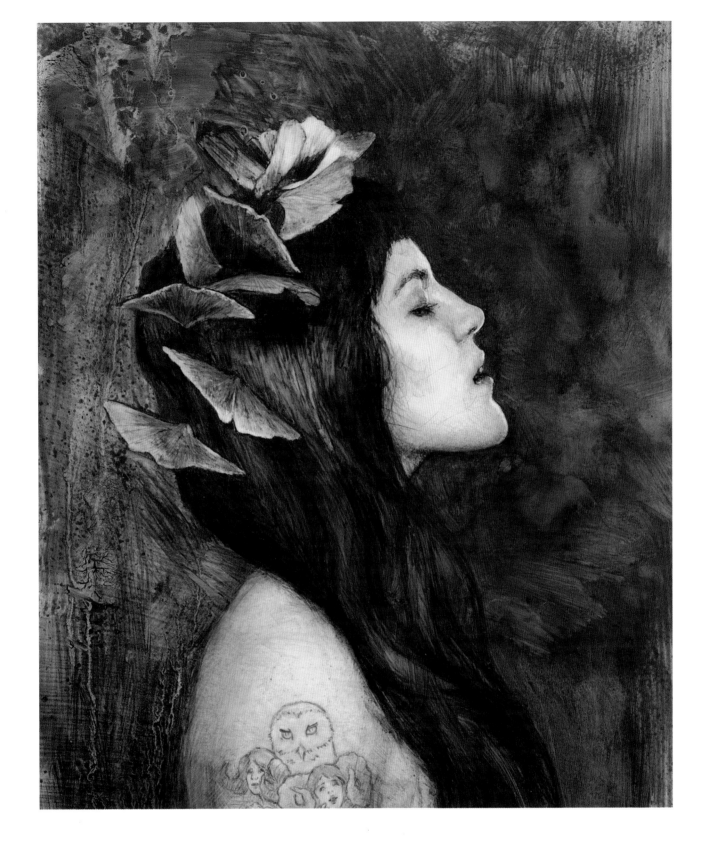

nature all around us. Also, in looking for a model with tattoos, Bohannon wanted a contemporary connection. She did two versions of this drawing, both using the same materials, the second being much more finished, but focused less on the connection of the breath and more on the actual portrait of the model. I included this one because it more closely matched her original vision.

ABOVE: Candice Bohannon, *Ascend*, 2015, mixed media on Mylar, 12½ x 7½ inches (31.7 x 19.1 cm)

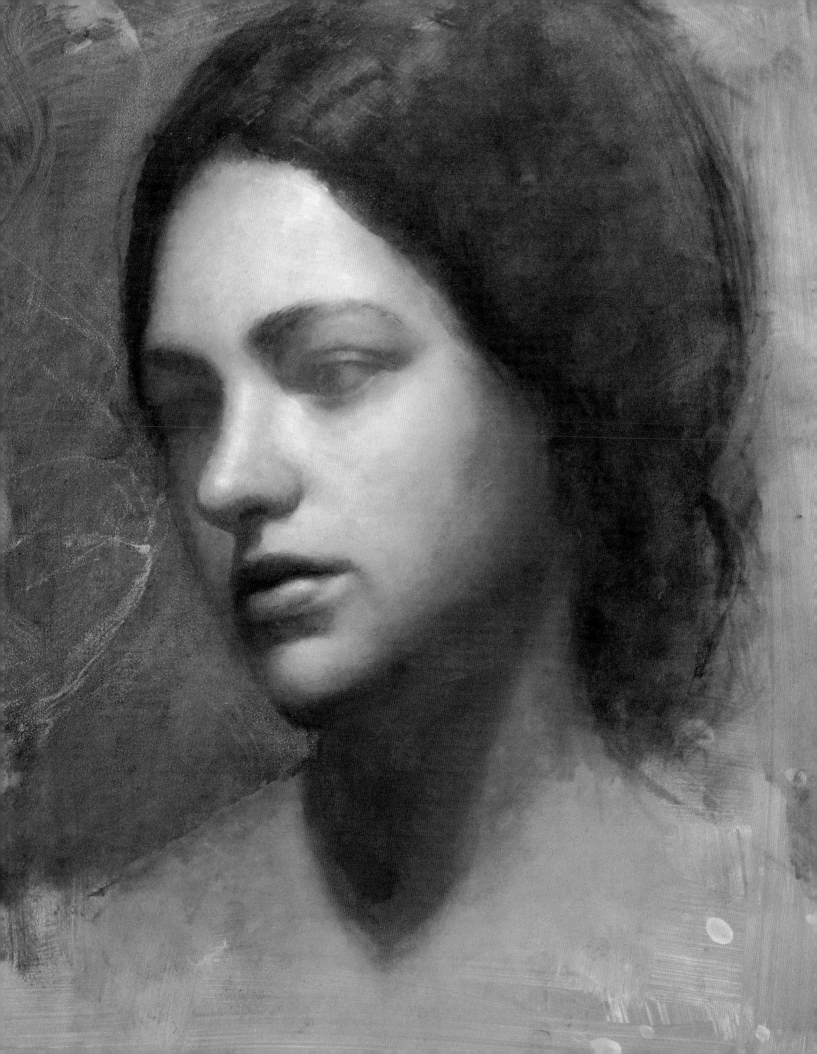

PORTRAIT PAINTING

O n the most basic level, there is not much difference between drawing and painting. I don't think this is a controversial state-ment, but it may be to some. The discipline of drawing is the bedrock of figurative art as we know it. Drawing and painting are simply variations on the same thing. One is rendering with dry mediums, the other with wet mediums. (The third branch of the fine arts is sculpture, but that discipline falls outside the scope of this book.)

The reality is, if you can draw well, you can paint well. Color is a variable to consider, but it can be introduced in either discipline. The actual challenge is in changing specificity of touch and focus.

OPPOSITE: Rob Zeller, *Leah*, 2013, oil on panel, 14 x 11 inches (35.6 x 27.9 cm)
A chameleon of sorts, this model has worked with many famous and talented artists in New York City, each of whom has captured a certain aspect of her. The best models are like that. Muselike. Here, I wanted to capture Leah's ethereal qualities.

In that regard, switching from pencil to charcoal is every bit as challenging as switching from pencil to oil paint. Both actions require a shifting of focus from something very specific to something a bit more general. A sharp pencil has a diameter of a couple of millimeters at most. A stick of charcoal is triple to quadruple that size. Brushes can get quite small, but can't carry much of a paint load at that size. Usually, they are much bigger than a pencil point.

The tough part for a realist draftsman is knowing that the precise mark you make with a pencil has to be generalized a bit, at least initially, when moving into a more fluid medium. For that reason, it is often said that artists who work in charcoal have an advantage when moving into painting. There is some truth to this. I think it's more apt to say, rather, that you need good instruction to paint well, no matter what type of drawing implement you favor. Also, I recommend relaxing a bit, accepting that things will be messy at times and not as precise.

When I teach portraiture to my students at the Teaching Studios of Art, my method is to paint alongside them. I work up a drawing and then a painting, from start to finish. I explain the process of what I am doing, step by step. I am a big believer of studying with instructors who walk the walk, not just possess the talk. As a student, I always sought out painters whose work I admired. But as an instructor, the "demo in front of your students" philosophy always carries some risk. No artist, no matter how accomplished, is immune to a bad day at the easel. Mine just happen to be in front of my students. But they need to see that part of the process also. On the whole, armed with knowledge, skill, and a good studio environment, I do demos for my students that come out rather well. We will see several of them in this chapter. And, though I have edited out the clunkers, I can assure you that they happen.

What follows is a step-by-step tutorial in how I execute a portrait for my students. I will reference the five concepts I have spoken of in preceding chapters, but the order will not be sequential. One of the things you will discover, or perhaps have done already, is that making art is often a nonlinear process. Steps that work for some paintings don't work for others. The order of events can get jumbled, seem confused, and yet all work out in the end. Or not.

STEP 1 | BLOCKING IN THE HEAD

In the block in for *Portrait of Tynisha* (page 224), you can see the general form of the head take shape. I have mapped the front and side planes. Because my eye level was identical to the model's, I did not need to consider either the top or the bottom plane.

I work everything off of center when I draw a head. That means I find the center line of the head. As you can see in the diagram on page 222, in this case the center line runs directly down the face. I look for five bony landmarks: the top of the forehead, the glabella (bony mass at the center of the brow ridge between the eyes), the base of the nose, the base of the mouth (under the bottom lip), and the mental process. Notice that all of these landmarks fall on bone. In general, try not to use flesh-based landmarks anywhere on the figure. They move too much, along with the skin. Bones are the bedrock of the figure and the portrait. In essence, you draw and paint the surface details, but you keep everything rooted to the skull.

The model had a most interesting mass of hair. Although I focused mainly on the structural aspects of the portrait in this block in, I put the hair in as large,

OPPOSITE: This is the initial block in of the portrait. Note how I kept the overall shapes as abstract as I could, and yet maintained the overall symmetry of the facial features.

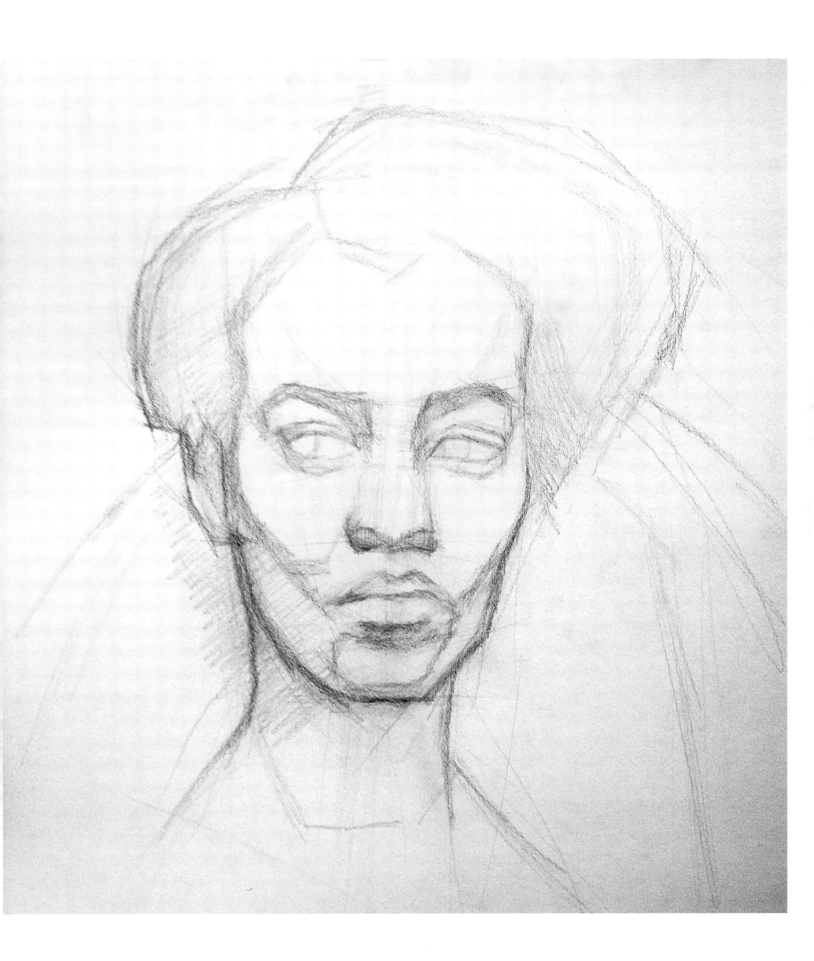

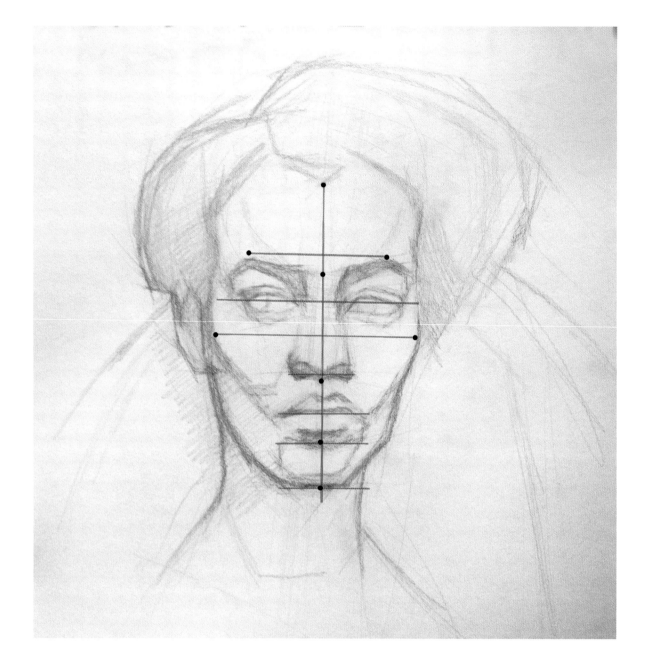

flat shapes. This type of variety (flat shapes versus form shapes) makes a drawing much more interesting than having only one element. I also articulated a strong division of light and shadow on the various subforms. Notice that even without any modeling, you know where the shadows are in the block in.

STEP 2 | MODELING THE FORM (A BIT)

I began to lay in an even value for the shadow and subtly model the major forms. At most, I used three values at this stage. The modeling is loose, and not terribly refined. I was aiming for accuracy of the values of the major planes. Immediately, the top planes of the cheekbones began to rise to prominence, and the eyes took on a really expressive character.

This was not an instance of the window shading you see in some of my other drawings. I have personally found that when I am doing a drawing with a painting in mind, I work better by moving from a general sense of the form to a more specific one. I am teaching myself the overall "lay of the land" first, really getting to know the model's face. I tighten things up a bit in the next step.

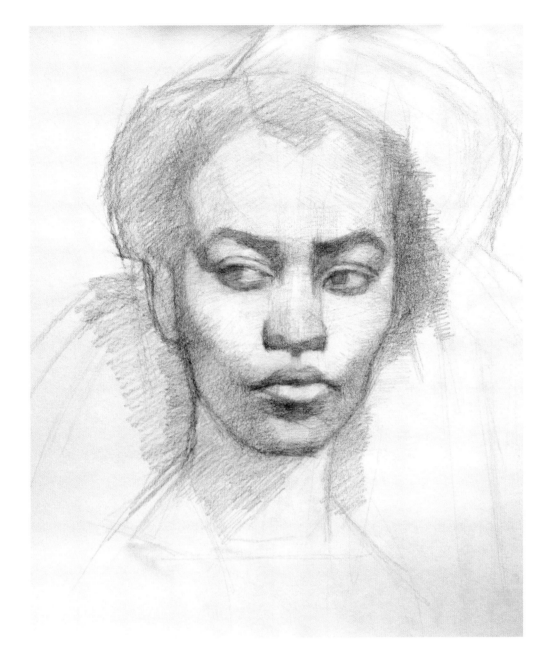

STEP 3 | ADDING THE FINISHING TOUCHES AND REFINEMENTS (TO THE DRAWING)

Having taken care of most of the major planes, I shifted to defining the details. Tynisha has interesting facial characteristics and I wanted to highlight them. The way her eyes were set, the expression of her lips, and the large shape of the cast shadow under her chin all held my interest. Oddly enough, though her hair fascinated me, I knew that I had to keep much of it unfinished, using gestural marks to indicate its shape and rhythm.

As I said, sometimes the steps come out of order.

OPPOSITE: This schematic identifies the center line and perpendicular axis of features and landmarks. These are the important spatial mapping coordinates you should internalize and overlay onto the model's face when you are drawing a portrait. Working off of center is referred to as *bilateral symmetry*.

ABOVE: I used three values at maximum at this stage, keeping things simple. I worked the largest planes until they read properly.

STEP 4 | TURNING THE DRAWING INTO A PAINTING

The first order of business in preparing to transition from the drawing process to the painting process is to transfer the basic outlines of the drawing onto a gessoed panel. You do not need to transfer all of the value modulations, only the most important lines. Having done that, I then applied a transparent wash of light gray over the drawing. My intention was to paint very directly, one section at a time, using the lines as guideposts.

Next I began to work the lights, using the basic 8-value scale that we discussed in chapter 2. As you can see from the image opposite, I put my drawing right next to my painting as I worked, and really looked at Tynisha only to get a sense of what colors to use. She became a secondary source of information to me during the painting process. My drawing was now the primary model. This pre-photographic way of painting was common in the Renaissance, and is still common with muralists today. When you are completing a large mural (or a ceiling painting, for that matter), it is highly impractical to have a model up on the scaffolding posing for you while you work.

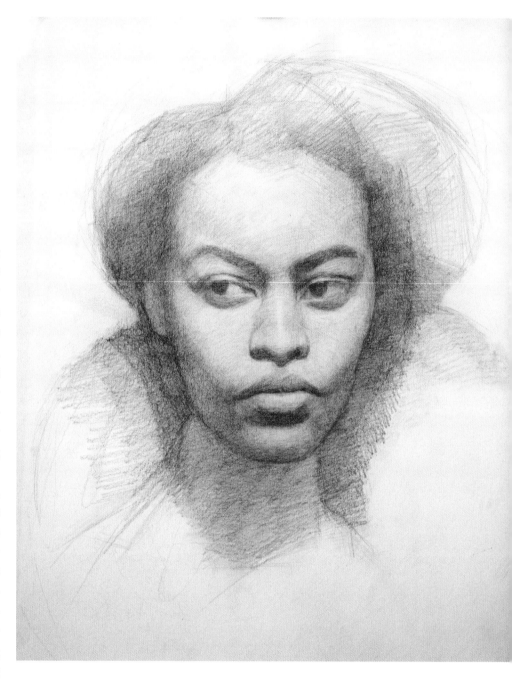

ABOVE: Rob Zeller, *Portrait of Tynisha*, 2015, pencil on paper, 20 x 16 inches (50.8 x 40.6 cm)

OPPOSITE: Here you can see the drawing and the very start of the painting. I looked more at my drawing at this stage than I did at Tynisha herself, since I already had much of the information I needed. In this stage of the painting, I am primarily creating a skull. The features are coming into play early on, but the main focus is on the quality of light hitting the skull.

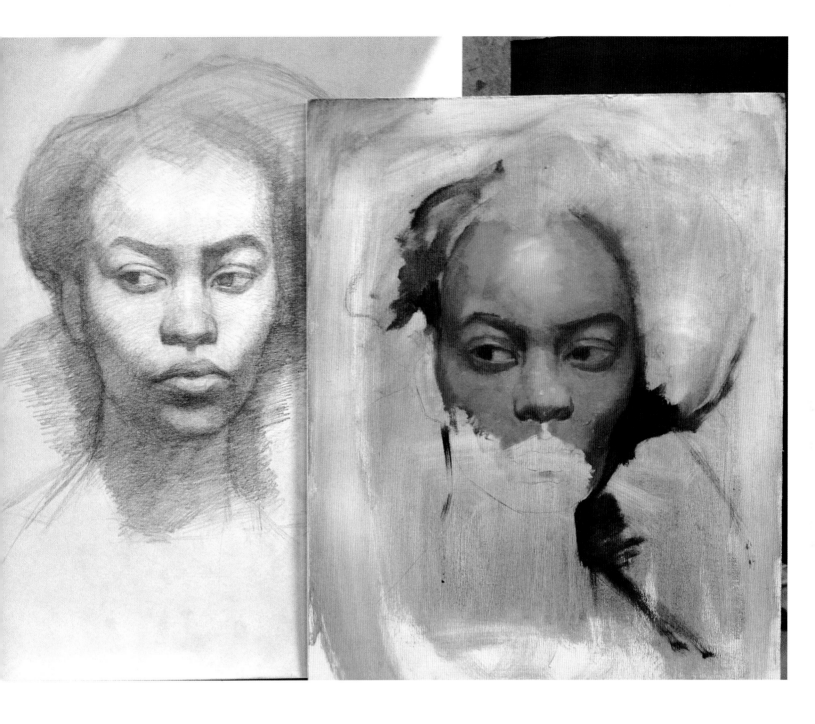

STEP 5 | BLOCKING IN THE HEAD (IN PAINT)

With proportion, block in, and form taken care of, I was free to explore color directly. The drawing essentially told me that this portrait would be about the clearly defined forms of the face juxtaposed against the looser and more gestural flat shapes of the hair. When you get most of the information that you need from the drawing, painting becomes simply a matter of translating that information into a wet medium, in color.

Some artists like to do small color studies of the model. They then paint a larger work from the drawing and the color study. In this case, I simply took the color from the live model. Either works fine. I personally do not find color from photographs that reliable. I much prefer to take color directly from life.

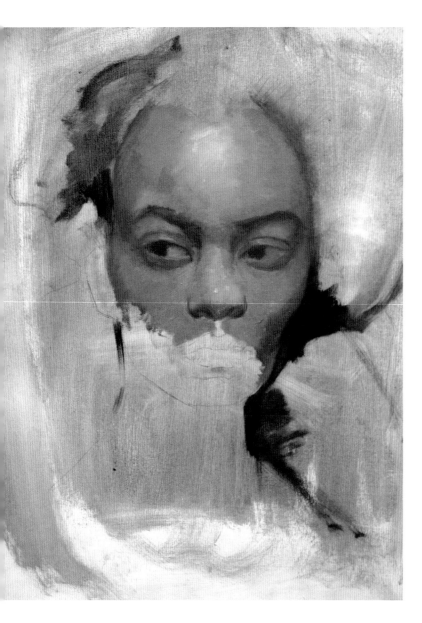 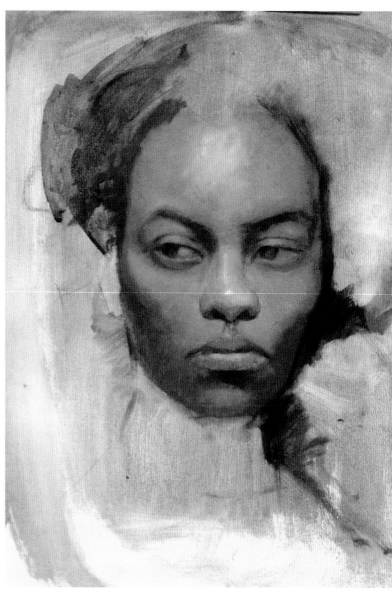

STEP 6 | TYING IT ALL TOGETHER

At the "nearly finished" stage, I was careful to keep the values simple and organized by planes. Notice the sections of lighter value on all the peaks of the major and minor forms on the planes most facing the light: the forehead and the bridge of the nose, the tops of the eyelids, the bottom lip, and so forth. All of the oblique planes that were not downward-facing got a middle value of light on them. Nothing was overmodeled, and at the finish, I simply pushed the contrast by deepening the shadows and increasing the saturation of the color in the light.

Once I knew I had struck the proper balance between gesture and form, I could put the brush down with confidence.

ABOVE LEFT AND RIGHT: Finally, the skull is in place. I have set the features in as well. I have the basic gesture. Now the question becomes: How far to take it?

OPPOSITE: Rob Zeller, *Portrait of Tynisha*, 2014, oil on panel, 14 x 11 inches (35.6 x 27.9 cm)

I took this as far as I dared. I can honestly say that it took more courage to stop working on it than to continue. The main focus of this portrait for me was the balance between gesture and form. The likeness to Tynisha, though quite accurate, was secondary.

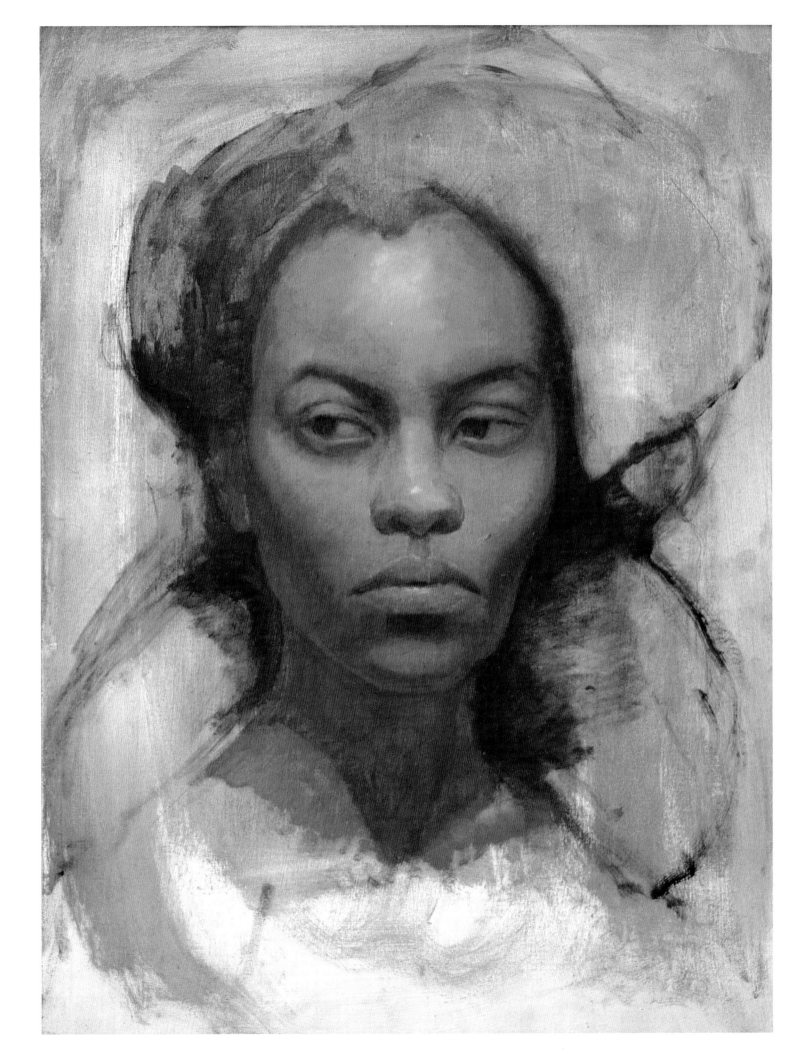

ADVANCED LESSONS | EXPLORING THE POSSIBILITIES OF PAINTING

To continue with our lessons in portraiture, I'm going to walk you through a few more demonstrations from my classes at the Teaching Studios. These will cover both grisaille and *alla prima* methods—and, as you will see, there is sometimes overlap between the two. I will also introduce you to the surprising way Alyssa Monks employs the grisaille method in her work.

Grisaille Techniques

Grisaille is a fabulous method when a student is first transitioning from the discipline of drawing into the discipline of painting. This method divides the painting process into two steps: First, the artist works with a monochromatic underpainting. Then, once the underpainting is dry, he or she applies transparent and opaque layers of color.

A grisaille can be either "closed" or "open." *Closed grisaille* refers to mixing white paint into either black or brown to created a monochromatic range of values. So, in essence, in a closed grisaille you are adding white to create the lights. By contrast, in an *open grisaille* you spread an even, middle value across a white or gray canvas, and "wipe out" where the lights are. When you remove the middle value, the tone of the ground comes through and functions as the light. The open grisaille is a subtractive method, where you are removing the darks to create lights.

Both of these types of "painting" are very much like drawing with charcoal and/or white chalk. The advantage of working in this way is that it takes color off the table as an issue in the initial stages of the painting. All of the great drawing concerns are worked out in the monochromatic stage, before color is introduced.

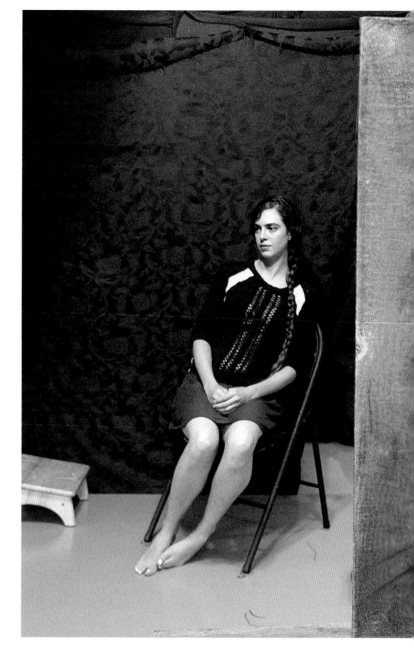

In the first image here, you can see the start of a closed grisaille. The photograph was taken from behind my easel while I gave a portrait demo to my students at the Teaching Studios of Art. It was a small panel, 12 x 9 inches, toned to a warm, middle-value ground. I mixed up eight values of gray, but used only six of them (no dark accents or reflected light). I painted a portrait of the model in the exact order that I would have drawn it. I started with gesture/rhythm lines and block-in shapes, many of which are still visible at this stage. Finally, I added a strong buildup of lights. I wanted to be sure that the viewer knew where the light was hitting the model's head most strongly.

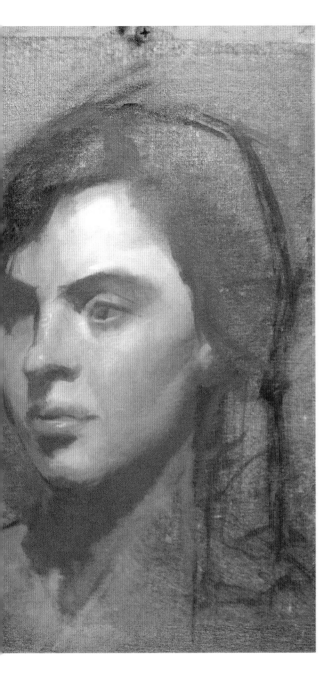

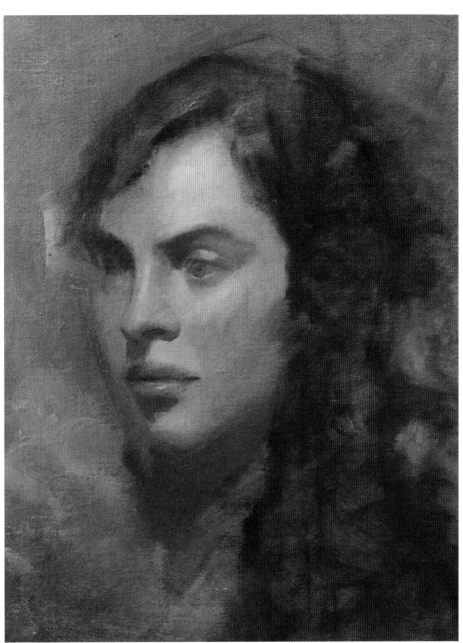

In the coloring stage, shown to the right, I went in with flesh tones that were thin and transparent in some places and opaque in others. As you can see, I massed in the dark of the hair in a general way, thinly, but kept the values on the forehead high enough overall to remain the place where the light was most intense. It is a general rule in traditional painting: Keep your darks thin and transparent and keep your lights thick and opaque. I followed this rule in this painting. But the semester ended before I could finish this demonstration. Since I often simultaneously teach and demo, my demos are usually cut short of completion. However, I think in this case it works fine in an unfinished state.

OPPOSITE AND ABOVE LEFT: Here, we can see a view of the model, Alexis, and a shot of my demo on the easel. The painting is in the grisaille stage at this point.

ABOVE RIGHT: Rob Zeller, *Alexis*, 2013, oil on linen panel, 12 x 9 inches (30.5 x 22.9 cm)

As often happens with my class demonstrations, I do not get to finish them because I'm teaching, in addition to painting. But they do make great teaching tools afterward, as you can see the process.

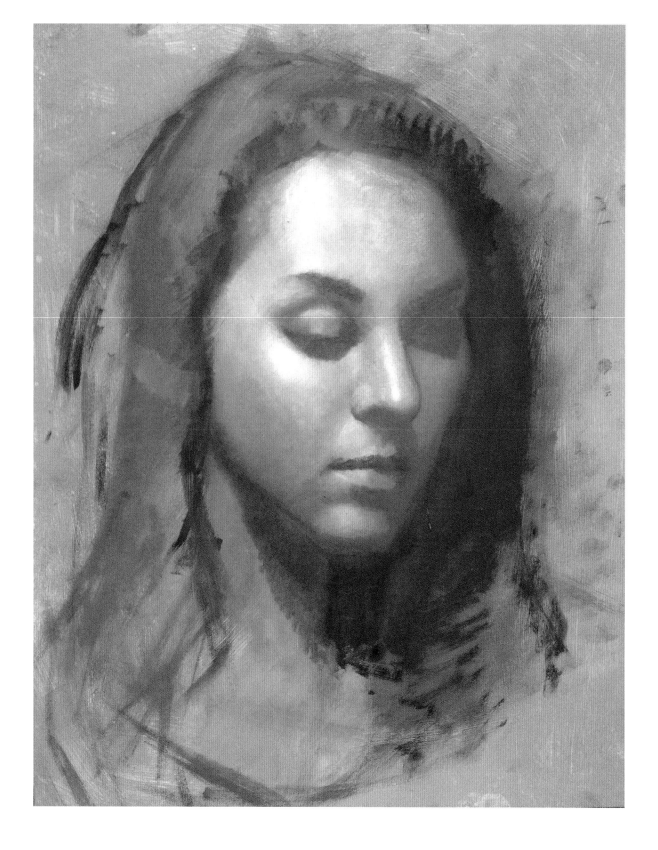

Here is another in-process sequence. On the left, we see the initial grisaille layer, then on the right, the coloring stage, and then the final version of the painting, *Kate*, on page 232. The values are already set up in the first stage of this closed grisaille method. So coloring

was the "icing on the cake," so to speak. As you can see in the earlier of the two coloring stages, I went in rather generally with the color, knowing that I would need to maintain the value structure of the grisaille. But in the final, you can see how much detail I was able to add. I

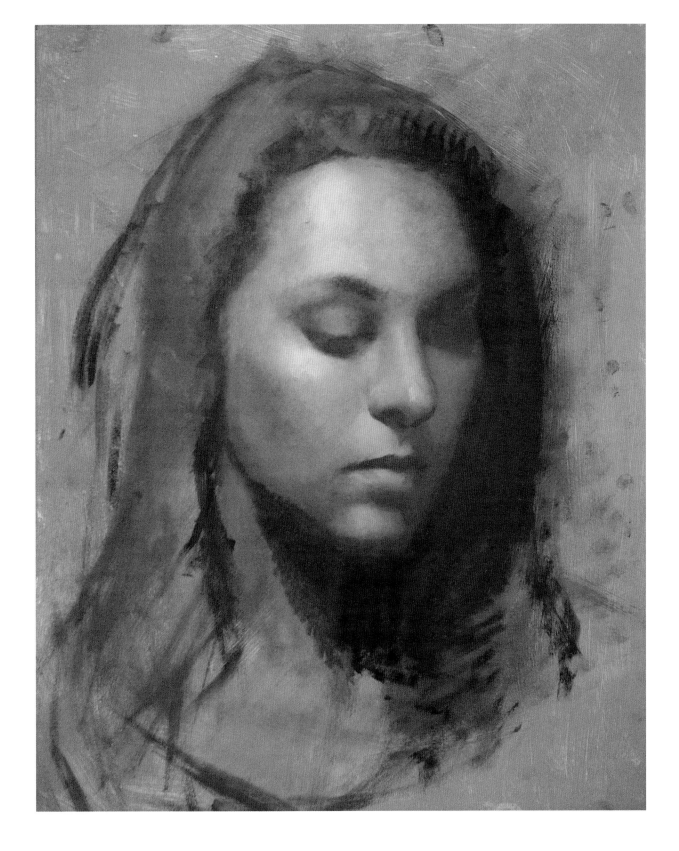

left a lot of the painting "open," with the grisaille coming through. The cool of the underpainting makes for a great transitional gray, if you can keep your touch light enough to let it show through in some areas.

OPPOSITE: The initial grisaille layer of *Kate* was done *alla prima*, with no preliminary drawing.

ABOVE: Here, I began applying both transparent and opaque layers of flesh color. I was mindful of keeping a sense of light hitting a skull, despite the interesting details of her face. I put them off until later.

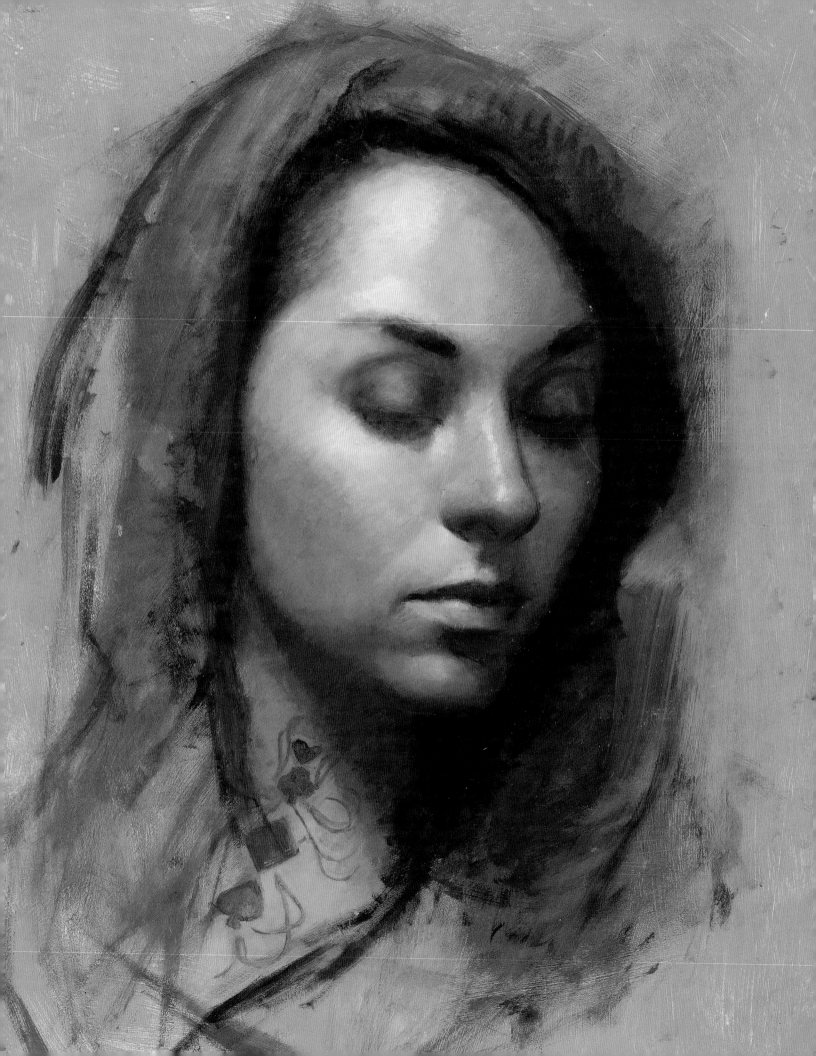

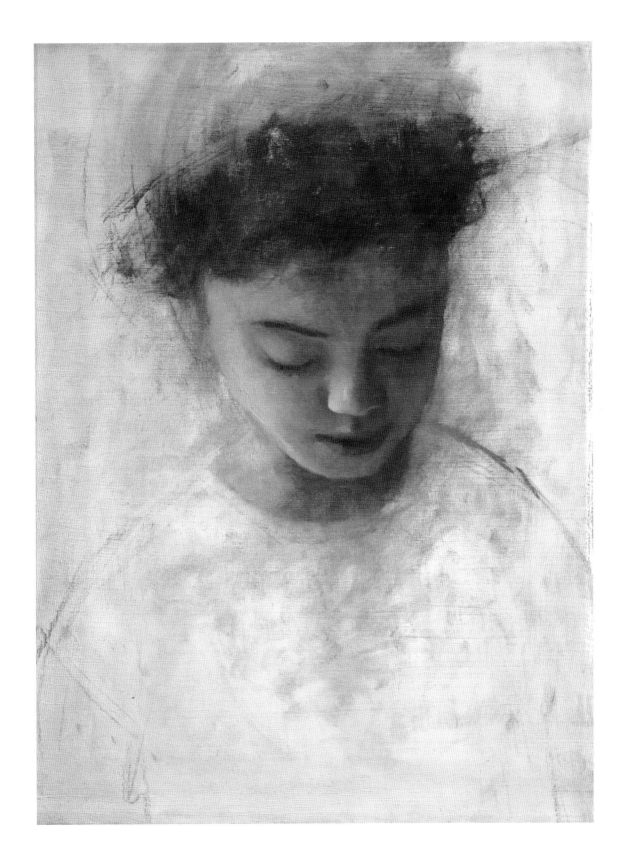

OPPOSITE: Rob Zeller, *Kate*, 2013, oil on panel, 16 x 12 inches (40.6 x 30.4 cm)

This was a rewarding class demo. Notice I was able to maintain a strong light source on her skull while getting into the details of her features.

ABOVE: Rob Zeller, *Olivia*, 2015, oil on linen, 24 x 18 inches (60.9 x 45.7 cm)

This portrait was painted in two steps using the closed grisaille method. The cool underpainting shows through the glazes of color in the transitions between light and shadow on the model's left side.

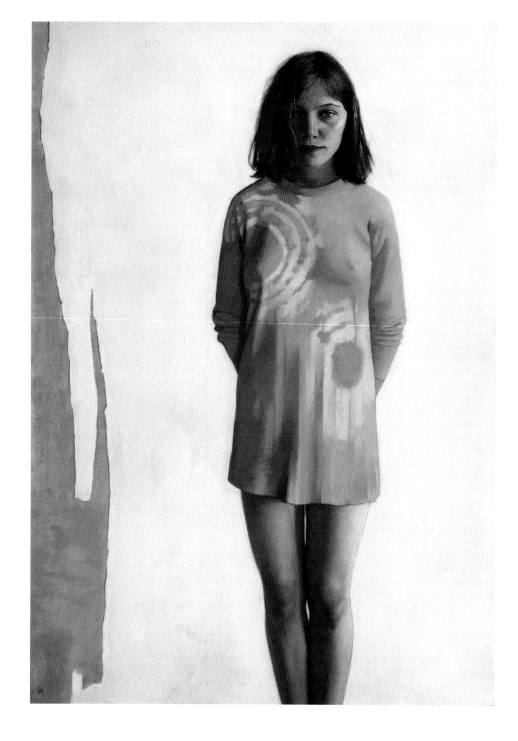

The Portrait Torso

Here we see two very interesting half-figure portraits. Sharon Sprung's *Gloria* is both formal and engaging. We see a young woman in a light-colored shirt standing against (or rather in) what looks like an Abstract Expressionist painting. Both the background and the model's clothing form an integrated figure-ground relationship, one rooted in abstraction. But the lighting and form of the figure create real space and a personal aspect: The model's body language is in contrast to the direct facial engagement with the viewer. Sprung has stated that *Gloria* is a poem painting about the self-conscious integrity of a young woman becoming herself, and we feel her keeping a safe distance from us.

ABOVE: Sharon Sprung, *Gloria*, 2010, oil on linen, 54 x 30 inches (137.2 x 76.2 cm)

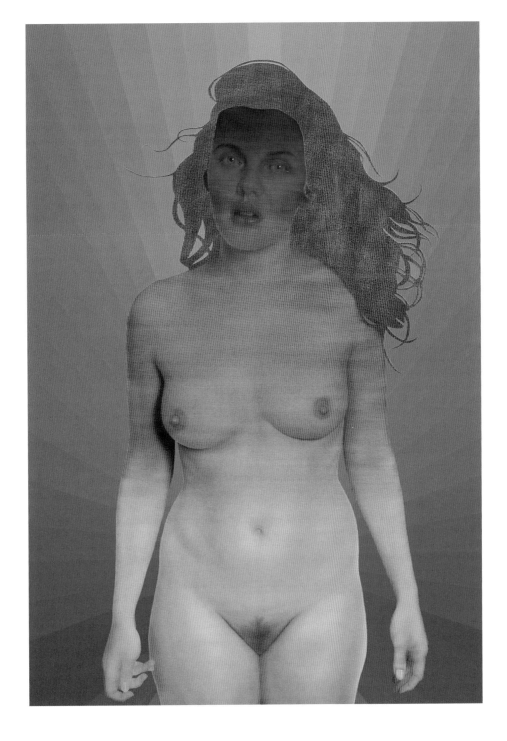

Jenny Morgan's painting is brazenly the opposite. *Dark Star* is a very Dionysian portrait of a model and her "aura." The narrative goes something like this: The model had gone to New York City's Chinatown to get her aura read, and brought back an image of it for Morgan to see. This painting is Morgan's response to that. It brings to mind so many adjectives all at once: classical, figurative, Pop, sexual, conceptual, and even graphic in an illustrative sense. But mostly, fun.

Morgan's images are full of wonder and channel youthful influences of late-1960s psychedelia. Her colors have the graphic punch of the Age of Aquarius and also tap into other lost threads of American artistic collective consciousness. In early Modernism, the figure was often mixed with abstraction as a sort of visual interference and distortion, as we saw in the work of Edwin Dickinson in chapter 1. But while some of the artists from that time period have a generally melancholic tone, Morgan's distortions are lush and sensual, with a playful mysteriousness.

ABOVE: Jenny Morgan, *Dark Star*, 2015, oil on canvas, 70 x 48 inches (177.8 x 121.9 cm)

Alla Prima Painting

Alla prima usually means "painted in one sitting" (*alla prima* being the Italian term for "at once"). Most often, the technique entails a careful and quick observation of the model in order to achieve an accurate likeness. Because of this method's rapid nature, usually an artist attempts a fusion of open- and closed-form conception to maintain a freshness of brushwork throughout the process. Both of these paintings were done from the same model. Kristin Künc and I were both working with her around the same time, both using *alla prima* techniques. Her painting, *Paulina*, was done in one three-hour sitting, as was mine, *Primavera*.

Notice Künc's buildup of texture in the lights, and the thinness and transparency in the shadows. She made incredibly accurate marks for the features. Each mark counts for much in this technique.

In the case of *Primavera*, I focused on each brushstroke as the potential final word on the subject. Notice how I integrated the dark background into the portrait. I did this to pop the contrast and also to create atmosphere. Neither Künc nor I is a huge fan of blending paint to achieve form. Rather, we try to mix up the intermediary values and lay them down in as few strokes as possible.

As you can see, the art of portrait painting is incredibly diverse in terms of technical approach. How you choose to work will be based on your artistic inclinations and temperament, the needs of the individual piece, and also the tastes of the client or collector.

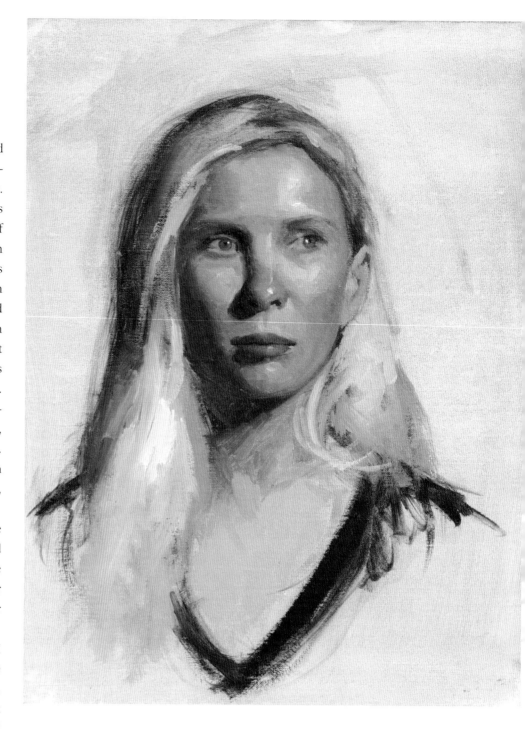

ABOVE: Kristin Künc, *Paulina,* 2010, oil on linen, 12 x 9 inches (30.5 x 22.9 cm)
 This head study was created in one sitting using bold, *alla prima* technique.

OPPOSITE: Rob Zeller, *Primavera,* 2009, oil on linen panel, 14 x 11 inches (35.6 x 27.9 cm)
 I painted this portrait when sitting in, for roughly three hours, during an allegorical-themed workshop that Patricia Watwood presented at the Teaching Studios of Art. There was only one spot open, in the far corner of the room, but it worked out nicely.

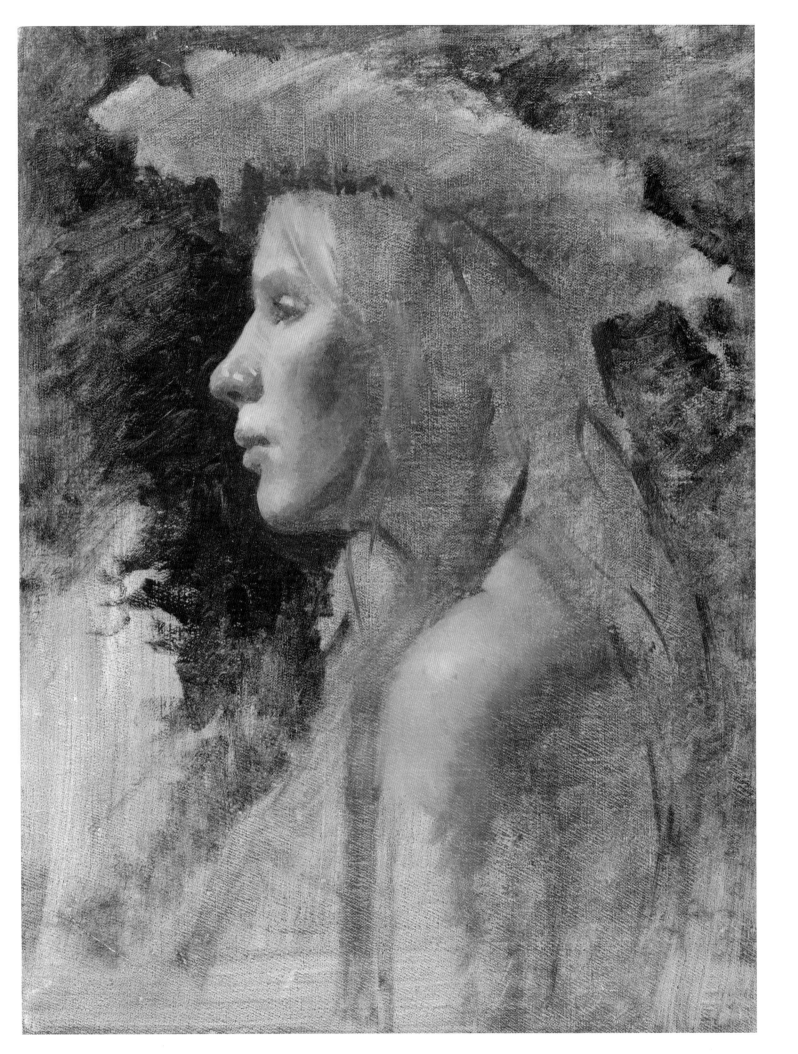

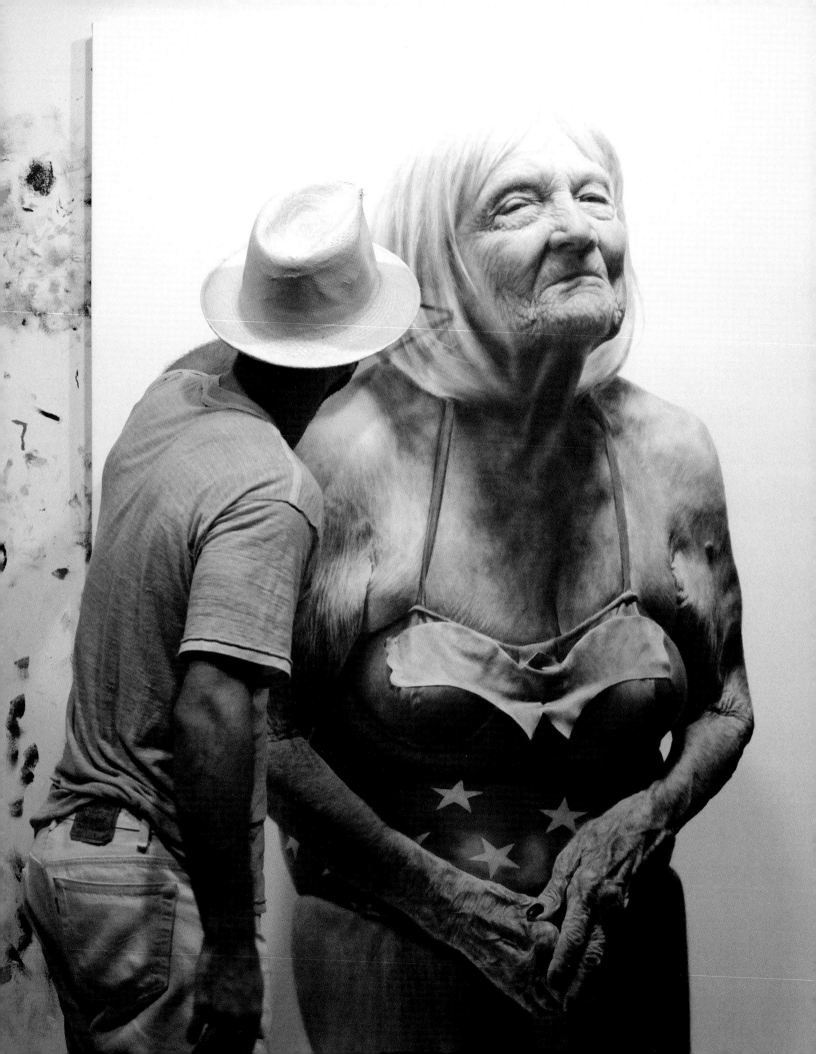

THE CREATIVE PROCESS

E ach artist who works with the figure goes through a process to create a composition. Some work things out in a meticulous fashion with preliminary thumbnails. Others employ additional steps, such as finished drawings, color studies in oil or pastel, and so forth. Still others prefer to go right in with color, directly on the canvas. There are as many different ways of moving from the germ of an idea to a finished concept as there are artists themselves.

OPPOSITE: Jason Bard Yarmosky has attempted to unify his drawing and painting techniques. At times he quite literally makes his paintings look like drawings. Here we see him working on a larger-than-life-size figure of his grandmother.

Each artist featured in this chapter has a unique plan of attack. The format of this discussion will be to show you a bit of their working method. This may include a sketch, related materials in other mediums, or process shots of a particular work in an unfinished state, and then the finished product. As you will see, many artists do things in an old-school way. But others utilize modern technology in a new and stimulating manner. Likewise, the process is linear for some and meandering for others.

A large movement is currently underfoot to bring traditional techniques into the contemporary age. You will see some of that in this chapter. Both Photoshop and 3-D-modeling software afford artists many fantastic opportunities to experiment with their compositions during the creative process. These advances in technology are coming at a moment of resurgence in interest in the figure. The inspiring results, as you will see on the pages that follow, highlight some of the imaginative strides made in the world of figurative art in recent years.

Regardless of your own current preferences in terms of working method, I hope this chapter will inspire your own compositions—and broaden your sense for the possibilities on the creative horizon. As I said in the opening chapter, the great movements in art cycle in and out of favor, and Figurative Realism is no exception. It appears that its time of ascendancy has come once again. More and more artists are working with the figure in a serious way, and the art establishment has finally stopped treating the trend with disdain. It is an exhilarating time to be working with the figure.

ANDREW WYETH

Andrew Wyeth's paintings are wonderfully quiet. Solitude seems to be an integral part of what makes his work so powerful. Perhaps that spartan simplicity is what caused him to be opposed by the art establishment for decades. He was seen as retrograde, an illustrator masquerading as a fine artist. But he kept working, quietly and with great power. When he revealed his long-hidden *Helga* series, he was accused by some of creating a publicity stunt. But like most things regarding his art, he kept largely silent about Helga as a person and as a model, both to his wife and to the public, choosing instead to let the paintings speak for themselves. Wyeth seems to bring strong personal associations to his art—whether it is a landscape, figure, or portrait—that imbue the images with spirit.

The *Helga* paintings are erotic and beautiful, but mostly enigmatic. We will never know the scope of the personal relationship between artist and model (nor is it important), but the intimacy and depth of their artistic relationship is on full display. It was obviously profound. Wyeth did later reveal that the *Helga* paintings became "the well" to which he repeatedly went in search of visual and emotional power to invest in his other, more public work.

Like all great artists, Wyeth developed his own sense of line, form, and color. In these two studies of a reclining Helga, opposite, we see Wyeth working out a composition about light on a woman's back. The images are full of spirit, energy, and life—and maybe love. The sensitivity and openness of the initial pencil sketch and watercolor give way to a meticulousness and specificity in the final painting. But in a great reversal, the very fair German woman with blond hair has been replaced

OPPOSITE TOP: Andrew Wyeth, *Study for Barracoon*, 1976, pencil on paper, 18 x 23³⁄₄ inches (45.7 x 60.3 cm), copyright © Pacific Sun Trading Company, courtesy Warren Adelson and Frank E. Fowler

OPPOSITE BOTTOM: Andrew Wyeth, *Study for Barracoon*, 1976, watercolor on paper, 19³⁄₄ x 25¹⁄₈ inches (50.2 x 63.9 cm), copyright © Pacific Sun Trading Company, courtesy Warren Adelson and Frank E. Fowler

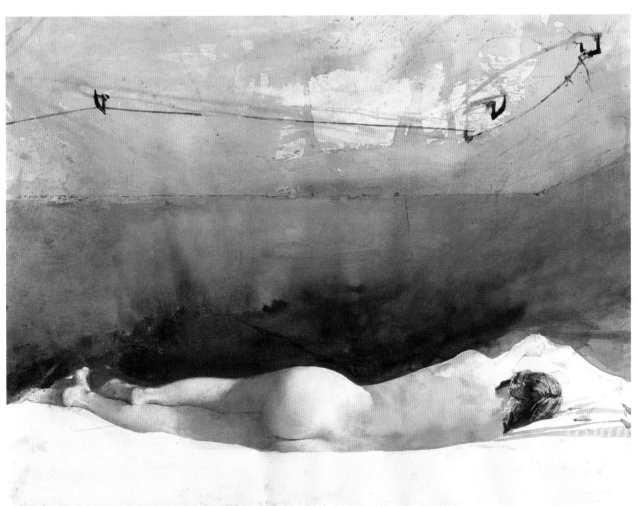

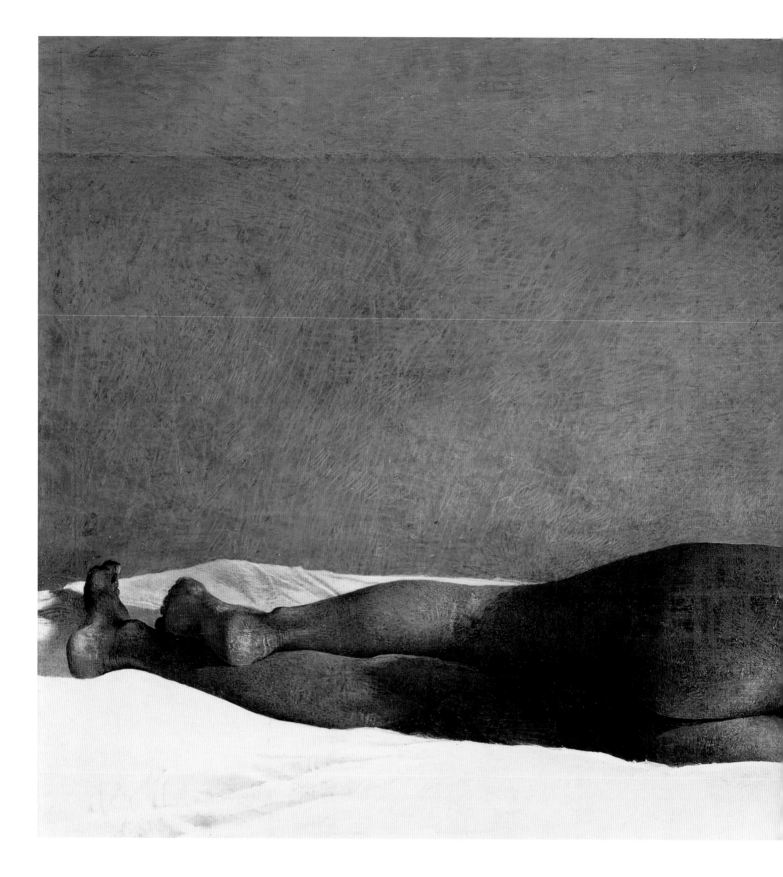

by a dark, African American woman. Why did he do that? Did he shift the focus from a specific woman and relationship to a completely different one as a form of subterfuge? Was Wyeth passing political commentary on the slave trade, or on the artist/model relationship? It is still a mystery to the public.

What *is* known is this: The word *barracoon* refers to a type of barracks used historically for the temporary

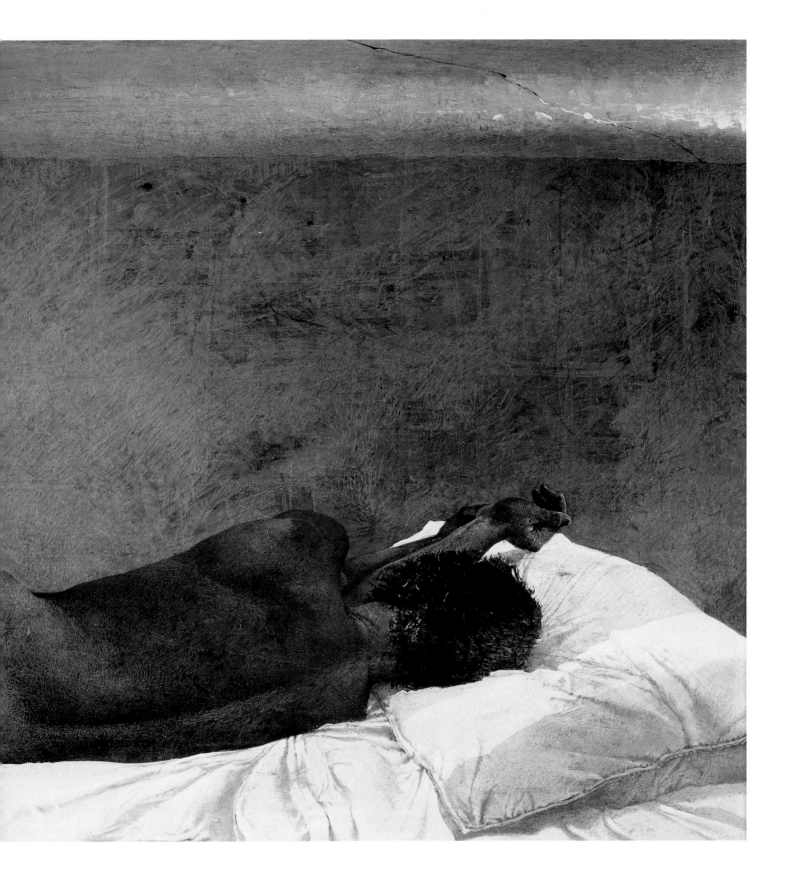

confinement of slaves or criminals. It's highly doubtful he simply decided to change Helga's pigmentation without purpose. Whatever his reason, it was likely intensely personal.

ANN GALE

Age-old questions for both artists and art enthusiasts alike: Is a portrait the documentation of the physical likeness of a person, or his or her inner, spiritual being? Can the former exist without the latter? Is portraiture the act of documenting a person, or documenting the process itself?

In Ann Gale's work, the answer is: all of the above. The act of painting a real *someone* and the process itself are on full display. These images are not the result of casual observation, but rather an act of scrutiny. In the drawing, one can see that Gale's vision has scanned across the grid, blocking in the form of the figure and its surrounding environment. In the painting, while she is working off the same grid, Gale incorporates small patches of color, each expressing a decision about the changing light and the shifting position of her model over time. These small decisions add up to a sober monumentality. And one does not feel rushed in any way when looking at her work, but rather, time unfolds slowly. The environment that Gale creates is not inviting or sentimental, but rather cool, gray, and more than a bit somber.

RIGHT: Ann Gale, *Peter with Striped Kimono*, 2014, graphite on paper, 28 x 19½ inches (71.1 x 49.5 cm)

OPPOSITE: Ann Gale, *Peter with Striped Kimono*, 2014, oil on canvas, 50 x 44 inches (127 x 111.8 cm)

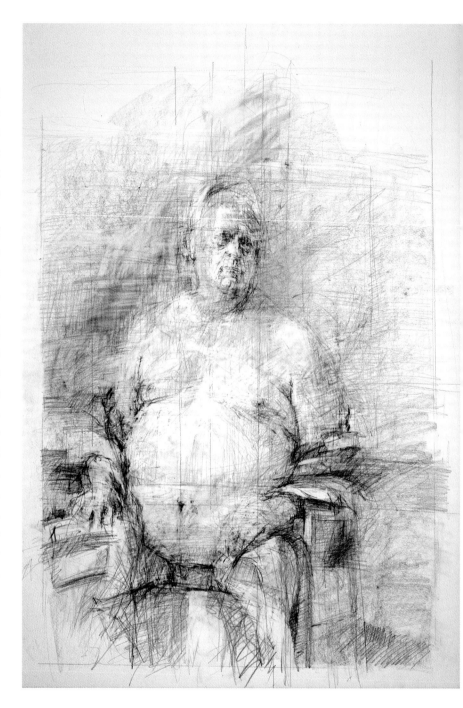

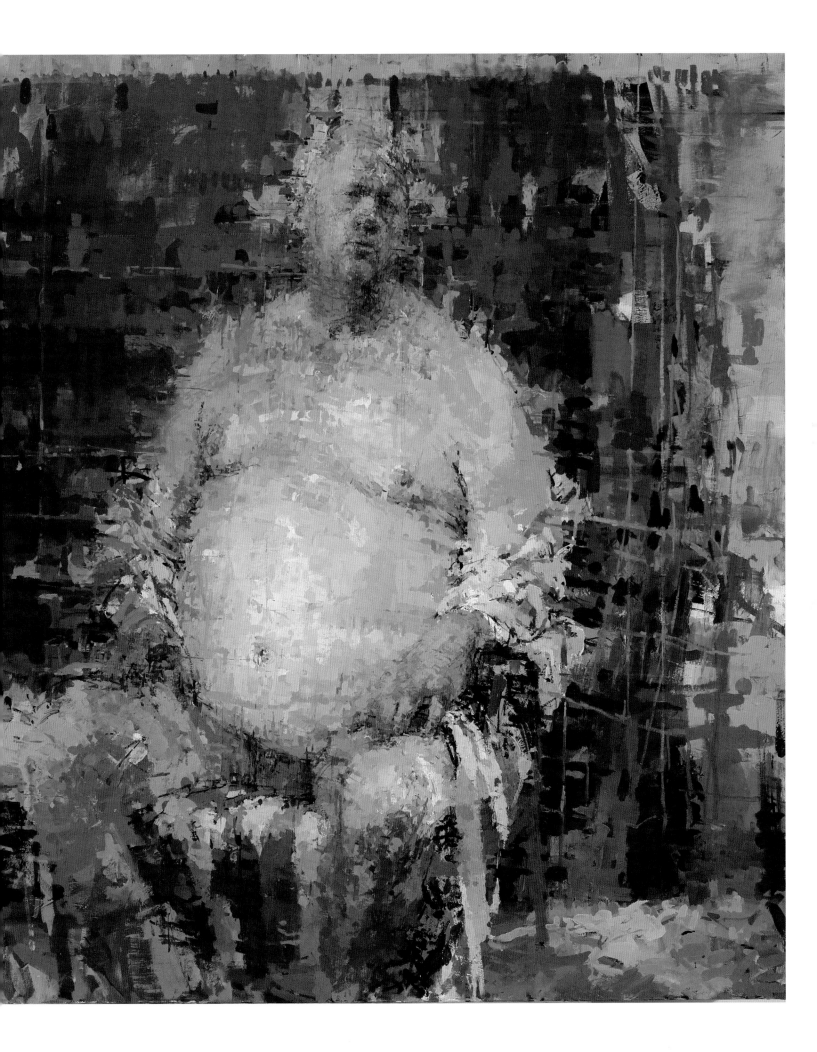

BRAD KUNKLE

Brad Kunkle's version of realism is beautifully unique, a study in quiet contrasts. The image opposite is one part tasteful symmetry, one part Fin de Siècle decadence. His painting style is simultaneously sensual, controlled, and meticulous. Kunkle works in a manner that references art history: echoes of Gustav Klimt, Lucas Cranach, John William Waterhouse, and many others filter through his oeuvre. Yet Kunkle still manages to forge his own way, saying something that is conceptually very different—social and political statements about the acceptance of same-sex relationships in our society.

Working with classically rendered figures and a limited palette enhanced by intricately applied gold and silver leaf, Kunkle populates this landscape with organic patterns of leaves, snakes, branches, and, in this particular case, apples—of the Adam and Eve variety. Kunkle subverts the traditional biblical narrative for a more modern, inclusive retelling by painting two women. But interestingly, there remains trouble in this updated version. The serpent, representing Satan, the great tempter and author of the Fall of Man, is still present, coiled in the background between them and with mischief in mind, no doubt.

The underpainting/drawing reveals a very traditional approach of using umber washes to map out the composition. In terms of line, the whole design is there, right down to the facial expressions of the figures. But the forms are more generally executed at this early stage. Notice the background being pulled into the composition behind the figure on the right. Kunkle weaves the elements together as a whole fabric, adding more richness as he goes along.

ABOVE: Kunkle works out his composition in an open grisaille, as shown in this studio shot.

OPPOSITE: Brad Kunkle, *The Proposition*, 2009, oil with gold and silver leaf on linen, 50 x 31 inches (127 x 78.7 cm)

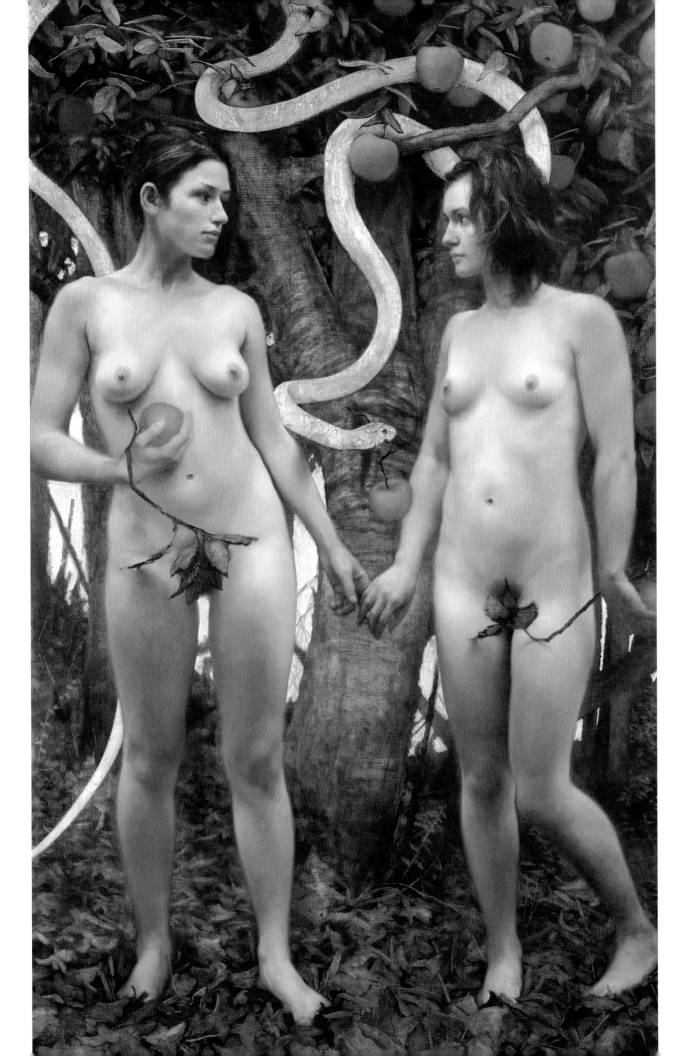

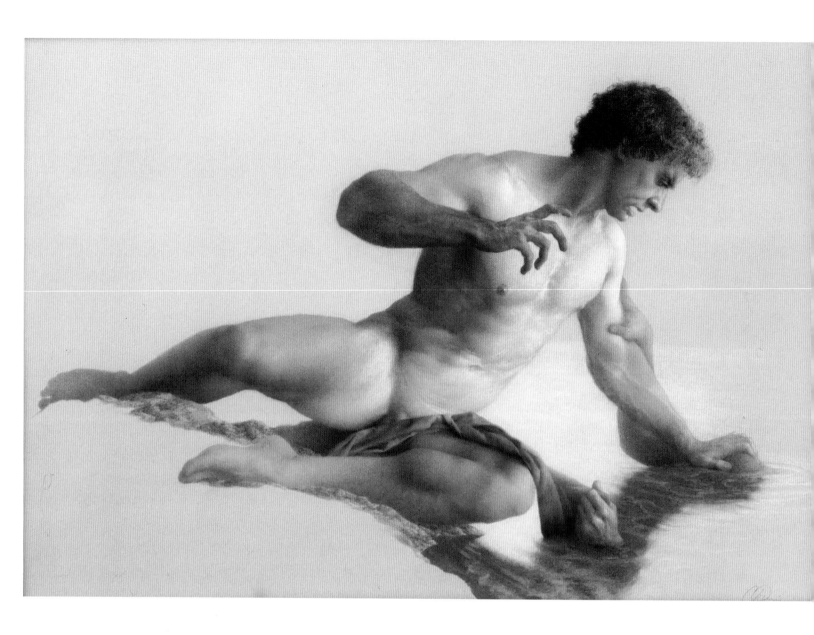

CAMIE DAVIS SALAZ

Few artists working today are as Neoclassical in their understanding of form as Camie Davis Salaz. Her working method is rooted in the French Academic system, and yet, as we can see in the finished composition opposite, her needs to express passion lead her to utilize the very same romanticized natural elements that many a Neoclassicist resorted to—namely, dramatic lighting effects over an idealized landscape. Salaz's style is a hybrid of both Neoclassical and Romanticism, which is not unusual in a historical context. As detailed on pages 46–51, the two movements essentially overlapped and complemented each other. What is unusual is that

Salaz, hundreds of years later, works within that tradition to such a degree of perfection.

Salaz's working method is the real deal in terms of academic drawing. As you can see here, she initially works up a full-value figure on toned paper. The focus at this stage of study is twofold: the form and structure of the figure and the direction and quality of the light hitting it. Notice the white chalk that she has built up on the model's left shoulder (to our right), and observe the way it slowly fades as we move leftward across the figure. By the time we get to the model's right knee (our left), there is barely any light left at all. That is the

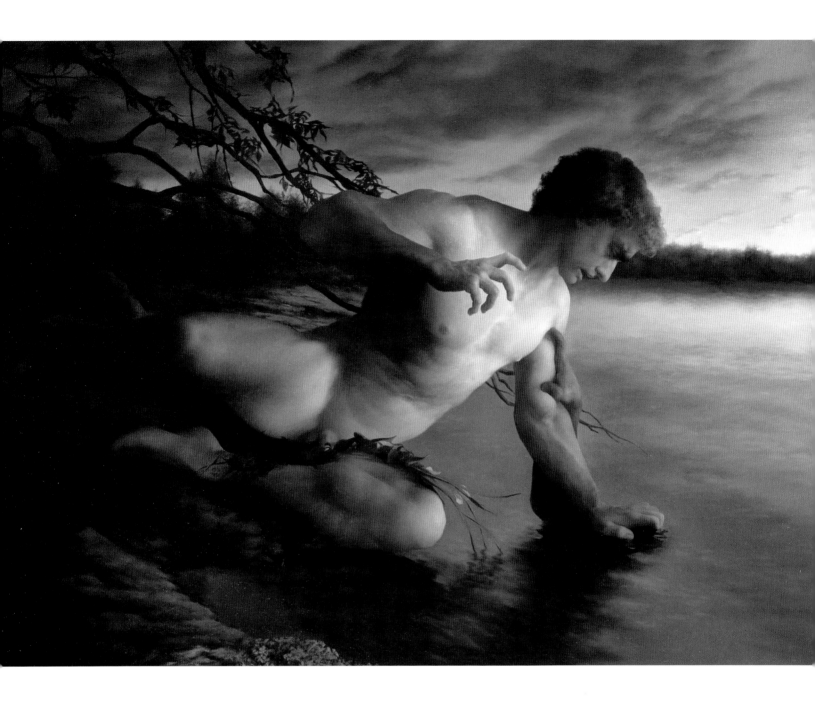

neoclassical method: executing a conceptualized rendering of light as it moves across various larger forms and subforms. Consistent with neoclassical technique, that drawing is then transferred, in outline form, to canvas and "worked up" in oil paint, resulting in the finished composition.

This painting is very different in temperament from John William Waterhouse's version of the same subject that we saw on pages 54–55. Here, Salaz shows a terrible moment of anguish as Narcissus struggles to tear himself away from his own reflection, yet he is gripped tightly by it and cannot escape. Cleverly, the artist does not let us see the reflection, but only a single, powerful arm as it pulls him down to certain death.

OPPOSITE: Camie Davis Salaz, *Study for* Narcissus, 2009, graphite and white chalk on toned paper, 16 x 20 inches (40.6 x 50.8 cm)

ABOVE: Camie Davis Salaz, *Narcissus*, 2009, oil on linen, 30 x 40 inches (76.2 x 101.6 cm)

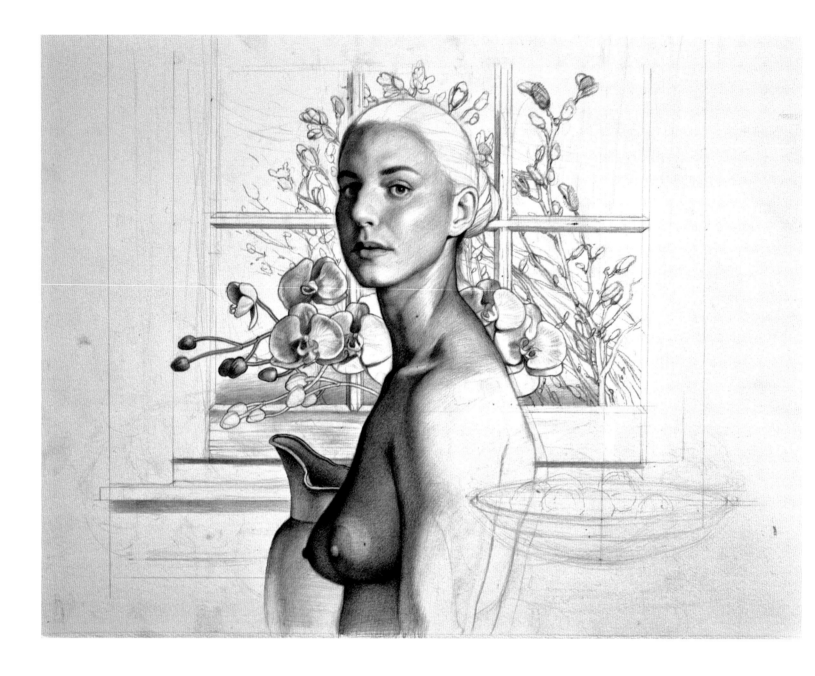

NOAH BUCHANAN

The term *classical* in modern usage has come to mean conventional, trite, and pretty. Think quaint still lifes and portraits of pretty girls. In other words, very much the opposite of what the Greeks invented and intended with Classical art. But some eddies of authentically Classical philosophy are still circling out there in the world of Figurative Realism. Noah Buchanan is an artist who uses the human figure metaphorically to represent grander themes. Much of his work could be described

as Humanist, but I think you can add Classical. The pretty girls are still there, mind you, but in Buchanan's case they mean something.

Here, in his own words, Buchanan describes the process of conceiving this painting: "I made *Spring* while living in NYC in the winter/spring of 2010. The year before, I had made a companion piece called *Introspection (Winter),* so this was the continuation of the series. The following summer, I painted *Summer*. This piece

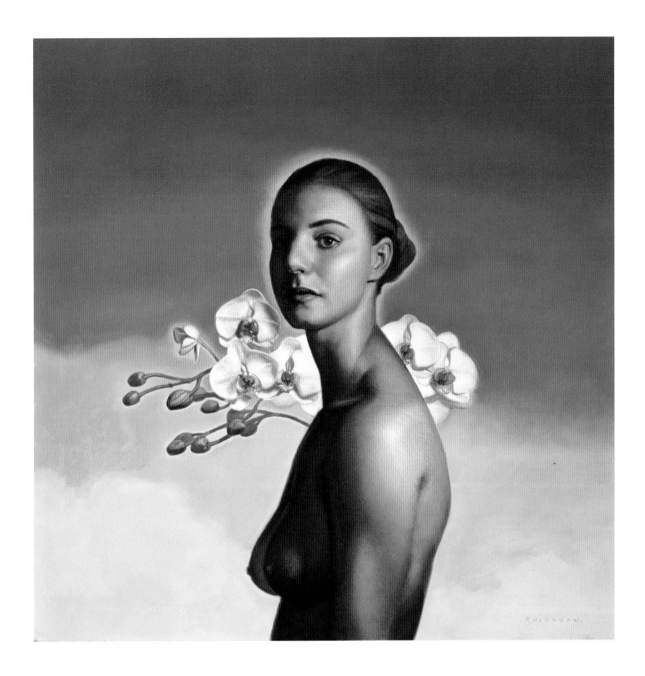

has all of the obvious meanings of spring arriving, and it was keenly felt during my life at that time—the beautiful, fresh arrival of spring—the waking up out of darkness. I wanted to show that her pose is turning out of the shadows and into the light. It's, of course, a deeper symbol for the spring arriving in the soul . . . the image is about the arrival/awakening of the sacred/divine in the soul."

Notice the process of simplification from the drawing, which places the figure in an interior setting, to the painting, where only the figure and flowers remain. This makes the composition more of a conceptual, than a literal, narrative.

OPPOSITE: Noah Buchanan, *Spring*, 2010, graphite on paper, 11½ x 15 inches (29.2 x 38.1 cm)

ABOVE: Noah Buchanan, *Spring*, 2010, oil on linen, 23 x 23 inches (58.4 x 58.4 cm)

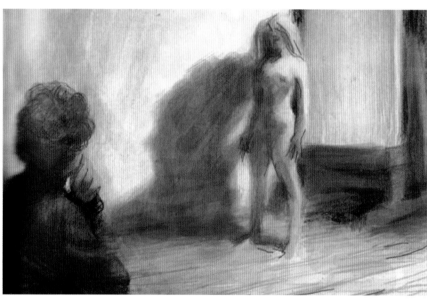

CHRISTOPHER PUGLIESE

Christopher Pugliese's work is often autobiographical. In the studies and painting on these two pages he deals with the grand theme that I refer to as "The Triangle": the artist, his model, and his canvas. This theme has fascinated artists for centuries. The Triangle can be a strictly formal relationship, but often it hints at a sexual one. With Andrew Wyeth's work on pages 241–243, we, the viewer, become the artist and see the muse through his eyes, in a quiet and personal way. Pugliese, in a bit of role-playing, flaunts what feminists refer to as the "male gaze." He inserts himself directly into the image, taking on the role of the impresario, an actor in his own autobiographical artistic drama. Studying the three stages of this image shown here (thumbnail sketches, a color study, and then the final painting), we, the viewer, watch as Pugliese and his muse work out their dynamic.

In the thumbnail stage the artist is seen in the left part of the image, hand to chin looking at both the

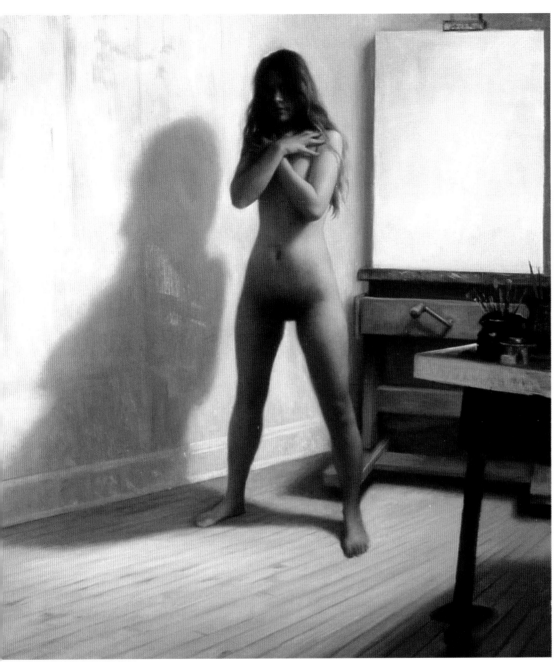

predominantly yellow, but he shifts to a cooler cast in the final painting.

By the time we get to the final painting, the drama is set. Pugliese's use of perspective creates a vey real space, leading us from artist to model to canvas. The viewer is on the model's eye level, and he, the artist, is below it. Her arms are now crossed in a defensive posture and her face is in shadow. She is hiding both the nurturing part of herself (breasts) and her personhood (face, obscured by her hair). She stands there, quite commanding, legs spread apart, quite literally smoldering, with an obvious triangle of negative space between her legs to make sure we get the point. She also casts an enormous shadow on the studio wall, making her more imposing to the art-

model and blank canvas equally. He appears to be in a creative struggle between the two, asking himself, "What to paint and how to paint it?" In the lower left of the page, notice the thumbnail where Pugliese is trying to figure out what to do with the model's eyes. Is her gaze important to the image? Pugliese will ultimately downplay that aspect.

In the color study, the emphasis, at least in terms of value contrast, distinctly shifts to the model. She becomes the focus. The light is stronger on her than on either the canvas or the artist, who loses his face at this point. Here, Pugliese sets the color scheme to being

ist. He stares directly ahead, face now visible in profile. Like a chess player, he tries to figure out his first move on the blank canvas.

OPPOSITE, TOP: Pugliese works out the positioning of the main elements of the narrative in thumbnail sketches.

OPPOSITE, BOTTOM: Notice at this stage, his color sketch, how the artist's face is now slightly turned from the viewer more directly at the model.

ABOVE: Christopher Pugliese, *Limits of Reason*, 2007, oil on linen, 32 x 45 inches (81.3 x 114.3 cm), collection of Larry Hyer

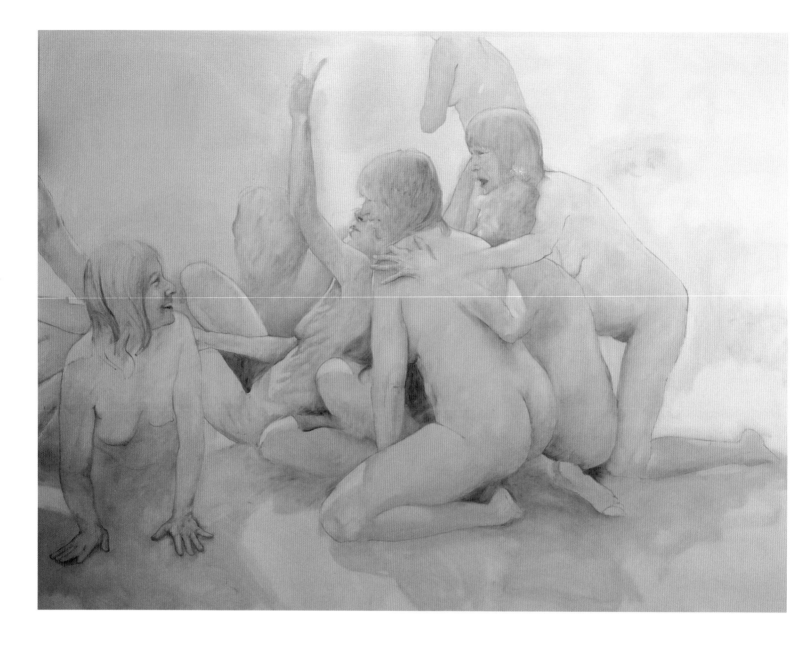

ALEAH CHAPIN

Aleah Chapin's work is a powerful statement that is at once personal, exuberant, and political. She paints women whom she has known personally during various stages of her life as they really are, with no idealization, no enhancements. This is more in line with the Realist philosophy that Courbet imagined. Her work is a celebration of female empowerment through naturalism. These women love their bodies and are not bothered about "imperfections." Chapin's work is often set in natural landscapes, such as woods or meadows. (She grew up in the Pacific Northwest and

that informs her work to a large degree.) Scale is also a factor in Chapin's work: Her figures are often twice life size, which creates an imposing presence that is ultimately a celebration of female flesh from a female perspective.

In the image above, we see Chapin work up a very large composition with a multiple-figure grouping. She does no preliminary dry-medium drawings, but rather starts with a white ground and a light yellow-brown wash, drawing directly onto the canvas. As we discussed on page 228, this method is referred to as an "open

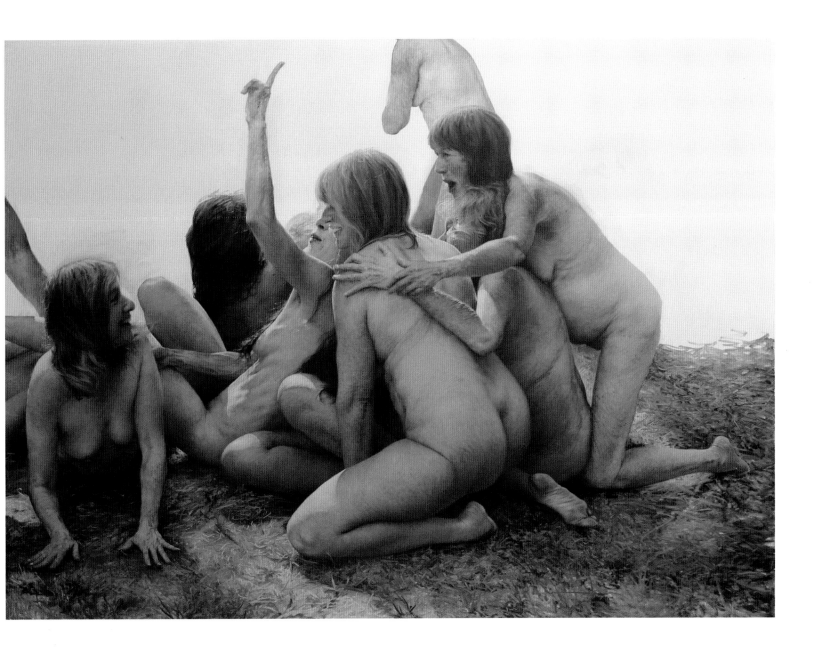

grisaille" form of underpainting. At this point in the process, Chapin starts in with a full range of color and values, working from the center of the image outward.

In the image above, notice the excellent balance of cool and warm flesh tones, and how dark Chapin pushes the value range from the very start. As we look at the finished piece on the following pages, we see that this composition is particularly challenging in that the value structure is mostly in the shadow range, relying on ambient "fill lighting." (Fill lighting is light that is bounced into the shadows. It is similar to reflected light, but is more evenly applied overall and stronger.) The direct light happens only in small patches, in the absolute center of the composition, resulting in "rim lighting"

on the heads, arms, and backs of some of the women. Chapin orchestrates this effect exceptionally well.

It is no secret that our society values youth and subscribes to a very limited definition of "beauty." There is a tendency in conservative artistic circles to play into those stereotypes and make art that features acceptably "beautiful" women. Chapin defines beauty in a very different and more meaningful way.

OPPOSITE: Chapin draws directly onto the canvas with a transparent layer of yellow.

ABOVE: Here, we see a huge jump in the composition as the artist begins to lay in a full range of values with opaque paint.

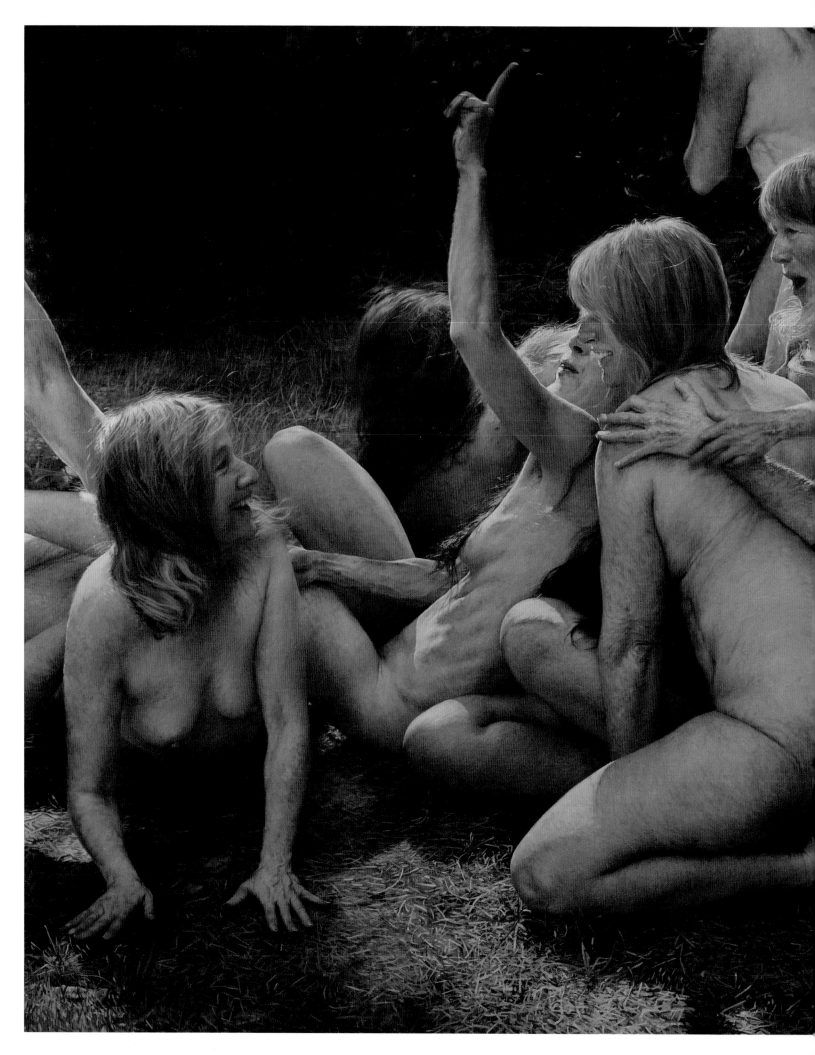

LEFT: Aleah Chapin, *The Last Droplets of the Day*, 2015, oil on canvas, 84 x 114 inches (213.4 x 289.6 cm)

JASON BARD YARMOSKY

Jason Bard Yarmosky's paintings are about the loving relationship he has with his grandparents as they make their way through the aging process. In his work, they maintain a youthful spirit inside, even as time ravages the outside shell. Yarmosky often depicts his grandparents dressed up in superhero costumes, with a strong element of pathos but also a sense of humor. They are in on the joke.

It is no secret that the West has a youth-obsessed culture. We simply don't celebrate old age the way we do youth, though both are important phases of life. As a result, some look at Yarmosky's paintings and feel uncomfortable. Others look past the meticulously rendered wrinkles and see the souls within. What is unique about his paintings is that they are not just about the physical aspects of aging, but about the psychological aspects as well. Yarmosky's grandmother Elaine began to suffer from dementia after he started to incorporate her into his art, and the painting opposite explores the profound impact of her disease. Wearing a Wonder Woman costume and a pink wig, Elaine becomes a heroine, a symbol of a life lived through perseverance, strength, and determination as she clings to her mind as it slips away. Around her is a sparse landscape reminiscent of Andrew Wyeth, a sort of bare Elysian Fields.

We can see this composition developed from the embryonic stage as a thumbnail on the upper left-hand

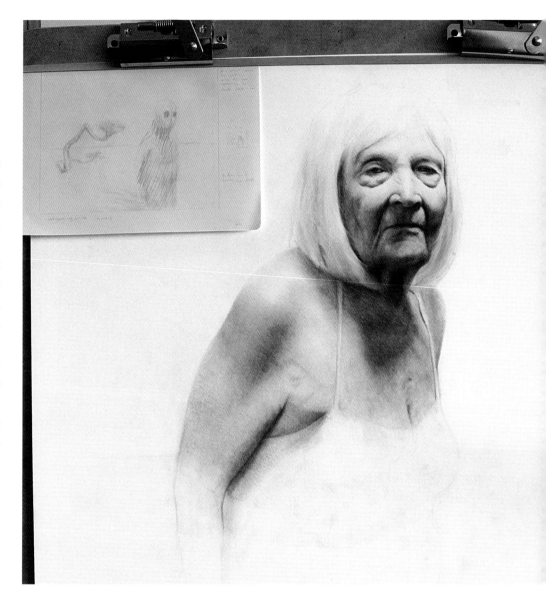

side of the clipboard above. In the drawing to the right of that, we can see Yarmosky's formidable command of drawing on full display with his portrait of Elaine. He paints as proficiently as he does because his drawing skills are at a masterful level.

ABOVE: In this studio shot, we see that Yarmosky referred to a thumbnail sketch and a finished drawing as part of the work-up for his painting.

OPPOSITE: Jason Bard Yarmosky, *Whispering Grass*, 2015, oil on canvas, 84 x 84 inches (213.4 x 213.4 cm)

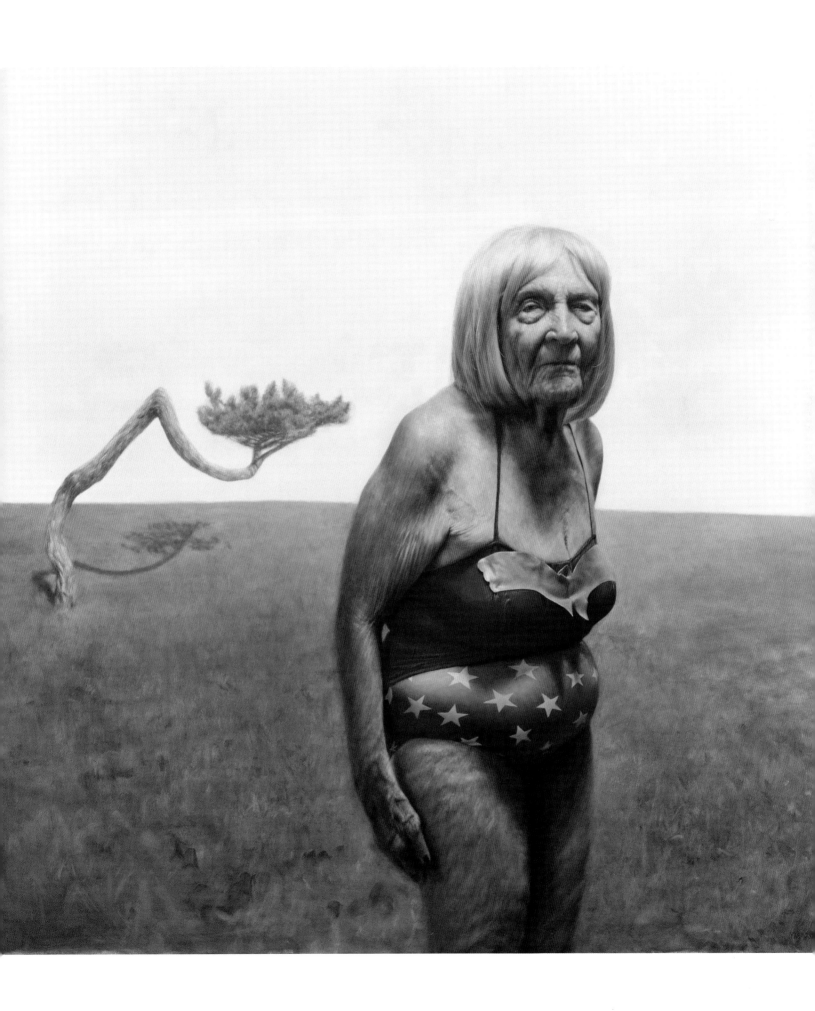

JOHN CURRIN

John Currin is an interesting artist on many levels. A true maverick, he pulled off the near impossible. He was embraced by the art establishment for painting figures with a high degree of polish at a time in the mid-1990s when *no one else* got away with that. One of the fundamental conventions of "contemporary" art is that you must turn your back on the past in order to say something new. Currin authored a new loophole in that convention: You can go back to the past if you are tongue-in-cheek about it. It did help that, in addition to skill and vision, he was armed with an MFA from Yale. Fortune favors the bold, and Currin made a big splash with the dissonance between his technique and his subject matter. But his work resonates precisely because you can tell he really loves the Old Masters and their techniques.

Currin followed a time-tested historical pattern: Bring back a figurative archetype and update it, thus making it original and relevant again. In Currin's case, he directly channels figures inspired by the Northern European master Lucas Cranach and others, but he does so in the spirit of Realism. And somehow, he makes that juxtaposition plainly evident. Currin's women may be painted using sixteenth-century techniques, but they are contemporary at their core.

The painting opposite features a scene that, at first glance, seems to be directly lifted from Lucas Cranach. But the temperament of Currin's work is entirely different. As mentioned on page 26, Cranach created a new type of female nude, pulling off a titillating artistic coup in the middle of the Reformation. Similar in spirit, Currin's two figures have a joyous rhythm that ties their forms together. An inside joke between the two figures is suggested: The directions of their gazes are different, and their expressions say very different things. But most important, *they don't share with us.* We are left out of their conversation.

Here we see both the completed oil painting, and a reverse-image monotype done eight years afterward, distilling the composition to its bare essentials.

ABOVE: John Currin, *The Pink Tree*, 2007, oil on paper (monotype), 18 x 12½ inches (45.7 x 31.4 cm), copyright © John Currin, courtesy of Sadie Coles HQ, London, and Gagosian Gallery, New York

OPPOSITE: John Currin, *The Pink Tree*, 1999, oil on canvas, 78 x 48 inches (198.3 x 122.1 cm), copyright © John Currin, courtesy Gagosian Gallery, New York

LUCIAN FREUD

Lucian Freud painted from life, and he painted life. The enormous gravity we feel when we look at his oeuvre is mainly due to this profoundly unusual fact: The man spent thousands of hours at a time working from a single model to create each painting. In the 1970s, he did a portrait series with his mother that took more than four thousand hours. Freud was so adamantly connected to working from a live human being that he demanded the model be present even while he was rendering the background of a painting.

In this day and age, many artists who do Figurative Realism rely on photographs—in part due to economic necessity, in part because doing so facilitates proceeding quickly and independently. With photographs, an artist can work until the early morning hours. A human model needs breaks to use the restroom, eat, and deal with other aspects of his or her life. It is difficult to imagine the expense of hiring a model for more than a thousand hours, and perhaps even more difficult to imagine laboring over the same painting for that long.

Freud's relationship to his sitters sometimes suggests the conscious or unconscious influence of his grandfather's psychoanalytical process. Given the quality of this interaction, Freud got to know each model with an intensity that is rare. In 1995, he began to work with Sue Tilley, and he continued the artistic relationship with her for five years. By this time, he had developed a method that he would continue until his death in 2011: He would paint a complete nude or portrait and then start an etching directly afterward of the same pose. He drew these poses from the live model directly on the plate, which caused the image to be reversed when printed, as is the case with the images here.

Tilley is an enormous force. Her large, fleshy presence spills out of the confining chair and overwhelms it. We experience her as Freud experienced her, from his perspective. Her head and upper torso are just below eye level. By the time we get down to her pelvis and

knees, distortions begin to creep into his proportions. Freud built up the paint of her body to the point where he seems to be sculpting her.

Many of Freud's later nudes feature rather unclean mattresses, adjacent to huge piles of linen rags (which he used to wipe his brushes), creating kind of a messy environment for a background. By contrast, this painting is particularly interesting because of its regal quality, with the large tapestry of lions hanging behind the model.

ABOVE: Lucian Freud, *Woman Sleeping*, 1995, etching, 29¾ x 23½ inches (75.6 x 59.7 cm), private collection, copyright © The Lucian Freud Archive/Bridgeman Images

OPPOSITE: Lucian Freud, *Sleeping by the Lion Carpet*, 1996, oil on canvas, 89¾ x 47½ inches (228 x 121 cm), private collection, copyright © The Lucian Freud Archive/Bridgeman Images

JENNY MORGAN

Good portraiture is more than an attempt to capture a likeness. It requires the artist to delve deeper. Jenny Morgan's portraits of her contemporaries show multiple layers to their personalities. Being young, they are still very much in development, and her work captures this. She makes use of many colored glazes and obscures details of her portraits and figures by softening, blurring the edges of form, sometimes to the point of leaving a ghost image. She does this alternately by sanding the area after the paint is dry, blurring it out while it is still wet, or going over the area with multiple colored glazes. The resulting interference gives her paintings much depth.

Here we see a process shot of the painting *Kings and Queens* that is a good example of her working method. Morgan begins by transferring the image to canvas with white chalk outlines and then paints in the forms of the figures. The completed *Link*, opposite, shows us her blending of traditional flesh colors with evocatively psychedelic glazes.

Sometimes Morgan's portraits are singular and iconic, like *Dark Star*, on page 235, but often they are group affairs that show people touching or embracing in some way. We are not clear on what the relationship is, but that seems beside the point. The cumulative effect of her sanded, blurred, and glazed version of realism is atmospheric, and somewhat Pop.

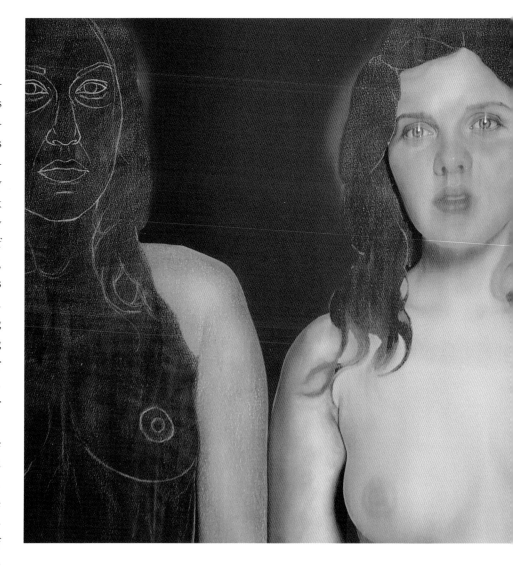

ABOVE: Here, we see an in-process shot of Morgan's painting *Kings and Queens*. She transfers an image in white chalk over a colored ground before working in opaque paint layers.

OPPOSITE: Jenny Morgan, *Link*, 2014, oil on canvas, 84 x 60 inches (213.3 x 152.4 cm)

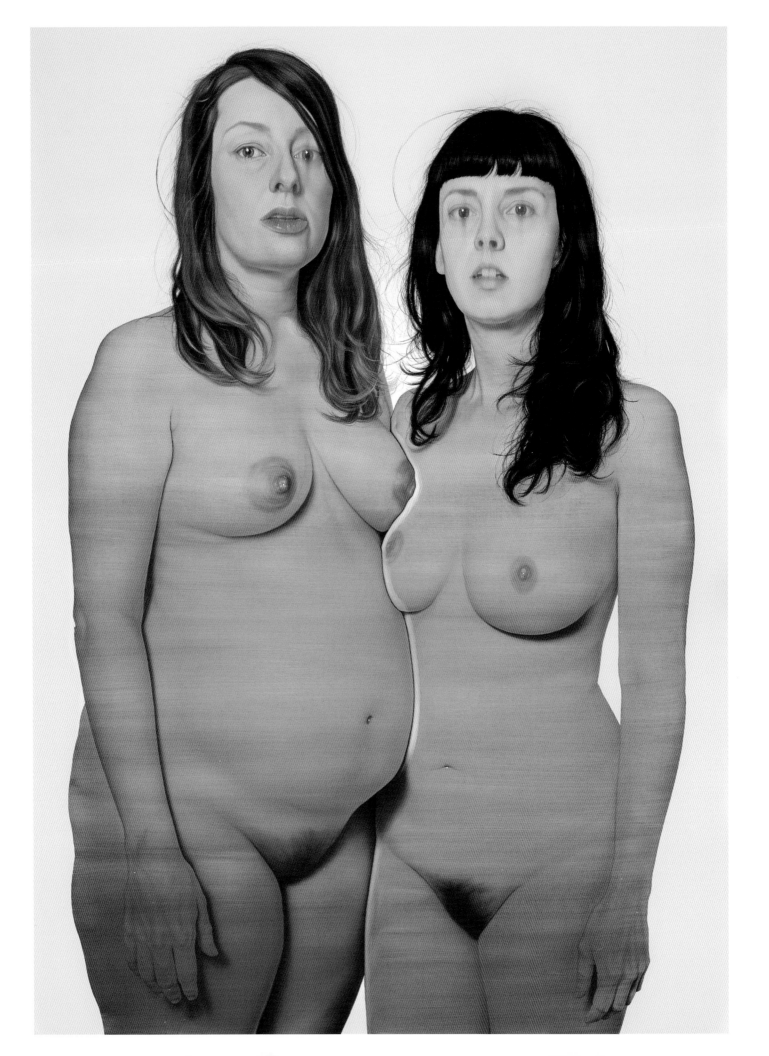

KURT KAUPER

Working with traditional techniques, but often culling his subject matter from the mass media, Kurt Kauper creates an interesting mix of the personal, the public, the established, and the contemporary. In the images shown here, Kauper used a photograph of Bobby Orr, a professional hockey player he admired, from a Boston tabloid and carefully worked out a conventional figure drawing. He kept the nonclassical facial expression of the photograph, but added in his own legs to finish what had been cropped. Again, in a very traditional manner he used a grid to scale up the drawing and transferred it to the canvas, and completed a life-size figure painting of Bobby Orr. The image is fairly conventional, except for the rather enigmatic and empty background. He has done similar work with likenesses of Cary Grant and other public figures.

Kauper does not consider this to be appropriation, but rather a form of expanding on an existing narrative. He admires Andy Warhol, who took media images that most people would consider to be static and standardized and placed them in unstable environments. Kauper believes that instability leads to narratives that force the viewer to confront his or her *own* place in the world. In defining one's self in relationship to broader contemporary culture, the vulnerability of the individual is exposed.

While Kauper's favorite artists—Ingres, Holbein, David, Titian, Veronese, and Caravaggio—all stayed true to the only process that was available to them (working directly from life), Kauper creates his compositions from photos for two reasons: First, because it is important to him to start with public figures he admires. And second, given the way the media saturates our lives, he doesn't think it makes sense not to interact with it, at least as a starting point.

TOP RIGHT: This newspaper insert provided Kauper with source material for the Bobby Orr image.

BOTTOM RIGHT: In the study, we see that Kauper re-created the figure of Orr using traditional drawing techniques, and added his own legs, as the source image cropped them off. Notice the grid he imposed in order to scale up for the larger painting.

OPPOSITE: Kurt Kauper, *Bobby #3*, 2007, oil on birch panel, 91 x 49 inches (231.1 cm x 124.5 cm)

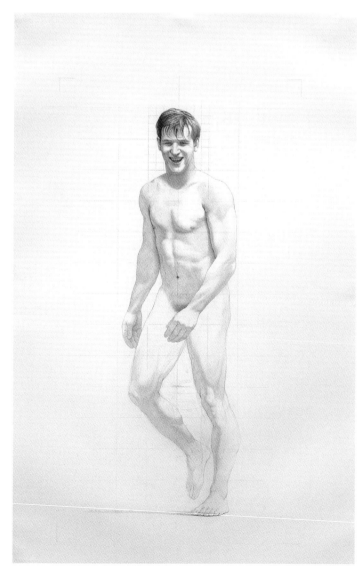

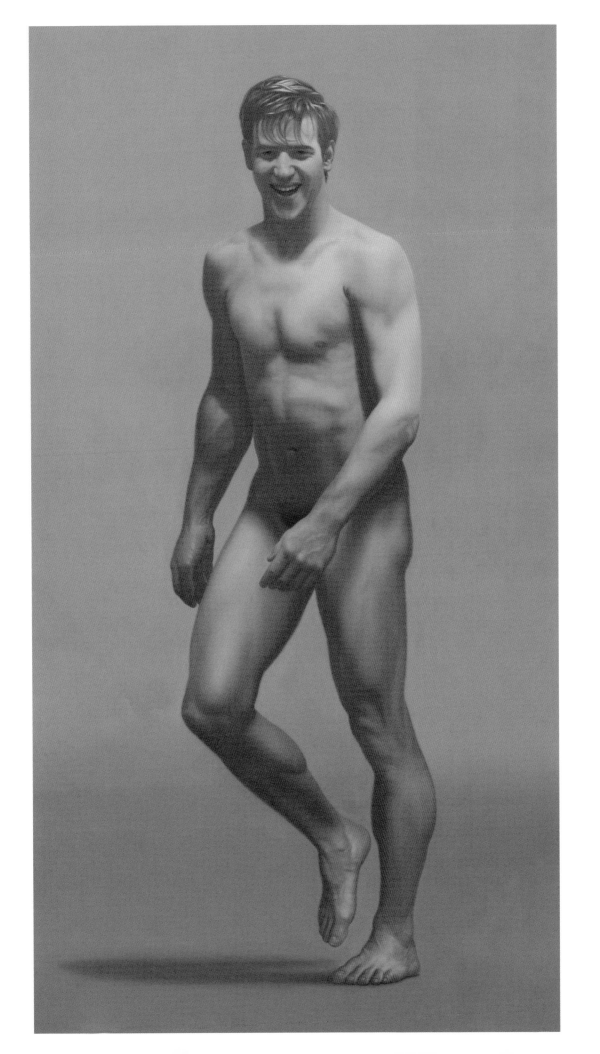

ODD NERDRUM

Odd Nerdrum's work depicts the grand themes of Humanism that have been constantly recycled throughout the centuries of Western art. He takes Greek myths seriously as acceptable subject matter. Unlike an artist such as John Currin, however, Nerdrum is not looking back to the Old Masters with his tongue planted firmly in cheek in order to say something new. Nerdrum confidently paints what he believes to be universal and timeless truths and he paints them in an Old Master style. That's the contemporary art establishment's version of a double negative, so he is no stranger to controversy or critical invective.

In the painting *Blind Passing*, we see a blind hermaphrodite on his visionary path pass by a beautiful young couple. The woman looks on with disdain, and grips her man tightly. She may be clinging to him for protection, but it also appears that she's worried he will go off on some vision quest. The young man looks ahead at the hermaphrodite with a mix of wonder and fear. He does not have the same look of disdain on his face that the young woman does, but he holds her tight. Domesticated, perhaps? Whatever is in the bag in the foreground seems to be key. Food? A child? This painting may or may not be related to the Greek myth of Tiresias, blinded by the gods for revealing their secrets and, as further punishment, turned into a woman for seven years. Many of the narrative elements are in place for it. The moral of that myth is a caution against judging others.

ABOVE: Odd Nerdrum, *Study for Blind Passing*, 2011, pencil on paper, 5⅚ x 5¹⁹/₃₂ inches (13.5 x 14.2 cm)

OPPOSITE: Odd Nerdrum, *Blind Passing*, 2014, oil on linen, 72½ x 74¾ inches (184 x 190 cm)

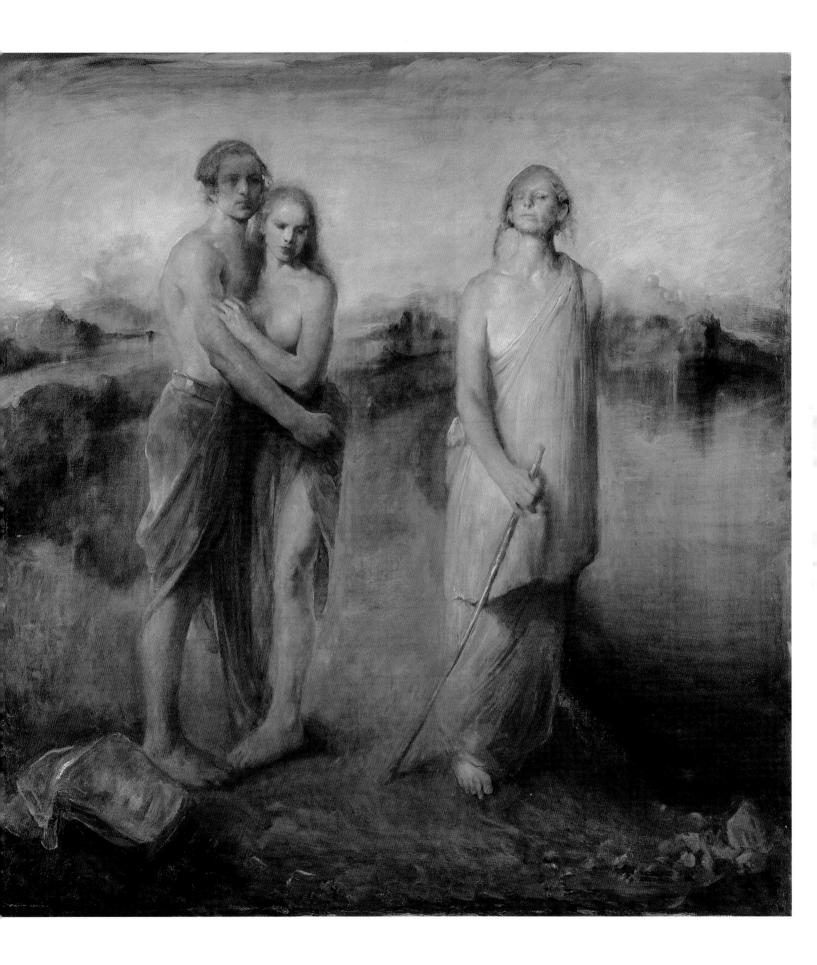

MICHELLE DOLL

Michelle Doll's artwork centers on the human figure in an attempt to portray intimacy. She feels this connection is a form of unspoken, touch-based communication. Along those lines, she paints only real couples and families, preferring to depict honest intimacy, rather than hiring two models as actors. She uses their bodies and their relationships as a metaphor for interconnectedness. Much of that connection is nonverbal and intuitive.

In Doll's own words: "The power of love and desire for connection can be found in a simple touch, a fragile unity, or a fleeting moment. My intent is to find inspiration and appreciation in seemingly banal, quiet moments and render them monumental. While working with others, I make suggestions or direct them with my own vision as a starting point, but typically unique moments between people are naturally revealed."

She usually works out her drawing in an open grisaille with a very saturated color. As we can see here, this one is done in a deep red. She then goes over the top of this grisaille with a mix of cool and warm opaque flesh tones. She shows all of the crevices, the overlaps, and skin folds that make up the topography of a couple.

OPPOSITE: Doll's careful underpainting was done in a deep, saturated red, with many subtle variations in value.

ABOVE: Michelle Doll, *Couple, JTCR3*, 2015, oil on canvas, 14 x 18 inches (35.6 x 45.7 cm)

NICOLA VERLATO

Nicola Verlato creates his works through a combination of classical techniques and modern technology, including 3-D modeling programs such as Maya and ZBrush. The question about whether or not to use photographs pales in comparison to the questions that Verlato is asking of technology. He is well past that twentieth-century debate. Verlato's use of computers didn't change his approach to painting—it simply expands the scope of what he can accomplish and how much control he has over the process.

In Verlato's words: "What struck me was the obvious similarity between this new way to create images and the one of the fifteenth-century perspective. It seemed to me that it was possible, on a new level of complexity, to pick back up from where the masters of the Renaissance left off."

Coming from someone else, that statement might seem like bravado, but Verlato actually delivers. He was classically trained by Fra Terenzio, a painter in the monastery of Franciscan monks in Lonigo, Italy. Adding the 3-D modeling technology to his already formidable arsenal of rendering skills has only enabled his work in painting and sculpture to take off to an incredible level.

Hostia is a project that Verlato created especially for the museum of Lissone in 2014. The exhibition was inspired by the tragic death of Pier Paolo Pasolini, an Italian film director, poet, writer, and intellectual who was violently murdered, presumably by the Mafia. In this project, Verlato presents his death as a suicide on the beach of Ostia. The huge painting is designed like a Renaissance altarpiece, showing the body of Pasolini crossing over from this life, passing through the hell of the world, and moving back through time to his childhood. In addition, the museum installation included a life-size sculpture of Pasolini suspended from the center of the room, six portrait sculptures, and a mural-size drawing.

Here we see Verlato's conception of the centerpiece of that exhibition, a huge painting called *Hostia,* from a thumbnail drawing to a three-dimensional sculptural rendering to the finished painting. Looking like a hybrid between a Michelangelo and a Tiepolo, reminiscent of a great Greek frieze with gigantic muscular figures set in battle, this painting is utterly classical in its understanding of form, rhythm, and overall design.

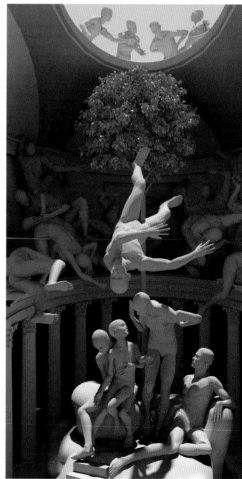

TOP RIGHT: Nicola Verlato, *Sketch for Hostia,* 2014, graphite on paper, 8½ x 5 inches (21.6 x 12.7 cm)

BOTTOM RIGHT: Using Maya, a 3-D computer modeling program, Verlato worked out the forms and composition of his thumbnail sketch and transformed it into a digital sculptural relief.

OPPOSITE: Nicola Verlato, *Hostia,* 2014, tempera on vinyl and linen, 112 x 66 inches (284.5 x 167.6 cm)

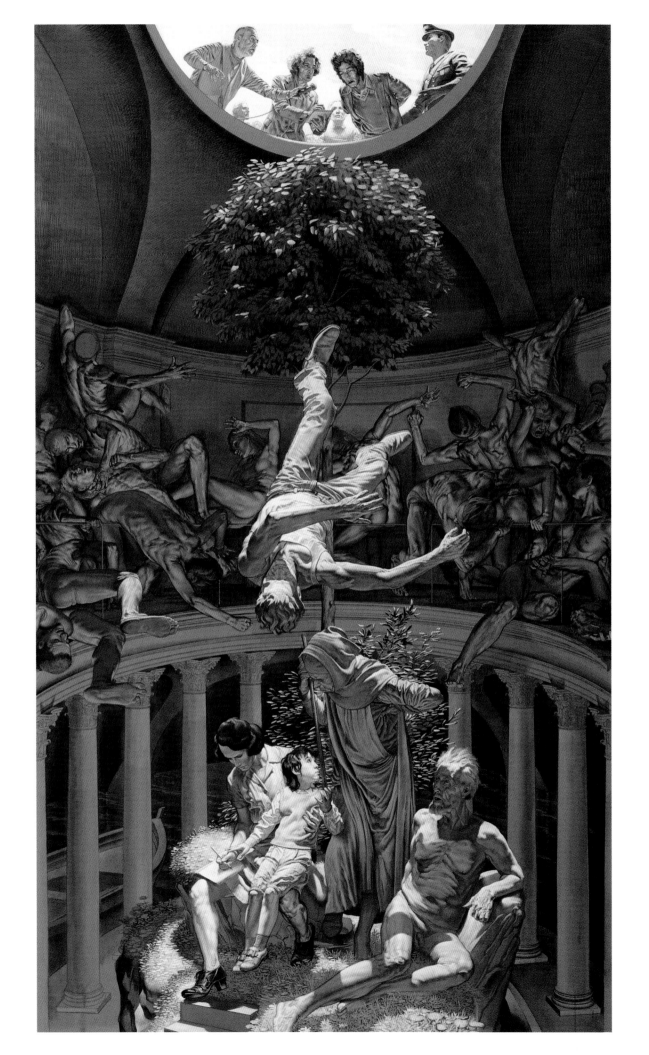

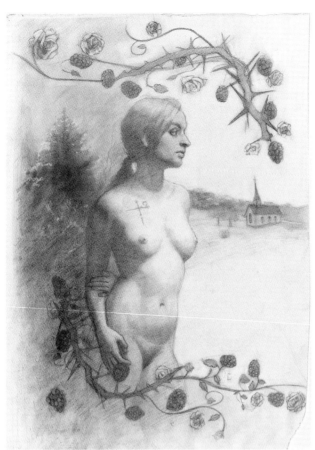

ROBERT ZELLER

I find the mural fragments of Pompeii in the Metropolitan Museum of Art fascinating and am quite inspired by them. As limestone is too heavy to work with in my studio, I've tried to recreate some of the fragmented effect by making paintings on torn and distressed sheets of paper and canvas. In an effort to avoid the historical pastiche effect I sometimes see of artists who try to affect the style of an earlier time period, I'm looking for a stylistic influence that reflects my own narrative concerns and aesthetic. That happened with this piece. One of my models told me a personal story about why she left her church and rural small town. I was very moved, so I set out to make a painting about the incident, a nocturne, set in a rural landscape. I wanted the focus to be on her and what the incident did to her faith. She is featured front and center as a torso bust, surrounded by an environment that reflects her small hometown.

This painting, *A Rural Departure*, is painted on an assemblage of fragments of large paper and board that I glued together and sealed. Simultaneous to that, I carefully worked up the finished drawing (above left) in pencil and charcoal. I then did the color study, shown above, working in a muted violet and blue color scheme. Finally, I combined the two for the final painting. It is meant to have both a Gothic and Classical feel. The bust is surrounded by decorative branches with symbolic blackberries and thorns. Her face is melancholy and in profile, neither looking back at her old church, or engaging us with her eyes. She is caught up in her own thoughts, past, present and future.

ABOVE LEFT: Rob Zeller, *A Rural Departure (Sketch),* 2014, graphite and charcoal on paper, 24 x 19 inches (61 x 48.3 cm)

ABOVE RIGHT: Rob Zeller, *A Rural Departure (Color Study),* 2014, oil on linen, 16 x 12 inches (40.6 x 30.5 cm)

OPPOSITE: Rob Zeller, *A Rural Departure,* 2014–2015, oil and acrylic on various papers, 42 x 30 inches (106.7 x 76.2 cm)

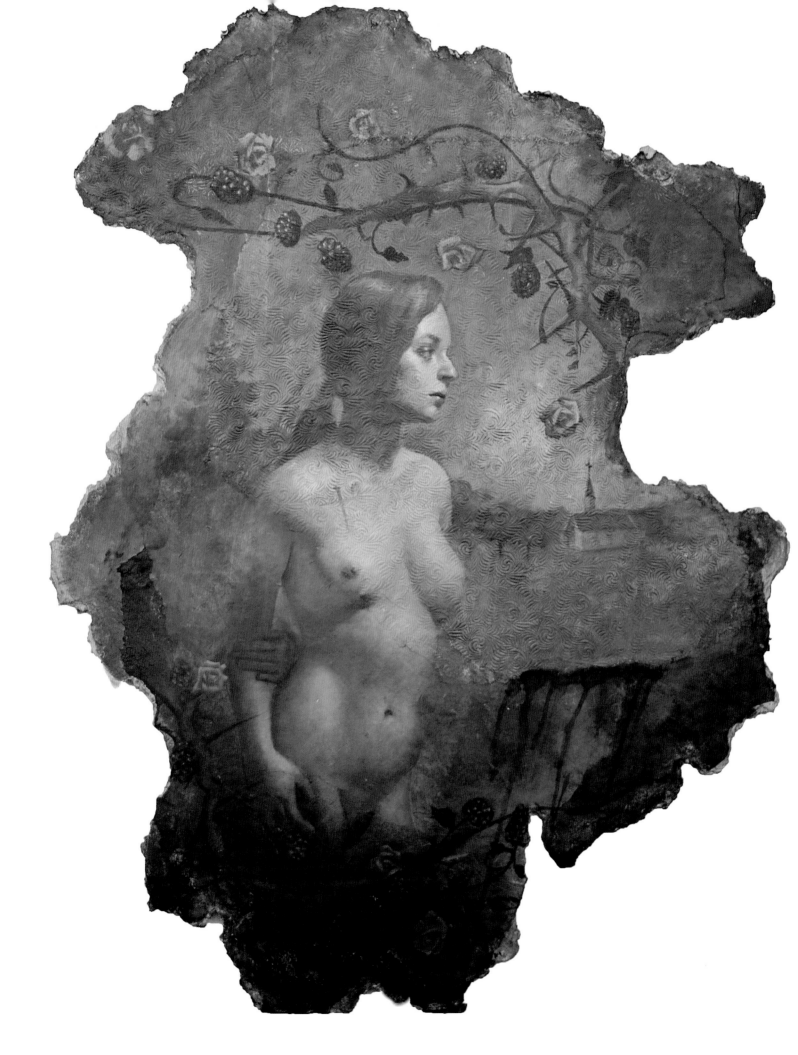

PATRICIA WATWOOD

Patricia Watwood shows us three steps of her process here—a tonal drawing in graphite and white chalk, a color study, and a finished painting. And there were actually a few more conceptual drawings and oil sketches not pictured here. In the painting, Watwood shows us Pandora after she has unleashed all of the evil spirits into the world (in this case, an industrialized waterfront). It is fascinating to see the progression of the pose of the model in each step. Rather than stay strictly loyal to her tonal drawing, the artist shifts Pandora quite a bit. I'll let her speak of her own process:

"I make figure paintings in oil, but almost all of my projects include drawing studies as a part of the development process. I create drawings as an act of 'practice' and develop drawings as a means of discovering new ideas for paintings. My drawings of people are done almost entirely from life. I sometimes continue working, or begin a concept drawing, from imagination and memory. Occasionally, I incorporate some photographic references (either taken myself, or found) to further develop a work. However, my primary method of working is observation and collaboration with a model to create the form I want. For me, producing figurative work is an activity of creating willed form—so making on paper or canvas an expression of a sculptural volume based on what I have seen and experienced. I am not so interested in creating images, or using an image taken from a photo, and developing work from that medium. I am more engaged with the process of direct observation, interaction with the environment around me, and the energetic presence of the person I am drawing or painting. I develop a drawing with a model in the studio, and can then use that drawing to work up the oil painting, and have the model return later in the process for finishing the details of the painting. The drawing thus becomes a flexible and valuable resource for creating subsequent work."

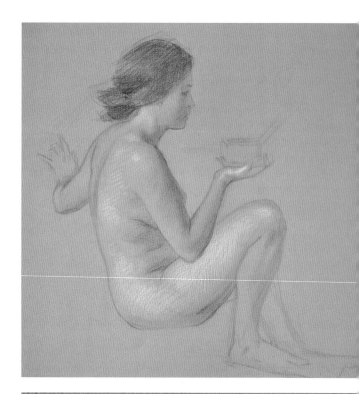

TOP RIGHT: Patricia Watwood, *Life Drawing for Pandora*, 2010, graphite and chalk on paper, 13 x 11 inches (33 x 27.9 cm)

BOTTOM RIGHT: Patricia Watwood, *Thumbnail Sketch for Pandora*, 2010, oil on paper, 8 x 6 inches (20.3 x 15.2 cm)

OPPOSITE: Patricia Watwood, *Pandora*, 2011, oil on linen, 30 x 26 inches (76.2 x 66 cm)

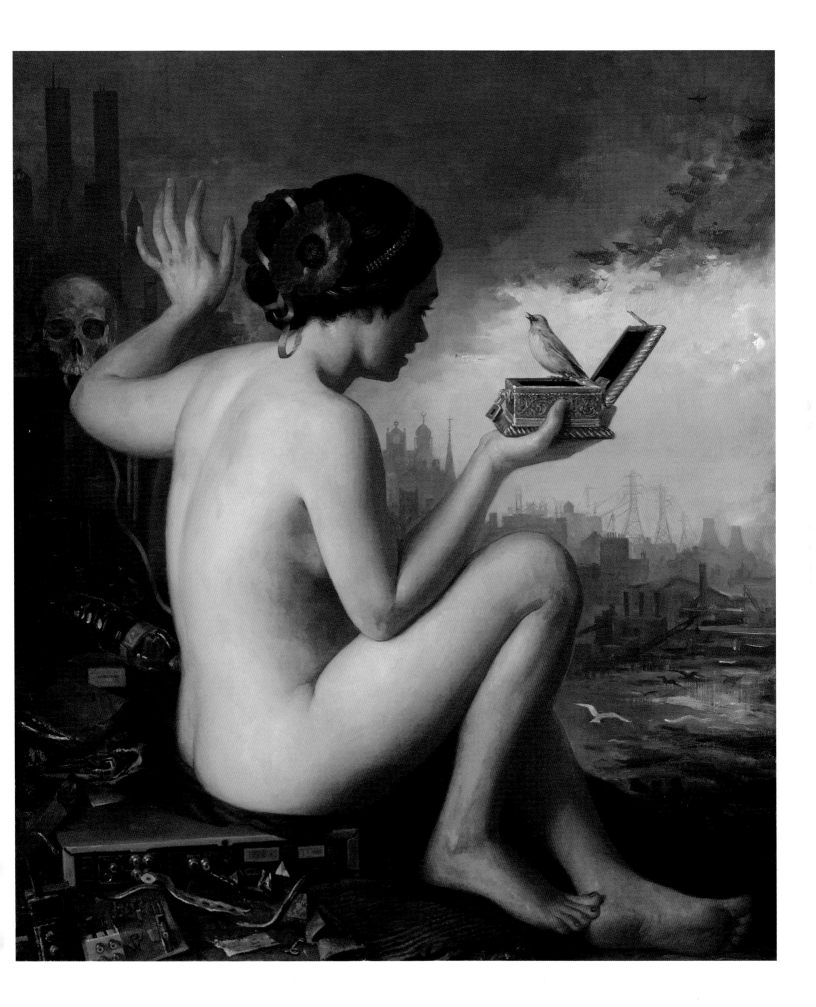

NELSON SHANKS

Nelson Shanks was an artistic icon, considered to be one of the foremost portrait painters of the twentieth century. His pedigree as a Figurative Realist was above reproach. As a young artist, he was Edwin Dickinson's monitor at the Art Students League. He studied privately with famed New York realist painter John Koch, the colorist Henry Hensche, and the renowned portraitist Pietro Annigoni in Florence.

Shanks enjoyed a very successful career as a portrait painter, receiving commissions from President William Jefferson Clinton; Diana, Princess of Wales, and Charles, Lord Spencer; His Holiness Pope John Paul II; U.S. Supreme Court judges; and many other celebrities and members of high society.

In 2002, he founded Studio Incamminati in Philadelphia with his wife, Leona, to provide a place where artists could study realistic painting with his unique understanding of Impressionist color. The school has produced some terrific artists who follow the lead of their prolific mentor. In 2013, I visited him in his studio in Gramercy Park (at that time, he had two studios, one in New York City and one in Bucks County, Pennsylvania), and can attest that there were piles of canvases literally everywhere. And the smell of *real* gum turps was a (wonderful) throwback to an earlier age. His studio practice was proof that if you want to be the very best and on top of your game, you simply have to work at your craft daily.

It was said by some that Shanks combined Pietro Annigoni's drawing skills with Henry Hensche's use of Impressionist color. As Shanks studied under both artists, it is no surprise that terrific drawing and vibrant color were always a part of his work. In the last few months of his life, he began an ambitious series of life-size paintings of belly dancers, painted from life in his Bucks County studio. He worked directly in paint, with no preliminary drawing, moving from the general to the specific, working up the entire composition at once.

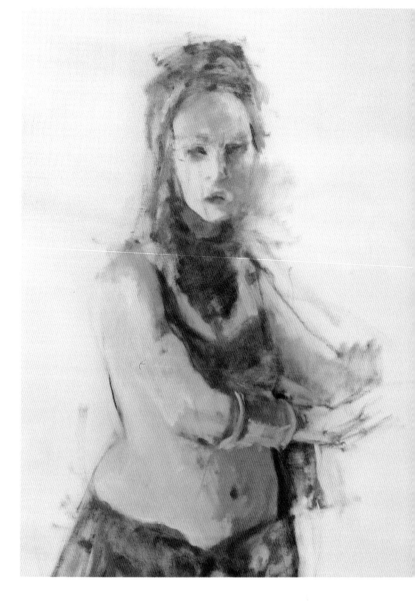

As you can see from the preliminary stage above, he lit the model with a cool light on the left and a warm light on the right, building up saturated color in both the light masses and shadows from the very beginning. He refined the drawing of the figure as he went along, while simultaneously harmonizing the balance of cool and warm light sources on the model until reaching the level of detail and finish you see in the final image.

ABOVE: Nelson Shanks, *Belly Dancer II*, 2015 (detail of start of painting)

OPPOSITE: Nelson Shanks, *Belly Dancer II*, 2015, oil on canvas, 81 x 51 inches (205.7 x 129.5 cm)

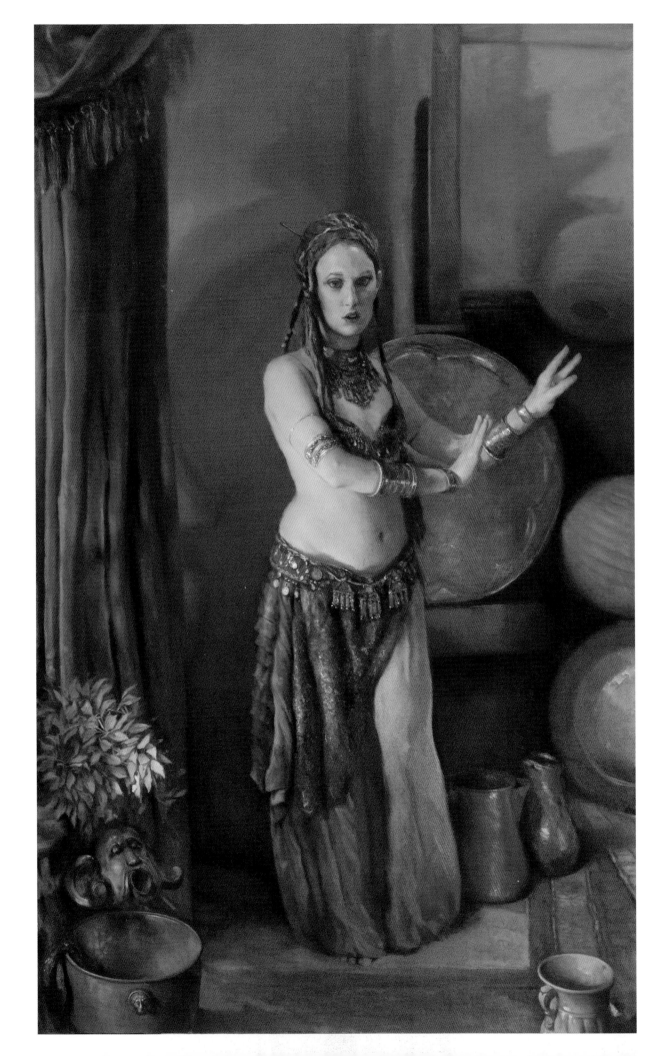

STEVEN ASSAEL

Steven Assael applies hundreds, if not thousands, of layers of paint on his large-scale compositions. He begins simply, by laying out the geometry first, and then he develops the drawing by first massing in the darks thinly and loosely. Once that is to his satisfaction, he blocks in the central figure in large, loose strokes of very bright paint. He abstains from adding detail for a very long time. Rather, he builds up the great planes of the figure, in a sculptural way, with layers of thick and thin paint.

Assael blends paint on the canvas. A lot. Over and over. He often takes a large fan brush and lays down a highlight the length of an arm, leg, or face (nothing is precious in the beginning stages) in pure white, which (if you were watching him do it) would seem much too light. But then he uses mixtures of cadmium red, yellow ocher, and burnt sienna and blends these loosely over the strip of white. And it works. Next, he might take a cadmium green and work out from the cool halftones. He is essentially creating tertiary colors not by mixing carefully on a palette, but seemingly recklessly, right on the canvas. But nothing could be further from the truth. Reckless, yes, in the sense that he risks destroying something beautiful. But Assael has a system and he makes it work. He subdues the intensity of white and all the many layers of cadmiums by mixing them together into a unified whole, with lots of broken color and texture. Then, he lets this dry. Later, he "oils out" (rubs the area with painting medium) and starts all over again.

For all of his nontraditional means of applying paint, Assael follows a very traditional progression, from general to specific, from a planar to a rounder surface morphology. He just happens to do so in a very idiosyncratic way. His figures have a monumentality and luminosity to them that is rare and best seen in person because of the many areas of "broken color," the result of his use of a layering effect where patches of color from previous layers are visible through subsequent ones.

TOP RIGHT: Assael begins his painting by working out a geometric grid for his composition.

BOTTOM RIGHT: He then blocks out the figures, sculpting their largest planes and forms first.

OPPOSITE: Steven Assael, *Bridal Preparation*, 2015, oil on canvas, 68 x 68 inches (172.7 x 172.7 cm), copyright © Steven Assael, courtesy of Forum Gallery, New York

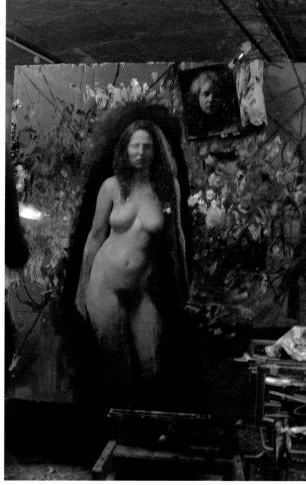

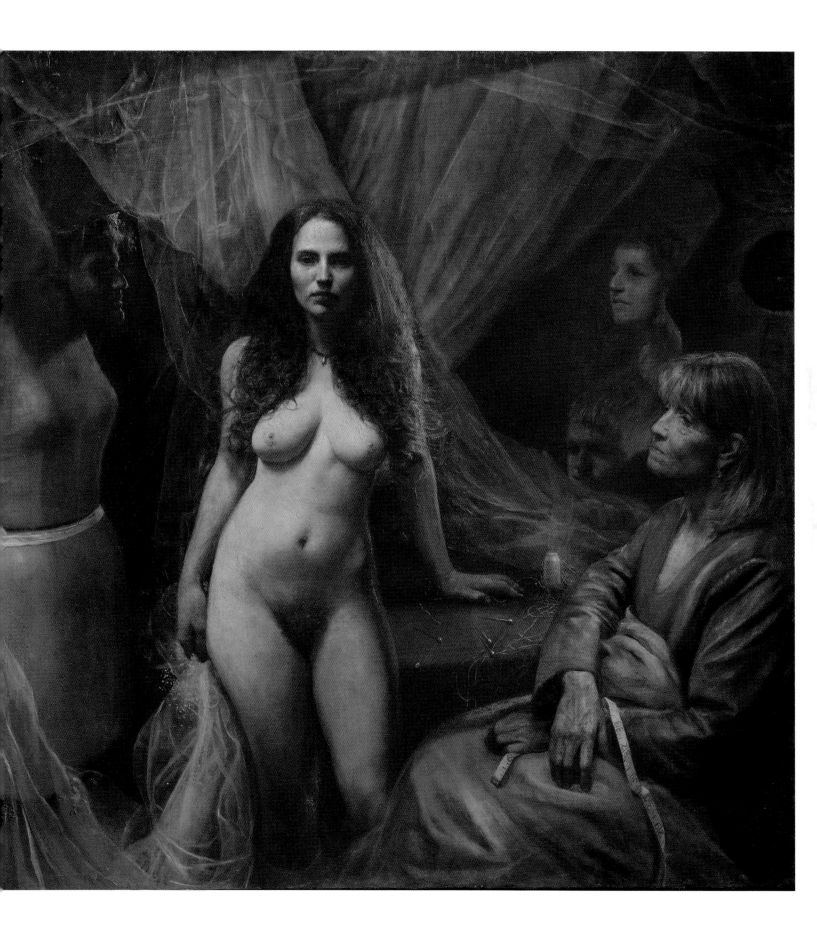

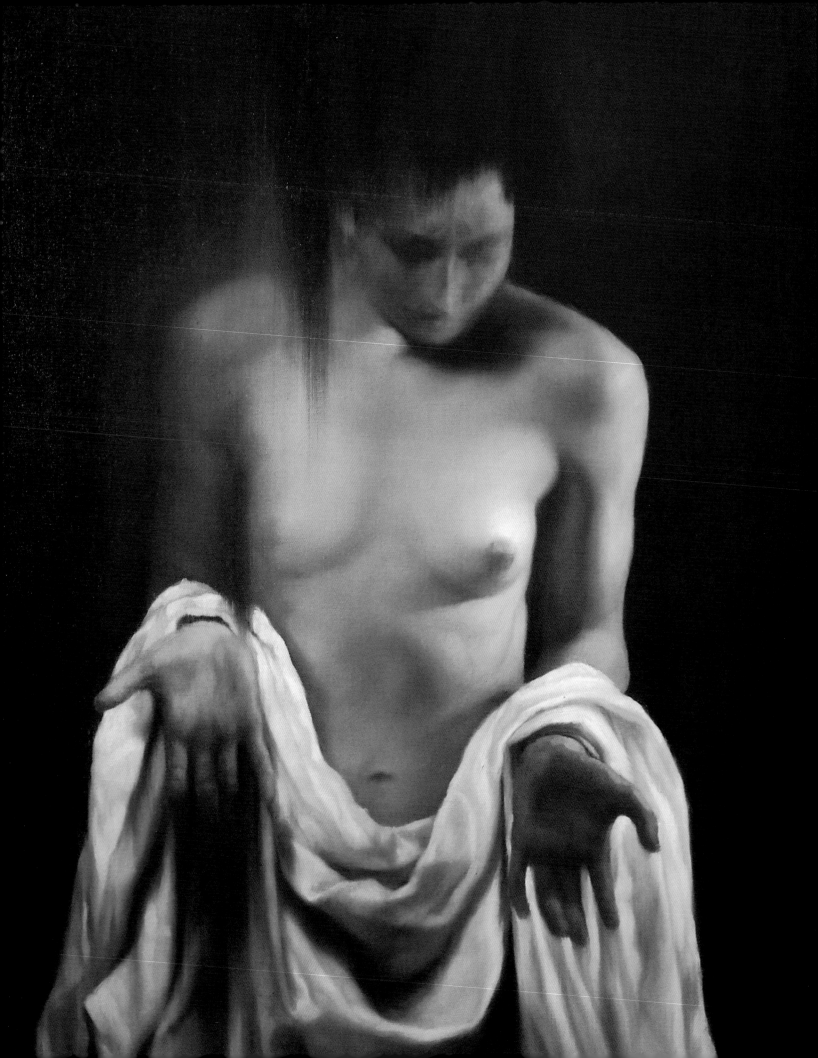

MARIA KREYN

Maria Kreyn uses religious and spiritual iconography in a very personal way, with themes and compositions that often seem to come from classical Greek sculpture. She seems to channel the heavy forms and simplicity of the Severe Style, which ran from about 490 to 450 B.C. Kreyn's images show a fusion of how she perceives the spiritual dimension and that of this reality. One of the ways Kreyn does this is with her symbolic use of light, which seems not to come from just a physical light source, but from the spiritual one.

An excellent draftsman, she often begins with herself as a main character, looking into a mirror or working from a photograph of herself in a certain pose. But she then transcends herself, beyond the reference, to create a character in a more metaphysical realm. Hers are not drawings of real people, but rather of spiritual beings, shamanistic in nature. Trappings of traditional Western Christian iconography, such as a vaulted cathedral or a saint kneeling in prayer, may be present in the scene, and her works often feature lots of drapery, but the theology is different. Her figures are more like classical deities who are powerful spiritually but also human in personality. The Greek goddesses had complicated alliances and antagonisms, and there is a sense of that in Kreyn's figures.

These are two unique works of art that are related to each other. The drawing came first, then the painting. The shifts in the position of the head, hands, and drapery are noteworthy, as is the cropping. Also, the heads seem to be out of focus to the viewer. The protagonist is focused on her own spiritual world.

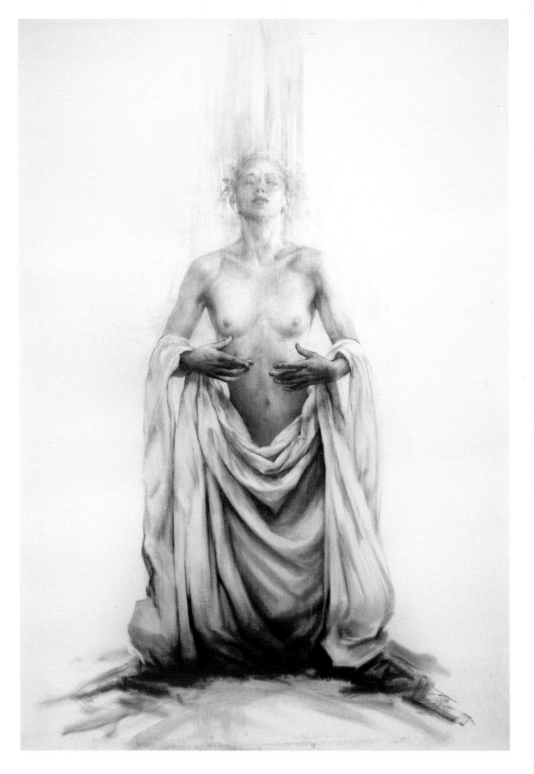

OPPOSITE: Maria Kreyn, *The Sieve*, 2015, pencil and charcoal on paper, 33 x 26 inches (83.8 x 66 cm)

ABOVE: Maria Kreyn, *Rising*, 2015, oil on linen, 80 x 54 inches (203.2 x 137.2 cm)

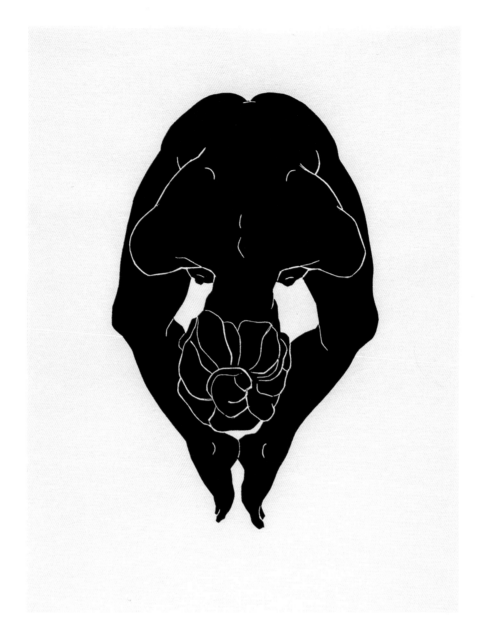

CHRISTIAN JOHNSON

Christian Johnson has tapped into artistic threads from early Modernism or Premodernism, but forged his own process. His designs for the figure are highly original and sophisticated as a result. He uses flat space and shapes not unlike Japanese prints from the Edo and early Meiji Periods, but his understanding of mark-making is rooted in the Western tradition. One can see traces of some of the great Fin de Siècle artists (such as Egon Schiele and Gustav Klimt) and Symbolists (like Odilon Redon), but Johnson has developed his own unique language for the figure, anatomy, and concept of space. Aesthetically, his palette can perhaps be best described as "Zen gray," reminiscent of the gray encaustics of Jasper Johns.

Here we see both a stenocut print and a large acrylic painting. His figures inhabit a quiet, very personal space while being quite formal in a design sense. One could say that Johnson uses the figure as a means of meditation on both.

ABOVE: Christian Johnson, *Twelve Easy Pieces, No. 1*, 2010, stenocut, 16 x 12 inches (40.6 x 30.5 cm)

OPPOSITE: Christian Johnson, *Untitled*, 2013, acrylic, ink, and graphite on canvas, 60 x 48 inches (152.4 x 121.9 cm)

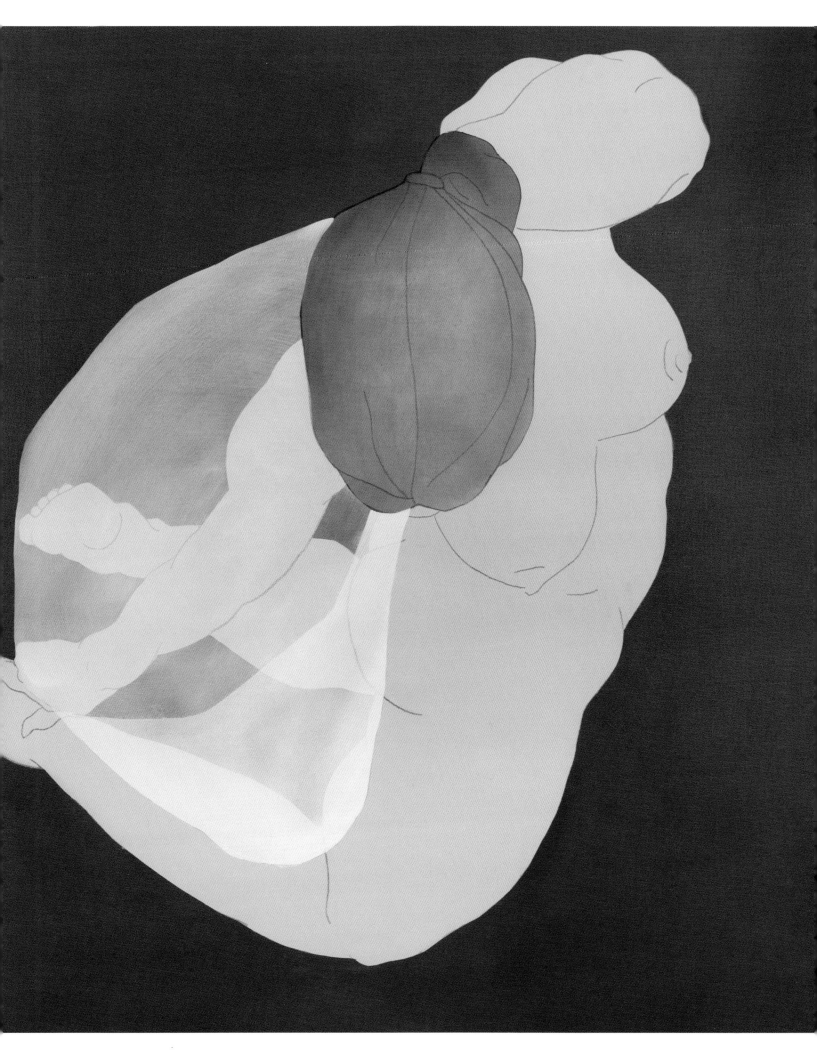

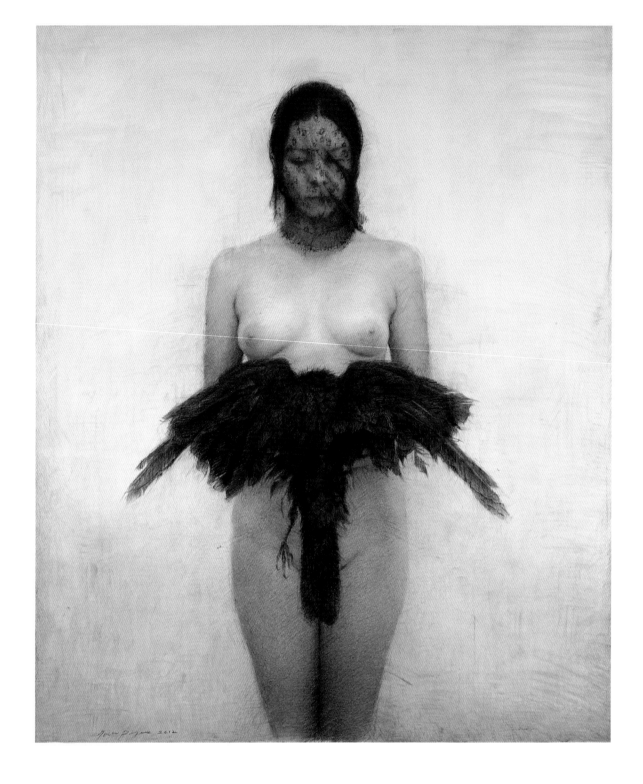

JULIO REYES

Julio Reyes uses the figure in a highly symbolic manner to convey thoughts about personal space and meaning. His work often features people who are in a moment of quiet introspection. He does not go for huge, heroic narratives or overly spartan ones, but rather, he favors depicting ordinary figures in extraordinary circumstances. Surrealism, allegory, and symbolism all make their way into his drawings and paintings. He also admires the connection between people and their environment that is found in the work of Andrew Wyeth.

In his words: "I found this crow literally on my doorstep one morning. I think a hawk had impaled it and it fell out of the tree in my front yard. It was stunningly perfect, enormous, and powerful. Its claws were like

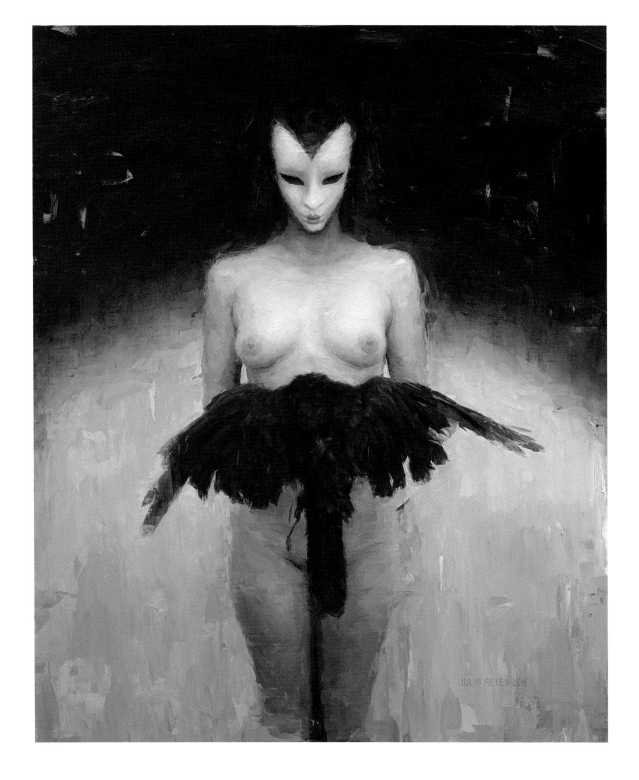

black armor and its feathers shimmered like an oil slick. I was truly blown away. It's not often you get to marvel so closely at something so majestic."

These two works offer two different treatments of that experience. The enigmatic drawing features a veiled face with an incredibly light touch. The painting removes the figure's face entirely, and puts the focus, and the light, on the figure's breasts and the crow. Sex and death, or sex and life, or both?

In Reyes's words: "I see flawed people capable of great heroism, who struggle quietly doing what human beings have done for centuries—trying their best to find meaning in what is often a very tough world."

OPPOSITE: Julio Reyes, *Black Veil*, 2014, charcoal on paper, 35 x 29 inches (88.9 x 73.6 cm)

ABOVE: Julio Reyes, *Enigma*, 2014, oil on aluminum panel, 35 x 29 inches (88.9 x 73.6 cm)

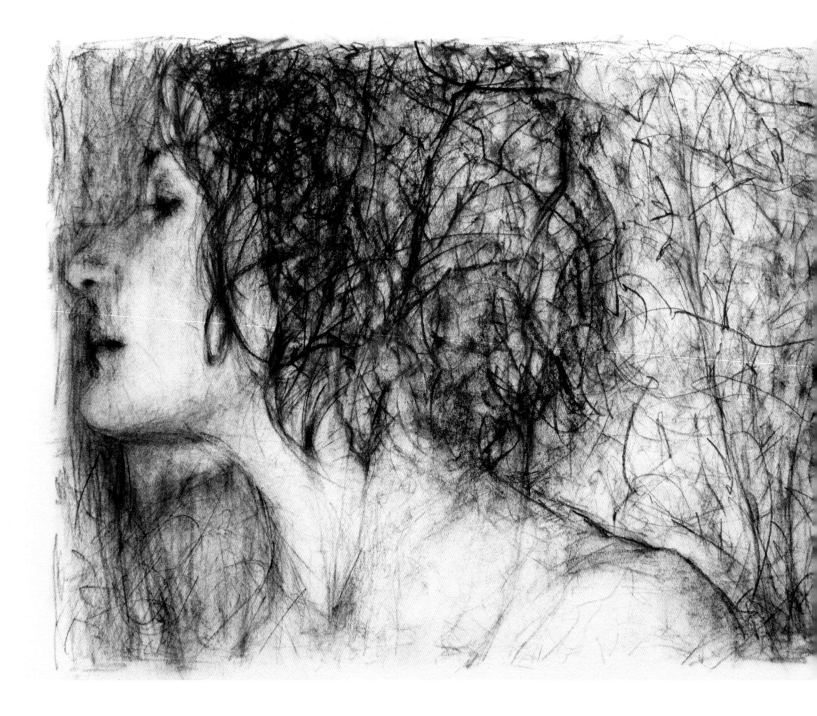

ALYSSA MONKS

During the development of Alyssa Monks's composi-
tions, the figure unravels and deconstructs itself until it
borders on abstraction. She accomplishes this by using
traditional materials, oil paint on canvas, and following
a traditional method of working. But the effect is con-
temporary. She achieves extremes of texture and color
by pushing the imagery to its breaking point, where
representational painting and abstraction meet. In her

painting *Assimilate* (pages 290–291), thick paint strokes
in delicate color relationships are pushed and pulled to
imitate flesh, hair, leaves, branches, and sky. The overall
effect is tactile in nature, the colors conveying emotional
qualities. Hers is a sensual realism, one that's Dionysian,
not Apollonian.

Technically, Monks's work relies on many layers of
opaque and transparent paint to achieve these effects.

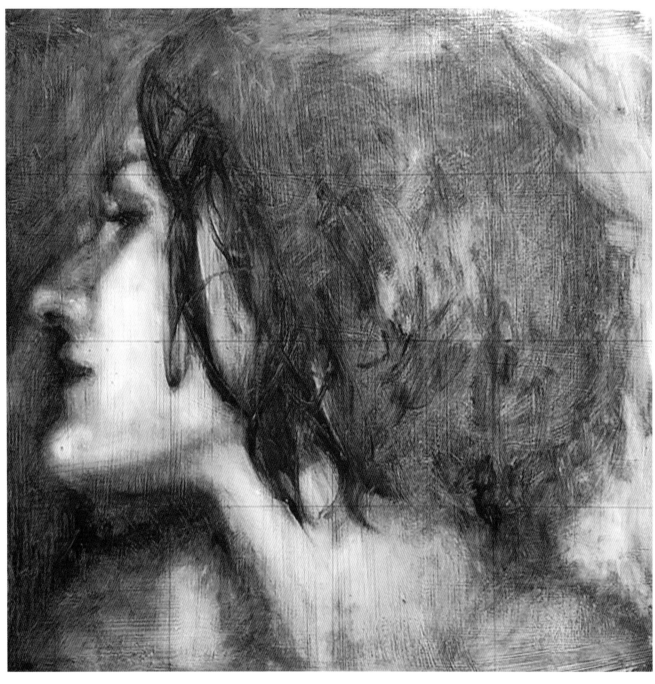

She starts off with a loose drawing in charcoal, then an *imprimatura* (shown above) using one evenly applied warm tone from which she then rubs out the lights. Monks does this until the image "appears." She does not use hard edges at this stage and stays away from any detail.

OPPOSITE: Alyssa Monks, *Study for Assimilate,* 2015, charcoal on paper, 16¼ x 22½ inches (41.3 x 57.2 cm)

ABOVE: Alyssa Monks, *Small Study for Assimilate,* 2016, oil on panel, 10 x 10 inches (25.4 x 25.4 cm)

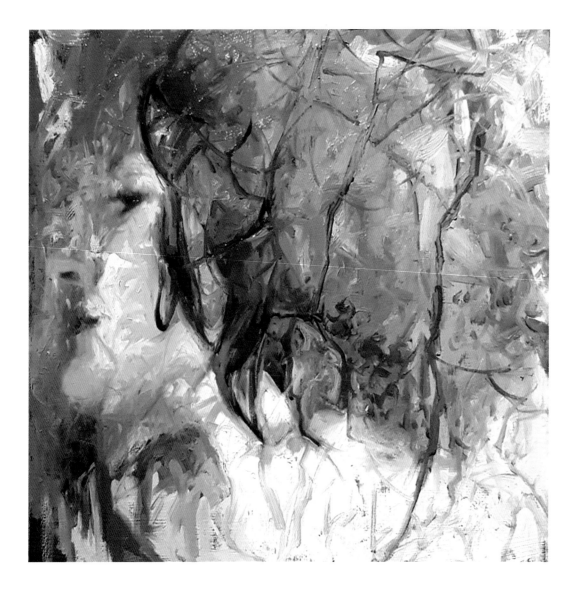

In the second pass she establishes space, volume, and texture, as you can see above. The brushstrokes come in with as accurate a color choice as possible, with subtle transitions and still not much detail. In the final layers she works in the details with vibrant and thick brushstrokes, enhancing the color in opaque and transparent glazes. Her intention is to pull something out of the painting into clarity. She has described the process as having the painting "speak" to her and following where it leads.

ABOVE: Alyssa Monks, *Finished Small Study for Assimilate*, 2016, oil on panel, 10 x 10 inches (25.4 x 25.4 cm)

RIGHT: Alyssa Monks, *Assimilate*, 2016, oil on linen, 56 x 56 inches (142.2 x 142.2 cm)

FRANK FRAZETTA

Frank Frazetta is widely considered to be the most influential and most emulated fantasy artist in history. As I am giving the great illustrators equal weight in this book, I think he belongs in the conversation. Conan the Barbarian was one of Frazetta's most famous characterizations, done for a series of fantasy books by Robert E. Howard. This painting was made for the cover of *Conan the Usurper*. It would be impossible to calculate how much of an influence he has had on subse-

quent generations of illustrators and artists (the author included). Here we see a watercolor study, a gouache study, and a final oil painting. The jump in detail to the final version is astonishing, but the basic concept is visible at every stage. The position of the snake, relative to Conan, shifts to a diagonal by the second image. There were more stages to the process, but these are all that are left in the archives of the Frazetta Art Museum, which graciously shared them.

Frazetta taps into the excitement and fun of the Baroque in a way that few contemporary artists have ever done outside the fantasy sci-fi world. It is interesting that certain modalities are acceptable for illustration and not for fine art, as we discussed in chapter 1.

According to Frank Frazetta Jr., it was not uncommon for Frank Sr. to do a complete sketch-to-finished composition in a twenty-four-hour period. He normally had a thirty-day deadline. Due to his heavy workload, he would often start the painting later in the month and rush to get it to the publisher on time. When it was returned, he would place it on his easel and assess it for possible improvement. If needed, he would repaint it, based on his own criteria. The job was done and paid for, but this

was his craft and he was proud of it. His normal habit was to sit down with a cup of coffee, turn on a baseball game, and get to work. Usually within a few hours or by the following morning, a totally new painting would be sitting on his easel, painted on top of the old one.

ABOVE LEFT: Frank Frazetta, *Conan the Usurper*, 1967, watercolor on paper, 10 x 8 inches (25.4 x 20.3 cm), courtesy of the Frazetta Art Museum, East Stroudsburg, Pennsylvania

In this stage, the relationship between Conan and the serpent is straight up and down, and the light is on the foreground.

ABOVE RIGHT: Frank Frazetta, *Conan the Usurper*, 1967, gouache, 10 x 8 inches (25.4 x 20.3 cm), courtesy of the Frazetta Art Museum, East Stroudsburg, Pennsylvania

Here, we see a diagonal shift in the relationship of the figures and the shift to a dark ground with light hitting the figures. The detail on the snake is worked out also.

OPPOSITE: Frank Frazetta, *Conan the Usurper*, 1967, oil on canvas, 23 x 17 inches (58.4 x 43.2 cm), courtesy of the Frazetta Art Museum, East Stroudsburg, Pennsylvania

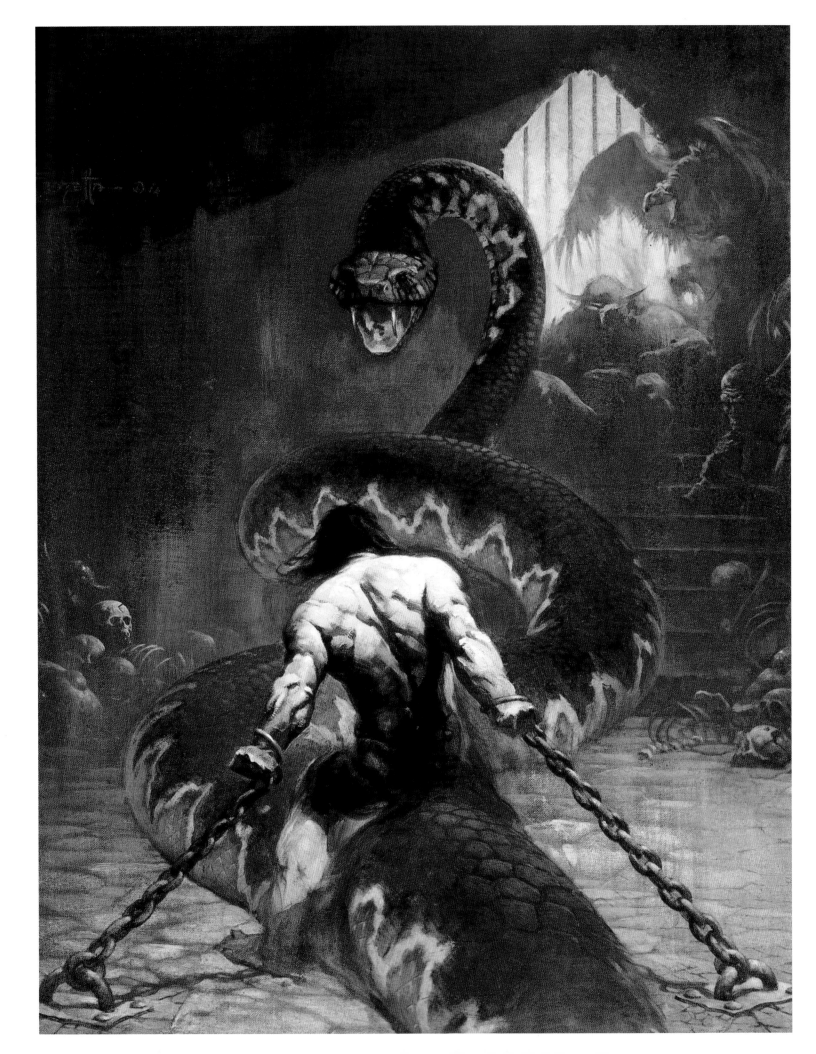

ADAM MILLER

Adam Miller's paintings are a mix of mythology, ecology, and Humanism. He's equally inspired by late Italian Mannerism, the Baroque, and Thomas Hart Benton. His narratives are Hellenistic in that they take a polytheistic approach to contemporary folklore. Simultaneously committed to Humanism and antiauthoritarianism, Miller questions our modern gods of progress and technological change and addresses the struggle to find meaning. Using his incredible drawing and painting skills, Miller creates large,

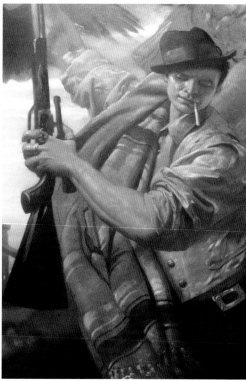

multiple-figure compositions about the modern dilemma of a civilization and culture at odds with Earth.

Miller's working methods are a fusion of traditional and contemporary approaches. He begins by making small thumbnail sketches. He then photographs costumed models in the desired poses, and does Photoshop mock-ups to assemble the composition. Next, he does a careful drawing of the entire scene, followed by a small color study. Miller then begins to work in grisaille, using raw umber and white oil paints. After working out his composition in monochrome, he then applies layers of color.

As with the artists of the Italian Renaissance, Miller's vision and theology drive his work, informing his compositional choices. His theology happens to be Humanism. The two paintings featured in this book, *Apollo and Daphne* (shown on page 77) and *The Roses Never Bloomed So Red*, come from his *Twilight in Arcadia* series. *The Roses Never Bloomed So Red* offers Miller's contemporary inversion (and update) of a traditional narrative—namely, the defeat of Satan by the archangel

Michael. But in Miller's version, a hunter takes the place of Michael, a female satyr that of the devil. The supposed savage is about to be violently abused by Progress. But, as you look around the composition, we are no longer in an Arcadian paradise. We see the bleakness of the "developed" landscape. We see the savagery in the destruction of the wild and free by the "civilized." The traditional religious narrative and composition is turned on its head. We end up siding with the female satyr and what she represents: our lost wildness and untamed nature, pre-Enlightenment, pre–Industrial Revolution, pre–technological revolution.

ABOVE LEFT: This color study was underpainted in the same transparent umbers as the final painting.

ABOVE RIGHT: Here, we see Miller just beginning to apply color over the grisaille underpainting.

OPPOSITE: Adam Miller, *The Roses Never Bloomed So Red*, 2013, oil on canvas, 96 x 60 inches (243.8 x 152.4 cm)

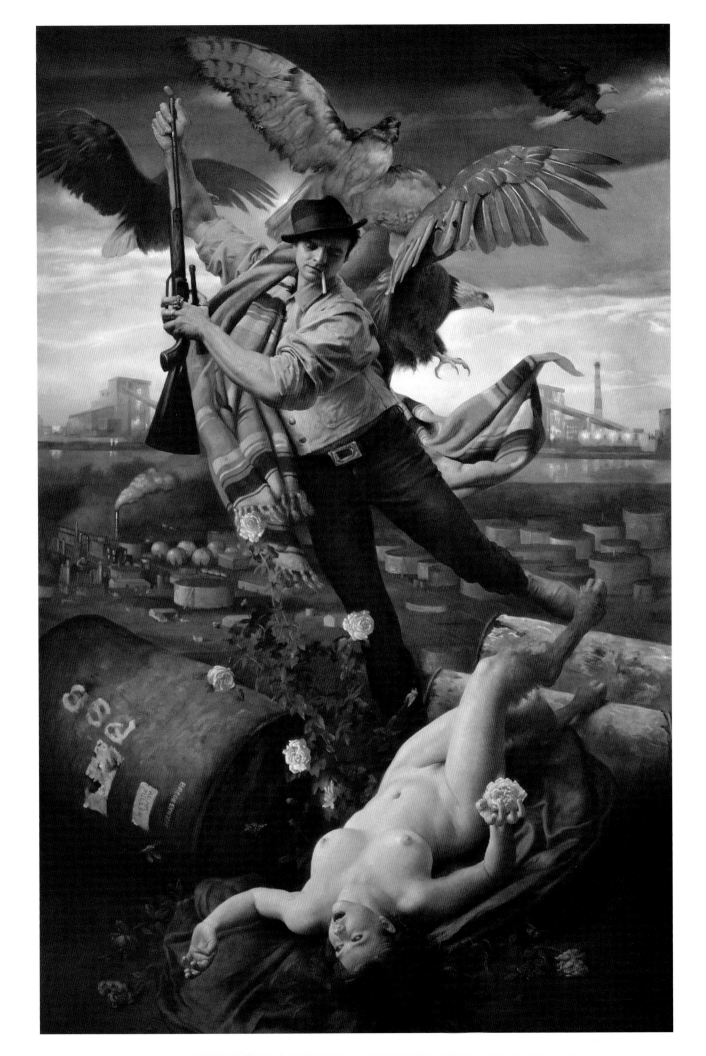

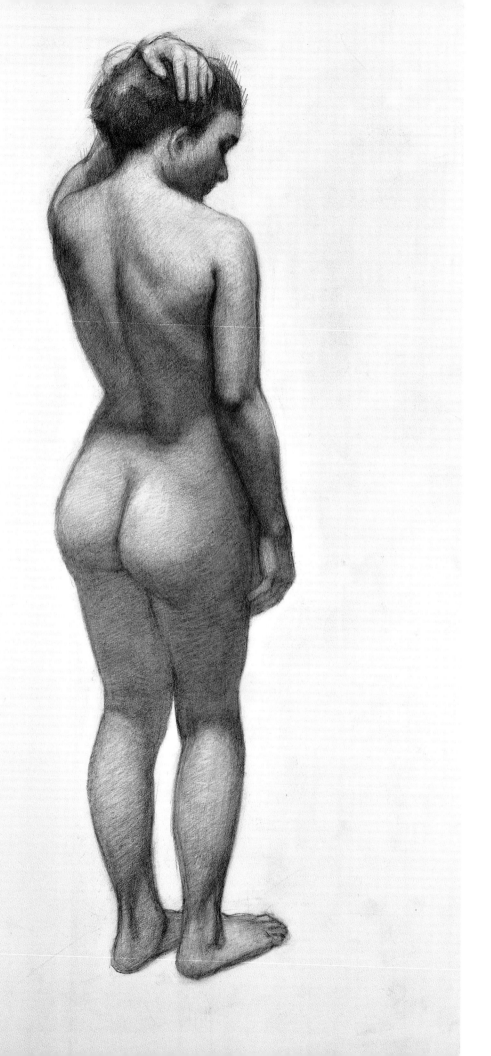

AFTERWORD

BY KURT KAUPER

Twenty years ago, while teaching at the School of the Museum of Fine Arts in Boston, I overheard my colleague Ron Rizzi tell another faculty member that, in his opinion, "traditional drawing techniques are both fundamental *and* profound." Such a simple and, on its surface, self-evident observation. In starting this afterword, I thought about that comment again. It occurred to me that although traditional structural, spatial figure-drawing skills are valuable in achieving mimetic representation, it is their "profound" intellectual and poetic potential that is ultimately most important for artists.

To be sure, the basic techniques Rob explains with such lucidity in this terrific book—linear perspective, the projection of volumes in space, understanding the human body as a geometric structure, the complexities of anatomy, the logic of light and shadow, etc.—allow an artist to attain a vastly greater illusion of the real than had been possible before their development during the Italian Renaissance. And yet, far beyond that, they themselves generate—they don't simply contain—the richly rhetorical, complex visual poetics of Western art, communicating content in a way unavailable to the medieval artist, whose work functioned primarily on a discursive register, inscribed like text across a flat picture plane. With the advent of artistic illusionism, however, content could be communicated so that the discursive aspect of the work was subordinated to the physical and visual experience of engaging with an elaborately layered illusionistic scene. Viewers experienced content as if they themselves had come upon it in life, instead of having passively received it from an authoritative source.

Anybody with more than a cursory knowledge of Western art since the Renaissance knows that illusionism isn't manifested only in perspectively, tonally, and atmospherically consistent imagery. Traditional drawing fundamentals, modified since the late nineteenth century to support newer visual paradigms, don't have to precisely mirror the pictorial devices of art before Modernism to have great poetic and narrative potential.

This was reinforced for me in 2012 when I visited the Willem de Kooning retrospective at New York's Museum of Modern Art with my friend the painter Dik Liu. Not being a huge admirer of de Kooning, I went to the show to encounter an artist whose importance I nevertheless acknowledged. But I left transformed, and have loved de Kooning ever since. I was most impressed by his *Woman #3*. Dik and I both remarked on the intricacy of de Kooning's deployment of structure and space. We followed the deeply convincing spatial movement from the vertical plane of the figure's lower legs to the backward drop of her lap (with its cannily placed perspectival triangle) to the broad sweep of paint that articulates the torso's volume to the vertiginous rearward movement along the oblique angle of the chest plane to the head

OPPOSITE: Rob Zeller, *Lilly*, 2011, pencil on paper, 24 x 18 inches (60.9 x 45.7 cm)

sitting farther back in exaggerated atmospheric perspective. The massive figure decisively occupies a location in front of louverlike planes in the background above her right shoulder and hazy, indeterminate marks above her left. The tension between volume, space, and surface is maintained throughout. De Kooning's paintings may, on a first viewing, seem chaotic, even arbitrary; they foreground gesture and material; they are composed of marks that confirm the picture's two-dimensionality. And yet, traditional structure, volume, and space assert themselves with great clarity: Line, shape, surface, and color have a weight and presence of their own—we experience them for what they are, instead of what they refer to—while unmistakably representing a female figure who dominates not only the pictorial space but also the viewer's space (undermining, in my opinion, any accusation that the *Woman* series is misogynistic). While adhering to the critic Clement Greenberg's insistence on flatness and materiality, the formal elements in de Kooning's work deliver a physical and psychological richness, not to mention a narrative range, that one spatial mode alone wouldn't accomplish.

De Kooning's *Woman* paintings are reductive and gleefully hedonistic; brutal and beautiful; recessive and progressive; profound and silly. They assert the polemical aesthetics of their time (the 1950s) while blithely dismissing them. De Kooning's knowledge of and thorough training in traditional drawing allowed him to make paintings that eschewed conventional ways of understanding art without ever becoming conventional themselves.

After spending much time admiring *Woman #3*, Dik said to me, "Very few people would talk about paintings this way anymore." That's probably true. The role of traditional drawing in devising the poetic content of a painting is rarely considered by most viewers of art, professional or amateur. Dik's observation underlines what I consider most valuable about Rob's book: not simply that it carries on the heritage of great drawing manuals, from Albrecht Dürer through Harold Speed; not simply that it will help artists create highly refined, illusionistic imagery; not simply that, as teachers used to say, one must learn to draw traditionally before one can "break the rules." Instead, it is because traditional drawing skills can, in the hands of the right artist, generate a visual language that is richly evocative and persuasive, no matter how he or she chooses to use them. Rob's book helps ensure that those particular visual poetics will remain an important part of our consciousness.

KURT KAUPER
Associate Professor, Painting, Queens College
(City University of New York), Queens, New York

SELECTED BIBLIOGRAPHY

There are so many great books on the subject of figure drawing and painting they are too numerous for me to list here. Please consider this small sampling as a go-to list of the books that I teach from regularly, and that I recommend to my own students.

FIGURE DRAWING INSTRUCTION

Loomis, Andrew. *Figure Drawing for All It's Worth*. London: Titan Publishing, 2011.

Originally published in 1943, this one of the best books on figure drawing ever. It is, however, geared toward artists working in the advertising field, not the fine arts.

Ryder, Anthony. *The Artist's Complete Guide to Figure Drawing*. New York: Watson-Guptill, 2000.

This guide provides an incredible explanation of working perceptually from the live model.

Speed, Harold. *The Practice and Science of Drawing*. Mineola, New York: Dover Publications, 1972.

Speed uses a very practical guide to develop drawing strategies, although the text can be dense at times.

Vanderpoel, John H. *The Human Figure*. Mineola, New York: Dover Publications, 1958.

This book includes beautiful, tasteful illustrations along with highly detailed text.

ANATOMY AND CONSTRUCTION

Bammes, Gottfried. *Die Gestalt des Menschen*. Ravensburg, Germany: Ravensburger Buchverlag, 1995.

Bammes's diagrams are great at illustrating a structural conception of the figure. The text is in German.

_____. *Sehen und Verstehen*. Ravensburg, Germany: Ravensburger Buchverlag, 1992.

This book features Bammes's classroom chalkboard drawings, and his students' classwork done under his instruction. This is an incredibly great resource for a figure-drawing teacher. The text is in German.

Bridgman, George B. *Bridgman's Complete Guide to Drawing from Life*. New York: Sterling, 2009.

A beautiful, highly stylized concept of drawing the figure in a structural way.

_____. *Constructive Anatomy*. New York: Sterling, 1973.

Originally published in 1920, this was the go-to guide for the structural approach to anatomy for most of the twentieth century. The illustrations are beautiful and a great learning tool for students to copy.

Fagin, Gary. *The Artist's Complete Guide to Facial Expression, 2nd edition*. New York: Watson-Guptill, 2008.

A terrific book for understanding how the face works. Like any other part of the body, to draw the face accurately, one needs to understand the muscles and structure underneath the skin.

Goldfinger, Eliot. *Human Anatomy for Artists*. New York: Oxford University Press, 1991.

This book provides the best diagrams for moving from a skeletal concept to a muscular one, and then finally to an actual model. The text is incredibly informative.

Osti, Roberto. *Basic Human Anatomy*. New York: The Monacelli Press, 2016.

Osti is another terrific structural anatomist, with the advantage over Bammes being his text is in English. His block system matches up with mine perfectly. Our differences lie in the way surface modeling is handled.

AESTHETICS AND ARTISTIC PRACTICE

Bayles, David and Ted Orland. *Art and Fear*. Eugene, Oregon: Image Continuum Press, 2001.

Bayles and Orland create a great book on how to keep making art after finishing art school. Being an artist is not an easy vocation, but this book provides strategies on how to make it work.

Clark, Kenneth. *The Nude*. New York: Doubleday, 1972.

This is a terrific book about the history of the figure. If you enjoyed my brief treatment of art history in this book, then look to Clark's book for a more in-depth exploration.

Leonardo da Vinci. *A Treatise on Painting*. Amherst, New York: Prometheus Books, 2002.

A wonderful although somewhat controversial collection of Leonardo's teachings originally compiled by Leonardo's students in 1540.

Saunders, Frances Stonor. *The Cultural Cold War*. New York: The New Press, 2013.

A very interesting read that explores exactly what factors came into play to wipe realistic painting out of the art market for nearly 50 years of the twentieth century.

ILLUSTRATION CREDITS

STEVEN ASSAEL
94, 112, 113, 131,
173, 184, 185, 211,
280, 281

CRAIG BANHOLZER
134, 194, 195

COLLEEN BARRY
130–131, 155, 171

BO BARTLETT
14–15

DAVID BELL
186, 187

GEORGE BELLOWS
64

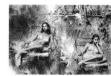

KENT BELLOWS
176–177

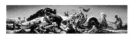

THOMAS HART BENTON
66–67

CANDICE
BOHANNON
217

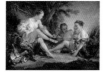

FRANÇOIS BOUCHER
44–45

GEORGE BRIDGMAN
93

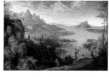

PIETER BRUEGHEL
THE ELDER
28

NOAH BUCHANAN
86–87, 92, 250, 251

MICHELANGELO BUONARROTI
32, 33, 88

SHERRY CAMHY
179

CARAVAGGIO
36–37

ALEAH CHAPIN
254, 255, 256–257

GUSTAVE COURBET
53

LUCAS CRANACH
THE ELDER
27

JOHN CURRIN
260, 261

JACQUES-LOUIS DAVID
48

GEORGE DAWNAY
153

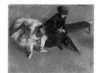

EDGAR DEGAS
56

EUGÈNE DELACROIX
50–51

EDWIN DICKINSON
69

CARL DOBSKY
172

MICHELE DOLL
270, 271

HOLLIS DUNLAP
125

ALBRECHT DÜRER
98

RANDALL EXON
76

ERIC FISCHL
72, 73

ZOEY FRANK
122, 156, 157

FRANK FRAZETTA
292, 293

LUCIAN FREUD
262, 263

MICHAEL FUSCO
200–201

ANN GALE
244, 245

DAVID GLUCK
154

SUSAN HAUPTMAN
216

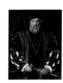

HANS HOLBEIN THE
YOUNGER
29

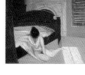

EDWARD HOPPER
67, 68

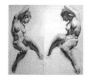

SABIN HOWARD
95, 99, 103, 159

JEAN-AUGUSTE-
DOMINIQUE INGRES
47

CHRISTIAN JOHNSON
284, 285

ALEX KANEVSKY
170, 196, 197

DAVID KASSAN
1

KURT KAUPER
266, 267

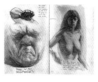

EVAN KITSON
188, 189

GUSTAV KLIMT
60

KÄTHE KOLLWITZ
59

MARIA KREYN
78, 282, 283

KRISTIN KÜNC
236

BRAD KUNKLE
246, 247

LEONARDO DA VINCI
34, 35

J. C. LEYENDECKER
63

ANDREW LOOMIS
128, 129

DANIEL MAIDMAN
178, 202, 203

SIMONE MARTINI
23

MASACCIO
31

MASTER OF GUILLE-
BERT DE METS
25

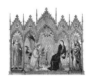

LIPPO MEMMI
23

ADAM MILLER
77, 294, 295

ALYSSA MONKS
288, 289, 290, 291

JENNY MORGAN
235, 264, 265

ODD NERDRUM
79, 268, 269

ASHLEY OUBRÉ
160, 174

GUNO PARK
198—199

MAXFIELD PARRISH
62

POLYKLEITOS
19

JACOPO PONTORMO
89

CHRISTOPHER PUGLIESE
127, 158—159, 252, 253

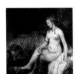

REMBRANDT
40

JULIO REYES
161, 175, 286, 287

NORMAN ROCKWELL
70—71

AUGUSTE RODIN
57, 58

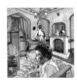

MATT ROTA
75

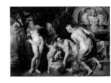

PETER PAUL RUBENS
12, 38—39

CAMIE DAVIS SALAZ
248, 249

DAVID SALLE
74

EGON SCHIELE
61

NELSON SHANKS
278, 279

JOHN SLOAN
65

DANIEL SPRICK
123

SHARON SPRUNG
234

DAN THOMPSON
124, 152

DORIAN VALLEJO
190—191

NICOLA VERLATO
272, 273

JOHN WILLIAM
WATERHOUSE
54—55

PATRICIA WATWOOD
176, 276, 277

ANTOINE WATTEAU
42—43

ANDREW WYETH
241, 242—243

JASON BARD
YARMOSKY
238, 258, 259

ELIZABETH
ZANZINGER
126

ROB ZELLER
2—3, 5, 8, 11, 80, 83,
84, 85, 91, 97, 100,
101, 102, 104, 105,

106, 107, 109, 110,
111, 114, 115, 116,
117, 118, 119, 120,
132, 135, 136, 138,

140, 141, 142, 143,
145, 146, 147, 149,
150, 162, 164,

165, 167, 168—169,
180, 182, 183, 192,
193, 204, 206, 208,

209, 210, 212, 213,
214—215, 218, 221,
222, 223, 224, 225,

226, 227, 228, 229,
230, 231, 232, 233,
237, 274, 275, 296

INDEX

Page numbers in *italics* indicate illustrations